LIQUIDITY, FLOWS, CIRCULATION

LIQUIDITY, FLOWS, CIRCULATION

THE CULTURAL LOGIC OF ENVIRONMENTALIZATION

EDITED BY
MATHIAS DENECKE, HOLGER KUHN, MILAN STÜRMER

DIAPHANES

GEFÖRDERT DURCH DIE DEUTSCHE FORSCHUNGSGEMEINSCHAFT (DFG)—PROJEKTNUMMERN 2114
UND 2252—UND MIT FREUNDLICHER UNTERSTÜTZUNG DER UNIVERSITÄT BIELEFELD
FUNDED BY THE DEUTSCHE FORSCHUNGSGEMEINSCHAFT (DFG, GERMAN RESEARCH FOUNDATION)
—PROJECTNUMBERS 2114 AND 2252—AND SUPPORTED BY BIELEFELD UNIVERSITY

ISBN 978-3-0358-0481-2

LAYOUT AND PREPRESS: 2EDIT, ZURICH
PRINTED IN GERMANY

WWW.DIAPHANES.COM

Contents

Mathias Denecke, Holger Kuhn, Milan Stürmer

Introduction

The Cultural Logic of Environmentalization

Today, it has become a truism that capital *circulates*, that data, populations and materials *flow*, that money offers *liquidity*. These terms appear crucial for any description of our contemporary situation, whether in economics, media studies, or contemporary art. This book asks whether the preponderance of talk of flow, liquidity, and circulation is an expression of the cultural logic of today's environmental capitalism.

In the context of financial economics, flow and liquidity primarily function as technical terms, having mostly lost their status as a metaphor: flows—as opposed to stocks—are those economic variables that have a time dimension (income, debt repayment, exports...) and liquidity is a property of an asset describing how easy it is to turn it into money. Yet, occasionally their metaphorical qualities are revitalized in order to, for example, focus our attention away from the lofty descriptions of market processes to the complex ecologies of mundane payment infrastructures. Focusing on the infrastructure for financial flows foregrounds a fee-based model of the economy where those in control of the financial infrastructure can charge transaction fees and penalties.[1] For the last few decades, as Bill Maurer puts it, "the money in money, so to speak, has been in fees."[2] Instead of focusing on speculation, preemption and financial performativity, those

1 See Michael Hudson, *The Bubble and Beyond: Fictitious Capital, Debt Deflation and the Global Crisis* (Dresden: Islet-Verlag, 2012).

2 Bill Maurer, "Late to the Party: Debt and Data," *Social Anthropology* 20, no. 4 (2012), pp. 474–481, here p. 475.

liquid metaphors constantly remind us that nothing flows without being regulated. It is no coincidence that "payment professionals name these [payment] infrastructures 'pipes'" as "private and public entities have built a series of channels complete with portals, locks, sieves and dams."[3]

In cultural and media studies, the vocabulary of flow, circulation, and liquidity grasps the specificity of our technologically conditioned world. The unanimous use of those words serves to describe the processual character of a networked globe connected through unimpeded flows of data.[4] For cultural scholar Antoinette Rouvroy, computational media essentially condition today's capitalism. Especially "digital and capitalistic flows," Rouvroy contends, produce "the fluidity of our techno-capitalist reality."[5] Such fluidity designates a mode of control exerted through media environments which is characterized by the totalizing logic of binary code. A world in flow, then, is synonymous with the indifference of always calculable and controllable persons, objects, and goods. In this "numerical, calculable reality,"[6] we have lost contact with a solid ground which provided us with

3 Ibid., p. 476.
4 See for example Mark B.N. Hansen, "Living (with) Technical Time: From Media Surrogacy to Distributed Cognition," *Theory, Culture & Society* 26, no. 2–3 (2009), pp. 294–315; Katherine Hayles, "RFID: Human Agency and Meaning in Information-Intensive Environments," *Theory, Culture & Society* 26, no. 2–3 (2009), pp. 47–72; Anna Munster, *An Aesthesia of Networks: Conjunctive Experience in Art and Technology* (Cambridge, Mass.: MIT Press, 2013); compare also Wolfgang Ernst, *Chronopoetics: The Temporal Being and Operativity of Technological Media* (London and New York: Rowman & Littlefield International, 2016); Timothy Scott Barker, *Time and the Digital: Connecting Technology, Aesthetics, and a Process Philosophy of Time* (Hanover, N.H.: Dartmouth College Press, 2012).
5 Antoinette Rouvroy, "The End(s) of Critique: Data Behaviourism versus Due Process," in *Privacy, Due Process and the Computational Turn. The Philosophy of Law Meets the Philosophy of Technology*, ed. Mireille Hildebrandt and Katja de Vries (New York: Routledge, 2013), pp. 143–167, here p. 160.
6 Ibid., p. 162.

the means to critique the contemporary environmental control regime.

In Hito Steyerl's video *Liquidity Inc.* from 2014 the following words recur, almost as the motto for the whole video: "Be formless, shapeless, like water. [...]. Be water, my friend." In Steyerl's video, those words, originating from a short clip featuring Bruce Lee, simultaneously address martial arts fighters, the subjects of financial traders, financialization, or a financialized art world. By linking and translating those diverse worlds into each other, and by diffusing their differences, her video itself becomes "like water," and it remains impossible to decide whether it was an affirmative or a critical appropriation of the talk about a financialized world in flux. Very recently liquidity has gained affirmative interest in the art world, certainly due to the fact that it is no longer just applied to financialization, but also to ecologization. In 2021, the *Videonale.18* at Kunstmuseum Bonn staged its festival for video and time-based arts under the headline *Fluid States. Solid Matter* with the aim of not only leaving behind the idea of a solid subject but of thinking about a "fluid body engaged in a constant exchange with other bodies and its human, natural and more-than-human surroundings."[7] What is at stake here is finding a common language for conceptualizing the relations between beings and environments in terms of liquidity and flow.

These brief examples provide us with a point of departure to enquire into the shared ground between all those conceptualizations: far from being arbitrary, liquidity, flow, and circulation exert an irresistible lure on scholars and artists engaged in depicting the principles that undergird the workings of our contemporary world. Drawing

7 https://v18.videonale.org/en/v18-ausstellung/ueber-die-ausstellung-kopie2 (accessed February 7, 2022). The thirteenth Shanghai Biennale *Bodies of Water* (2020/21) addresses very similar issues. See https://www.biennialfoundation.org/2020/05/bodies-of-water-the-13th-shanghai-biennale/ (accessed February 7, 2022). Both biennales refer to the thinking of feminist writer Astrida Neimanis. See the contribution by Yvonne Volkart in this volume.

on Fredric Jameson's work, we asked the authors contributing to this volume whether the concepts of liquidity, flow, and circulation might provide a useful means to grasp the cultural logic of today's capitalism. We comprehend this stage of capitalism as Environmentalization, a historical periodization which serves as a heuristic rather than as a totalizing claim.

Without a doubt, concepts of the environment significantly structure our contemporary endeavors to make sense of our world. Recent decades have witnessed a real hype around the concept of the environment, encompassing the terms ecology, milieu, and *Umwelt*.[8] The media philosopher Erich Hörl, who has traced this far reaching theoretical movement, attests that there are "thousands of ecologies today: ecologies of sensation, perception, cognition, desire, attention, power, values, information, participation, media, the mind, relations, practices, behavior, belonging, the social, the political—to name only a selection of possible examples."[9] With this broadening of the semantic scope of the concept of ecology, it loses its historical connection to nature as it becomes increasingly denaturalized.[10] The turn towards the concept of ecology is part of a larger critique of anthropocentrism, both in the analytical primacy it affords to the human/nonhuman distinction and in its implication in anthropogenic effects of industrialization and global warming. These concerns are no longer limited to research in a specific academic field, but articulated and analyzed in such different realms as the arts, architecture, design, philosophy, psychology,

8 Florian Sprenger, "Zwischen *Umwelt* und *Milieu* – Zur Begriffsgeschichte von *Environment* in der Evolutionstheorie," *Forum Interdisziplinäre Begriffsgeschichte. Herausgegeben von Ernst Müller. Zentrum Für Literatur- und Kulturforschung Berlin* 3, no. 2 (2014), pp. 7–18.

9 Erich Hörl, "Introduction to General Ecology: The Ecologization of Thinking," in *General Ecology. The New Ecological Paradigm*, ed. Erich Hörl (London and New York: Bloomsbury, 2017), pp. 1–73, here p. 1.

10 See Timothy Morton, *Ecology without Nature: Rethinking Environmental Aesthetics* (Cambridge, Mass.: Harvard University Press, 2009).

or human geography, where the need to envision new forms of sustainability is urgently felt. However the use of the concept may vary in each context and individual instance, ecology has nevertheless become "something like the cipher of a new thinking of togetherness and of a great cooperation of entities and forces."[11]

This, Hörl contends, signals a fundamentally new sense-culture, dissolving the human as the sole carrier of meaning. The classical, teleological sense-culture revolved around the scene of technics, where the human took center stage as the one carrying the tools and with them the whole instrumental relation to the world. Today, this tool-carrying scene is hardly more than a nostalgic remnant, as instrumental tools are dissolved into techno-ecological environments saturated with distributed agency (ubiquitous computing, sensorial environments, etc.) and a new, now technological, or rather, techno-ecological, sense-culture emerges.[12] Yet, instead of simply affirming the new sense of meaning (and meaning of sense) it inaugurates, Hörl sees it as a symptom of two inseparable developments: the becoming-environmental of technology and capital. Where all too often "conformity with or [...] imitation of this new historical semantics [of ecology] is the norm," Hörl maintains a deep ambivalence, as environmentalization is, by the same token, a "question of the apparatus of capture of Environmentality."[13] Current media technologies allow for new forms of exploitation: platform capitalism fuels the advertising economy; smart and connected sensors alter existing forms of surveillance;[14] supply

11 Hörl, "General Ecology," p. 3.
12 Marita Tatari and Erich Hörl, "Die technologische Sinnverschiebung: Orte des Unermesslichen," in *Orte des Unermesslichen: Theater nach der Geschichtsteleologie*, ed. Marita Tatari (Zurich: Diaphanes, 2018), pp. 43–63, here p. 45 and p. 62.
13 Hörl, "General Ecology," p. 4.
14 Jennifer Gabrys, *Program Earth: Environmental Sensing Technology and the Making of a Computational Planet* (Minneapolis: University of Minnesota Press, 2016); Hayles, "RFID."

chain capitalism increases revenue especially in the sphere of circulation through technologies that promise to meticulously keep track of workers and to intensify the volume of transported goods and materials;[15] this holds for the emergence of the logistical state, too.[16] Ultimately, our media technologies cannot be separated from the natural environment: they depend on the mining of resources, which comes with disastrous effects for nature and dangerous working conditions;[17] and the supposedly immaterial digital sphere impacts our natural environs.[18] This expansion of the zones of exploitation "indicates the environmental metamorphosis of the Capital-Form that [...] drives and sustains the process of Environmentalization"[19] and marks a new stage in the history of capitalism.

In light of the diagnosis of a new, environmental situation we take up Fredric Jameson's notion that each stage of capitalism is accompanied by its own cultural logic. This term was coined by the Marxist literary theorist, most prominently in his book *Postmodernism, or, The Cultural Logic of Late Capitalism* from 1991. By speaking of a cultural logic, Jameson put a problem on the table that is certainly still haunting contemporary theory: what is the relation between the history of capitalism and cultural forms? Jameson's own analysis leaves it open to some degree in what terms this relation might be most adequately grasped. On the one hand he

15 Erich Hörl, "The Environmentalitarian Situation," trans. Nils F. Schott, *Cultural Politics* 14, no. 2 (2018), pp. 153–173, here p. 161.

16 Ibid., p. 162; Alberto Toscano, "Lineaments of the Logistical State," *Viewpoint Magazine*, September 28, 2014, https://viewpointmag.com /2014/09/28/lineaments-of-the-logistical-state/ (accessed February 17, 2022).

17 Martín Arboleda, *Planetary Mine: Territories of Extraction under Late Capitalism* (Brooklyn: Verso Books, 2020).

18 Sean Cubitt, *Finite Media: Environmental Implications of Digital Technologies* (Durham: Duke University Press, 2017); Nicole Starosielski, *The Undersea Network. Sign, Storage, Transmission* (Durham: Duke University Press, 2015).

19 Hörl, "Environmentalitarian Situation," p. 162.

describes the "whole global, yet American, postmodern culture" as "the internal and superstructural expression of a whole new wave of American military and economic domination throughout the world."[20] But understanding Postmodernism only in terms of ideological superstructure or false consciousness would miss the most crucial points. To be sure, he certainly claims that his "global theory of these three cultural stages or moments [Realism, Modernism, Postmodernism, which are related to the stages of monopoly capitalism, industrial capitalism, and late capitalism, eds.] will be staged on the level of the mode of production."[21] Building on Giovanni Arrighi, Jameson argues that any historically identifiable capitalist center enters the phase of financial capital at the end of a multi-stage process. When profits can no longer be made from the exploitation of production, capital has no other alternative but to generate profit from financial transactions and speculations: "Capital itself becomes free-floating."[22] Because of the progressive deregulation of the financial markets starting in the 1970s, and the accompanying neoliberal policies, this logic has escalated on an unprecedented global scale. Financial capital can no longer be thought of in terms of referentiality and the expansion of value of assets produced elsewhere. Financial capital estab-

20 Fredric Jameson, *Postmodernism, or, The Cultural Logic of Late Capitalism* (Durham: Duke University Press, 1991), p. 5. Evidently, this approach might tend to be paralyzed by the "totalizing dynamic" of its cultural logic which also implies that capitalism has subsumed all levels of existence under its reign and culture has become nothing else than another version of the capital form itself. By speaking of a *dominant* cultural logic, Jameson simultaneously affirms that this logic is not the only game in town, it rather acts as the "force field" in which also "'residual' and 'emergent' forms of cultural production [...] make their way." Ibid., pp. 5–6. Consequently, his description offers ways to cognitively map the space of capital while also holding alternatives in view.

21 Fredric Jameson, "Culture and Finance Capital," in *The Cultural Turn. Selected Writings on the Postmodern 1983–1998* (London and New York: Verso, 1998), pp. 136–161, here p. 144.

22 Ibid., p. 142.

lishes a purely self-referential communication, it lives from its own "internal metabolism"[23] and circulates without any referent. This is exactly why it is homologous to the circulation of signs and floating signifiers within postmodern cultures. The postmodern logic makes clear what is already at stake in the earlier phases: the relation between culture and capitalism is not only one of ideology, but it leads back to deeper epistemological and aesthetical concerns. Following Jameson, who understands his notion of cultural logic as following from Raymond Williams' "structure of feelings,"[24] it is not simply reflected or expressed in the content of a text or a work of art, but structures the production of culture itself. It structures not the things "represented" by any form of art or culture, but the ways in which the cultural forms operate themselves, their syntax, their grammars, their formats. It may structure the spatial conditions in the case of architecture, or the spaces, milieus or environments of installation art, or of scenic and performative events.

A recent attempt at updating Jameson for the twenty-first century was undertaken in 2016 within a special issue of *Social Text* dedicated to *The Cultural Logic of Contemporary Capitalism*. The issue's editors, Nico Baumbach, Damon R. Young, and Genevieve Yue, make a strong case for Jameson's gambit "that the formal features that recur in current cultural production might index in some way (more complex than simply reflecting or expressing) the deeper logic of the new global system."[25] This methodological claim, that attaches form to politics and to historical stages of capitalism, is

23 Ibid., p. 161.
24 See Jameson, *Postmodernism*, p. xiv.
25 Nico Baumbach, Damon R. Young, and Genevieve Yue, "Introduction: For a Political Critique of Culture," *Social Text*, Special Issue: *The Cultural Logic of Contemporary Capitalism* 34, no. 2 (2016), pp. 1–20, here p. 4.

taken up by our contributions.[26] But in a central point our approach differs from the one chosen by Baumbach, Young, and Yue: by analyzing the cultural logic of *contemporary capitalism*, they leave the question open, whether the historical stage called "late capitalism" by Jameson has morphed into something new, or whether we are still confronted with the same problems as during the 1980s.[27] In contrast, the volume at hand wants to introduce this current of materialist thinking into the ongoing discussions of ecologies and environmentalization. First, it is based on the assumption that (certainly not all, but some important) aspects of contemporary capitalism can be analyzed by turning to the environmental situation, and second, we are interested in the genuine cultural logic that is specific to capitalism in its environmental form.

As is well known, Jameson sketched out several "constitutive features"[28] of the postmodern: depthlessness, weakening of historicity, intensities as a new emotional ground tone, and the postmodern return of the sublime. The age of environmentalization seems to be marked by a different set of features: a valuing of the relation as primary or even primordial[29] and the associated impulse to think terms and their relation "from the middle,"[30] the suspension of the nature/culture dis-

26 See the contributions by Maryse Ouellet, Yvonne Volkart, Yannick Schütte, Jacob Soule, and Stefan Young, who explicitly address this problem.

27 Since then a plethora of alternatives to Jameson's favored term *late* capitalism has been suggested: neo-capitalism, neoliberal capitalism, post-Fordist capitalism, postmodern capitalism, biopolitical capitalism, semiocapitalism, cognitive capitalism. McKenzie Wark summarizes this list as "adjectival-capitalism theory." McKenzie Wark, "The Vectoralist Class," *e-flux* 65 (2015), https://www.e-flux.com/journal/65/336347/the-vectoralist-class/ (accessed January 19, 2022).

28 Jameson, *Postmodernism*, p. 6.

29 Hörl, "General Ecology," pp. 6–7.

30 For this see, among others, Gilbert Simondon, *L'individuation à la lumière des notions de forme et d'information* (Grenoble: Éditions Jérôme Millon, 2005), pp. 310–316; Anselm Franke, "Animism: Notes on an Exhibition," *e-flux* 36 (2012), https://www.e-flux.com/journal/36/61258/animism-notes-on-an-exhibition/ (accessed February

tinction[31] and an unraveling of the differences between human and nonhuman agency, simultaneously accompanied by a return of vitalist thought,[32] both the scientification and mystification of affect,[33] and the predilection for organic thinking to counter a postmodern sense of fragmentation. At the initial conception of this volume was the question whether the boom in engagement with concepts of liquidity, flow, and circulation could be read as an expression of an underlying logic of environmentalization.[34]

Recent studies, which have considered the relation between cultural forms and economic periodization,[35] have indicated (sometimes implicitly) that *liquidity*, *flows*, and *circulation* might be means of expressing the

14, 2022); Isabelle Stengers, *Thinking with Whitehead: A Free and Wild Creation of Concepts* (Cambridge, Mass.: Harvard University Press, 2011), p. 24.

31 See for example Philippe Descola, *Beyond Nature and Culture* (Chicago and London: The University of Chicago Press, 2013); Donna J. Haraway, *Staying with the Trouble: Making Kin in the Chthulucene* (Durham: Duke University Press, 2016).

32 Rosi Braidotti, *Posthuman Knowledge* (Cambridge: Polity Press, 2019); Sebastian Olma and Kostas Koukouzelis, "Introduction: Life's (Re-) Emergences," *Theory, Culture & Society* 24, no. 6 (2007), pp. 1–17.

33 Brian Massumi, *Parables for the Virtual: Movement, Affect, Sensation*, Twentieth anniversary edition (Durham: Duke University Press, 2021).

34 Concerning art and visual culture studies these issues have been discussed separately. On liquidity, see Kassandra Nakas, ed., *Verflüssigungen: Ästhetische und semantische Dimensionen eines Topos* (Paderborn: Fink, 2015); Marcel Finke and Friedrich Weltzien, eds., *State of Flux: Aesthetics of Fluid Materials* (Berlin: Reimer, 2017); Ulrich Pfisterer and Christine Tauber, eds., *Einfluss, Strömung, Quelle: Aquatische Metaphern der Kunstgeschichte* (Bielefeld: transcript, 2018). On ecologies, see Daniela Hahn and Erika Fischer-Lichte, eds., *Ökologie und die Künste* (Paderborn: Fink, 2015); Susanne Witzgall, Marietta Kesting, Maria Muhle, and Jenny Nachtigall, eds., *Hybrid Ecologies* (Zurich and Berlin: Diaphanes, 2020/21).

35 This approach has been used by a variety of studies especially in literary criticism, with most of them focusing on the cultural logic of neoliberalism. In this vein, Rachel Greenwald Smith has shown that recent literary forms become "complicit with the logic of neoliberalism." Rachel Greenwald Smith, *Affect and American Literature in the Age of Neoliberalism* (New York: Cambridge University Press, 2015), p. 11. On the spread of *Neoliberalism Studies* see Leigh Claire La Berge and Quinn Slobodian, "Reading for Neoliberalism, Reading like Neoliberals," *American Literary History* 29, no. 3 (2017), pp. 602–614.

cultural logic of our current economic situation. Annie McClanahan has argued that the spread of debts due to financialization has led to a formal rearrangement in horror narratives in literature and film, which feature liquidity on many levels (blood, body liquids, toxic liquids as well as more metaphorical liquidifications of genre conventions). The relation between liquid forms in those narratives and phantasms of financial liquidity, which emerged especially after the financial meltdown of 2008, should be understood as a symptom: "the visual excesses of gore become the signs of financial contagion and toxicity."[36] In film studies, Steven Shaviro has developed his seminal concept of the post-cinematographic dispositif by relating "[i]ntensive affective flows" generated by post-cinematographic filmmaking to "intensive financial flows" predominant in deterritorialized late capitalism. They both "alike invest and constitute subjectivity."[37] In the field of art, post-Internet art in particular is seen as an affirmative embrace of fluid and precarious conditions. Ana Teixera Pinto succinctly summarizes this observation: "The Post-Internet style [...] carries the promise of complete malleability: all materials are made to behave like water—a convention of plasticity that sublates the process of precarization through which labor is rendered ever more flexible."[38] Far from seeing a culture where everywhere, everything is simply in flow, Mark Bould's recent work, which partly aims at

36 Annie McClanahan, *Dead Pledges: Debt, Crisis, and Twenty-First-Century Culture* (Stanford: Stanford University Press, 2017), p. 18. These films "figure liquid credit as a dangerous toxicity, which allows them to represent a credit economy in which unpayable debt leads to social violence, and they depict the violence of dispossession and resettlement consequent to the globalization of financial risk." Ibid., p. 144.

37 Steven Shaviro, *Post-Cinematic Affect* (Winchester: O-Books, 2010), p. 5.

38 Pinto, "Can the Cultural Logic of the Digital Era Be Exhibited? A Tale of Two Shows," *Witte de With Review* (2016), https://www.fkawdw.nl/en/review/desk/can_the_cultural_logic_of_the_digital_era_be_exhibited_a_tale_of_two_shows (accessed February 14, 2022).

rewriting the "arthouse tales of our liquid world"[39] in terms of an Anthropocene Unconscious, draws out the animating dialectic of the liquidity of flowing capital and cargo with the solid persistence of petrocapitalist infrastructure and our own stuckness.

These studies subscribe to the idea that the aesthetics, the syntax, the grammar, or other formal traits of recent literature and film can be described as expressions of a cultural logic genuine to recent historical changes in capitalism. What unites these approaches—despite their obvious differences—is an interest in concepts of liquidity and flow. Indeed, this seems to be a trait that distinguishes these recent studies from similar approaches during the 1980s and 1990s, when a paradigm emerged inside U.S. literary criticism that came to be canonized as "new economic criticism."[40] Authors such as Walter Benn Michaels, Marc Shell, and Jean Joseph Goux shared the thesis that money and thus questions of value should be thought of as semiotic and discursive problems. They argued that money could be considered as a form of language, which generates value from differential sign movements.[41] In comparison to these older approaches, more recent studies have partially maintained the idea that cultural forms and financial processes and media do share some epistemological as well

39 Mark Bould, *The Anthropocene Unconscious: Climate Catastrophe Culture* (London and New York: Verso, 2021), p. 100.

40 Compare Martha Woodmansee and Mark Osteen, eds., *The New Economic Criticism: Studies at the Intersection of Literature and Economics* (Abingdon and New York: Routledge, 1999).

41 These approaches are primarily committed to poststructuralism in the variants proposed by Jean Baudrillard and Jacques Derrida, and were developed from non-Marxist perspectives. This was precisely the novelty of the homology approach. At the center of their analyses is not a deterministic relationship between economic basis and cultural products but rather an equivalent homology between monetary and cultural signs. Although Fredric Jameson prominently formulates the thesis of homology at many points, his critique is also sparked by this problem. For him, the homology itself remains a symptom of financialized capitalism, the history of which needs to be analyzed. Compare Jameson's critique of the paradigm of homology in Jameson, *Postmodernism*, pp. 180–216.

as aesthetical traits, but nonetheless, they have shifted their focus "from signs to asignifying or deterritorialized flows, from form to liquidity, from subjective feelings to non-subjective affects, from the paradigm of exchange and credit to that of control and debt, from realistic or postmodern genres (of novels or films) to post-human narrative techniques."[42]

As flow, liquidity and circulation have pervaded our critical vocabulary, the words themselves as well as their usage warrant careful examination.[43] While the three concepts are not opposed or mutually exclusive, they accentuate different aspects and point towards differing logics. If they draw their persuasiveness from their naturalization, the contributions to this volume illustrate that the terms do in fact come with quite different meanings, depending on at least three levels: their linguistic function, their semantic context, and their historical backdrop. First, different linguistic functions alter the meaning of the words. An illustrative example is the talk about the flow of data, money, or goods, where it seems to be clear what the respective word addresses. Data are conveyed continuously, money is transacted without loss or impediments, and goods are moved without interruption. As the words' respective meanings are taken for granted, we could speak of a self-evident usage. However, the words "flow," "circulation," and "liquidity" can also be put to use in terms of a metaphor. Either we use them in a rhetorical, ornamental sense; or, in case we are "lost for words,"[44] the

42 Holger Kuhn, "Crisis—Unrest—Common Sense: Melanie Gilligan, Critique, and the Cultural Logic of Environmentalization," in *Critique and the Digital*, ed. Erich Hörl, Nelly Y. Pinkrah, and Lotte Warnsholdt (Zurich: Diaphanes, 2020), pp. 147–184, here p. 177. See ibid. for a closer analysis of this recent shift in cultural criticism.

43 See Mathias Denecke, "Capitalism in Flow: Epistemic Metaphor and Logistical Calculation," in *Fluidity. Materials in Motion*, ed. Marcel Finke and Kassandra Nakas (Berlin: Reimer, 2022), pp. 23–38.

44 Moritz Gleich, "Liquid Crowds: Regulatory Discourse and the Architecture of People Flows in the Nineteenth Century," *Grey Room* 67 (2017), pp. 44–63, here p. 47.

epistemic function of the "metaphorical image" might help us to make sense of something otherwise not yet describable. To further complicate this situation, liquidity, flow, and circulation are also deployed as scholarly concepts: Raymond Williams' TV-*flow* describes how American TV programmers try to keep viewers attached to the TV,[45] Zygmunt Bauman's *liquidity* designates specific characteristics of Modernity,[46] and Foucault's *circulation* is embedded within a milieu that is the medium through which a population is regulated.[47] Clearly, with varying linguistic functions—self-evident, metaphorical, conceptual—come different meanings.

On a second level, this becomes even more intricate when we consider in which semantic context the vocabulary is employed, from management discourse and advertising to mechanical engineering or the arts. Williams' *flow*, for example, allows us to grasp an aspect of the mass media's attention economy, and while it may be relatable to Mihaly Csíkszentmihályi's psychological flow-concept which discusses cognitive states of focused attention,[48] it is unrelated to the packet-switching flow of message blocks in the early Internet.[49] Bauman's diagnosis of a *liquified* world may work as a grand narrative of modernity, yet it works less well in terms of financial liquidity. Foucault's *circulation* describes a mode of regulation adapted to uncertain movements in early French cities, but does hardly contribute to understanding the circulation of digital images on Instagram or atmospheric circulations.

45 Raymond Williams, *Television: Technology and Cultural Form*, Routledge Classics (London and New York: Routledge, 2003).

46 Zygmunt Bauman, *Liquid Modernity* (Cambridge, UK: Polity Press, 2000).

47 Michel Foucault, *Security, Territory, Population: Lectures at the Collège de France, 1977–1978*, ed. Michel Senellart, trans. Graham Burchell (Basingstoke and New York: Palgrave Macmillan, 2007).

48 Mihaly Csíkszentmihályi, *Flow: The Psychology of Optimal Experience* (New York: Harper, 2009).

49 Janet Abbate, *Inventing the Internet* (Cambridge, Mass.: MIT Press, 2000).

Eventually, and thirdly, the meanings depend on the historical context, on the particular communities of speakers which make use of liquidity, flow, and circulation in a certain period in history. Williams' *flow* pertains to the early North American cable TV-dispositive, not to picking movies from personalized online libraries. Likewise, understanding Bauman's *liquidity* can not be disembedded from the context of a massive surge in publications on flows and globalization, especially in sociology and ethnography. In the case of Foucault, the talk of *circulation* hinges on the popularity of cybernetics and systems theory which has ebbed since.[50] To summarize, nuances between linguistic functions, semantic contexts of usage, as well as their historical embedding account for different meanings. And this matters since it does make a difference for how we grasp our contemporary world as a world in flow.

The volume at hand discusses the cultural logic of environmentalization through these three key concepts: flow, liquidity, circulation. Where are the sites where this cultural logic could be analyzed? And what is its history? How does this cultural logic shape theory, art, architecture, theater, literature, film? What gets lost in this narrative, what is obstructed from view? And finally, how can we engage in an adequate cognitive mapping of our condition in order to retain our capacity to act politically? The five sections of this book explore these questions in turn.

1. Ecologies and Elements

The concern for ecologies and elements is common to recent art production and media theory: a lot of recent

50 Florian Sprenger, *Epistemologien des Umgebens: Zur Geschichte, Ökologie und Biopolitik künstlicher Environments* (Bielefeld: transcript, 2019), pp. 61–87.

artistic production has tried not only to generate knowledge about ecologies, but to work and produce (with) all kinds of ecologies and other-than-human agents. Relations that had for centuries been excluded from the singular work of art and its viewers' attention—its relation to climate, to microbiomes, to temperature, etc.— have entered the sphere of artistic production, or, as one should rather say: they have decentered the figure of the artist as producing agent and opened the space for all kinds of other-than-human co-producers from the tiniest bacteria to planetary systems. In the field of media theory and under the headline of media ecology, it has become common sense that media can no longer be understood as instruments, as tools, or as expansions of organs. Media and its technologies have become environmentalized, pervasive, ubiquitous, seamless, imperceptible, or as John Durham Peters has aptly summarized this observation: they have become elemental. They form the existential infrastructures of our lives, a kind of background that is barely noticed, and yet has become as life-supporting as the "natural" elements water, earth, fire, and air.[51] The three contributions to this section take this recent awareness of the existential—ecological and elemental—backgrounds as a starting point for thinking about recent shifts concerning epistemological, aesthetical and economical questions.

With her contribution, the artist Ursula Biemann leads us into the terrain of ecological concerns in contemporary art. Having dealt extensively with the flow of carbon and mineral resources, capital, and migration from the 1990s onwards, she has recently shifted her focus to more explicitly environmental works on the larger planetary streams affecting the climate. What is at stake here is a shift away from practices of represent-

51 John Durham Peters, *The Marvelous Clouds: Towards a Philosophy of Elemental Media* (Chicago and London: The University of Chicago Press, 2015).

ing ecologies in the context of the art world. Instead, she is looking for new tools, new characters and propositions that could provide agency to those human and more-than human agents that have become most vulnerable due to a diverse range of extractive practices. Thus her approach aims at "bringing art to ecology by directly intervening in, and co-creating, material and epistemic realities on the ground." In two of her recent video works, *Forest Law* (2014) and *Acoustic Ocean* (2018), she has dealt with the figure of the indigenous scientist in order to develop a different epistemology, for example by exploring the human-nature symbioses. In recent projects, she has also been engaged with instituting an Indigenous University in the Amazonian south of Columbia and with creating the internet platform *Devenir Universidad* that generates, assembles and communicates artistic and audio-visual productions for the future University. Both projects aim at a different way of knowledge-production, in which the Amazonian territory is not simply a stage for culture but a "sentient and cognizing being, that is, a living 'agent' of knowledge."

Maryse Ouellet's contribution is also situated at the intersection of ecologies and art. Based on the observation that recently the sublime has become an important aesthetic category, she asks whether this re-emergence of the sublime can be deciphered as a new cultural logic of the Anthropocene. In order to do so, she sheds light on the history of the concept of the sublime and especially on the difference between its modern and postmodern formulations. The modern sublime, whose most famous definition stems from Immanuel Kant, conceived of nature as a domain to be mastered by the power of reason. In contrast, the postmodern sublime developed by Jean-François Lyotard and Fredric Jameson mostly stressed the question of the unrepresentability of forces which are too large to be grasped, such as multinational capital and its technological networks. In contrast to

these formulations Ouellet highlights that the Anthropocene demands a new conception of the sublime (a question that will also be picked up by Stefan Yong in the context of logistical networks, see below). The contemporary sublime can be understood as a force, or a power that consists in connecting humans and nonhumans, as she makes clear by analyzing two recent films: *Watermark* (2013) by Jennifer Baichwal and Edward Burtynsky and *Deep Weather* (2013) by Ursula Biemann. Both works still refer to the modern and the postmodern imaginaries and concepts of the sublime, but they gradually develop them into a new cultural logic of the Anthropocene.

Whereas the shift in the cultural logic is described by Ouellet as a shift in the modes of representation, the third contribution suggests that we can analyze this shift by looking at its ramifications for the economic sphere. Katerina Genidogan claims that during recent decades the cultural logic of late capitalism has been superseded by the cultural logic of green capitalism, which aims at producing value not in spite of the exhaustion of resources and environmental destruction, but *through* those means. At least three recent developments characterize this new economic regime. First, the climate change discourse has generated an apocalyptic, dystopian thinking of the future and become predominant in large parts of today's mainstream culture. The narrative of a looming catastrophe tends to obscure the social and historical understanding of climate change (and its dependence on colonial and racist modes of exploitation). Second, the means to reassure the hegemonic western way of living have been found in insuring it: financial instruments like weather derivatives have offered means of securitizing catastrophe risks, they produce "new assets out of future risks." Third, this new financial regime is inflicted most predominantly on the global South. What sounds like well-intended means

of mitigation for the most vulnerable populations and ecologies is also rooted in colonial history.

2. Genealogies of Circulation

This section picks up the concern with the history of environmentality as a mode of power by offering historical genealogies that link this discussion back to Michel Foucault's analysis of governmentality, which he developed in his two lecture series at the Collège de France between 1977 and 1979.[52] In these lectures, Foucault analyzes the emergence of a power formation during the eighteenth and nineteenth centuries that operates on a different field than the sovereign power and the disciplinary regime he previously analyzed. In contrast to those other power-formations which aimed at the individual, governmentality aims at the control of the population by means of regulating circulations. Commodities, energies, humans, viruses: all those entities are circulating anyway, and "it was a matter of organizing circulation, eliminating its dangerous elements, making a division between good and bad circulation, and maximizing the good circulation by diminishing the bad."[53] Governmentality thus operates via small and non-repressive interventions. By not intervening too much it intervenes in minimal but effective ways in milieus, and

52 Foucault, *Security, Territory, Population*; Michel Foucault, *The Birth of Biopolitics: Lectures at the Collège de France, 1978–1979*, ed. Michel Senellart, trans. Graham Burchell (Basingstoke and New York: Palgrave Macmillan, 2008). On Foucault's concept of milieus and circulation in the context of his analysis of governmentality compare Sprenger, *Epistemologien des Umgebens*, pp. 61–87; Maria Muhle, *Eine Genealogie der Biopolitik: Zum Begriff des Lebens bei Foucault und Canguilhem* (Munich: Fink, 2013); Friedrich Balke and Maria Muhle, "Einführung," in *Räume und Medien des Regierens*, ed. Friedrich Balke and Maria Muhle (Paderborn: Fink, 2016), pp. 8–23; Malte Hagener, Sven Opitz, Ute Tellmann, "Zirkulation: Einleitung in den Schwerpunkt," *Zeitschrift für Medienwissenschaft* 23 (2020), pp. 10–18.
53 Foucault, *Security, Territory, Population*, p. 18.

it does so in order to secure the living processes of all beings from all kinds of threats that might result from unrestricted circulations.

This section opens with a contribution by Martin Doll, who analyzes Charles Fourier's community buildings called the "Phalanstères." In the early nineteenth century Fourier conceived of the Phalanstères as an ideal architectural environment to bring into harmony the different passions that—according to Fourier's anthropological framework—drive all human endeavors. The Phalanstères, as an ideal place for working and living, should enable a kind of self-stabilizing regulatory system. The Phalanstères thus were designed as a specific milieu that should ensure all kinds of circulatory processes: the Phalanstère members were put in circular movement "like the planets in our solar system are orbiting around the sun." Although Fourier derived his ideas in the context of a social-emancipatory project, it can, according to Doll, nevertheless be situated in the genealogies of circulation, control and governmentality: in Fourier's project the milieu emerges as a political field of intervention. Unfortunately Fourier was never able to build the Phalanstères, but he inspired a plethora of communal projects during the 1840s in the United States. Doll concludes his analysis by tracing the specific US-American way of adopting Fourier's ideas.

In a similar vein, Sebastian Kirsch stresses that the history of environmental control predates the history of digital media. Ecological thinking—from its earliest formulations in the nineteenth century on—has been conceived of as knowledge about governing and optimizing the mutual relations between beings and surroundings. Kirsch shows that Gerhart Hauptmann's Naturalist social drama *Vor Sonnenaufgang* (*Before Daybreak*, 1889) can be interpreted against this background. The play takes place in a coal mining area in Silesia. The Krause family, which is at the center of the play, has gained the rights to sell the coal that lies beneath

the fields of neighboring farmers. The historical turn from agricultural to fossil energy is one of the reasons for the "control revolution"—a term which was coined by James Beniger in 1986. According to him, the "processing of material flows"[54] became inadequate with the unleashing of energetic forces during the industrial revolution and required new technologies of control and management. Metaphorically, the Krause home becomes an overheating steam engine, producing symptomatic flows and liquid phenomena. The latter can be seen on a formal level, as the play clearly manifests the liquefaction of life, labor and language around 1900, and it can be analyzed with regard to stage settings and contemporary lightning technologies, which no longer focus on the individual protagonist but rather on a "multilayered collective – [...] connective – body and its interrelations." Whereas the problems of control emerge very clearly in the play, the means to solve these problems are delegated to physiologists, eugenicists and biopolitical measures; it centers "not yet around psychologists and designers."

The latter are addressed by Malte Fabian Rauch in his contribution. While it has become rather popular to point to the United States—and most prominently to the New York art scene of the 1960s—in order to explore the design of environments and the ensuing problems of control, Rauch claims that the efforts undertaken by the Situationists in Paris during the 1950s already dealt with similar questions. The Situationists actually used ecological semantics and concepts, which also informed their critical stance when dealing with contemporary urban sociologists. Furthermore, Rauch shows that these ecological semantics can shed new light on some of the Situationists' most prominent concepts: as a form of

54 James R. Beniger, *The Control Revolution. Technological and Economic Origins of the Information Society* (Cambridge, Mass.: Harvard University Press, 1986), p. 12.

moving in the urban ecology, the *dérive* aims at a praxis that might unsettle heterogeneous flows in contrast to the restricted forms of circulation (of goods, money, and people) as installed by the "everyday" use of the urban milieu. The architectural designs developed by Constant Nieuwenhuys tried to translate "the free flows discovered through the *dérive* into actual architectural form." But as Rauch argues, the Situationists' endeavors to update society by designing relations between beings and their environments is ambivalent. It remains an open question whether the Situationists' approach was really suitable for overcoming restricted forms of environmental power formations or whether it was just a historical step in exploring new modes of fluid relationships that have today been coopted by 24/7 neoliberalism.

3. Flows of the Living

At the heart of this section is the relation of language and world. The process-philosopher Alfred North Whitehead once remarked that the claim that "'all things flow' is the first vague generalization which the unsystematized, barely analysed, intuition [...] has produced."[55] It would indeed require a lot of mental gymnastics to deny outright that things become, change, and perish, that the world, including ourselves, is not in some sort of process, to deny the self-evidence[56] of a world in flow. To speak of flows seems imbued with some metaphysical

55 Alfred North Whitehead, *Process and Reality: An Essay in Cosmology*, ed. David Ray Griffin and Donald W. Sherburne. Corrected ed. Gifford Lectures 1927–1928 (New York: Free Press, 1978), p. 208.
56 Our usage of the term is not identical with Whitehead's, for whom it is a precise technical term. See Stascha Rohmer, "The Self-Evidence of Civilization," in *Beyond Metaphysics? Explorations in Alfred North Whitehead's Late Thought*, ed. Roland Faber, Brian G. Henning, and Clinton Combs (Leiden: Brill, 2010), pp. 215–225; Milan Stümer and Daniel Bella, "Inheriting Cosmopolitics: Pericles, Whitehead, Stengers," *Theory, Culture & Society* (2022), pp. 1–19.

truth about how the world *is*—malleable, liquid, plasmatic, changing—to the point that flow-talk becomes the *de facto* language to describe any and all phenomena in and of the world and even to construct the totality called "world" as a whole in the first place. Flow-talk produces its self-evidence by shaping both our tools of enquiry, as well as our metaphysical claims. It is this self-evidence, this passage from one to the other, that this section interrogates.

This "passage from language to world and world [...] into language" is taken up by Esther Leslie. Observing the rhetorical power of flows to indiscriminately describe the movement of electrons, people, money or goods, her contribution counters with a poetic mode of inquiry. Leslie leverages the "slipperiness" of language, how its metaphors move in and out of science, and unsettles the familiar conviction of a liquid world in flow. Pushing the assumed liquidity of a fluid world to its limits, Leslie follows up with a range of different states and metaphors: the *froth* on a latte served to a cognitive worker in the new economy, the toxic *foams* on the surface of our oceans, a *cloud* of viral droplets spreading a global pandemic, the *fog* around the criminal tragedy that was the fire of London's Grenfell tower. Far from being merely playful, this poetic trait is a political mode of inquiry: poetry becomes the technique "through which occurs an exploration and communication of the raising, harnessing, and manipulating of the political temperature of the times." Leslie suggests that "flow is an updated version of a colonial conception of the world," inseparable from the frenetic industrial activity and global warming. Instead of a world peacefully in flow, the froths, foams, fogs, clouds are part of a turbulent world. Yet, hers is not a tale of a radically new world, because underneath all that turbulent fog, she concludes, "is business as usual and we are doomed."

Further destabilizing a seemingly self-evident political ontology of "one flow," displacing it from the doomed

business as usual, "from the ruinated [...] progressivism of this world," Christian Schwinghammer meditates on the recent revitalization of ontological modes of enquiry against the backdrop of quantum physics. The ontological turn, especially when grounded in the texture of the natural sciences, always runs the risk of subsuming everything, even its anti-substantialist pretensions, under the same basic fluent condition, under "a grand flow of change." Engaging with contrapuntal theoretical work and practices ranging from the writing of Karen Barad and Denise Ferreira da Silva to sculptural performances by Fred Moten and Wu Tsang, Schwinghammer develops an original reading of the concept of decoherence, to think—and, crucially, to contextualize—questions of touch and entanglement with, in and through the environment. Never losing sight of the slippages of the poetic mode already addressed by Leslie (see above), Schwinghammer raises the question of "one flow" and the lure it exerts on the current theoretical landscape by moving between the most general and the here and now, between "life itself" and the entangled life-conditions, between the particular and the particulate.

The final contribution to this section picks up this "drive to create a comprehensive whole" when dealing with "life itself." Speaking as an artist and a filmmaker, Beny Wagner addresses the central tensions in the artistic "expansion of human subjectivity into previously imperceptible realms" at work in contemporary artistic practices: do we escape the limits to our perception, or do we simply force everything else to conform to those limitations. Looking at moving image technology as the mediator between human perception and such imperceptible realms as the environment on a microbiological scale, Wagner employs two historical objects: Sergei Eisenstein's famous essay on Disney, where he celebrates the plasmaticness of animation, and *The Enemy Bacteria*, a 1945 educational short produced for the US Navy. If for Schwinghammer, it was quantum physics

that fueled the talk of one flow, here it is the life sciences with their primordial protoplasms and plasmatic organic phenomena that vouch for a fluid world in flux. Yet, it is not the question of *one* flow, not the "comprehensive whole" to which Wagner seeks to give expression; rather, the central challenge for artists engaged in these questions is to find an "operative 'plasmaticness' [which can] account for multiple orders of being, situating what we can experience directly in relation to everything we can't."

4. Unruly Liquids

It is not just the case that the language of flow is slippery and multiple: it also always brings with it its other. Instead of continuous flow, data can be lost or leaked; instead of being liquid, financial assets are stored and can be frozen; instead of circulating freely, shipping traffic can get stuck. The authors in this section challenge the conventionalized connotations of liquidity, flow, and circulation to provide a counter-logics. In doing so, they propose a different reading of the cultural logic of environmentalization. The authors strictly oppose conventionalized meanings of liquidity, flow, and circulation by referring to the leaky, the uncontained, and the sweaty. Contrary to the imperative of capitalist flow demanding individuals to change and adapt permanently, there is our existential porosity and connection with other-than-humans; instead of being apolitical, descriptions of media technologies in terms of "contained" and "leaky" are coupled with gendered imaginaries of dysfunctional bodies; and idealized descriptions of smoothly flowing architectural forms neglect the sweat of construction workers. The contributions in this section share the problematization of flow-vocabulary and the emancipatory gesture of uncovering that which is their neglected other.

Yvonne Volkart continues her previous investigations of fluid bodies in feminist media art, which she had already focused on in the mid-2000s. Under the premise of a "'fluid' techno-capitalism" she elaborated how ideas and images of fluid bodies are used to renegotiate concepts of subjectivity. In the text at hand, Volkart once again focuses on the aesthetics of fluidity under the condition of environmentality. This condition encompasses both the dispersal of media technologies into the environment and "planet Earth's grounding on physical forces like atmospheric and oceanic flows, and humans' dependence on them." Volkart discusses the artworks of Rikka Tauriainen, Carolina Caycedo, and Tabita Rezaire, which foreground the reciprocal dependence of human and non-human beings and negotiate the relation between body and environment. Contrary to the apparent lack of alternatives to capitalism, the aim is "to reconnect with the existential flow of living in a colonized world" as a decidedly political endeavor. Volkart eventually states that "we are always already leaky and porous, toxic and swampy, connected to others and collective."

Hannah Schmedes' contribution directly ties in with this emphasis on the leak. She interrogates the imaginaries linked to the female gender and focuses on containment and leakiness. Her starting point is a sieve in a painting portraying Queen Elizabeth I. As an attribute to the queen's body, which is supposed to be contained and not leaky, the sieve indicates the welfare and prosperity of the queen's kingdom, which is "guaranteed by Elizabeth's pledge to remain virgin." Such devaluing normative assumptions of a contained female body as a proper body resurface today. To explicate her argument, Schmedes draws on recent academic writings on gendered imaginaries of leaks and containment which relate to media technologies. Pointing towards the normative assumption of an inherently dysfunctional female body, the analysis ranges from "revenge-porn" through

leaked sex tapes, truth-telling as "a gender-specific sexualization of women speaking out," and "speaking out" against sexual harassment at university as becoming a leak. Clearly, leakage and containment come with different connotations—yet, in relation to female bodies they carry a pejorative meaning. Regarding this "dys-appearance," Schmedes unsettles seemingly neutral assumptions which accompany flow-talk by referring to gendered imaginaries of leakyness.

Yannick Schütte connects liquidity with the question of labor. The background of his contribution is the information economy, characterized by flows of finance, logistics, and work. These flows, he argues, have an impact on architecture, too. Precisely, this refers to the built form of "so-called 'digital architecture'" which is supposed to be all smooth and curvy. Using the example of a fish sculpture by architect Frank Gehry, Schütte—in line with the prominent role of architecture for Jameson—elaborates on the recent history of the "cultural logic of fluidity in architecture which succeeds the dominant spatial conception of postmodernism." On this basis, he explains that computer-aided design first allows the design and implementation of such intricate architectural forms. However, this alludes to an imaginary of production "where abstract intelligence replaces sweaty and greasy physical labor practices." Ultimately, Gehry's fish is not only a symptom of the information economy's promises and hints towards the overemphasis of cognitive labor. Due to "violations of fire code" and lead, the fish sculpture is also a "toxic and fire-hazardous artefact," symbolically irritating assumptions of digital cultures' seeming immateriality. Schütte invites us to shed light on the "material conditions of labor within a cultural logic of fluidity."

5. Logistical Circulation

The final section returns us to the social material processes of our present and the demand to respond to what is directly before us. For Jameson, the "fundamental ideological task" of a cultural logic lay in "coordinating new forms of practice and social and mental habits [...] with the new forms of economic production and organization thrown up by the modification of capitalism."[57] Taking the circulationist modification of capitalism after the logistics revolution[58] as crucial to the new forms of economic organization, this section explicates the particular quality of social experience under logistical capitalism. This new structure of experience, or, to use Raymond Williams' preferred[59] term, this *new structure of feelings*, is not presented as a radically epochal break, but as a certain reorganization of elements[60] that is nevertheless what "gives a sense of a generation or of a period."[61] To uncover cultural evidence of this new period in "new semantic figures"[62] and their interconnection, the three contributions turn to the city novel, the role of minor aesthetic experiences, and the genre of worker's inquiry.

In his reading of Tom McCarthy's *Remainder* (2005), which he understands to be a "city novel after the city,"

57 Jameson, *Postmodernism*, p. xiv.
58 Jasper Bernes, "Logistics, Counterlogistics and the Communist Prospect," in *Endnotes* 3 (2013), https://endnotes.org.uk/issues/3/en/jasper-bernes-logistics-counterlogistics-and-the-communist-prospect (accessed February 9, 2022).
59 For Williams, structure of experience and structure of feeling are synonymous, though he avoids the broader term "experience" as it might imply a relation to the past instead of lived practical consciousness.
60 See Fredric Jameson, "Postmodernism and Consumer Society," in *The Anti-Aesthetic*, ed. Hal Foster (Port Townsend: Bay Press, 1983), pp. 111–125, here p. 123.
61 Raymond Williams, *Marxism and Literature*, Marxist Introductions (Oxford: Oxford University Press, 1992), p. 131; see also Raymond Williams, *The Long Revolution* (Cardigan: Parthian, 2011), pp. 64–66.
62 Williams, *Marxism and Literature*, p. 134.

Jacob Soule draws out the peculiar logic of a circula-
tion that characterizes the urban as distinct from pre-
vious conceptions of the city as a space characterized
by density. This new, circulatory space of the urban,
with its concern of a population in motion, cannot be
adequately captured by the image of circular repetition
alone. Rather, as Soule argues, this repetition is in the
service of ever-expanding processes of capital accumu-
lation: circulation is both repetition and accumulation.
In this context, the city ceases to be a site of profound
meaning and is dissolved into its function as a "con-
duit for *flows*: flows of affect, flows of money, and flows
of traffic." Soule tracks this development through both
the formal structure of the novel and its affectless narra-
tor and protagonist. This narrator, Soule argues, who is
affectlessly repeating one thing after the other, embod-
ies the cultural and economic logic of the circulatory
space of the urban, "rotely insist[ing] on the incorpora-
tion of all phenomena into a poorly defined but irre-
sistible process." Consequently, a novel adequate to the
logistical logic of repetition and accumulation is one
where "the plot goes nowhere, there is no development
of character, no profound reckoning." Following Jame-
son's famous diagnosis of a waning of affect, now under
the heading of the logistical city,[63] all that *Remainder*'s
protagonist achieves is a pleasant "tingling sensation."

When dealing with the experience of capitalist cir-
culation coupled with merely a tingling sensation, the
concept of the sublime becomes fundamentally inade-
quate and requires us to turn to post- or anti-sublime
aesthetic categories. This is what Stefan Yong argues in
his reading of Sianne Ngai's work as an important con-
tribution to the "aesthetico-political project of cogni-
tive mapping." By criticizing three concepts of the sub-
lime—Sam Halliday's logistical sublime, Bruce Robbins'

63 Deborah Cowen, *The Deadly Life of Logistics: Mapping Violence in
 Global Trade* (Minneapolis: University of Minnesota Press, 2014).

sweatshop sublime, and Fredric Jameson's technologi-
cal sublime—Yong foregrounds how the sublime always
entails its own strategies of containment, and doubly so.
As ideological containment, the overwhelming sublime
presents itself as a barrier to human activity, whereas
in its Kantian formulation, it contains through the ulti-
mately inverted triumph of reason over the sublime.
As Yong shows, this "place[s] the subject in a double
bind: awestruck paralysis or a retreat into cognition."
Faced with this impasse, Yong appeals to weaker aes-
thetic categories, which he traces through Ngai's three
major works: the stuplime, the interesting, and the gim-
micky.[64] Ultimately, Yong concludes, "[p]ractical con-
frontations with capitalist circulation can, and perhaps
must, begin with rather unspectacular forms of inquiry,
action, and affective orientation."

This "turning away from the vastness of supply chains
[…] toward their intimacy, the human labor whereby
goods move hand to hand to hand" takes center stage in
Annie McClanahan's contribution. Following the pro-
found challenge to the genres employed for a cognitive
mapping of our contemporary crisis that both Soule and
Yong address, McClanahan turns to the genre of work-
er's inquiry, not as a genre of the sublime but as a "genre
of intimate solidarity." Thinking about the sublime, and
the vastness of supply chains, is "first-world thought,
boom-time thought." Taking the mundane experience
of the pandemic as a starting point, McClanahan thinks
through both the hands that touch every item delivered
to our doors and the hand as a metaphor in the not-
so-hidden abode of circulation. Countering the circula-
tionists' imaginary with the figure of the hand begins

64 Sianne Ngai, *Ugly Feelings* (Cambridge, Mass. and London: Harvard
University Press, 2007); Sianne Ngai, *Our Aesthetic Categories: Zany,
Cute, Interesting* (Cambridge, Mass. and London: Harvard University
Press, 2012); Sianne Ngai, *Theory of the Gimmick: Aesthetic Judgment
and Capitalist Form* (Cambridge, Mass. and London: The Belknap
Press of Harvard University Press, 2020).

to develop a thinking adequate to a time of crisis. Juxtaposing the long history of inquiries from below with the narratives of the twenty-first-century circulation economy takes her from Marx's account of the nineteenth-century sweating system to Wuhan's delivery riders. Instead of "the awe of the unrepresentably sublime totality," McClanahan concludes this volume with a call for us to return to the "demand to respond to what is directly before us."

Acknowledgements

This volume assembles the contributions to the workshop *Liquidity, Flow, Circulation: The Cultural Logic of Environmentalization* which took place in December 2020 and April 2021. It was hosted as an online event at the Leuphana University Lüneburg by the DFG research training group "Cultures of Critique" and the DFG research group "Media and Participation. Between Demand and Entitlement."

We wish to thank those who supported the workshop by chairing or responding to the presentations for their invaluable questions and remarks: Miglė Bareikytė, Anne Breimaier, Jakob Claus, Lisa Conrad, Rahma Khazam, Kassandra Nakas, and Ana Teixeira Pinto.

We received multiple support from the "Cultures of Critique" group. As spokesperson, Beate Söntgen ensured the whole project and granted us all the help we could wish for. As coordinator, Catharina Berents kept us on track during all the stages of the project and Stephanie Braune helped us with administrative concerns.

We have received further support from the DFG research group "Media and Participation." We would like to thank the project's spokesperson Beate Ochsner and all members of the research group for the continued discussion over the years and particularly our colleagues Roberto Nigro and Eduardo Delfin Alcaraz Bracho from

the subproject "Elements of a Critical Theory of Media and Participation" for their support with this project. Michel Schreiber has generously provided us with feedback and invaluable support throughout.

Evidently one name is missing in all the lists above: Erich Hörl, who joined the discussion as respondent, who is deputy spokesperson of "Cultures of Critique," and acts as principal investigator in the "Elements of a Critical Theory of Media and Participation" project. We are deeply indebted to him as an eminent thinker on ecologies and environmentalization, as generous colleague, and as academic advisor. Without him this book would certainly never have been brought into existence.

The final stages of producing this book were completed after one of its editors, Holger Kuhn, had started a new assignment at Bielefeld University and he wishes to thank his new colleagues, especially in the field of *Historische Bildwissenschaften und Kunstgeschichte*.

We also wish to thank Michael Heitz from Diaphanes for accepting this project as part of the "Critical Stances" series and his fast responses to all our inquiries. Thanks also to Catherine Lupton for her careful and conscientious copy-editing.

Finally, we would like to thank the German Research Foundation (DFG) for the generous funding that facilitated the entire venture.

Ecologies and Elements

Ursula Biemann

Devenir Universidad

Art, Indigenous Science and the Biocultural Reconstruction of Amazonian Knowledges

The environmentalization sweeping through art and academia in the last fifteen years has transformed our respective fields of studies in significant ways. In a series of territorial video investigations, I have gone through several stages of reshaping my artistic practice in relation to the decisive shift of focus from a global to a planetary scope, driven by the growing awareness of the sheer magnitude of the environmental and climatic crisis we are facing. While earlier works examined the correlation between the flow of carbon and mineral resources, big capital, and migration, I later turned to create more explicitly environmental works revolving around the larger planetary streams affecting the climate and experimented with new artistic narratives tackling topics that are traditionally the domain of natural science. For this, new tools were needed, and new characters had to be invented who could mediate the increasingly alarming ecocrisis. Also, perhaps more importantly, the critique of the devastating conduct by powerful players had to be replaced by propositions that could provide agency. This is the attitude and content of the recent works *Forest Law* and *Acoustic Ocean* which eventually led to my current involvement in co-creating a Biocultural Indigenous University in the south of Colombia, all of which I'm going to discuss in this text.

A New Charismatic Figure

Forest Law (2014)[1] addresses the complex entanglement of oil, forest, climate, and geopolitics on a larger plane by bringing Indigenous cosmologies and the Rights of Nature into the arena. For *Forest Law*, I was filming in the oil contaminated zones of Lago Agrio in the north of Ecuador, where Texaco-Chevron left hundreds of leaking oil ponds all over the forest in the 1970s. There, I met an Indigenous Scientist, Donald Moncayo, who was taking toxic soil and water samples for a chemical lab in Quito. When international journalists visit Lago Agrio to report on the contamination case, Moncayo takes them to the devastated sites and, dressed in a white protective suit, makes a forensic performance so they have something explicit to film. He is enacting a scientific gesture, not in a search for data, not a useful gesture, but one that simply makes matter expressive. I was intrigued by Donald's multiple roles as a scientist, environmental activist, and performer, for each of these roles mediate the relationship between the human and Earth on their own terms. (plate 1)

When looking for new figures that could accurately reflect global currents and that could move us away from the Digger who relentlessly extracts from the Earth, some suggest we should become Gardeners of the Planet. I come to see the Indigenous Scientist as a vital signifying figure of the twenty-first century, in a similar way that the Worker or the Migrant were pivotal figures in the twentieth century around whom the major social transformations were built. The Indigenous Scientist has the capacity of merging the contradictions of being at once scientific and political actor, studying the natural world while being part of it. Most importantly,

1 *Forest Law*, collaborative project with Brazilian architect Paulo Tavares, sync two-channel video installation, document assemblage, and publication, 2014.

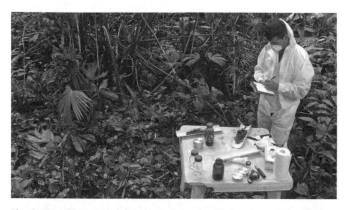

Fig. 1: *Donald Moncayo acting as a forensic soil chemist.* Video still from: Ursula Biemann and Paulo Tavares, *Forest Law*, 2014, 38 min., sync 2-channel video essay.

this figure stands for a different kind of epistemology that reconnects us to other ways of knowing and understanding the human-nature symbioses. In other words, it embodies some of the most fundamental problems in our mind-nature conception which brought forth the very concept of environment as a direct expression of the modernist separation paradigm. The Indigenous Scientist plays a leading role in the paradigm shift from an extractivist to a more generative and ecocentric worldview. I have been thinking about the possible role of art in this paradigm shift apart from generally highlighting the role of art in mediating "environmental" knowledge. Obviously, artistic research should go beyond merely adding another perspective to science. Rather it should help to challenge the separation of these different forms of thinking. To invent new charismatic figures, retell history and propose bold speculations: all aim at planting new seeds in the collective imaginary.

The Indigenous Scientist makes various entrances in my videos, some of them empirical, others more science-fictional like the one in a more recent work, *Acoustic Ocean* (2018). Located on the Lofoten Islands in north-

ern Norway, *Acoustic Ocean* sets out to explore the sonic ecology of marine life in the cold North Atlantic. The scientist as an explorer and important mediator of the contemporary understanding of our planetary ecosystems is the central figure here. She makes her appearance in the person of a Sami (Indigenous of northern Scandinavia) marine biologist-diver, who enters into communication with the submarine living world through a range of hydrophones, parabolic microphones and a kind of interspecies sound mixing desk. Her task is to sense the submarine space for bioacoustic and other forms of expression.

The submarine immensity of the Atlantic Ocean is a layered three-dimensional space where countless species are interacting with one another. Given the poor visibility in this penumbral liquid universe, the sonic dimension is the primary means of communication, navigation and survival. Formed by a difference in water density, the horizontal layers of the ocean allow for distinct sound frequencies to travel. In the mid-1940s, post-WWII, scientists discovered a deep sound channel, the so-called SOFAR channel (SOund Fixing And Ranging), where low-frequency sound travels great distances. Because of its specific physical nature, the water in this SOFAR channel can relay submarine sound waves over several thousand kilometers. During the Cold War, arrays of hydrophones were placed on the North Atlantic seabed to locate enemy submarines operating in deep sea layers. These instruments of espionage also detected sounds that were unknown, later decoded as low-frequency blue whale and finback whale vocalizations. Their acoustic range extends across the ocean floor through the media of nature. For a long time, the submarine environment was thought to be a silent place until these spy technologies initiated a new understanding of the ocean as an acoustic and semiotic ecosphere. At the end of the Cold War, the hydrophone installation was made accessible to scientists. While the

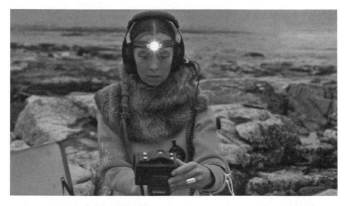

Fig. 2: *Marine biologist.* Video still from: Ursula Biemann, *Acoustic Ocean*, 2018, 18 min., video installation.

military operators made great efforts to filter out from the recordings any interfering sonic waves emitted by animals or seismic activities, scientists today would be overjoyed having these precious recordings of the vocalizations. Given today's maritime traffic, seabed drilling and deep sea sonar mapping it has become next to impossible to get an accurate portrait of the acoustic ecology of the ocean. (plate 2)

Environmental sounds have been often neglected in video recordings by ocean divers who focus mostly on the visual appearance of submarine life. The fact that the sonic frequency of communication often exceeds the human hearing range led to the misleading assumption that most water creatures do not speak or think. In recent years, marine biologists and acoustic engineers have improved, and increasingly apply, hydrophones in their research, enhancing the access to this formerly hidden dimension. Alongside, numerous studies interpreting fish songs and other submarine voices have emerged.

The female sonic marine biologist in *Acoustic Ocean* is dressed in an orange neoprene suit wearing a headlamp.

Standing on the shore in this stunning twilight land-scape, the aquanaut is operating a set of hydrophones and audio cables emerging from the ocean, connecting them to a technical device in two yellow Peli cases. The sound that we hear changes when she turns the dials. The devices not only render the sound of the marine organisms audible to the human ear, they also mount a sound event. Plugging and tuning the channels like a DJane, she is performing submarine radio broadcast.[2] The setup in *Acoustic Ocean* suggests that there is no objective distance between the scientist and the object of investigation. The Indigenous figure merges with the environment and through her sensory perception, reveals a sea full of intelligence. The environment is not external to the human subject here, nor is it something that is already there. Environment is something that needs to be actively generated. Whales, for instance, through their long-distance vocal signals across the ocean floor, are themselves emitting vast environments and imbuing them with meaning.

A Biocultural Indigenous University in the Amazonian Rainforest

Continued interest in Indigenous knowledge produc-ers has led to my current engagement with an Indig-enous University in the Amazonian south of Colombia. The project locates itself at a pivotal historical and geo-graphic point where several crucial temporalities come together. One timeline precisely has to do with the rise of modern Western thinking, when the human relation-ship with nature was taken out of the public sphere and

2 Yvonne Volkart elaborates on *Acoustic Ocean* in her text "NEAR GALE: Forming a New Organ," in *The Work of Wind: Sea*, ed. Christine Shaw and Etienne Turpin (Berlin, Toronto: K. Verlag and the Blackwood Gallery, University of Toronto Mississauga, 2021), pp. 240–257.

delegated to the natural sciences, where it was denied any political agency. This moment coincides with the timeline unrolling the trajectory of the first European botanists making contact with the exceptional biodiversity of the tropical forests in South America, Colombia in particular, which became a major driver for the advancement of natural science in Western universities. The beginning of modern science is intimately linked with the project of conquest and colonization. Since Indigenous peoples were considered part of the natural realm, they were placed in the scientific area shorn of any political agency. Their knowledge systems and cosmologies were quickly colonized, converted, and eventually delegated to a new academic discipline where they could be studied under anthropological parameters. As a result, the Indigenous peoples were put in a particularly vulnerable spot, not only by colonization, but also by the premises of modern Western science and teaching. In the postcolonial context of Colombia, this becomes evident in that education and knowledge production is still primarily a colonial project.

Against this backdrop, in terms of an aesthetic strategy, to cast the Indigenous not only as a political subject owning a voice and a territory—this is something that has been done by activists and film makers since the 1980s—but to posit him or her as a knowledge producer, an epistemic agent, is getting to the core of the crisis of the modern separation paradigm, which still largely determines our relationship to the living world. In the Latin American Indigenous context, despite the violent impact of colonization, the understanding that humans are an equal part of all life systems has enjoyed a long uninterrupted history from which we have much to learn at this time of global eco-crisis. Hence the university is not a project that happens over there. It has very much to do with Western institutions of learning.

The Amazonian peoples have spent millennia getting to know their living forests with whom they have

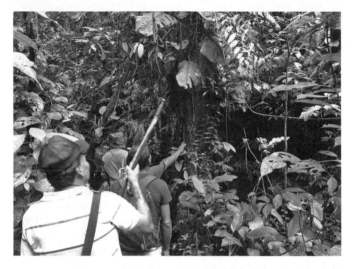

Fig. 3: *Visiting the future site for the university in Piamonte*, March 2021.

coevolved. Their accumulated knowledge is invaluable for protecting and restoring the forests and the diversity of living beings and cultures. Yet decades of armed conflict and an enduring history of colonial occupation of territories and knowledge systems in the Colombian forests have left the Indigenous communities without a viable system to foster their epistemic cultures.

The project started as a commission for a new artwork, extended to me by the Museum of Contemporary Art at the National University in Bogota shortly after Colombia signed the 2016 peace contract with FARC (The Revolutionary Armed Forces of Colombia). On an extended joint field trip through the south, the leader of the Indigenous Inga people, Hernando Chindoy, introduced me to his community and on the last day, invited me to co-create with them an Indigenous University. Curator Maria Belen Saez kindly conceded that my project would not be a film but rather a university and granted her full support. After holding a major kick-off meeting

in the fall of 2019 in Mocoa, capital of the Amazonian province of Putumayo, together with Inga educators and a group of international scholars emerging from this first meeting, we began to design a visionary project that combines Indigenous knowledge systems and modern science with the aim to foster peace and protection for the Andean-Amazonian forests and the Indigenous communities who thrive in and with these territories.

The Indigenous University holds a vision for a future founded on ecological concepts of mind, knowledge, and the inherent intelligence of life. Knowledge is viewed as embedded in the environment and knowing something means becoming part of this field of meaningful relations. This field of relations is what Indigenous people in Amazonia call territory, it is intimately connected to knowledge, wisdom, perceiving and caring. In this regard, the project is a real territorial university, collectively processing the ever-changing interactions between the different entities involved in meaning and world-making.

This form of ecological thinking is a practice that encounters the other as mind. A fundamental problem this university wants to address is the objectifying practice of science. In the modern scientific paradigm one knows something when one is able to see it from the outside, that is, when the world is objectified and no intentions are attributed to the object of study (e.g. plants, animals, complex tropical ecologies). In contrast, for traditional medicine people (*sabedores)* in Amazonia, to know something well is to be able to attribute intentionality, thus turning it into a subject with whom we can have a conversation between *persons*.[3] The university will be a space for reckoning with plants, animals, rivers and other beings as persons of knowledge, a space for

3 Ivan Darío Vargas Roncacio, "The Legal Lives of Forests: Law and the other-than-human in the Andes-Amazon, Colombia," (Ph.D diss., McGill University, 2021).

practicing the subjectifying view of Indigenous science. It proposes the co-creation of a teaching and research experience and place that actively integrates a living cognitive terrltory into any educational agenda. This will be a radical departure from traditional universities, but we recognize that there are also links between Western and Indigenous knowledge traditions that have gone unnoticed, undoubtedly because of the fragmentation and coloniality of Western knowledge but also due to enduring misinterpretations and misappropriations of Indigenous conceptual practices. Many phenomena, which in the past would have been considered supernatural, of the realm of shamanism or cultural belief, now lie within the fences of science. And the overlapping areas are steadily increasing. To open a contemporary pluri-epistemic dialogue, we align with innovative approaches in scientific fields such as ethnobotany, the anthropology of science, Earth law and the rights of nature, environmental sciences and philosophies engaging with the life of forests and plants, all of which put forward ideas that are compatible with Amazonian cosmologies.

The Indigenous-led initiative emerges from a history of violent encroachments upon the Indigenous ways of life and territories in Amazonia, a trend that in the Colombian context continues today through colonial expropriation of lands, constant violation of rights, rampant deforestation, drug traffic, and social and armed conflicts. Fifteen years ago, the Inga people embarked on a remarkable path of self-determination to strengthen their Indigenous identities and practices and reweave their ancestral way of life based on a philosophy of Good Living—Sumak Kawsay.

Knowledge transmission is founded on the biocultural principle that nature and culture are not separate but form relationships of interdependence and continuity. In this sense, the territory, with its visible and invisible beings, human and non-human, is not simply the

stage where culture occurs but, rather, is a sentient and cognizing being, that is, a living "agent" of knowledge. Instead of using knowledge as a tool for domination and wealth generation, the biocultural paradigm on which this university is founded, advocates the co-emergence and ethical cohabitation of and between humans and non-humans.

The project of building a Biocultural Indigenous University in the south of Colombia involved a cooperation with the architecture studio of Anne Lacaton at ETH Zurich, joined by a parallel studio at the Javeriana University in Bogota, resulting in a book that is widely used by the territorial planners in the territory now. Territory is not a geometric space, it emerges from space-making practices, and is alive. Fittingly, the Inga conceive of the university as a composition that spreads across the entire territory in an organization of sites and paths where particular knowledge can be produced. For Indigenous people knowledge is meaningful only in relation to the specific sites where it can be produced: the *chagra* research gardens, the rivers, the primary forest, the *paramo*, the amazing high moor ecology. A university structure, both material and intangible, would have to take all these factors into account. In this decentralized configuration, the new institution will be a departure from the campus cities of Western universities.

Devenir Universidad

To locate the project in relation to the art world and beyond, I proposed to create the platform *Devenir Universidad*[4] to set conceptual and aesthetic impulses and support the university project by generating, assembling and communicating artistic and audio-visual productions for memory keeping, teaching and learning at

4 www.deveniruniversidad.org (accessed September 18, 2021).

the future university as well as communicating with the global community. It is a hub where different knowledge traditions converge, nurture each other, and mutually translate. In this sense, *Devenir Universidad* acts as an initiator and aesthetic companion to the future university in the form of exhibitions, events, publications and this comprehensive online platform. Going live in August 2021, *Devenir Universidad* is not the website of this future university. Rather it documents the process of becoming university and that which is becoming university is not primarily the Indigenous Inga people but the territory per se, the totality of relationships—cultural, ecological, psychic, political and cosmological—that constitute this living territory. Meanwhile, the platform has expanded to encompass the materials and activities of an interdisciplinary group of academics who have emerged from the initial Mocoa meetings, committed to working together in the areas of intercultural pedagogies, nature rights, territorial planning, forest epistemologies, architecture and Indigenous territorial rights for the Biocultural Indigenous University.

This new institution fulfills many vital functions for the Inga. Their territories are under great pressure from state interests who see this region as empty and unproductive. Cattle farms and oil extraction grab more and more land, pushing the Indigenous further away from good fertile land. The Indigenous University is also a symbolic way of claiming the land and stemming the land grabbing endeavors by powerful actors. The Inga recount their history as a continuous struggle to get the territories under legal protection, emphasizing the importance of being in the territory for that to happen. They lead a dual strategy of working before the state to obtain the titles and of dwelling in the territory to reproduce and constantly rearticulate the recognition. The university project is crucial as a form of occupation, by insisting on walking through the territory to produce knowledge and forming bonds with the living world.

Fig. 4: *Community meeting with the Inga authorities on the university project*, March 2021.

The institution operates as a decentralized nervous system of the Inga people. On the other hand, the preservation of ancestral knowledge of the local ecologies is vital for the subsistence of the forests and the communities who inhabit them. The shamans spend many years learning from and with the plants, because the learning is also a form of healing, which takes a lot of time. The learning with plants teaches to heal the territory. We can think of the university as a healing practice for a territory that has been injured by colonial intervention, by extractivist projects and epistemological occupation. The university becomes the possibility of restoring the territory, always remembering that the territory is a bunch of relationships, not a material place. This is how the new university may play an important part in assuring the ongoingness of relationships seized by extractivist economies, acting as a decolonial as well as a relational university.

From the perspective of an artist, I want to offer a few reflections on how I see myself and my visual practice transforming in and through my involvement in this project. The images I make in this context work differently from my artistic practice up until now. The first video collection I produced was the conversations among Inga, other Indigenous representatives and Western academics during the four days of the kick-off meeting in Mocoa. Then, as soon as the travel bans lifted last winter, I went back to the territory to collaborate with Inga educators and social leaders[5] in conducting interviews with the elders on their memory and the territorial history of the Piamonte region in the south of Colombia. The production and circulation of these images operate in multiple ways. As a result of colonization and the armed conflict, the Inga people are fragmented and dispersed across the country which makes communication difficult, it's hard to keep everyone on the same page. The platform and the images have the purpose of reconnecting a dispersed people. This is important because a lack of information generates misunderstandings, or worse, exclusion, and these images can contribute to reducing misunderstandings. The platform *Devenir Universidad* is a way of letting everyone in on the conversation, generating inclusiveness and bringing everyone onto the same page. This enhances transparency of the process, making it comprehensible within the community, between different Indigenous communities inhabiting the region, towards the outside and on all scales. Also, these images help to give form to the cognitive and mental stuff this university will be made of. They actively help rearticulate the community by reassembling its cultural identity. A few years ago, they just considered themselves *campesinos*, peasants, often bearing adopted Spanish names. With the conscious choice

5 Waira Nina Jacanamijoy Mutumbajoy, Flora Macas and Ivan Vargas Roncancios conducted the interviews.

to relink to older traditions they took up their Indigenous names again and remembered their cosmology, thus the images also help to reconnect and remember. The story of the Inga connects to a larger movement that has gathered momentum in the 1980s and 1990s across Latin America and in the global arena, where the new vocal public persona and globalizing public voice of the Indigenous made itself heard. It's not returning to some historical version of Indigenous identity, this movement seeks a contemporary edition of what it means to be Indigenous in the twenty-first century, as James Clifford explains so well.[6] The rising Indigenous and their self-defined knowledge is a historical moment in the making that needs imaging to enter the collective imaginary. As always, to achieve sovereignty of signification over themselves and their way of being, is a major purpose of such a project.

Of course, I have asked myself what my role and contribution could be in this project and the answers have been multiple and shifting over time. I see this art and media project as an aesthetic companion to the Indigenous-led project. It translates the issues and concepts for intercultural communication and hence acts as a mediator and connector for international partnerships and participation. As an extended art project, it shifts the focus from bringing ecology into art to bringing art to ecology by directly intervening in, and co-creating, material and epistemic realities on the ground. Perhaps the process of devenir universidad is also one of becoming environmental, where the outside and inside dissolve in a gradual ecologization of the university. In spite of the restrictions and destructive conducts by the state and corporate forces in the region, *Devenir Universidad* pursues a propositional mode of thinking and imagining in a caring and highly speculative way. In

6 James Clifford, *Returns, Becoming Indigenous in the Twenty-First Century* (Cambridge, Mass.: Harvard University Press, 2013).

Fig. 5: *Field excursion with ETH students of Studio Anne Lacaton in the Inga territory*, October 2019.

doing so, it disrupts the modern operation of critique and replaces it with a performative imagination, a collectively produced fiction. And when this fiction joins the world, it becomes the world.[7]

7 Maria Hlavajova, "Propositions #10: Instituting Otherwise," lecture, BAK basis voor actuele kunst, December 7, 2019, https://www.youtube.com/watch?v=MPSej-ALupI (accessed September 18, 2021).

Maryse Ouellet

A Realist Aesthetic of the Sublime

Art, Environment and
The Cultural Logic of the Anthropocene

To revisit Fredric Jameson's analysis of the "Cultural Logic of Late Capitalism" also entails reconsidering the meaning attached to the notion of the sublime. Indeed, one of the conceptual legacies of the book was to disseminate a postmodern understanding of the sublime as the "unrepresentable." Although the concept had been previously theorized by Jean-François Lyotard in his writings on aesthetics,[1] it is Jameson who defined it as the hallmark of postmodern *culture*. According to him, postmodernity was not a style, but a moment in history, dominated by late capital's global "network of power and control" that resisted representation due to its scale and decentralization.[2] Moreover, this domination was felt in art and culture through an aesthetic of

1 See, for instance, Jean-François Lyotard, "Réponse à la question: qu'est-ce que le postmoderne?," *Critique*, no. 419 (1982), pp. 357–67; Jean-François Lyotard, "Le sublime à présent," *Po&sie*, no. 34 (1985), pp. 97–116; Jean-François Lyotard, *L'inhumain: causeries sur le temps* (Paris: Galilée, 1988).

2 "The technology of contemporary society is therefore mesmerizing and fascinating not so much in its own right but because it seems to offer some privileged representational shorthand for grasping a *network of power and control* even more difficult for our minds and imagination to grasp: the whole new decentered global network of the third stage of capitalism itself. [...] It is in terms of that enormous and threatening, yet only dimly perceivable, other reality of economic and social institutions that, in my opinion, the postmodern sublime can alone be adequately theorized." [Emphasis added] Fredric Jameson, *Postmodernism, Or, The Cultural Logic of Late Capitalism* (Durham: Duke University Press, 1991), pp. 37–38.

the simulacrum that manifested the unrepresentability of global capital.

Thirty years later, Jameson's description of global capital remains relevant. Yet, the climate emergency and the growing awareness of humanity's interconnectedness with nonhumanity, fostered by theories of the Anthropocene, have reoriented culture toward questions of matter, resources and sustainability. Rather than mirroring aesthetically what Jameson named a postmodern "depthlessness,"[3] a number of artists now adopt realist approaches to expose capital's invisible network of power and control and its impact on the planetary equilibrium. This environmental turn compels us to ask whether an aesthetic of the sublime still has contemporary relevance.

The sheer number of publications[4] and exhibitions[5] on the sublime that marked the first decades of the new century indicates that the notion indeed strongly echoes contemporary concerns, in particular with regards to nature, the nonhuman, and human "difference." While some argue that the modern category of the "natural" sublime returns within contemporary representations of

3 Ibid., p. 6.
4 As a concept, the sublime has exerted an undeniable power of attraction in the humanities over the last twenty years and across disciplinary fields. Accordingly, numerous monographs and edited volumes have sought to provide an account of what could be a contemporary sublime and surveyed the various historical interpretations of the sublime. See, in particular: Temenuga Trifonova, ed., *Contemporary Visual Culture and the Sublime* (New York: Routledge, 2017); Gillian Borland Pierce, ed., *The Sublime Today: Contemporary Readings in the Aesthetic* (Newcastle upon Tyne: Cambridge Scholars Publishing, 2012); Timothy M. Costelloe, ed., *The Sublime: From Antiquity to the Present* (Cambridge and New York: Cambridge University Press, 2012); Philip Shaw, *The Sublime* (London and New York: Routledge, 2006).
5 For instance, Suzanne Ramljak et al., *Natural Wonders: The Sublime in Contemporary Art. Thirteen Artists Explore Nature's Limits* (New York: Rizzoli Electa, 2018); Hélène Guenin and Centre Pompidou-Metz, *Sublime. Les tremblements du monde* (Metz: Centre Pompidou-Metz, 2016); Tate Britain (Gallery), "The Art of the Sublime," 2012, http://www.tate.org.uk/art/research-publications/the-sublime (accessed October 21, 2016).

environmental catastrophes,[6] others claim that the post-modern notion of the "unrepresentable" is better suited to account for the imperceptibility of our entanglement with the nonhuman and the scale of climate changes.[7] Nevertheless, we must be wary of apparent parallels as well as of a certain tendency to conflate "the" sublime with specific historical and ideological interpretations. To fully grasp the relevance of the sublime in the context of the environmental turn, we must first ask if and how the sublime has been reinterpreted. Such a reinterpretation would not entail the identification of a single or a radically new sublime embodiment (e.g. "nature" or the "nonhuman")—after all, multiple emblems of the sublime can coexist in a single historical period, but also persist throughout time—so much as the redefinition of the specific power or force contained in those embodiments (e.g. the divine, the supersensible, the "unrepresentable") and the way it manifests itself (e.g. through rapture, violence or shock).

In what follows, I argue that a reinterpretation of the sublime is at work in contemporary art, taking as a case study a documentary film and a video that address the relation between humanity and water: Jennifer Baichwal and Edward Burtynsky's *Watermark* and Ursula Biemann's *Deep Weather*, both from 2013. While the tension between humans and nonhumans has underpinned theories of the sublime since the eighteenth century, it has led to diverging and sometimes opposite representations of the forces in play: whereas the Moderns conceived nature as an alterity to be mastered by the power of reason, and the Postmoderns, as culture's withdrawn and inaccessible other, Baichwal, Burtynsky and Biemann represent nature, or more precisely *water*, as a

6 See, for instance, Hélène Guenin and Centre Pompidou-Metz, *Sublime. Les tremblements du monde*.
7 Eva Horn and Hannes Bergthaller, *The Anthropocene: Key Issues for the Humanities*, Earthscan (London and New York: Routledge, 2020), p. 102.

power that consists in *connecting* humans and nonhumans. Drawing on John Durham Peters' notion of "elemental media," I argue that water is an "existential" and "infrastructural" form of interconnection that stands, in the artists' work, for the powerful, sublime force that, in recent history, has been successively defined as reason's supersensible faculty or nature and capital's unrepresentable excess.[8]

To demonstrate this shift from a modern to a postmodern and a contemporary interpretation of the sublime, I first take an etymological and historical look at the notion of the sublime, understood as a confrontation between a subject and a force so great that it suspends, at least momentarily, beholders' ability to make sense of their experience. I thereby disentangle the general meaning of the sublime from its historical and cultural reinterpretations. I then turn to Baichwal, Burtynsky, and Biemann to highlight how their reinterpretation of the sublime correlates with the cultural logic of the Anthropocene. Through an analysis of their realist aesthetic, I demonstrate that the artists move beyond postmodern interpretations of the sublime by redefining it as an interconnecting force actualized in the elemental medium that is water.

1. From Modern to Postmodern Sublime: A New Cultural Logic

The infatuation for the sublime in not only the art world, but the humanities more broadly, emerged around the same time as theories of the Anthropocene began to disseminate. Paul J. Crutzen and Eugene F. Stoermer's 2000 article introduced the concept of "Anthropocene" to a larger audience, while eight years later the

8 John Durham Peters, *The Marvelous Clouds: Toward a Philosophy of Elemental Media* (Chicago: University of Chicago Press, 2015).

Tate Britain initiated a research project to examine the history and current relevance of the sublime in art.[9] We can easily understand the appeal of the sublime in the first decade of the new century: this was a time of both anxiety and hope, and the sublime, as an experience, is a category that expresses precisely such dualities. Moreover, the modern category of the natural sublime appeared to many as particularly fitting to express growing environmental concerns. Recently, Timothy Morton's notion of the "hyperobject" has reinvigorated the postmodern "unrepresentable," by suggesting a connection between the scale, yet ungraspability of global warming and the experience of powerlessness described in Lyotard and Jameson's writings on the sublime.[10] That being said, the apparent congruence of the modern and postmodern sublime with contemporary environmental awareness should not obliterate that discussions of the Anthropocene have precipitated a questioning of the duality between humans and nonhumans that forms the basis of, precisely, the natural sublime *and* the postmodern sublime that theorists invoke today. Only a historical outlook can illuminate this incompatibility too often left unexplored.

To better discern the historical and cultural specificity of the modern and postmodern sublime, it is necessary to establish a general definition of the concept. While today, the sublime is generally conceived as an ambivalent experience of awe and terror, the word's connotations are, linguistically speaking, distinctly positive. What became known, in the seventeenth century, as "the" sublime was largely inspired by the *Peri Hypsous*, the earliest known treatise on grandeur written in the

9 Paul J. Crutzen and Eugene F. Stoermer, "The 'Anthropocene'," *IGBP Global Change Newsletter* 41 (2000), pp. 17–18; Tate Britain (Gallery), "The Art of the Sublime."

10 Timothy Morton, *Hyperobjects: Philosophy and Ecology after the End of the World*, Posthumanities (Minneapolis: University of Minnesota Press, 2013).

first century AD by the Greek Longinus. The Greek noun *hypsous* literally meant "height"[11] and designated both a grand speech and the experience of awe and "transport" (*ekstasis*) it inspired.[12] The Latin adjective *sublīmis*, from which the contemporary use of the term is derived, meant "who goes while rising" and suggested a "dynamic movement upward."[13] Like *hypsous*, *sublīmis* described a speech's elevated style as well as the uplifting feeling it aroused. If the notion of elevation has been recently eclipsed by the more negative connotations associated with the postmodern sublime, that of a duality between a perceived object—originally, a speech—and a witness whose senses are strongly affected by that object and who is moved to a state of awe, has been upheld through time.

With the emergence of aesthetic theories of the sublime, in the eighteenth century, this duality became the expression of a dualism opposing man to nature. Immanuel Kant, who inspired postmodern theorists, based his idealist theory of the sublime on the existence of an unknowable core at the heart of the visible or sensible. He defined the sublime as an experience through which that essence manifests itself by virtue of man's ability to make sense of the infinite or the powerful perceived (mostly, but not only) in nature thanks to his faculty of reason.[14] Kant's interpretation is representative

11 Baldine Saint-Girons, "Sublime," in *Dictionary of Untranslatables: A Philosophical Lexicon*, ed. Barbara Cassin (Princeton: Princeton University Press, 2014).

12 W. Rhys Roberts and Longinus, *Longinus on the Sublime: The Greek Text Edited after the Paris Manuscript* (Cambridge: Cambridge University Press, 2011).

13 Baldine Saint-Girons, "Sublime," in *Encyclopedia of Aesthetics. Oxford Art Online.*, ed. Michael Kelly (New York: Oxford University Press, 1998), http://www.oxfordartonline.com/subscriber/article/opr/t234/e0490 (accessed September 21, 2021).

14 Immanuel Kant, *Critique of Judgment*, trans. Walter S. Pluhar (Indiana: Hackett Publishing, 1987). I use the term "man" deliberately to emphasize the gendered conception of the term in the eighteenth century. Feminist scholars have shown that Kant did not believe that women possess the ability to rise above their instinct and fear

of what the anthropologist Philippe Descola has labeled the "naturalist" or modern "cosmology": a representation of the world that establishes a separation between nature and culture, and that formed the basis of the Moderns' scientific and cultural ambitions.[15] Kant indeed interpreted the sense of elevation that characterizes the sublime as the feeling of one's own superiority over the sensible realm.[16] But what caught the attention of postmodern thinkers was the role he attributed to imagination in this process. Although its outcome was undeniably "satisfying," the Kantian sublime involved a feeling of *pain* corresponding to the faculty of imagination's initial attempt to provide a presentation of the unlimited or greatness observed in nature. According to Kant, it was indeed the imagination's failure that prompted reason to step in to comprehend the phenomenon, thereby exerting "violence" upon sensibility.[17] Kant's legacy in contemporary thought has largely hinged on this concept of a "negative" feeling, a preference symptomatic of a shift in the representation of the nature-culture relationship.

Although it chronologically succeeds to the modern sublime, the postmodern sublime as described by Lyotard and Jameson can be understood as a development of its modern antecedent: it expresses aesthetically what happened after the modern separation with nature has been led to its breaking point. For Lyotard, the postmodern aesthetic of the sublime was as much an ethical as an aesthetical response to the failure of modern grand narratives. The "unrepresentable" evoked an ethical mandate entrusted in art "after Auschwitz" to testify formally—that is, through abstract and non-resembling style—to the impossibility of representing, conceived

in order to reach the sublime. See, for instance, Christine Battersby, "Kant and the Unfair Sex," in *The Sublime, Terror and Human Difference* (London and New York: Routledge, 2007), pp. 45–67.

15 Philippe Descola, *Par-delà nature et culture* (Paris: Gallimard, 2005).
16 Kant, Critique of Judgment, § 28.
17 Ibid., § 27–28.

as the ethical lesson of the historical catastrophe.[18] For Jameson, the postmodern aesthetic of the sublime was rather the consequence of the commodification of culture under the third stage of capitalism. If modernity was responsible for having "othered" nature, postmodernity, according to him, was what remained after nature has been colonized by capital and culture.[19] Postmodern theories of the sublime thus went so far as to evacuate nature completely and, along with it, the positive feeling of elevation inscribed in the very etymology of the term. The sublime was understood essentially as an experience of shock and powerlessness in the face of an unrepresentable or unattainable excess. In a reversal of the modern hierarchy that saw the subject experiencing the greatness of their own spirit, the postmodern sublime thereby elevated the very sense of *limits* aroused by what resists the subject's grasp. Jameson attributed that resistance precisely to global capital's decentered network of power and control.[20]

In the realm of culture, this new logic of global capitalism manifested itself in what Jameson described as "depthlessness": after everything had turned into culture, the critical distance that art used to provide disappeared, giving way to surface and "derealization" effects.[21] In *Postmodernism*, Jameson takes as an example of this derealization Andy Warhol's *Diamond Dust Shoes* (1980), a colored print based on a photograph representing rows of women's luxury shoes. Jameson conceives of the silk-screen technique used by Warhol and the resulting X-ray appearance as a metonymy for the depthless culture of "simulacrum," arguing that the motifs cannot be restituted to any historical, literary

18 See, for instance, Lyotard, "Réponse à la question: qu'est-ce que le postmoderne?"; Lyotard, *L'inhumain: causeries sur le temps.*
19 Jameson, *Postmodernism*, p. ix.
20 Ibid., p. 38.
21 Ibid., p. 34.

or simply any "lived" context:[22] once "the external and colored surface of things—debased and contaminated in advance by their assimilation to glossy advertising images—has been stripped away," what remains is not a meaningful story that would restore some humanity in the object; rather, it is only "the deathly black-and-white substratum of the photographic image which subtends them."[23] For Jameson, the sublimity of the images corresponds less to the actual reaction one might have when contemplating Warhol's artwork, than to its aesthetic qualities: the "intensities" and splendor of the image magnify the "society of the spectacle,"[24] rather than put it into perspective. By abandoning the principle of representation, namely the reference to something outside the image itself, postmodern aesthetics thus materializes the cultural logic of global capital as "unrepresentable."[25]

As a manifestation of culture's reduction to surface effects, the postmodern sublime marks a departure from the modern concept whose bedrock was critical distance. We can indeed trace the notion of critical distance back to Kant's third *Critique*. The philosopher conceived the experience of the sublime as the product of the faculty of judgement, which is effective only inasmuch as the observer is situated at a secure distance from the object he contemplates, such as a storm on the sea.[26] As a stepping stone to critical judgement, distance can also be thought of as a mental or aesthetic exercise in putting things into perspective: Friedrich Schiller, for instance, argued that art derives political efficacy from the aesthetic distance that allows it to represent reality anew, offering beholders the possibility to train their

22 Ibid., p. 8.
23 Ibid., p. 9.
24 Guy Debord, *La société du spectacle* (Paris: Gallimard, 1996).
25 Jameson's analysis of nonrepresentational art is perhaps best articulated in his examination of E. L. Doctorow's novel *Ragtime*. See Jameson, *Postmodernism*, pp. 23–25.
26 Kant, *Critique of Judgment*, § 28.

critical judgement.[27] Jameson claims, however, that by not only becoming a commodity, but also appropriating commercial and advertising aesthetics, art loses such critical and political efficacy. The cultural shift that the postmodern sublime represents has therefore little to do with the environmental one we are experiencing today. Just as the natural sublime manifested the modern cosmology, the unrepresentable stands for the postmodern reinterpretation of the relation between humans and nonhumans or, more accurately, the retreat within the realm of culture, which is also the realm of capital.

2. A Realist Aesthetic of the Sublime

Although it may be tempting to adopt the postmodern concept of the unrepresentable to describe the scale and power of global warming, which is at the root of the environmental turn we are currently witnessing, we must remember that the unrepresentable is neither specific to the sublime, nor to a particular object that would embody it, but rather a historically and ideologically determined interpretation of that object. As theorists Eva Horn and Hannes Bergthaller rightly point out, an aesthetic theory of the Anthropocene "must question the notion of nature as the other and opposite of the human."[28] I contend, however, that contrarily to what they suggest, "Lyotard's diagnosis of the sublime object's resistance to representation"[29] offers no remedy

27 See "On the Sublime" [1793], "On the Pathetic" [1793], and "Concerning the Sublime" [1801], in Friedrich Schiller, *Essays*, ed. Walter Hinderer, trans. Daniel O Dahlstrom (New York: Continuum, 1993), pp. 22–85.

28 Horn and Bergthaller, *The Anthropocene: Key Issues for the Humanities*, p. 101. For an earlier discussion of the reinterpretation of nature in contemporary art representations of the sublime, see Maryse Ouellet, "Par-delà le naturalisme: médiatisation du sublime dans les oeuvres d'Olafur Eliasson et Ryoji Ikeda," *RACAR : Revue d'art canadienne / Canadian Art Review* 41, no. 2 (2016), pp. 105–20.

29 Ibid.

to the modern hubris: while it may suggest the object's autonomy from the subject, it effectively grounds the sublime in the subject's faculty of representation—and its failure. In doing so, the postmodern theory of the sublime takes up Kant's idealism that posits the human faculty of representation as objects' determinant and the measure of their sublimity.

Therefore, to identify how the sublime is transformed by the cultural logic of the Anthropocene, we may start by asking, What is the measure of the sublime today? If we want to carry on Jameson's legacy of historical rigor and maintain the meaning of his notion of a "cultural logic," we cannot be satisfied with pairing postmodern theory with modern descriptions in the way Horn and Bergthaller do when they identify the "unrepresent-able" with nature's "unpredictable and potentially dangerous force" or "the almost incomprehensibly vast—in Kant's terms: 'absolutely great'—scope of anthropogenic impact."[30] Instead, we need contemporary theoretical tools and a different set of descriptions. In what follows, I analyze two visual forms of description, Baichwal and Burtynsky's film and Biemann's video, that address precisely the anthropogenic impact on nature. While aesthetically, the film and the video evoke both the modern and the postmodern sublime, they do not dwell on sublime landscapes. Rather, they use juxtaposition and combine close-ups and aerial perspectives to bring about a *realist* aesthetic. In so doing, Baichwal, Burtynsky, and Biemann do not evacuate the sublime, but reinterpret it. They indeed locate the sublime not so much within the "vast" and the "ungraspable" excess of human destruction—although they document it thoroughly—but more so within the sense of interconnection actualized by water.

Jennifer Baichwal and Edward Burtynsky's 100-minute documentary film *Watermark* visualizes the inter-

30 Ibid., pp. 102–103.

connection that binds humans with their environment around the globe through a dialectical montage that manifests a shift from a modern to a contemporary realist aesthetic. In this regard, the opening sequence is revealing. The documentary begins with close-ups of dark brown water rushing through the screen in slow motion with sublime force. No indication, however, mentions at first exactly what is shown. While the viewer is left wondering where these torrents of water are bursting from, the image cuts to the basin where the cascades come crashing in. Suddenly, a solid yet frail-looking walkway appears in the mist, turning the picture into a powerful evocation of J. M. W. Turner's or Victor Hugo's Romantic marines where the sublime, infinite forces of nature confront the fragile, finite silhouettes of boats. The film then cuts again abruptly to a desertic landscape. As the camera slowly pans out to the horizon up to which the desert extends, any idea of water as an infinite resource suddenly comes to a halt. In the middle of this barren landscape, an elderly woman recalls in Spanish that the Colorado River used to provide her community with lots of fish, before "people" drained the territory of its water, forcing them to leave. The desertification of that territory, eventually identified as the Colorado Delta, in Mexico, is in fact the result of dams built on the river.[31] Although that cause is never explicitly named, it is alluded to through the montage: as the camera flies over the river and its tributaries dying into the sand (plate 3), the film suddenly reverts to the initial torrents of water. This time, the view is firmly grounded, at a safe distance from the water: the first plane of the image shows a concrete rampart along which tourists take photos, while in the background, the infrastructure of a dam from which the water gushes is revealed, extending from left to right. As a caption appears, iden-

31 See Yvonne Volkart's article in this volume for the discussion of (the concept of) dams in art works.

Fig. 1: Edward Burtynsky, *Xiaolangdi Dam #1*, Yellow River, Henan Province, China, 2011.

tifying it as the Xiaolangdi Dam on the Yellow River in China (fig. 1), the viewer is made to understand that this film is not only about nature and its sublime, infinite power; rather, the dialectical montage highlights the relation of checks and balances between humanity and environment, capital and nature, that is sealed through water as the infrastructure of life itself.

Ursula Biemann's nine-minute video-essay *Deep Weather* similarly uses juxtaposition to highlight an otherwise invisible connection between foreign territories at two ends of the globe. The film is structured in two parts: the first consists of images captured by Biemann in a helicopter over a site of tar sand extraction in the Northern Boreal Forest in Alberta, while the second was shot in the Ganges' delta in Bangladesh, where people are faced with rising seawaters that threaten to swallow their territory. The video opens up with bird's-eye views of the tar sand mines of Fort McMurray in Canada (plate 4). The

shots were photographed 1000 meters above the ground. As a result of the helicopter's trembling, most images are blurred. Adding to this fuzziness, the boundaries of the dark, humid territory also remain undiscernible. Moreover, the images are devoid of human presence apart from dispersed machinery. Whereas *Watermark* conjures up the modern sublime, *Deep Weather* initially evokes the postmodern notion of an unrepresentable, totalizing power, in this case, the extraction industry or more generally capital. Like global warming, global capital can be conceived as a "hyperobject," a notion that Biemann borrows from Timothy Morton to refer to a phenomenon's scale and non-locality that seem to resist comprehension—and, might we add, to qualify it as a sublime, transcending force.[32]

However, just like in *Watermark*, the montage interferes with the seemingly postmodern aesthetics. After only two minutes, "Carbon Geologies" comes to an end and the film reverts to sea level, in the Ganges Delta. The opening shot of the 7-minute second part, titled "Hydro-Geographies," follows two inhabitants paddling in a boat toward a bank entirely made of sandbags and crowded with people. Locals are seen carrying the bags meant to protect their territory from the erosion caused by the melting of the Himalaya ice field, rising seawaters, and cyclones (fig. 2). It is on such shores, suggests Biemann's narration, that the effects of the extraction economy and the toxic clouds "that warm and swell the seas," are being felt. The contrast between the still and quasi-abstract images of desolate landscapes and the filmed sequences of humans at work suggests a dialectical overcoming of the aesthetics of the unrepresentable: if global capital's imperialism over nature seemingly escapes cognition, then a realistic aesthetic is needed to bring within the reach of our senses the elemental con-

32 Ursula Biemann, "Deep Weather," *Intervalla* 3 (2015), pp. 10–12.

Fig. 2: Ursula Biemann, "Hydro Geographies," embankment. Video still from Ursula Biemann, *Deep Weather*, 2013, 9 min., video in color.

nection to the earth and to water that enables any kind of growth—economic, natural, human.

Baichwal and Burtynsky's approach has in common with Biemann's that it restitutes, to paraphrase Jameson, the apparent sublimity of landscapes to a "lived" context.[33] Their realism can be understood not only as a formal strategy, consisting in identifying a referent that adds "plausibility" to the image,[34] but also as a historical and conceptual rupture with the idealism of postmodern aesthetics that opposed the unrepresentable to realism. While Jameson defined the unrepresentable as a *de*-realizing aesthetics, Lyotard theorized an opposition between what he called a "realist" aesthetic, concerned with representing reality as a referent, and a postmodern aesthetic, focused on making the impossibility of representing appear "in presentation itself."[35] Interestingly, Baichwal and Burtynsky's sublime representations of

33 Jameson, *Postmodernism*, p. 8.
34 Ibid., p. 8.
35 Jean-François Lyotard, "Answer to the Question, What Is the Postmodern?," in *The Postmodern Explained: Correspondence, 1982–1985* (Minneapolis: University of Minnesota Press, 1993), p. 15.

torrents of water and Biemann's pictures of disfigured
territories may, at first, evoke the unrepresentable. Yet,
dialectical montage, juxtaposition and narration serve
to introduce referentiality in the images, connecting
the sublime visualizations of natural exploitation with
their lived and social underpinnings, thereby rekindling
a realist aesthetic.

Juxtaposition not only introduces context; it also
allows critical distance to take place. Indeed, context
provides the images with a degree of that depth whose
loss Jameson lamented. Such critical distancing was
very much part of avant-garde forms of realism since
Gustave Courbet. Let us remember that realism was
concerned less with imitating reality than democratiz-
ing the visible by introducing the figures of peasants,
workers and mundane subjects into academic painting.
Similarly, *Watermark*'s and *Deep Weather*'s realism can
be described as an attempt to give a fuller, more faceted
version of reality by putting the appearance of a natural
or postmodern sublime into perspective. They use jux-
taposition to challenge our habitual representations of
the world by bringing together activities that we are not
accustomed to put in relation, worlds that clash in their
geographic, economic, political, and cultural situations.
In doing so, they call for what Schiller designated as the
viewer's "critical judgment" and resist the postmodern
idealism that turned viewers' alleged inability to com-
prehend an object's magnitude into the measure of its
force. That being said, the artists' realist aesthetic does
not fall back into a dualism that would simply oppose
the sublime. Rather, it serves to reinterpret it as a force
located within the elemental medium of water.

3. Sublime Water Infrastructures

Infrastructure theory is particularly apt to make sense of
contemporary interpretations of the sublime because it

locates mighty powers within often overlooked, yet existential networks that bind humans and their environment together. This existential understanding of infrastructure lies at the root of John Durham Peters' concept of "elemental media," which he defines as "infrastructures of being."[36] In *The Marvelous Clouds*, he advocates for a more generous, hybrid conception of media that recuperates an earlier understanding of media as natural elements.[37] Two aspects of his definition of media are particularly useful in illuminating the sublimity of water as represented in both Baichwal and Burtynsky's, and Biemann's work.

First, to conceive water as a medium implies paying attention to the role water plays *in between* humans as well as between humans and their environment. As Peters points out, the original meaning of the term "medium" refers to that which allows "contact at a distance," that is to say, through an intermediary space.[38] Elemental media is therefore a notion that refers to a medium's fundamental "hybridity," a Latourian concept that has gained traction in theories of the Anthropocene, because it suggests that the world is not simply made of humans on the one side and nonhumans on the other but also of hybrids *in between*.[39] Second, to think of water as medium means to consider what it *does*, and Peters points out that media provide *leverage*. After all, water is that "by the means of which" we can make our environments habitable. It is precisely why, according to Peters, elemental media are infrastructural: their function is existential, not informational.[40] Navigated, canalized or contained, water is an elemental force that has long been logistically exploited to allow,

36 Peters, *The Marvelous Clouds*, p. 15.
37 Ibid., p. 2.
38 Ibid., p. 47.
39 See, in particular: Bruno Latour, *Nous n'avons jamais été modernes: essai d'anthropologie symétrique* (Paris: La Découverte, 2010).
40 Peters, *The Marvelous Clouds*, p. 15.

among other things, civilizations, but also capitalism to prosper. Yet there are two ways of interpreting this relationship: while modern and postmodern theories of the sublime have underscored humanity's and capital's dominion over nature, Peters' infrastructural perspective emphasizes how, particularly in times of global warming, humans and nonhumans depend upon each other, like checks and balances.

Similarly, *Watermark* suggests that the sublime emerges from the mediation *between* humanity and its natural habitat. If humans build the infrastructure that materializes this mediation, water is the force that actualizes it. The Abalone Farms, for instance, a network of houses built on water in China, explicitly demonstrate how water enables communities. Water is both the resource in which the farmers grow the abalone mollusk collectively, and a menace to their property and livelihood because of the typhoons that threaten the area. The farmers therefore tie their houses together to better withstand natural disasters. Water is thus the medium through which both human and nonhuman collectives grow together. Its existential force of connection is documented throughout the film in other forms of traditional infrastructures, including rice paddies in the Yunnan provinces (fig. 3), where many families share the same source of water. A local farmer explains how a simple piece of carved wood allows to distribute the flow equally between each family; a system, however, that is prone to manipulation. Together, these two examples point to a sublime force that becomes increasingly tangible in times of global warming: not the "unrepresentable" magnitude of water consumption and exhaustion, but the infrastructural, existential power of water that challenges the modern dichotomy between humans and nonhumans. The sublimity of that connection comes down to the sense of belonging to something bigger than oneself and that manifests itself through not only majestic infrastructures such as the Xiaolangdi Dam or the

Fig. 3: Edward Burtynsky, *Rice Terraces #2*, Western Yunnan Province, China, 2012.

spectacular terraces formed by rice paddies in the Chinese mountains, but also through that narrow stream of water upon which entire families depend. One of the film's interviewees, Oscar Dennis, from the Tałtan community of Iskut, in British Columbia (Łuwechōn nasde), points out how "we fit" in the water cycle that unites the sky and the earth: if we consume the same water as the other living beings in a local territory, then we are seventy percent the same water, he reasons. As leverage and connection, water is therefore both what we mobilize to establish our habitats on Earth and what mobilizes us as creatures of the land.

Nevertheless, as vital as it is, this connection is too often overlooked. *Watermark* illustrates our immutable connection to water by looking at industries and populations whose fate is determined by their own unsustainable ways of harnessing and exploiting the enabling power of that elemental medium. Through spectacular aerial views of Texas' patchwork of farmlands, *Water-*

mark documents, for instance, the use of the center-pivot irrigation system that allows agriculture to spread over the Ogallala Aquifer in the United States. In a rare voice-over commentary, Burtynsky points out that the Aquifer represents approximately nine Lake Erie's of water and that "they've used two to three Lake Erie's as best as they can estimate." As if to visualize the impact of Western economic greed, of which the draining of the Aquifer is but one example, the documentary subsequently turns to tanning factories in Bangladesh, whose products are destined for the Western market. In the dark rooms where the leather is treated with heavy chemicals, thousands of liters of water are used at every stage of the process. The waste water is dumped into the Buriganga River, where, as images reveal, entire families go bathing. What emerges from the film as sublime thus hardly amounts to human infrastructural "achievements," which Baichwal and Burtynsky counterbalance with their environmental and human impact. Yet it does not let itself be reduced either to the idea that nature has become unrepresentable, colonized by humans, for the power water holds over human lives informs the entire film. Indeed, the measure of capital's and nature's respective power is constantly boiled down to the fragile equilibrium on which they rely: if too much water is used, everything collapses. Seen from this standpoint, the sublime resides neither in the one nor the other, but rather in the infrangible connection that governs their fate and that water actualizes within multidimensional environments shaped by civilization, traditions, capital, the elements, and technology.

In *Deep Weather*, water's infrastructural force of connection is highlighted mostly through narration. In the first part of the video, a whispered commentary describes in the manner of a poem, whose text is superimposed over the images, the logistics and consequences of the extraction industry's reliance on water. It recounts the economic value of fresh water required in huge amounts

by tar sands extraction; the precarity and preciousness of that value, attested by the decrease of the Athabasca River's level of water that leads the fauna to retreat; the acidic pollution that contaminates the shimmering pools of dark water; and this other form of interconnection, namely the long mystic temporality of the native communities of hunters and trappers who once sustained themselves on the Athabasca ecosystem and have been displaced in the name of the short-term interests of global capitalism. While the extraction economy prospers from the colonization of nature, visualized by Biemann's aerial shots of a disfigured territory, another form of power is hinted at in her speech, namely the elemental medium that provides both leverage to the industry and life to an ecosystem.

Narration, however, does more than simply describe the role that water plays in enabling life and capital, it also manifests it through form, but in a way that differs from the postmodern aesthetic of the unrepresentable. While Morton, for instance, upholds Lyotard's definition of the sublime as an ungraspable excess, *Deep Weather* highlights not the excess of the (hyper)object—in this case, water—but the relation of causality between remote situations that flows actualize. It is this inalienable relation, which, like the narration itself, dominates the specific stories filmed in Canada and Bangladesh. Throughout the film, Biemann adopts a soft, murmuring tone to describe the images. The texture of the soft-spoken words evokes the atmospheric forces that unite the human and the nonhuman actors of not only the ecosystem of the Ganges Delta, but of a planetary network. It also serves to create a sense of intimacy, accentuated by how the voice occupies the sonic foreground. This approach contrasts with the aesthetic of hyperobjects that Morton formulates in his book of the same title. The scholar argues that art can only convey the magnitude of hyperobjects by forgoing any rational approach addressed to viewers' judgement and seeking

instead an aesthetic of "shock."[41] If Biemann's video may well evoke the *concept* of the hyperobject, its *aesthetic* tends toward proximity rather than shock. The presence and corporeality of the voice suggest the physical and embodied bond that unites humans with water, rather than an otherness whose power would only manifest itself through the violence of shock. The video thereby rethinks the way in which sublime forces exert their power: no longer through domination nor resistance, but through a mediation between humans and nonhumans.

Because it manifests humans' existential interrelation with environment both conceptually and formally, Biemann's, Baichwal and Burtynsky's realist aesthetic of the sublime is a testament to the cultural logic of the Anthropocene. As such, this aesthetic foregoes both the postmodern notion of the unrepresentable and the modern imaginary of the natural sublime. For Jameson, the postmodern sublime came about as the result of very specific historical and cultural conditions, in particular the colonization of nature by global capital. Similarly, Biemann's, Baichwal and Burtynsky's realist aesthetic of the sublime attests to an environmental turn that gives new weight to the nonhuman to lay bare the foundations of that capitalist power. A realist sublime, indeed, conveys the awareness that where water stops flowing, capital also comes to a halt. It is a sublime that keeps humans' infrastructural ambitions in check, emphasizing the fluid medium on which they depend and that connects them to the mundane, earthy terrain above which the Moderns sought to rise. To rise, we are reminded, one needs leverage power, and that elemental force is what captivates today's imaginary of the sublime.

41 Morton, *Hyperobjects*, p. 189.

Katerina Genidogan

The Cultural Logic
of Green Capitalism

A New Coalition of Geo- and Chronopolitics

Today, we face a cultural logic of green capitalism that is distinct from the cultural logic of late capitalism described by Jameson. Green capitalism entails a strong affiliation with the contemporary apparatus of international environmental governmentality and can be understood as the attempt to produce value out of the exhaustion of resources and the environmental destruction which capitalism itself has induced. Looking at the *longue durée* of colonial history and its relationship to capitalism, rather than solely focusing on capitalism's development in the West since the 1940s, we can see that capitalism has always already been both racial and environmental in an interrelated way. More precisely, capitalism has been connecting the logic of flow, circulation, and liquidity by taking advantage of those epistemologies and ideologies that led to the *naturalization of race*, the *racialization of non/life* and thus the demarcation of zones of disposability.

Capitalism emerged after 1450 as a way of organizing nature through value relations according to its own law of value. This, Jason W. Moore writes, is the law of Cheap Nature(s), articulated primarily in the "Four Cheaps" of labor-power, food, energy, and raw materials, which "led to an epochal shift in the scale, speed and scope of landscape transformation in the Atlantic

world and beyond."[1] This way of organizing nature, which I call environmentalization, was built on the combination of practices of appropriation, displacement, extraction, and exploitation.[2] Mining of both gold and bodies[3] (mineralogical and corporeal matter),[4] plantation economies and Triangular Trade testify to the long-lived legacy of exploiting nature and its relationship with the *circulation* of capital, which consisted predominantly of forcibly taken Africans, treated as commodities, the so-called commodities "that could speak";[5] the *flow* of products from the colonies to the metropoles and to other colonies; and the *liquidity* of money, which was accumulated and re-invested in the metropoles, enabling the emergence of new industries such as shipbuilding, banking, and insurance.[6]

My intention here is to point out how capitalism has been operating through the fusion of racialization, produced via the logic of differentiation, and environmentalization, and how therefore "raciality"[7] has been substantial to environmental destruction. This is necessary

1 Jason W. Moore, *Capitalism in the Web of Life: Ecology and the Accumulation of Capital* (London and New York: Verso, 2015), p. 14, p. 16, p. 182.
2 For more, see the foreword by Robin D. G. Kelley in Cedric J. Robinson, *Black Marxism and the Making of Black Radical Tradition*. Revised and updated third edition (Chapel Hill: The University of North Carolina Press, 2020), p. xvi.
3 Saidiya Hartman notes that the Gold Coast was a source of both gold and slaves and was itself referred to as "the Mine." *Lose Your Mother: A Journey along the Atlantic Slave Route* (New York: Farrar, Straus, and Giroux, 2007), p. 51.
4 Kathryn Yusoff, *A Billion Black Anthropocenes or None* (Minneapolis: University of Minnesota Press, 2018), p. 14.
5 Stefano Harney and Fred Moten, *The Undercommons: Fugitive Planning & Black Study* (Wivenhoe, New York and Port Watson: Minor Compositions, 2013), p. 92.
6 It is in this context that Harney and Moten have traced back to the Atlantic slave trade the foundation of modern logistics.
7 According to Denise Ferreira da Silva, raciality is "the onto-epistemological arsenal constituted by the concepts of the racial and the cultural and their signifiers, those which produce persons (ethical-juridical) entities not comprehended by universality." "No-Bodies: Law, Raciality and Violence," *Griffith Law Review* 18, no. 2 (2009), pp. 212–236, here p. 213.

in order to grasp how this fusion works within green capitalism today. Moreover, I also consider a partial shift in accumulation patterns designated on environmental destruction, from initial accumulation to what David Harvey calls "accumulation by dispossession" and perhaps even more appropriately what Byrd et al. consider to be "the constitutive role of both colonization and racialization for capitalism," that is "economies of dispossession."[8] By underlining this shift, my purpose is to show how in green capitalism value is created exactly because of the workings of, and the violence perpetrated by, the endless loops of dispossession and environmental degradation. The process of value creation can be best grasped though an argument that Michael Hardt and Antonio Negri have most prominently put forward. Capitalism, when it is no longer able to generate value from material assets, because these have been exhausted, starts to generate value out of itself. Amidst this process, capital is forced to use the future as one of its main resources.[9] I claim that today the logic of racialization and environmental exploitation delineated so far continues, facilitated by the notion of "adaptation" on the basis of a climate change framing and the uses of the future as a main resource.

There are two ways that allow green capitalism to produce value out of the exhaustion of resources and the environmental destruction which capitalism itself has induced. First, by the change from the presentism leading to the cheap valuation of nature under the imaginary of endless progress (future as promised land) to a mode of thinking for and with the future (future as restraint and impediment), indicated also by the con-

8 Karl Marx, *Capital Volume 1* (New York: Vintage Books, 1977); David Harvey, *The New Imperialism* (New York: Oxford University Press, 2003); Jodi A. Byrd, Alyosha Goldstein, Jodi Melamed, and Chandan Reddy, "Predatory Value: Economies of Dispossession and Distributed Relationalities," *Social Text* 135, vol. 36, no. 2 (2018), pp. 1–18.
9 Michael Hardt and Antonio Negri, *Empire* (Cambridge, Mass: Harvard University Press, 2000), p. 272.

cept of sustainability, and the related pricing up of nature that has accrued from the gradual exhaustion of resources. Especially the concept of sustainable development, defined in the 1987 Bruntland Report as development that "meets the needs of the present without compromising the ability of future generations to meet their own needs,"[10] essentially unsettles the previously established *limits to growth* idea,[11] and reveals this relationship with the future as a constitutive element of green capitalism. This level of chronopolitics, as I will show throughout the paper, is operatively consistent with the chronopolitics of climate change related to the silencing of the past and the domination of the (predicted) future. That is to say that the only reason why green capitalism manages to operationalize this discussion about future generations, is because climate change has first managed to structurally obscure issues of environmental debt incurred upon the global South by centuries of exploitation by the global North. Discussing how the concept of sustainability itself can be highly antagonistic to other imaginaries, Philip Catney and Timothy Doyle use the term "green post-politics of the future," and declare that they use "the concept of the 'post-political' to interpret how the global North dominates debates on the environment and how it can be quite dismissive, and even negligent, of welfare issues in the global South."[12]

Second, the emergence of climate markets, such as carbon markets for carbon offsetting, and weather derivatives and catastrophe bonds for risk offsetting, attest to the way in which these mechanisms provide temporal and spatial fixes, by using the future itself as a

10 World Commission on Environment and Development, *Our Common Future* (Oxford: Oxford University Press, 1987), p. 15.
11 Donella H. Meadows, *The Limits to Growth Report: A Report for the Club of Rome's Project on the Predicament of Mankind* (New York: Signet, 1972).
12 Philip Catney and Timothy Doyle, "The welfare of now and the green (post) politics of the future," *Critical Social Policy* 31, no. 2 (2011), pp. 174–193, here p. 174.

resource. This is possible exactly because green capitalism under neoliberalism manages to capture and incorporate exception, transforming threats into profitable businesses. How? Concentrating on the second aforementioned category of climate markets, this happens through the proposal put forward that the financialization of weather and the securitization of catastrophe risk can help us deal with the challenges and uncertainties caused by climate change. Within an adaptation framework that indicates preparedness planning and resilience building in the face of future climatic turbulence, contemporary capitalist accumulation produces new assets out of future risks. This kind of operation emanates from a more preemptive relationship with the future, which entails an environment of sheer uncertainty, and action as if disaster had already struck.

Therefore, although we read from Jameson that "nature is gone for good," I want to argue that recently, we have been witnessing the "return of nature"; its return as a specter via the climate change framing that has been conditioning substantial diversions from the cultural logic of late capitalism. Coming to terms with the ways in which climate change discourse has affected the interrelationship of the *cultural* and the *economic*, and their collapse into one another,[13] is very important for us in order to be able to grasp the existing discontinuity in the cultural logic. To that purpose, I will discern and concentrate on three interrelated points.

The first point is related to Jameson's argument about "inverted millenarianism":

> The last few years have been marked by an inverted millenarianism in which premonitions of the future, catastrophic or redemptive, have been replaced by senses of the end of this or that (the end of ideology, art, or social class;

13 Fredric Jameson, *Postmodernism, or, The Cultural Logic of Late Capitalism* (Durham: Duke University Press, 1991), p. ix, p. xxi.

the "crisis" of Leninism, social democracy, or the welfare state, etc., etc.); taken together, all of these perhaps constitute what is increasingly called Postmodernism.

The next point, stemming from the "inverted millenarianism", concerns the waning of affect, which is replaced by what Jameson calls, drawing on J. F. Lyotard, "intensities," which are "free-floating and impersonal and tend to be dominated by a peculiar kind of euphoria." The third point again follows from the second and is his overall claim that culture is "increasingly dominated by space and spatial logic."[14]

Climate change discourse has very much affected, in fact *inverted*, this "inverted millenarianism." The quintessence of climate change discourse is not in the "end of the world" narrative, but in the apocalyptic, dystopic thinking about the future, which emanates from the prediction of climate (change) and the arbitrary reduction of the future to the (prediction of) climate,[15] through the various climate change impacts assessments. In other words, the kind of thinking that I am talking about here can be best approached not through the notion of "the end," but through the figure of climate terror.[16] This figure of climate terror is ubiquitous even in today's mainstream culture, especially through films and documentaries such as *Before the Flood* (2016), with protagonist the green idol Leonardo DiCaprio, and *David Attenborough: A Life on Our Planet* (2020), as well as particular science fiction novels, such as Kim Stanley Robinson's *The Ministry for the Future*.

In this context, the waning of affect that Jameson refers to is replaced by threat, which nevertheless retains

14 Ibid., p. 1, p. 10, p. 16, p. 25.
15 For more on these processes, see Mike Hulme, "Reducing the Future to Climate: A Story of Climate Determinism and Reductionism," *Osiris* 26, no. 1 (2011), pp. 245–266.
16 For a comprehensive analysis of climate terror, see Sanjay Chaturvedi and Timothy Doyle, *Climate Terror: A Critical Geopolitics of Climate Change* (Basingstoke, Hampshire: Palgrave Macmillan, 2015).

an impersonal character; a threat that although it is just looming, fills the present without presenting itself and translates into fear.[17] Taking into consideration the fact that the popularity and proliferation of climate change discourse have transformed it into a household concept through its very presentation as a product of "bad planning and human error,"[18] the virtual threat presented by climate change, although still not in existence, comes under the operative logic of preemption, which instrumentalizes it in such a way that the way is paved for the proliferation of a politics of risk. As a consequence, what dominates culture today is a temporal logic, rather than space, as Jameson had argued. Yet, we should not consider that the primacy of time over space analyzed here takes us back to modernism, to "the excitement of machinery in the moment of capital preceding our own, the exhilaration of futurism."[19] On the contrary, what overwhelms us now is a catastrophe threat diffused through futurity, which, in other words, is the way that the future feels in the present.

This imaginary of the future catastrophe is not to be conflated with the three modern grand narratives of temporality as progress (upward motion), decline (downward spiral) and cycle. In this context, the idea of decline emanated from the idea that stable equilibrium means death in classical thermodynamics, an idea that haunted a lot of modern anxieties about extinction and decay in the second half of the nineteenth century. In order to understand the emergence and function of the catastrophe threat as different from the modern notion of decline, it is necessary to first identify the relationship between futurity and virtuality. The best way to do

17 Brian Massumi, *Ontopower: War, Powers, and the State of Perception* (Durham: Duke University Press, 2015), especially pp. 171–187.
18 This statement by David Attenborough in *David Attenborough: A Life on Our Planet* indicates the abstracted, depoliticized and dehistoricized way in which the climate change debate has been inflected and reproduced by mainstream culture.
19 Jameson, *Postmodernism*, p. 36.

this is to start by thinking futurity as "the *present* space of the future, what can be seen *today* as the future." Keeping in mind that futurity explains what the future "*does* and what we *do* with the future"[20] illuminates the virtual character of futurity, and that futurity is essentially the time-form of threat.[21] Secondly, it is necessary to look into the epistemological premises that have enabled the proliferation of prediction.

In order to better outline what is at stake here, I want to begin by drawing attention to the fact that climate change is only a recent incarnation of environmental and green movements. It came to prominence in the 1990s, emerging from the discourses of ecological modernization and sustainable development, becoming "the most widely advocated of all environmental issues." Of course, this would not have been possible "[w]ithout the transition from early oppositional environmental politics" in the 1960s and 1970s "to more corporatist forms of politics, which produced EM and SD," in the 1980s.[22] These forms of politics were related to elite policy-driven processes, more indicative of post-political governance rather than social struggle, ignoring "issues of participation and reducing the rest of society to passive consumers to be provided with enough information to make informed (but market-based) choices."[23] In this context, climate change was used as a term to describe global warming as a consequence of the greenhouse effect that is itself caused by human-induced emissions, and that would eventually lead to large-scale shifts in weather patterns, and hence changes in climate itself.

Due to this very definition of climate change, most of the discussion on environmental issues and poli-

20 Jean-Paul Martinon, *On Futurity: Malabou, Nancy and Derrida* (Basingstoke, Hampshire & New York: Palgrave Macmillan, 2007), p. xi.
21 Massumi, *Ontopower*, pp. 174–175.
22 Chaturvedi and Doyle, *Climate Terror*, p. 22, p. 30.
23 David Gibbs, "Ecological Modernisation, Regional Economic Development and Regional Development Agencies," *Geoforum* 31, no. 1 (2000), pp. 9–19, here p. 11.

tics today on an international and transnational level is focused on global warming.[24] Subsequently, on one hand, it focuses on the reduction of greenhouse gas emissions, especially carbon reductions, and thus the burning of fossil fuels (coal, oil, natural gas), which by and large has brought with it a preoccupation with mitigation and sustainability. On the other hand, the focus is on the forecast of weather due to the increase in temperature and the prediction of subsequent climate-related disasters, which consequently has led to a rise of concerns regarding adaptation and resiliency. Substantially in/forming climate change discourse and trans/forming the representation and analysis of environmental issues, this weather forecasting capacity has been developed through the breakthroughs in modelling and climate change science. It is based on systems thinking, whereby climate is analyzed as a system that includes the ocean, land, and ice on Earth, and "what is known about the correlation between carbon dioxide levels and temperature, and what has been gleaned from the geological record about previous episodes of climatic upheaval."[25]

It becomes evident, therefore, that the climate change debate has not been framed historically, but only in a future sense through the workings of prediction. It testifies to the systematic avoidance of "situating climatic change within a broad and suitably historicised understanding of societal reproduction at interlinking scales of analysis,"[26] and, thus, notably to the disposition of (re)assuring "our way of living," and in many cases insuring it. Eventually, this perspective helps us to

24 For the specific scientific framing of global climate change, see Dimitri Demeritt, "The Construction of Global Warming and the Politics of Science," *Annals of the Association of American Geographers* 91, no. 2 (2001), pp. 307–337.
25 Eileen Crist, "Beyond the Climate Crisis: A Critique of Climate Change Discourse", *Telos* 141 (Winter 2007), pp. 29–55, here p. 31.
26 Marcus Taylor, *The Political Ecology of Climate Change Adaptation: Livelihoods, agrarian life and the conflicts of development* (Oxford and New York: Routledge, 2015), p. 65.

identify the chronopolitics of climate change, namely the system(at)ic attempts to silence the past, erase the present and predict, project, anticipate, speculate and eventually trade the future that configure the climate change debate. In this way, by completely dodging the question of whether capitalism itself is sustainable, climate change operates as a dehistoricizing apparatus, as a depoliticizing machine that accommodates the reinvention of capitalism through its prescription of green (as in thinking for/with future generations), market-based and future-oriented (as in thinking from the future) solutions.

The logic of prediction emanates from the epochal shift from certitudes (trajectories) to probabilities (or amplitudes). This shift has been taking place in science over the last several decades and signifies the dawn of an era that could be best described by the homonymous book of Ilya Prigogine with Isabelle Stengers, as *the end of certainty*.[27] In this context, theories of complexities and non-linearity have emerged that attempt to grasp the spaces of possibilities of dynamic processes.[28] This was also the basis for the emergence of climate science, which is itself based on complex systems that have non-linear behavior and are near or far from equilibrium. On these premises, we can decipher that the catastrophe threat imaginary that dominates culture and economy today (indicative also in the notion of "disaster economics") does not stem from the aforementioned decline following stable equilibrium. Instead, it comes, in a rather paradoxical way, via "the spectacular growth of non-equilibrium physics and the dynamics of unstable systems," which have led to concepts such as self-organization and dissipative structures, which themselves have

27 Ilya Prigogine in collaboration with Isabelle Stengers, *The End of Certainty: Time, Chaos and the New Laws of Nature* (New York, London, Toronto, Sydney, Singapore: The Free Press, 1996).

28 For a detailed analysis of this see Manuel DeLanda, *Intensive Science and Virtual Philosophy* (London: Continuum, 2002).

been widely used in a large spectrum of disciplines, ecology included.[29]

Although it is beyond the scope of this text to elaborate more on this aspect, it is crucial to underline here that through this shift in science, the world seems to have become more contingent and thus unknowable, and yet new forms of knowledge have been developed that can accommodate this contingency and, even more importantly, can get a grip on it.[30] This happens exactly through what I previously described as "rather paradoxical." Although the possibility of events does not mean that they are to be reduced to "deductible, predictable consequences," as Prigogine writes,[31] they are indeed reduced to this status in the case of climate scenarios, followed for example by climate change impact assessments. In this context, getting a grip on contingency begins with prediction, and continues with the act of restoring linearity to the present through the logic of preemption that can be best summarized through the idea of "catch[ing] threats that have not yet emerged," inflecting "imminent danger" toward "immanent threat."[32] This brings us to the final level of chronopolitics analyzed here: the threats of future natural disaster are first identified, and exactly because of their virtual nature, their translation to economic impacts through the law of value relations, as well as the workings of the operative logic of preemption, become the cause for action in the present.

Preemption, in this context, is characterized as an operative logic, which, according to Brian Massumi, is a logic that combines an epistemology of uncertainty, where the threat is unknown (epistemological uncertainty), with a

29 Prigogine in collaboration with Stengers, *The End of Certainty*, p. 3.
30 Jakob Arnoldi, "Derivatives: Virtual Values and Real Risks," *Theory, Culture & Society* 21, no. 23 (2004), pp. 23–42, here p. 35.
31 See Prigogine in collaboration with Stengers, *The End of Certainty*, p. 189.
32 Massumi, *Ontopower*, pp. 224–225.

threat that has not yet fully formed or not even emerged (ontological uncertainty). As Massumi argues, "[t]his form of threat is not only indiscriminate, coming anywhere, as out of nowhere, at any time; it is also indiscrimin*able*." It is principally under these conditions that, in cultural terms, the figure of the environment has been shifting and can now best be grasped through the figure of climate terror: "from the harmony of a natural balance to a churning seedbed of crisis in the perpetual making."[33] In the "permanent state of emergency" that we currently live in,[34] preemption emerges as the most suitable mode for capturing *non-linear change*, and becomes "*effectively, indefinitely, ontologically productive*"[35] in the following way: no matter how existentially incommensurable the threats are, they are abstracted from the concrete universe of uncertainties, objectified through the logic of risk connecting fear and value and become assets under the doctrine that demands the continuation of "business as usual" and even "*better-than-usual*."[36] Under this spectrum, it becomes evident that risk management, distribution and transfer technologies stand for the knowledge that promises to practically, ontologically, get a grip on contingency. This happens particularly through "virtual goods,"[37] e.g. financial instruments that have been themselves structured on the basis of futurity. This means that the (increasing certainty about the uncertain) future becomes the very condition of possibility for the writing of these instruments, in such a way that the financialization of weather and the securitization of

33 Ibid., pp. 4–5, p. 9, p. 10, p. 22.
34 Ibid., p. 16.
35 Ibid., p. 15.
36 Chaturvedi and Doyle, *Climate Terror*, p. 79, p. 80, p. 82, p. 99.
37 This is a term that Arnoldi uses in "Derivatives." I borrow the term to refer to a particular category of derivatives, namely weather derivatives, as well as catastrophe bonds, due to the fact that the term can conceptually grasp the mode of operation of both instruments.

catastrophe risks operate as time management.[38] In this way, the virtual nature of these financial instruments as predictive technologies is operatively compatible with the futurity/virtuality of catastrophe threat.

As preemption is a self-propelling tendency that can govern in its own dynamic, we can start thinking about how, on a state level, governmentality molds itself to *threat*.[39] What is the agency of the risk/(re)insurance industry[40] in the identification and quantification of climate risks, which are themselves socially mediated through culture? In a (presented and sensed as) "threat *generating*" or, otherwise, "threat-o-genic" global situation, "[t]he operative logic of preemption is that of security," discursively and materially underpinned by the risk/(re)insurance industry, which is itself reproduced through the constellations of science, value and fear, namely the "political ecology of risk." The industry, by promising to get a grip on contingency, "attempts to make climate change impacts insurable, and therefore, profitable lines of business"[41] through the identification and quantification of climate risks. As both climate risks and our knowledge of them grow, so does the market for new insurance and risk-management

38 This draws on David Burrows and Simon O'Sullivan, "Financial Fictions," in *Fictioning: The Myth-Functions of Contemporary Art and Philosophy* (Edinburgh: Edinburgh University Press, 2019), pp. 381–395.

39 Massumi, *Ontopower*, pp. 174–175.

40 Following Leigh Johnson, I employ the term "risk industry," not technically used in the business or academic literature, due to the fact that the examined field, designated on what Philip Bougen has explained as the "crossbreeding of insurance and capital markets," exceeds the boundaries of the (re)insurance industry as typically conceived (restricted to direct insurers, reinsurers and brokers). The use of the term is also consistent with the purpose of highlighting the role of the different players involved in the *reproduction of risk*. For more on this, see Leigh Johnson, "Climate change and the risk industry: the multiplication of fear and value," in *Global Political Ecology*, ed. Richard Peet, Paul Robbins, Michael J. Watts (London and New York: Routledge, 2011), pp. 185–202; Philip D. Bougen, "Catastrophe Risk," *Economy and Society* 32, no. 2 (2003), pp. 253–274.

41 Johnson, "Climate change and the risk industry," p. 186, p. 185.

products, reproducing the industry's own conditions of existence.[42] Henceforth, it becomes obvious that the creation of virtual goods—like weather derivatives and catastrophe bonds for the management and distribution of risks related to climate change—did not evolve as a self-evident solution, but was "invented" as the result of "conscious deliberate processes of design,"[43] for the continuation of *business as usual* (namely through risk hedging and not altering the conditions that create the "risks"), eventually leading to *business better than usual* through the sponsoring of academic climate studies[44] and the proliferation of fear. This proliferation of fear essentially led to the expansion of the industry through the creation of new assets and new marketplaces in the global South.

Therefore, the fusion of environmentalization and racialization processes plays out in the context of green capitalism through the coalition of geopolitics and chronopolitics. This new coalition has led to a new articulation of the relationship between race and nature. Upon these premises, the constant reinforcement of racialization processes in the foreclosure of the future through the cultural circulation of images of dark-skinned people amidst natural disaster and despair is indispensable to green capitalism and environmental governmentality.[45] As with carbon markets, the construction of the South as the most environmentally degrading people/threat on the planet is necessary for them to exist and func-

42 Michael J. Watts, Paul Robbins and Richard Peet, "Global Nature," in *Global Political Ecology*, ed. Michael J. Watts, Paul Robbins and Richard Peet (London and New York: Routledge, 2011), pp. 1–47, here p. 38.

43 Donald MacKenzie, "The Material Production of Virtuality: Innovation, Cultural Geography and Facticity in Derivative Markets," *Economy & Society* 36, no. 3 (2007), pp. 355–376, here p. 359.

44 For more see Johnson, "Climate change and the risk industry."

45 See Katerina Genidogan, "Race Re(con)figurations through Speculative and Environmental Futurity," *View. Theories and Practices of Visual Culture* 28 (2021), https://www.pismowidok.org/en/archive/28-imageries-of-racc/race-reconfigurations (accessed September 11, 2021).

tion, so it is with weather risk markets their construction as the most "vulnerable," the ones that will suffer first and most. Upon these premises, zones of disposability are transmuted on the basis of the exhaustion of resources and destruction, into new zones of value creation through the transformation of predicted future threats to future risks and, eventually, to present assets.

In a context where climate change operates as a transboundary stick for the purpose of climate security, insurance is no longer construed as optional.[46] As the narrative goes, particularly the least affluent need to be forced within its rubric exactly because they seem most likely to experience the largest impacts, and they lack the resources and the expertise to respond to the risks posed by climate change.[47] The most recent 2019 *Action Plan on Climate Change Adaptation and Resilience: Managing Risks for a More Resilient Future* by the World Bank constitutes an example of these strategies that operate through "a mainstreamed, whole-of-government programmatic approach."[48] Through the instruments that these strategies put forward, "[p]arametric insurance with its allied financial securitization manoeuvres is inscribed within complex private-public partnerships between sovereign states, (re)insurance companies," and in some cases, international organizations, such as different agencies of the UN, the International Monetary

46 Chaturvedi and Doyle, *Climate Terror*, p. 101.

47 Centre for Climate Change Economics and Policy and Grantham Research Institute on Climate Change and the Environment, *Building effective and sustainable risk transfer initiatives in low- and middle-income economies: what can we learn from existing insurance schemes?*, by Swenja Surminski and Delioma Oramas-Dorta, 2011, https://www.lse.ac.uk/granthaminstitute/wp-content/uploads/2014/03/PP_sustainable-risk-transfer-initiatives.pdf (accessed September 11, 2021).

48 World Bank Group, *Action Plan on Climate Change Adaptation and Resilience: Managing Risks for a More Resilient Future*, Washington, DC: World Bank, 2019, https://documents1.worldbank.org/curated/en/519821547481031999/pdf/The-World-Bank-Groups-Action-Plan-on-Climate-Change-Adaptation-and-Resilience-Managing-Risks-for-a-More-Resilient-Future.pdf (accessed September 11, 2021).

Fund and the World Bank.[49] Through a position that has been called new prudentialism, operating equally on a principle of prudence and risk-embracing,[50] the modern state is expected to employ its traditional sovereign power for the purpose of providing "populations with a form of security that will allow them to get back in circulation," to bounce back once catastrophic environmental events have taken place. Through neo-liberal post-political modes of governance and the "entrepreneurialization of sovereign power," the global (re)insurance industry comes to play a fundamental role, especially in enabling this sovereign provision of security,[51] which is itself a product of international environmental governmentality.

In this context, environmentalization addresses the broader strategy of adaptation, which is one of the most popularized climate change solutions that enables the cultural logic of green capitalism to thrive. This operates through preemption and the overall chronopolitics of climate change that itself relates to both the dismissal and the reinforcement of racialization processes in the foreclosure of the future. Taking into consideration "the strange temporality of specific financial instruments which allow a kind of engineering of the future from the present and, indeed, the capitalization of that feedback from the future in the present,"[52] I showed how green capitalism uses the future as a resource, and how a historically specific conception of risk gets a grip on the a/effect of catastrophe threat. The current cultural

49 Louis Lobo-Guerrero, *Insuring Security: Biopolitics, Security and Risk* (Oxford and New York: Routledge, 2011), pp. 75–77.

50 Tom Baker and Jonathan Simon eds., *Embracing Risk: The Changing Culture of Insurance and Responsibility* (Chicago: Chicago University Press, 2002); Tom Baker, "Embracing Risk, Sharing Responsibility," *Duke Law Review* 56, no. 2 (2008), pp. 561–571; Brian J. Glenn, "Risk, Insurance and the Changing Nature of Mutual Obligation," *Law and Social Inquiry* 28, no. 1 (2003), pp. 259–314; Pat O'Malley, *Risk, Uncertainty and Government* (London: Greenhouse Press, 2004).

51 Lobo-Guerrero, *Insuring Security*, p. 75.

52 Burrows and O'Sullivan, *Fictioning*, p. 381.

logic of green capitalism, dominated by time and temporal logic, apocalyptic thinking and proliferative fear, is mainly defined by its permeation by the climate markets' aspirations, the reproduction of various future disaster imaginaries and the overall rise of a new coalition of geopolitics and chronopolitics that retains and reproduces anew the logic of differentiation leading to racialization and value creation.

Genealogies of Circulation

Martin Doll

Utopias of Flow and Circulation in the Nineteenth Century

Phalansteries by Charles Fourier and Others

Introduction

Against the background of this book, which concentrates on cultural logics of environmentalization in terms of liquidity, flows, circulation, this paper will provide insights into its prehistory by analyzing Charles Fourier's architectural concepts for his community building "Phalanstère" in the beginning of the nineteenth century from a media studies point of view.[1] From this perspective, understanding architecture not as a static construct, but as a medium,[2] it has to be examined in terms

1 This article is a rewritten part in English of a larger book project in German on the technologization of politics/the politicization of technology in the nineteenth century.

2 Architecture as a medium is based on other perspectives also a prominent topic of Wolfgang Schäffner and Bernhard Siegert. In a Kittlerian spirit, Schäffner, however, focuses on the "control of energy and information flows," so that architecture for him stands in no further important relation to humans. Living beings of any kind seem to play no role in his description of the insulating, lighting, and ventilating functions of architectural media such as the window, understood as a filter. See Wolfgang Schäffner, "Elemente architektonischer Medien," *Zeitschrift für Medien- und Kulturforschung* 1 (2010), pp. 137–149, here p. 139, pp. 146–149 [translated by Martin Doll]. For a comparable approach, see Susanne Jany, "Operative Räume. Prozessarchitekturen im späten 19. Jahrhundert," *Zeitschrift für Medienwissenschaft 7, no. 12 (2015)*, pp. 33–43, and on the door as a medium of architecture from a Lacanian perspective likewise in a Kittlerian frame, see Bernhard Siegert, "Door Logic, or, the Materiality of the Symbolic," in *Cultural Techniques. Grids, Filters, Doors, and other Articulations of the Real* (New York: Fordham University Press, 2015), pp. 192–205.

of its ability to interact with people that stay or rather move around in a building. Through the way a building co-organizes its use, it becomes part of the social processes that take place in it: e.g., by connecting or separating rooms, by enabling or blocking views, by making action and communication possible or not, thus leading to relations or divisions between people, fostering collectivity or individuality.[3] Albena Yaneva writes: "Buildings are not projections of the social, but they could become social, because they possess an immense capacity of connecting heterogeneous actors."[4] Together with Bruno Latour she has expressed very clearly the processual quality of buildings understood with Gilbert Simondon as moving modulators "regulating different intensities of engagement, redirecting users' attention, mixing and putting people together, concentrating flows of actors and distributing them so as to compose a productive force in time-space."[5] By speaking of a modulator connected to assemblage thinking, this approach is clearly to be distinguished from a technological determinism, as actions in buildings are never completely predetermined by the building's structure. Instead, certain activities in a building are to be analyzed as a result of the interrelations between a building's properties, taken with Latour as non-human actors (think of steps, doors, windows, bridges, hallways etc.) *and* the activities of the inhabitants, workers or visitors, taken with Latour as human actors.

3 See Dirk Baecker, "Die Dekonstruktion der Schachtel. Innen und außen in der Architektur," in *Unbeobachtbare Welt. Über Kunst und Architektur*, ed. Dirk Baecker, Niklas Luhmann, and Frederick Bunsen (Bielefeld: Haux, 1990), pp. 67–104, here p. 99.

4 Albena Yaneva, "Mapping Controversies in Architecture: A New Epistemology of Practice," *ALF*, no. 6 (n.d.), http://leidiniu.archfondas.lt/en/alf-06/albena-yaneva-mapping-controversies-architecture-new-epistemology-practice (accessed October 15, 2021).

5 Bruno Latour and Albena Yaneva, "'Give Me a Gun and I Will Make All Buildings Move': An ANT's View of Architecture," in *Explorations in Architecture: Teaching, Design, Research*, ed. Reto Geiser (Basel, Boston and Berlin: Birkhäuser, 2008), p. 80–89, here p. 87.

In this framework, this paper is specifically interested in historical concepts of flow and circulation. This leads to my central question: how can the Fourierist architecture be understood as a social medium based largely on movement, in order to make connections, a coming together as likely as possible? Different from Marx, who will later in his *Grundrisse* (1857/58) consider "circulation" as a genuine capitalist "process of transformation," "as it appears in the different forms of money, production process, product, reconversion into money and surplus capital,"[6] circulation in the context of architecture is considered here in terms of opening up possibilities of sociability connected to the history of socialisms.

This will also prove that a sort of "movement of Environmentalization," a perspective upon the historical development of "the culture of control" Erich Hörl has prominently elaborated on was already aborning in the beginning of the nineteenth century. Whereas for Hörl the process of "general ecologization" only began around 1900[7] with the "control revolution,"[8] I would argue that there is a certain genealogy to it with ramifications back to 1800. For sure, at that time we do not find the idea of environmental agency advanced as much as today. But as Michel Foucault, from whom Hörl adopts the term "environmentality," has recognized, at that time there existed a plethora of ideas about how to politically act upon a milieu—milieu understood here with Foucault not just as a surrounding but in strictly environmental

6 Karl Marx and Friedrich Engels, *Economic Manuscripts of 1857–58, in Collected Works*, vol. 28 (London: Lawrence & Wishart, 2010), p. 447.
7 It is followed by the second phase of second-order cybernetics beginning in the late 1960s and the third phase of the "neocybernetic facts of our present." See Erich Hörl, "Introduction to General Ecology. The Ecologization of Thinking," in *General Ecology. The New Ecological Paradigm*, ed. Erich Hörl and James Burton (London: Bloomsbury, 2017), p. 1–73, here p. 9.
8 James R. Beniger, *The Control Revolution. Technological and Economic Origins of the Information Society* (Cambridge, Mass.: Harvard University Press, 1986).

terms as a tight coexistence "between men and things."[9] Out of this multiplicity of political measures Fourier is just one extraordinary example, because his ideas on acting upon a milieu in terms of producing circulation and flow were linked to social-emancipatory ideals and not to the contrary, as it is more or less the case today.[10] At the end I'll add some insights on how Fourier's ideas—after several failed attempts to realize them in France—circulated in the United States.

Fourier's Circulations: The Phalanstère

As Fourier's diagnoses are to be understood as initial reactions to the one-sided increase in wealth of the new French bourgeoisie based on trade and the textile industry, one has to call to mind the specific living conditions at the beginning of the nineteenth century. A later text from Adolphe-Jérôme Blanqui, the brother of Auguste Blanqui, *Des classes ouvrières en France pendant l'année de 1848*, draws a clear picture of the life of the working classes in France:

> The main district of Lille's misery [...] is a series of blocks separated by dark, narrow streets, leading to small courtyards known as *courettes*, which serve both as sewers and garbage dumps, where humidity is constant at all times of year. The windows of the dwellings and the doors of the cellars open onto these hideous passages, at the bottom of which a grid rests horizontally on sinkholes which serve as public latrines by day and night. The community's dwell-

9 Michel Foucault, "The Eye of Power," in *Power/Knowledge. Selected Interviews and other Writings, 1972–1977*, ed. Colin Gordon (New York: Pantheon Books, 1980), pp. 146–165, here p. 150.

10 This is also discussable when one thinks of the "emancipatory" entanglement of high tech and hippie culture in the so-called "Californian Ideology." See Richard Barbrook and Andy Cameron, "The Californian Ideology," *Science as Culture 6*, no. 1 (1996), pp. 44–72.

ings are distributed all around these pestilential homes, from which one is happy to draw a small income.[11]

When you take a closer look at Blanqui's wording, the description of the milieu in Lille is a condemnation of a situation of non-circulation, non-flow, and this even in a staggered form. Basically, this is related to a "negative [...] notion" of a milieu.[12] Not only are the inhabitants crammed together like cattle in their buildings. A vital environment does not exist either. Everything stagnates, nothing flows: rubbish and excrements remain in their place; stench stands in the alleys; even light is no longer able to get through to the people because of the dampness that is everywhere.

Blanqui's text is closely connected to discussions on circulation in cities that had already been going on since the end of the eighteenth century, in the context of the general "problem of the accumulation of men."[13] According to Foucault, this was a fundamental difficulty of coexistence in two respects: "either between men, questions of density and proximity, or between men and things, the question of water, sewage, ventilation."[14] Alain Corbin traces this obsession with circulation back to Harvey's discovery of the circulation of blood a century earlier: "Harvey's [...] model of the circulation of the blood created the requirement that air, water, and products also be kept in a state of movement. Movement was salubrious."[15] As a consequence, projected actions to

11 Adolphe-Jérôme Blanqui, *Des classes ouvrières en France, pendant l'année 1848* (Paris: Pagnerre, 1849), pp. 98–99. [Translation by Martin Doll]
12 In the beginning, the notion of milieu is, according to Foucault, "negative," especially in the eighteenth century, insofar as it was at first used rather for "variations and diseases." See Michel Foucault, *History of Madness*, ed. Jean Khalfa, trans. Jonathan Murphy and Jean Khalfa (New York: Routledge, 2006), p. 365.
13 Foucault, "The Eye of Power," p. 151.
14 Ibid., p. 150.
15 Alain Corbin, *The Foul and the Fragrant. Odor and the French Social Imagination* (Cambridge, Mass.: Harvard University Press, 1986), p. 91.

produce this movement included the extensive paving of urban squares, the intensification of street cleaning, the construction of sewers, the planting of trees, new architectural concepts and housing layouts, and hygiene rules, e.g. for correct ventilation.[16] Here one encounters "a positive notion of a milieu,"[17] insofar as it is assumed to be a political field of intervention, e.g. "to change the air temperature and to improve the climate."[18] By circulating stagnant water through drains, the goal was to produce "a new climate."[19] In this context, Fourier's projects form part of these contemporary measures to achieve a new healthy milieu. Accordingly, he condemns

> [v]andals who use their imagination to jeopardize hygiene and beauty by grotesque constructions, caricatures, which are sometimes more costly than a well-designed and pleasant building. Often, out of murderous avarice, such vandals build unhealthy and unventilated houses in which they cram whole mob colonies to save costs.[20]

As a remedy, as most readers will know, Fourier designed a specific system of arcades in his Phalanstères. But in order to not fall back into any technological determinism, one has to conceive of their function in connection with his general concept of a "Phalange"—"Phalange" is his name for the community, "Phalanstère" for the

16 Ibid., pp. 91–110; see also Richard Sennett, *Flesh and Stone. The Body and the City in Western Civilization* (New York: W.W. Norton, 1994), esp. pp. 256–270.

17 Foucault, *History of Madness*, *p. 365*.

18 Michel Foucault, *Security, Territory, Population. Lectures at the Collège de France, 1977–78*, ed. Michel Senellart, trans. Graham Burchell (Basingstoke and New York: Palgrave Macmillan, 2007), p. 22.

19 Ibid. See also Chris Otter, *The Victorian Eye. A Political History of Light and Vision in Britain, 1800–1910* (Chicago: University of Chicago Press, 2008), p. 17.

20 Charles Fourier, *Théorie de l'unité universelle*, vol. 3, 2nd ed., *Œuvres complètes*, vol. 4 (Paris: La Sociéte pour la propagation et la réalisation de la théorie de Fourier, 1841), p. 309. Wherever Fourier is quoted from the French editions in this text, the translations are by Martin Doll.

building. Its core principle is an intertwining of complex movements being in accordance with a cosmological order that Fourier derives from the dynamics of the universe or rather the gravity of the planets. Thus, he presumes that all human relations have to be based on the complex and multi-layered combination of individual passions or drives. Fourier also uses the word agent (*agent*). His central idea was that, if one achieves their proper arrangement, one might inevitably arrive at a new social order. Utopias generally being under suspicion for aiming at a closed and homogeneous totality, Fourier's goal is anything but that, because it is about reaching a maximum diversity. The passions are technically speaking potentials that develop their impact only in interaction with others. Thus, Fourier's Phalange is a sort of modulator in which work teams, groups or "series" (as he calls them) would develop spontaneously "without an order of a boss."[21] Fourier's dictum is: you cannot change the passions but you can combine them properly and guide them in the right direction.

Explaining Fourier's complex combinatorics of passions in detail (fig. 1) would go beyond the scope of this paper. He continuously reworked it by providing new lists, more diagrams with finer ramifications. But in order to understand the organization of a Phalanstère, one should at least know some of the core passions in Fourier's system. Amongst others, as, e.g., the "affective passions" love and friendship, there are three "distributive passions." He calls them distributive because they happen in-between. These are the "papillonne" which can be translated as the flighty passion, the passion that strives for change; the "cabaliste," the passion that strives for competition; and the "composite," the passion that strives for combination or union.[22] Derived

21 Charles Fourier, *Le nouveau monde industriel et sociétaire*, 3rd ed., *Œuvres complètes*, vol. 6 (Paris: Librairie sociétaire, 1848), p. 58.
22 Ibid., pp. 50–51.

Fig. 1: Charles Fourier, *Plan of the Treatise of the Passionate Attraction*, oblong folio, approx. 34 x 51 cm, [Paris], imprimerie E. Duverger, n.d. [1844].

therefrom, Fourier's calculations had come to the result that a Phalange has to incorporate at least 1620 members in order to arrive at an ideal combinatorics of the 810 different characters and their passions.[23]

In compliance with this order of passions Fourier wants to organize work in his Phalanges, eventually rendering it an "attractive" delight. Even if the workday would be long (12–14 hours) no task would take longer than 2 hours (following the "papillone"-passion); furthermore, the different workgroups would compete with one another (following the "cabaliste"-passion); last but not least, the "composite" passion would help to produce an "enthusiastic accord" between the members of a group. A paradigmatic workday in a model Phalanstère (fig. 2) would start at 3.00 a.m. and end at around 7.30 p.m. But it would be interrupted by several breaks for breakfast, lunch, refreshments and supper.

23 Le Corbusier will later allude to this number in his concept for the "Unité d'habitation à Marseille" for 1600 people. See Le Corbusier and Pierre Jeanneret, *Œuvre complète 1938–1946*, ed. Willy Boesiger (Zurich: Les Éditions d'Architecture, 1971), pp. 178–193.

Morning	From 3 to 4½, a.m.	Session of the little hordes at the stables.
	„ to 5¾..............	*1st repast, on rising.*
	From 5 to 6¼..............	Session of grand culture, mowing
	From 6¼ to 8..............	Session of grand culture, vines.
	From 8 to 8½..............	*Breakfast,* 2nd repast.
	From 8¼ to 10½............	Session of small culture, under tents in the garden.
		Interlude.—Refreshment.
	From 10¾ to 12¾	Session of studies or of kitchen.
	At 1 p.m.	*Dinner,* 3rd repast *(Parcours).**
Evening	From 2¼ to 4 p.m.	Session of workshops, of green-houses, of fish-ponds.
	From 4¼ to 5¾	Session of forests, sylvans.
	At 6 p.m.	*Tea* in the forest, 4th repast.
	From 6¼ to 7¼	Session of gardening, watering.
	From 7¼ to 9, the Exchange..	Session of the plays, ball, concert, court of gallantry.
	At 9 o'clock	*Supper,* 5th repast.
		The amusements prolonged till 11 o'clock.†

Fig. 2: Charles Fourier, *Table with Daily Sessions of Labor with Meals in a Phalanstère.*

Following this, Fourier's architectural concept is mainly characterized by a balance between places for private retreat and communal areas for work and leisure time. At central locations of the site (fig. 3) we find: communal dining areas, communal kitchens (a, aa) and larger meeting places like an interdenominational church and an opera house (S, ss).

Following his dictum, to ensure a multiplicity of combinations in every respect, the assemblage of the individual accommodations is very important for Fourier. Even if the rooms differ in size according to the income of the inhabitants, a Phalanstère would distribute them equally in order to prevent the development of ghettos. He writes: "One should separate the classes but not isolate them from each other."[24]

On the one hand, these accommodations would allow for the individualization of the members of the Phalanstère. On the other hand, as children would live in

24 Fourier, *Le nouveau monde industriel et sociétaire*, p. 127.

Fig. 3: Charles Fourier, *Ground Plan of a Phalanstère.*

other places, in order to make Phalansterian promiscuity possible, these accommodations would not be bourgeois one-family apartments producing a total unrelatedness. Fourier's ideal building, even if Walter Benjamin rejects it as reactionary, as a "colorful idyll of Biedermeier,"[25] would be not just a dwelling for individualization, if one takes the collectivizing dimension of it seriously. First, one eighth of the space would be reserved for public places; second, a lot of meeting rooms, "Seristères" in Fourier's language, would be installed, in order to produce passionate series over and over again.[26]

In contrast to self-sufficient housing, Fourier's apartments would not include a kitchen, thus forcing the Phalansterians to leave their home in order to eat in the common dining rooms. And what's more, as the different places of work would be situated in the opposite wing of the accommodations (handicraft) if not on the

25 Walter Benjamin, "Paris, the Capital of the Nineteenth Century," in *Selected Writings*, vol. 3: 1935–1938, ed. Michael William Jennings and Howard Eiland (Cambridge, Mass.: Belknap Press of Harvard University Press, 2002), pp. 32–49, here p. 34.
26 Fourier, *Théorie de l'unité universelle*, vol. 3, p. 302.

field (farming) and all the workers would have to change their type of work at least every two hours, the building complex would produce an incredible amount of constant relocation activities. In other words, the distances between work and life would not be just a necessary evil, but a part of the site's dynamic effect. The Phalanstère would thus become a gigantic contact zone for all the Phalanstère members being continuously in movement and meeting each other accidentally and frequently. In the end, this would significantly contribute to the combination of passions, that were so important for Fourier. He writes: "Everybody is always in the Séristères or public spaces, in the workshops, on the field, in the stalls; one stays at home only in case of illness or a tryst; then a bedroom and a dressing room is sufficient; thus, even the richest have at the utmost a three-room-apartment."[27]

As a medium of these circulation processes Fourier designed the so-called *"rue-galerie"* (see fig. 3 and fig. 4 / plate 5), arcades which he also calls, taken as a whole, the "room of universal link" (*salle de lien universel*).[28] Each part of the building would be connected to others by this covered and vitrified large inner street. This "main room of the palace of Harmony,"[29] as Fourier writes, would be ventilated in summer and heated in winter. All the doors of the apartments would directly lead to it. With this Fourier has in mind that the Phalansterians could move about as if at home, i.e., go everywhere "in light clothing" and "colourful shoes."[30] As a result, like the structure of the workday, Fourier's architecture would be in perfect analogy with his logic of passions: you'll find individuality in the apartments; the "affective passions," love and friendship, are lived in the Séristères, whereas the distributive passions (for example change and general unity) have their place in

27 Ibid., p. 539.
28 Ibid., p. 469.
29 Ibid., p. 462.
30 Fourier, *Le nouveau monde industriel et sociétaire*, p. 468.

Fig. 4: Charles-François Daubigny, *View of a Phalanstère (1847)*, lithography, 44.8 x 30 cm, imprimerie Prodhomme.

the arcades.[31] As a whole, the Fourierist building would be the modulator to bring people into circular movement, like the planets in our solar system orbiting around the sun. This material dimension of the building is very important for Fourier, as he underlines very clearly: "If the arrangement fails on a material level, it will also fail on the level of the passions."[32] But again, the material structure alone would be a necessary not a sufficient condition. It would only unfold its impact in combination with the necessary endless commuting of the people resulting from the "job rotation" and the food breaks. This would be the crucial momentum that would interrupt any isolation in the individual housings. Therefore, the arcades would serve as transitory rooms, in which every Phalansterian would get or sometimes would have to get in public contact with

31 See ibid, p. 69 and Peter Serenyi, "Le Corbusier, Fourier and the Monastery of Ema," *The Art Bulletin* 4, no. 9 (1967), pp. 277–286, here p. 281.
32 Fourier, *Le nouveau monde industriel et sociétaire*, p. 123.

Fig. 5: Charles Fourier, *Aerial View of a Phalanstère*, approx. 1814, ink on paper, National Archives, Paris.

the others, independently of the weather. But the result would not be a forceful homogenization but a free play of diversification. The arcades in their dynamics between "people and things" would be environments that would only offer opportunities, e.g., to decide to pause for a moment and to have a chat or not.

Hence, the arcades must be thought of as a kind of canal system bringing two forces together: the flow of people and the bandwidth of the corridors guiding it, speeding it up or down. In order to achieve a balanced ratio between speed of movement and connection-making Fourier insists that a certain building size of a Phalanstère should not be exceeded. If expansion seems necessary, one should rather add more floors to accommodate more people. If one looks at one of the rare drawings Fourier made (fig. 5), one might have the impression that he drew the canals before and added the rooms afterwards, "like apples to a tree."[33]

33 Robin Evans, "Figures, Doors and Passages," in *Translations from Drawing to Building* (Cambridge, Mass.: MIT Press, 1997), pp. 55–91, p. 78. Evans uses this wonderful phrase in another context.

Unfortunately, Fourier never realized any Phalanstère. He obsessively insisted on a certain minimum scale of the building so that he never got enough money from investors. Other attempts made without Fourier, as in Condé-sur-Vesgre in 1833, failed after one year because of a lack of money. It was initiated in collaboration with him, but then he withdrew. And in retrospect he called the building "rubbish."[34] Another attempt in Citeaux was never realized.

Sometimes Jean-Baptiste André Godin's so-called "Familistère," for which building began in 1852 in Guise, is mentioned as Fourierist architecture. But its foundation took place under circumstances that were quite different from those Fourier had in mind. It was built by a paternalistic industrialist in order to foster the productivity of *his* workers in *his* factory. Even if Godin called himself Fourierist, in the end the Familistère was an ordinary company housing project.[35]

Whereas all early attempts to realize a Phalange in France were doomed to failure, later efforts were made in the USA, above all in the Northeast. They are also a manifestation of the specific US-American way of adopting Fourierist ideas.

Circulations of Fourier: "Fourierism" in the USA

One of the reasons why Fourierism became attractive in the USA was the decline of the economic situation

34 Charles Fourier, *La Fausse industrie morcelée, répugnante, mensongère, et l'antidote, l'industrie naturelle, combinée, attrayante, véridique, donnant quadruple produit*, vol. 1, Œuvres complètes, vol. 9 (Paris: Bossange père, 1835), p. 725; see also Jonathan Beecher, *Charles Fourier. The Visionary and his World* (Berkeley: University of California Press, 1986), ch. 23, pp. 454–471.

35 See Julius Posener, "Stadtutopien gegen die Stadt: Foucault, Godin, Buckingham, Howard," in *Utopie heute? Ende eines menschheitsgeschichtlichen Topos?*, ed. Karin Wilhelm (Vienna: Passagen, 1993), pp. 71–108, here p. 91.

of many people after the so-called "Panic of 1837," an economic depression that hit the Eastern USA hard. It led to the closedown of 90% of all factories on the East Coast, the bankruptcy of a lot of farmers and a wave of unemployment. New York on its own had fifty thousand unemployed people. Thus, the farmers and the unemployed got to embrace alternatives and social experiments like Fourierism.[36] Against this background, the US Fourierists should not be mistaken for a marginal crazy group of non-conformists. Instead, Fourierism was a seriously, if not uncontroversially, discussed movement in the middle of the nineteenth century.[37] Publications such as *The Phalanx* (1843–1845), later called *The Harbinger* (1845–1849), were the medium of Fourierism. Alongside other publications, Fourierist conventions and extensive lecture tours fostered the enthusiasm.[38] In 1840 Albert Brisbane, founder of the journal *Phalanx* and of the "Fourierist Society" published the highly influential book *Social Destiny of Man*.[39] In it you find sometimes literal translations of Fourier's complex thoughts, sometimes heavy adaptations to the American conditions and sensitivities.[40] For example Fourier's

36 For further details on the circumstances of the economic crisis and the flourishing of reform movements as its consequence, see Philip F. Gura, *Man's Better Angels. Romantic Reformers and the Coming of the Civil War* (Cambridge, Mass.: Belknap Press of Harvard University Press, 2017), esp. pp. 1–18.

37 See John Humphrey Noyes, *History of American Socialisms* (Philadelphia: Lippincott, 1870), p. 22.

38 See Yaacov Oved, *Two Hundred Years of American Communes* (New Brunswick, NJ: Transaction Books, 1988), p. 148. On further publications of the Fourierists and on the influence of Brisbane see Mark Holloway, *Heavens on Earth. Utopian Communities in America, 1680–1880*, 2nd ed. (New York: Dover, 1966), p. 141; concerning the "Fourier conventions" in Pittsburgh, Boston and New York as well as the lecture tours see Carl J. Guarneri, *The Utopian Alternative. Fourierism in Nineteenth-Century America* (Ithaca: Cornell University Press, 1991), pp. 230–241.

39 Albert Brisbane, *Social Destiny of Man, or, Association and Reorganization of Industry* (Philadelphia: C.F. Stollmeyer, 1840).

40 The arcades—"one of the principal charms of the Palaces of Association"—are given the same importance by Brisbane as by Fourier. See ibid., p. 371.

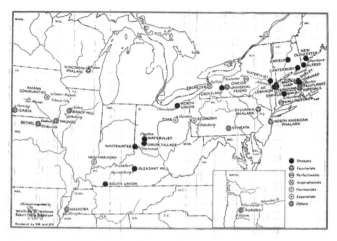

Fig. 6: Alice Felt Tyler, *Map of Utopian Settlements in the USA before 1860.*

ideas on collective orgies and promiscuity were entirely left out.[41] In 1843 alone twelve Fourierist settlements were founded (fig. 6). Altogether there were twenty-nine Fourierist settlements and more than twenty Fourierist societies, with an estimated hundred thousand followers between 1824 and 1846—the year when most of the projects were closed down.[42]

Like in France the circulation of Fourier's concepts made them fluid in many respects. The concepts traveled between different kinds of texts, e.g., literary uto-

41 Oved, *Two Hundred Years of American Communes*, p. 130. A contemporary attempt to invalidate Fourier's ideals of promiscuity can be found in Parke Godwin, *A Popular View of the Doctrines of Charles Fourier* (New York: J.S. Redfield, 1844), pp. 88–90. Goodwin was co-editor of The Phalanx. However, there were also Fourierists who advocated free love less offensively to the outside world than practiced it casually, e.g., in the settlement of Oneida under the name "complex marriage." See Guarneri, *The Utopian Alternative*, pp. 353–363.

42 See Noyes, *History of American Socialisms*, p. 24; Oved, *Two Hundred Years of American Communes*, p. 132; Guarneri, *The Utopian Alternative*, p. 60. Also, the high number of publications on Brook Farm, some by former members, is a proof of the prominence Fourierism had in the nineteenth century in the eastern United States.

pias, political books and translations, journal articles, architectural drafts, constitutions, conventions, talks, manifestos etc. And the concepts were amalgamated with other already existing utopian movements: there were the Transcendentalists in Brook Farm, who converted to Fourierism; there were the Owenites or liberal Swedenborgians that later became Fourierists, or Fourierists that adopted "Swedenborgianism."[43] In 1840, Ralph Waldo Emerson writes in a letter to Thomas Carlyle: "We are all a little wild here with numberless projects of social reform. Not a reading man but has a draft of a new Community in his waistcoat pocket."[44]

From an architectural perspective, among all the bold settlement projects started at that time Brook Farm near Boston is the most interesting, as it shows at least some resemblance with Fourier's original drafts.

Brook Farm (1841–1846)

Even if the idea to build mostly individual family accommodations was not in accordance with Fourier's designs, a lot of properties of the projected "unitary building," even in their adapted form, call to mind Fourier's specifications. First, a dining room for up to three to four hundred people was planned, to make large meetings possible and to host collective lunches. Second, the kitchen and the adjacent bakehouse had rather huge dimensions to enable collective cooking and baking, because, as in Fourier's Phalanstères, the individual apartments did not have kitchens. Thus, like the Phalansterians, if they wanted to or not, the members

43 See Noyes, *History of American Socialisms*, p. 24, pp. 537–550.
44 Letter from Ralph Waldo Emerson to Thomas Carlyle, October 30, 1840, in Thomas Carlyle and Ralph Waldo Emerson, *The Correspondence of Thomas Carlyle and Ralph Waldo Emerson, 1834–1872*, vol. 1, ed. Charles Eliot Norton (Boston, Mass.: James R. Osgood, 1883), pp. 307–309, here p. 308.

of Brook Farm were sort of impelled to eat and cook outside their apartments. Third, public places were also of great importance: the Brook Farmers projected two public meeting rooms, a common reading room and a lecture hall.[45] Even the most characteristic trait of the Fourierist architecture, the arcades, was adapted to the specific conditions of the settlement. It was planned to link all the individual apartments on every level along the whole length of the building with a roofed patio (so-called *piazzas*). Codman describes them as follows:

> From the main hall or entry, which was on the left of the centre of the building, arose a flight of stairs which led out on to a corridor or piazza which extended across the whole front of the building. This corridor was duplicated by one above it, and the roof jutted out to a line with the lower story and covered them both. Pillars supported the roof, and were attached to and supported the corridors. On the lower corridor or piazza were the entrances to the suites. [...] Thus could privacy be maintained and sociability increased.[46]

The last sentence is significant, as one can see that in Brook Farm privacy and collectivity should have been brought into a balance like Fourier wanted. For reasons of sociability the Brook Farm Phalanstery should have had a small version of the canal system Fourier had planned for in his Phalanstères. Like the arcades in the Phalanstère, the Brook Farm canal system can be understood as the core medium to produce contacts between the inhabitants as much as possible. Unfortunately, the building was never finished. Shortly before completion it caught fire and was destroyed. According to the personal stories of its members, this was one of the reasons

45 John Thomas Codman, *Brook Farm. Historic and Personal Memoirs* (Boston, Mass.: Arena Publishing Company, 1894), p. 98.
46 Ibid., p. 114.

why the whole Brook Farm project was later dissolved.[47] But as always, the reasons were more complex.

If one looks at the historical development of other architectural projects in the context of the US variety of Fourierism, in the cascade of transcriptions the multiple versions were farther and farther removed from the original complex model. Like a stamp losing ink with every repeated impression, the projects got more and more detached from Fourier's complex principles for the combination of passions. In the end they became just a weak trace of a much larger idea and none of them succeeded.

In view of the failure of another project, Raritan Bay Union in Perth Amboy, Jayme Sokolow argues that the further development of socialism rendered its early versions obsolete: "The romantic or religious socialism of the early nineteenth century was being replaced by a more 'scientific' socialism which emphasized economics and the class struggle rather than isolated utopian colonies."[48] But this is a highly anachronistic argument. What Sokolow in fact does, is to take the later critique from Karl Marx and Friedrich Engels on utopian socialism and to declare it a historical force. In other words, the later critique becomes the reason for the former failure of the projects. Without adopting this cause-and-effect perspective, it is remarkable that Marx and Engels will later formulate a totally different take on media technology and politics, particularly on forms of circulation in terms of political economy. And they developed this by rigorously renouncing socialist utopianism in which they saw merely a preliminary stage of scientific socialism.[49] Engels writes: "To speculate on how a future soci-

47 Marianne Dwight Orvis, *Letters from Brook Farm, 1844–1847*, ed. Amy Louise Reed (Poughkeepsie, NY: Vassar College, 1928), pp. 145–149.

48 Jayme A. Sokolow, "Culture and Utopia: The Raritan Bay Union," *New Jersey History* 94 (Summer/Autumn 1976), pp. 89–100, here p. 100.

49 See Friedrich Engels, "Socialism: Utopian and Scientific," in Karl Marx and Friedrich Engels, *Collected Works*, vol. 24 (New York: International Publishers, 1975), pp. 281–325.

ety might organise the distribution of food and dwellings leads directly to utopia."[50] And "it is not our task to create utopian systems for the organisation of the future society."[51] Which tasks Marx and Engels exactly tackled is another story.

50 Friedrich Engels, "The Housing Question," in Karl Marx and Friedrich Engels, *Collected Works*, vol. 23 (New York: International Publishers, 1975), pp. 317–393, here p. 389.
51 Ibid., p. 330.

Sebastian Kirsch

"Where the Sun Does Not Reach, There the Doctor Will Appear"

Environmentalization in Gerhart Hauptmann's *Before Daybreak*

The term "environmentalization," which has become a prominent diagnostic concept in recent years, is derived from a short but very important manuscript belonging to Michel Foucault's 1979 lectures on governmentality.[1] Coined by Foucault only casually, the concept refers to what were then the most advanced manifestations of a type of governing which neither appears primarily as sovereign legal power nor operates by means of disciplinary techniques. Instead of shaping and addressing individuals directly, environmental power tries to steer and control living beings and things via their mutual embeddedness in all kinds of human and non-human relations. Simultaneously, the forms of leadership connected with this type of steering power appear at first sight much softer and more well-meaning in comparison to the methods of traditional authorities: neither do they rely on the "Sword of the Law," nor do they work on the level of panoptic confinement and surveillance, as was the case with Jeremy Bentham's utilitarian prison. It is probably mainly due to these properties that the term "environmentality" has recently been adopted for describing today's everyday life informed

1 See Michel Foucault, *The Birth of Biopolitics: Lectures at the Collège de France, 1978–1979*, trans. Graham Burchell (New York: Palgrave MacMillan, 2008), pp. 259–260.

by ever smaller digital applications, assistants and wearables. In other words, the term is often used to characterize the current emigration of computing capacities into the environment; it is no exaggeration to note that "environmentality" in this sense has by now gained an influence that resembles that of Gilles Deleuze's similar concept of "societies of control."[2]

At the same time, however, recent discussions have also sharpened the view that environmental controlling by no means only began with digitalization and the so-called "Internet of Things," but has in fact a far more comprehensive pre-digital and even pre-cybernetic history. From this point of view, particularly the rise of ecological discourses and milieu theories from the late nineteenth century on, as well as the development of so-called "planetary" techniques, can be re-read as important components of a historical thrust of environmental power. As several cultural theorists have shown in more detail, ecological thinking, from its first explicit formulations, has been full of various considerations of how to govern and also to optimize the interrelations between beings and surroundings.[3] It is against this background that I would like to shed new light on a classic theater play which, as I attempt to show, is indeed a genuine play on an early wave in the emergence of systematic environmental control. This play is Gerhart Hauptmann's most famous social drama *Vor Sonnenaufgang* (*Before Daybreak*, 1889) which not only symbolizes the breakthrough of German Stage Naturalism but whose

2 See Gilles Deleuze, "Postscript on the Societies of Control," in *Negotiations 1972–1990*, trans. Martin Joughin (New York: Columbia University Press, 1995), pp. 177–182.

3 For the German-speaking context, see, for instance, Benjamin Bühler, *Ökologische Gouvernementalität. Zur Geschichte einer Regierungsform* (Bielefeld: transcript, 2018); Marietta Kesting, Maria Muhle, Jenny Nachtigall, and Susanne Witzgall, eds., *Hybrid Ecologies* (Zurich: Diaphanes, 2020); Florian Sprenger, *Epistemologien des Umgebens: Zur Geschichte, Ökologie und Biopolitik künstlicher Environments* (Bielefeld: transcript, 2019).

title already bears witness to its relation to contemporaneous environmental topics (as will become clearer in the subsequent analysis).[4]

When it first premiered in Berlin in 1889, *Before Daybreak*—which was Hauptmann's first play to be staged—provoked one of the major scandals in the history of German theater. Particularly Hauptmann's explicit thematization of issues like alcoholism and incest was perceived at the time as an outrageous moral transgression—as can be seen exemplified in an article by literary critic Conrad Alberti, who condemned the play as "a mixture of crudities, brutalities, vulgarities, filthiness, such as had hitherto been unheard of in Germany. The feces were carried onto the stage in buckets, the theater was turned into a dung pit."[5] In contrast, today *Before Daybreak* is shelved or sometimes even decried as a high-school classic. Moreover, Naturalism generally lacks a good standing in contrast to the later avant-gardes, and this has further discouraged an engagement with this seemingly all-too-familiar piece. Nevertheless, as I will try to argue here, it is striking how precisely

4 Gerhart Hauptmann, *Vor Sonnenaufgang. Soziales Drama* (Berlin: C.F. Conrad's Buchhandlung, 1889). I will quote this first edition here, which I prefer to the version in the *Sämtliche Werke*: Gerhart Hauptmann, *Vor Sonnenaufgang*, in *Sämtliche Werke I. Dramen*, ed. Hans-Egon Hass (Frankfurt am Main and Berlin: Propyläen, 1966), pp. 9–98. The latter not only smooths out punctuation and orthographic peculiarities, especially in dialect and argot passages, in favor of easier readability, but also makes some strong interventions in the text: For example, it replaces Hauptmann's titling of his characters as "Handelnde Menschen" ("acting human beings," p. 5) with the stereotypical "dramatis personae" (p. 13). As a translation of the piece I quote Peter Bauland, *Gerhart Hauptmann's Before Daybreak: A Translation and an Introduction* (Chapel Hill: University of North Carolina Press, 1978).

5 "[E]in Gemisch von Rohheiten, Brutalitäten, Gemeinheiten, Schmutzereien, wie es bisher in Deutschland unerhört gewesen war. Der Kot wurde in Kübeln auf die Bühne getragen, das Theater zur Mistgrube gemacht." Conrad Alberti, "Die 'Freie Bühne'. Ein Nekrolog," *Die Gesellschaft. Realistische Wochenschrift für Literatur, Kunst und öffentliches Leben* 6 (1890), Vollständiger Nachdruck [complete reprint] (Nendeln, Liechtenstein: Kraus Reprint, 1970), pp. 1114–1112, here p. 1111. [Translation by Sebastian Kirsch]

Before Daybreak reflected the historical environmental transition. Seen from today, Hauptmann dealt outstandingly with the status of flows and rays, circulation and regulation at the turn of the twentieth century. In what follows I want to focus on three aspects of *Before Daybreak* that are arguably the clearest inscriptions of late nineteenth century environmentalization processes. These concern (1) logics and conditions of processes of liquefaction at the time (2) their reflections in Hauptmann's stage and also in contemporary innovations in stage machinery and (3) the related historical attempts at controlling and regulating.

Set around 1889, *Before Daybreak* takes place on the homestead of the Krause family in a coal mining area in Silesia. The Krauses recently made a great fortune because of a legal scam: Hoffmann, an engineer married to daughter Martha Krause, tricked the family into the right to sell the coal that lies beneath the fields of neighboring farmers. He also leads the profitable alpine railroad project to transport coal: a project Martha's first fiancé developed until he was outpaced by Hoffmann and committed suicide. The drama begins when an old college friend of Hoffmann shows up on the Krause homestead. It is Loth, a social reformer, who plans a study on the living conditions of the local mine workers. The Krauses take in the guest, but as Hoffmann welcomes him it becomes apparent that Loth mistrusts the actual circumstances behind the façade of the nouveau riche family. In turn, Hoffmann is familiar with Loth's history, too: years ago, he had emigrated to the US temporarily to found a socialist model state there. Then, after having failed and returned to Europe, Loth spent two years in prison for his political ideas. It is no wonder that tensions between Loth and Hoffmann are rising fast. Especially Loth, who is not only a life reformer and sun worshipper but also a dedicated anti-alcoholic, is disgusted by the Krauses excessive drinking. And not only does the whole family turn out to be a veritable

Fig. 1: Interior of the Krause's homestead, sketch from Gerhart Hauptmann, *Vor Sonnenaufgang*, 1889.

clan of drunkards: at the climax of the play, pregnant Martha's doctor also reveals to Loth that her and Hoffmann's firstborn was already a victim of alcoholism. As a three-year-old, he was fatally injured by the shards of what he thought was a brandy bottle. Furthermore, there are sexual and incestuous entanglements among the family members, ranging from an affair between

Fig. 2: Exterior of the Krause's homestead, sketch from Gerhart Haupt-mann, *Vor Sonnenaufgang*, 1889.

mother Krause and her nephew Kahl to the attempts of the permanently drunk father to sexually coerce his second daughter Helene. Helene, in turn, is that member of the Krauses who tries to cut herself out of the family web. Unsurprisingly, she falls in love with Loth, who for his own part confesses his love for Helene, planning to leave the Krause homestead with her. But things turn

out differently: first Loth has a falling-out with Hoff-mann, then Martha loses her baby. The doctor discloses the full extent of alcoholism in the family to Loth. Loth, a devotee of genetics, assumes that the curse of alcohol-ism will pass on to Helene and therefore leaves secretly and in a hurry. In the end, Helene discovers Loth's fare-well letter and commits suicide with a hunting knife. Meanwhile, at dawn, father Krause returns home bel-lowing from the local tavern.

This is, in short, the story arc of *Before Daybreak*, and it already reveals a lot about the first point I would like to highlight here, i.e. the status of liquids and fluids. The most striking aspect in this context is certainly the role of alcoholic beverages in *Before Daybreak*: over the course of the entire play, a wide variety of intoxicating bev-erages are constantly poured, offered, and drunk, from fine champagne to mundane beer to various schnapps and liqueurs. But also through the theme of (incestuous) sexuality, *Before Daybreak* deals with fluids—although in this case it is bodily fluids that threaten to mix unreg-ulated within the Krause clan. It can be noted that in both cases the exuberant appearance of liquids is also linked to a decomposing of traditional paternal orga-nization. After all, Father Krause appears not only as the biggest drunk of them all, but also as a particularly intrusive lecher in his incestuous desire.

On closer inspection, however, there are at least two further topics in *Before Daybreak* in which fluids and processes of liquefaction play a conspicuous role. The first one concerns the sudden wealth and thus the money which the Krauses gain from the coal mining business. In fact, their home is literally overflowing with riches, as Loth makes clear: "affluence seems to spill out of every door and window"[6]; and more than once the Krause's excessive drinking as well as their free-floating sexual

6 "[D]a guckt ja der Ueberfluß wirklich aus Thüren und Fenstern." Hauptmann, *Vor Sonnenaufgang*, p. 21 / *Before Daybreak*, p. 16.

drives appear to be symptoms of their inability to handle the permanent money flow properly. Then again, this money flow itself springs from the coal business (or "coal upstream"), and thus another stream: the never-ending stream of coal which is extracted from the earth and carried away by the new-built railroad—which evokes the topic of logistics and material flows. And it is all the more striking that in the case of these money and coal flows, too, a crisis of older paternal systems of order plays a role. This time it is not so much about the personal representatives of this order (i.e. the father), but the related symbolic and written-cultural forms. Not only did Hoffman coax the neighboring farmers out of their coal rights by making them sign an unfair and oppressive contract; it is particularly significant that he managed this by intoxicating them with champagne before the act of signing.

The third thematic area in which liquefaction plays a major role cannot be inferred so much from the plot, but concerns Hauptmann's Naturalistic poetics itself. It is the crucial role of verbal dialects, argots and oral notations in *Before Daybreak*, which already on the level of typeface evoke permanent slurring, spitting and babbling rather than "clean" articulation: "'s Gaartla iis *mei*-ne! ... d'r Kratsch'm iis *mei*-ne ... du Gostwerthlops! Dohie hä!" ("Th' yard 'sh mine! ... So's th' inn ... 'Sh mine! ... Horsh's ash of a barkeep! . . . Whoooo-heeee!! . . . Oh, boy."), drunken father Krause sings on his way home.[7] But also stone-sober figures like Beibst, a Silesian peasant who is working during the sunrise, sound as follows: "Die Staadter glee – ekch! – de Staadter, die wissa doo glee oals besser wie de Mensche vum Lande, hä?" (City folk! Ecchhh!! – Every one of 'em I ever met allus thought he knew all there is to know better'n us.)[8], or "Mei Suhn meente, 's käm' do dervoone, meent' a,

7 Ibid., p. 37 / p. 28.
8 Ibid., p. 39 / p. 30.

weil se zu schlecht verzimmern thäten, meent' a, de Barchmoanne, 's soatzt zu wing Luhn, meent' a, und do giht's ok a su: woas hust'de, woas koanst'de, ei a Gruba, verstiehn Se." ("My son, he thinks them miners don't get nearly enough pay, so none of 'em gives a damn. Only kind o' work ya get down in them shafts is hit or miss, a lick 'n a promise, y'unnerstand?")[9] Nephew Kahl in turn, who is a stutterer, talks like this: "D..d.. die M..mm..maus, das ist 'n in...in..infamtes Am..am.. amf..ff..fibium." ("F-f-fieldmice is inf-f-famous amph-ph-phibians!")[10] With such writing—which is of course ultimately impossible to translate—standard language begins to drift into the realm of the non-signifying, which means that language itself is in a way "lique-fied" here. However, in Naturalism this of course does not happen in a Dadaistic manner. Instead, Hauptmann composes a kind of musical score from minor dialects and intonations, which for their part have a constitut-ing effect on milieux, connecting or separating groups of speakers below the level of conventional written norms. In other words: if those written norms are in a way the solid form of language then dialects and orality can be seen as its liquid aggregates—and these come to the fore here with all determination.[11]

Systematically summarized, then, *Before Sunrise* depicts three particularly striking areas of flows and streams: alcohol and sexuality, coal and money, dialects and orality. This allows for a first broader conclusion, which leads back to the already mentioned Foucault. These

9 Ibid., p. 41 / p. 32.
10 Ibid., p. 26 / p. 20.
11 Against this background it is particularly interesting that a first translation of the play was made by James Joyce in 1901: *Joyce and Hauptmann: Before Sunrise – James Joyce's Translation, with an In-troduction and Notes by Jill Perkins* (San Marino: Huntington Li-brary, 1978). In fact, Joyce appreciated Hauptmann so much that he learned German just to be able to understand this piece. However, on the level of meaning, Joyce's translation is full of mistakes—which would make it even more worthwhile to compare both versions in detail.

three areas invoke precisely the three powers that Foucault's early book *The Order of Things* depicted as the most characteristic discursive formations of the modern episteme beginning around 1800: life, labor and language.[12] Or to be more accurate here: in *The Order of Things*, Foucault outlined that life, labor and language emerged as "transcendentals" at the end of the eighteenth century, which, however, did not refer to a subject and its epistemic capacities, but, on the contrary, to object cultures. Put simply, this process involved implementing temporalizing and causal-mechanical moments into the older classification systems of species, riches and words—corresponding to the bourgeois era as an epoch of history. Therefore, after 1800, the sciences of life began focusing more on the evolutionary process and less on classifying species as continuous creation: a tendency that culminated above all in Darwin's theory of evolution. The riches, on the other hand, turned into capital and started to produce a surplus-value from the moment that labor was to be measured in time—a mechanism later analyzed by Marx. And the philologies, finally, began to write diachronic histories of the development of languages and tied these to the idea of nations. The crucial point, however, is that in *Before Daybreak* one can observe how these transcendentals themselves literally became liquid and fluid at the end of the nineteenth century: streams and flows of labor, life, and words swell, spill, and overflow in all directions here, finally adding to a suicidal machine, where coal is robbed below and then gets converted into a drug frenzy above. Therefore, the contemporaneous problem that persists with this situation is obviously this: how to regulate these flows again? How to find new techniques of controlling and steering them? How to make them

12 See Michel Foucault, *The Order of Things. An Archeology of the Human Sciences*, trans. Alan Sheridan (New York: Random House, 1970), particularly chapter 8.

part of a limited ecology? Then again, in the light of Fou-cault's later lectures on governmentality, it is fair to say that this is exactly where processes of environmentaliza-tion happened at that time—which brings me to my sec-ond point which is about the stage of *Before Daybreak*.

The cited examples of Hauptmann's handling of dia-lect and orality have indicated that his Naturalistic language has a certain inherent tendency towards self-liquefaction. Interestingly enough, in *Before Daybreak* something very similar happens on the level of the stage and its imagery itself. Contrary to a first impression, one can find here a clear tendency to transgress the classi-cal picture frame stage. To grasp this aspect more pre-cisely, one should first recall that the picture stage, as it was established during the Early Modern period and perfected with bourgeois theater from the late eigh-teenth century on, was not only designed in strict anal-ogy to the Renaissance idea of an image as a "window on the world," hung vertically and at the viewer's eye level. Because of its central perspective, it also focused on the single, sharply contoured individual—and thus matched a conception of the living being that was par-ticularly adequate to disciplinary techniques, but began to lose its relevance with the rise of environmental pow-ers at the latest.[13] In *Before Daybreak*, therefore, one finds at least two components that clearly refer to this transformation. The first one concerns Hauptmann's understanding of the stage's spatiality and visibility, as it can be derived already from his two sketches of the play's locations: what those drawings clearly reveal is that Hauptmann treats the stage not so much as a verti-

13 The connections between the disciplinary regime and the dispositif of the (bourgeois) picture stage have been widely discussed in the-ater studies, see, for instance, Roland Dreßler's classic study *Von der Schaubühne zur Sittenschule. Das Theaterpublikum vor der Vierten Wand* (Berlin: Henschel, 1993). To date, however, compared to the prominence of this topic, the question of how theatrical develop-ments correspond to the history of governmentality in the Foucaul-dian sense has remained largely underexposed.

cal mirror which confronts the audience, or—as I mentioned above—as a "window on the world" in the Renaissance tradition. Instead, since Hauptmann depicts the interior of the Krause house and the whole homestead *from above*, both locations appear ultimately as horizontal planes filled with various steps, paths, and ultimately forces, vectors, or flows—in other words: as environments (fig. 1, fig. 2). One might also think of Gilles Deleuze's concept of the map here, which "can be present in painting insofar as a painting is less a window on the world, à *l'italienne*, than an arrangement [agencement] on a surface."[14] Moreover, due to the same logic, the status of the "dramatis personae" changes as well: Hauptmann does not refer to them as "figures" but as "Handelnde Menschen" ("acting human beings").[15] And to name the decisive point here in all brevity: in *Before Daybreak*, as in the milieu depiction of Naturalism in general, the focus shifts from the individual protagonist and its body image to a spatial in-between, holding the bodies together in nettings and clews. It is therefore a multilayered collective—or even more precisely: con-nective—body and its interrelations that become essential in Naturalist theater.

This shift concerns also the second important aspect that indicates the transformation of imagery and visibility. In fact, this aspect is not only related to questions of stage machinery but also points to the whole play's eponymous topic, for one can draw a clear connection between the title *Before Daybreak* and new techniques of stage lighting in the 1880s, particularly the invention of the so-called "Edison Glühlampe," which belongs to the rise of contemporaneous environmental techniques in general. The most important innovation brought by the "Edison Glühlampe" was the possibility to modu-

14 Gilles Deleuze, "What Children say," in *Essays Critical and Clinical*, trans. Daniel W. Smith and Michael A. Greco (London and New York: Verso, 1998), pp. 61–67, here p. 66.
15 Hauptmann, *Vor Sonnenaufgang*, p. 5. [Translation by Sebastian Kirsch]

late stage light over more extended periods of time, to let it slowly become light or dark and thus also to simulate sunrises and sunsets by technical means. Before the invention of this new technique, when sunlight was simulated in indoor theaters this was only possible in the limited logics of "on" or "off"—and this even applies to the first electric lamps which were used on European stages from the 1850s. To refer to the work of theater scholar Ulf Otto, who has worked on the history of stage light in more detail:[16] in the field of lighting techniques and their respective subjectivizing functions, one can ultimately distinguish three logics that correspond in an amazing way to the three stages of sovereignty, discipline, and control. In the Early Modern period indoor theaters usually had no other lighting techniques than candles or lamps which did not allow for any modulations. Simultaneously, since in this period the sun was frequently treated as an allegory or a personification of the sovereign, it could also appear, especially in baroque theater, as a heavenly body on stage, allegorizing the entrance of the king himself. Due to the limited possibilities of lighting, however, these theater suns were often just made from papier-mâché which could be pulled across the stage. In turn, bourgeois theater reformers not only abolished allegoric representations but also called for "natural" light on stage—a light which literally belongs to enlightenment. However, the gas lights and the first "electric suns" typical for this period were once again bound to a rather simple mechanism of "on" and "off," which was in fact structurally parallel to the logics of a protagonist figure entering the stage or leaving it. In other words, they defined a classical frame of subjectivation and thus were completely in line with the coordinates of panopticism. Therefore, the very moment when

16 See Ulf Otto, "Auftritte der Sonne. Zur Genealogie des Scheinwerfens und Stimmungsmachens," in *Auftritte. Strategien des In-Erscheinung-Tretens in Künsten und Medien*, ed. Annemarie Matzke, Ulf Otto, and Jens Roselt (Bielefeld: transcript, 2015), pp. 85–104.

the electric Edison light took hold in theater marked a crucial epistemological moment: just as the binary logics of "on" and "off" were suspended in favor of more continuous flows of light and of luminary atmospheres, so the clearly defined protagonists began to liquify. And it is indicative of the development of a new control culture at the time that the invention of the Edison light resulted in the institutionalization of the stage operation as so-called "Technische Einrichtung" ("technical facilities") and monitoring signal boxes.

Now, how is this new technique of regulating and modulating artificial sunlight then reflected in *Before Daybreak*? The first thing that catches the eye is certainly Hauptmann's construction of the second act, which is entirely devoted to the process of the sunrise. While the action takes place in the Krause's courtyard, the sun slowly rises over the scenery, so that the act begins while it is still dark and finally ends in the bright morning light. However, this playing with lighting atmospheres is by no means just a demonstration of technical potentials. Instead, a closer look reveals that Hauptmann deals with a new order of temporal simultaneity which stands in a problematic relation to the new techniques of light modulation: in particular, the uplifting sunlight competes against the electrified indoor lighting of the inn where Father Krause gets drunk until dawn. As Hauptmann's stage directions read: "It is about four in the morning. The lights are still shining through the windows of the inn. Through the gateway to the farmyard, we see the first signs of an ashen grey dawn which, during the course of the action, develops into a darkly reddish sky before gradually breaking into bright daylight."[17] In a recent essay on Naturalism's general

17 "Morgens gegen vier Uhr. Im Wirthshaus sind die Fenster erleuchtet, ein grau-fahler Morgenschein durch den Thorweg, der sich ganz allmälig im Laufe des Vorgangs zu einer dunklen Röthe entwickelt, die sich dann, eben so allmälig, in helles Tageslicht auflöst." Hauptmann, *Vor Sonnenaufgang*, p. 36 / *Before Daybreak*, p. 28.

"solar orientation" (which is also visible in several titles of other plays, in the case of Hauptmann *Helios* and *Vor Sonnenuntergang* [*Before Sunset*]), literary scholar Juliane Vogel has pointed out that this competition between light sources is just one part of *Before Daybreak's* broader "Sonnenpartitur" ("solar score").[18] According to Vogel, the crucial point is that Hauptmann's "solar score" does not relate to a linear temporal order which would fit the traditional course of the sun. Even though *Before Daybreak* seems to fulfill a classical dramaturgical arc covering a period of (roughly) 24 hours, what comes "to light" here is only a collage-like variety of parallel milieux, and thus a fragmented and splintered society: "Hauptmann not only juxtaposes lamplight and sunlight, he also sets the clamor of departing guests from the inn against the stammering of drunks, the confusion of cock cries against the rhythmic denning of the old Beibst."[19] Vogel therefore comes to the conclusion that, contrary to the first impression, Naturalism's distinctive "solar orientation" ultimately bears witness to the sun's general loss of organizing and synthesizing powers at the end of the nineteenth century: "As a directional constant that would bring together and linearize particular impressions, the sun ceases to exist."[20] Against the background of what I have said here, this diagnosis can be extended further: on the one hand, it is highly significant (and most ironic as well) that the sun arc lost its organizing powers—or its epistemological value, so to speak—the very moment it could be simulated by new

18 Juliane Vogel, "Sonnenpartituren. Solarität im Drama des Naturalismus," *Poetica* 51, no. 1–2 (2020), pp. 148–169.

19 "Hauptmann setzt nicht nur Lampen- und Sonnenlicht gegeneinander, er setzt auch das Geschrei aus dem Wirtshaus abziehender Gäste gegen das Gestammel der Betrunkenen, das Durcheinander der Hahnenschreie gegen das rhythmische Dengeln des alten Beibst." Ibid., p. 161. [Translation by Sebastian Kirsch]

20 "Als Richtungskonstante, die partikulare Eindrücke zusammenführen und linearisieren würde, fällt sie [die Sonne, S.K.] aus." Ibid., p. 160. [Translation by Sebastian Kirsch]

lighting techniques. And on the other hand, with regard to the question of environmental power, it is important to underline that these were also the years in which the so-called "Lichtbiologie" ("light biology") started to explore the effects that different lighting conditions— regardless of whether "natural" or "artificial"—have on living organisms: in 1891 dermatologist Friedrich Hammer published the first systematic German-language study on the effects of light on the skin (*Über den Einfluß des Lichtes auf die Haut*), and in 1895 Danish physician Niels Finsen invented the first artificial light source to be used in modern "heliotherapy" (which earned him a Nobel Prize in 1903).[21] This touches now the third and final aspect I would like to draw attention to, i.e. Hauptmann's reflection of forms and attempts of environmental controlling which evolved at the turn of the twentieth century.

At this point, I want to come back to the critical situation which the late nineteenth century's emerging culture of control tried to react to. In the 1980s, the American sociologist James Beniger undertook a highly interesting and still illuminating genealogy of the then most up-to-date computer-based logics of control, tracing their roots back to the technological and economic innovations of the late nineteenth century. As Beniger argued in his study *The Control Revolution* (1986), the so-called "Information Society developed as a result of the crisis of control created by railroads and other steam-powered transportation in the 1840s."[22] Information and control thus appear to be paradigms that reacted to growing problems of applied thermodynamics, i.e. of classical factory production, of coal and steel industries, and in general

21 See Albrecht Scholz, *Geschichte der Dermatologie in Deutschland* (Berlin and Heidelberg: Springer Verlag, 1999), particularly chapter 11.1 ("Zur Geschichte der natürlichen und 'künstlichen' Lichttherapie").

22 James R. Beniger, *The Control Revolution. Technological and Economic Origins of the Information Society* (Cambridge, Mass: Harvard University Press, 1986), p. 25.

to the dynamic effects of the industrial revolution. Or to put it in a little more detail: according to Beniger, the industrial revolution in the wake of the development of steam engines unleashed a dynamic, exponentially growing productivity force. However, at the end of the nineteenth century the increase and distribution of goods had become unmanageable with conventional administrative technologies. This "crisis of control," as a result, prepared the ground for new communication technologies and data processing. Beniger speaks of a historical change "from the government of men to the administration of things,"[23] which marked the rise of non-personal management, bureaucracies, logistics, and rationalization. Dysfunctional, older modes of organization, dependent on face-to-face communication and personal relationships, were replaced systematically by new, nonpersonal structures at the end of the nineteenth century.

Now, it is not hard to see that *Before Daybreak* does indeed deal with the processes of production and distribution addressed by Beniger, in the motifs of coal extraction and the associated railroad. But what makes Beniger's study even more interesting here is the vocabulary he uses to describe the contemporaneous difficulties with managing and recapturing the energetic forces of the industrial revolution: "Never before had the processing of material flows threatened to exceed, in both volume and speed, the capacity of technology to contain them,"[24] Beniger writes, equating the aforementioned crisis of control explicitly with a crisis of containing flows. Against this background, the aforementioned liquefaction of the transcendentals life, labor and language as well as the transgression of the order of visibility connected to the picture frame stage can also be understood as symptoms of this very "crisis of containment"—which also connects the Foucauldian

23 Ibid., p. 15.
24 Ibid., p. 12.

perspective I developed in the first part to a more economic- and techno-historical argument.[25] Or to put it more pointedly: in Hauptmann's play, the Krause home, which is literally bursting with wealth gained from the coal business, ultimately resembles an overheating steam engine. Therefore, it can indeed be understood as a direct symptom of thermodynamics "out of control."

However, the crisis of containment as depicted by Beniger is not the only problem which gave rise to the *Control Revolution*. What must also be taken into account is the notorious fear of entropy which resulted from the second law of thermodynamics and famously haunted the second half of the nineteenth century. In this case, the key point is that while the entropy discourse is also inextricably linked to the nineteenth century's thermodynamics, it does not denote exactly the same problem as that of an overheating and possibly exploding steam engine. Instead, fear of entropy was for a more long-term "thermal death." The idea was that, due to irreversible processes of energy release, the universe would in the long run reach maximum energetic equilibrium, meaning a state of total dissipation and dispersion of each and every particle. Now, what makes this topic extremely complex is that it was also widely discussed in the life sciences, where entropy was to become another name for the irreversible aging processes each and every organism is subject to. Moreover, historians have widely noted the fatal co-development of "the entropy discourse and the debate on social or racial decay,"[26] which resulted in numerous pseudo-scientific

25 For the connection between infrastructure, flows, and containment from a feminist perspective, see the article by Hannah Schmedes in this volume.

26 Christian Hoekema, "Entropy," *Forum interdisziplinäre Begriffsgeschichte (FiB)*, no. 1 (2020), pp. 7–28, here p. 14. In his essay Hoekema elaborates, among others, on Michel Serre's epistemological distinction between classical mechanics, thermodynamics and information theory. As Serres showed in several of his books, early communication theory around 1900 sprang directly from the entropy discourse,

theories about eugenic counter-measures against (for instance) genetic entropy. Again, this leads back to the historic discourses thematized and problematized in *Before Daybreak*. In particular, the motif of a sun which has lost all its traditional organizing powers to a chaotic simultaneity of different light milieux can also be read as an echo of the contemporaneous fear of entropy. This becomes even clearer if one takes into account—as Vogel mentions—that Hauptmann himself had indeed a lifelong fear of the sun darkening or cooling.[27] Vogel also quotes a note from Hauptmann's drama fragment *Helios* that dates from the 1890s: "Where the sun does not reach, there the doctor will appear."[28] And interestingly enough, this line could also serve as a one-sentence summary of *Before Daybreak*, where the historic rise of medical discourses indeed appears as the reverse side of the sun's "downfall." At least, it is a medical practitioner—the Krause's family doctor—who together with the political activist Loth stands for the attempt to bring the flows "back into balance" (or as one would say in German: "ins Lot bringen," which is an expression very close to the name "Loth"). And moreover, as a social reformer Loth is not only constantly referring to medical ideas about alcoholism, heredity and indeed eugenics, but also appears as a dedicated sun worshipper. Accordingly, the second act sees him standing in the sunrise and idealizing, in comparison to urban (light) conditions, the sunlight over the rural homestead and the "Landleben" ("pastoral") in general, with its "Sonne

establishing "a series of concepts such as information, noise, and redundancy, for which a link to thermodynamics was rather quickly demonstrated." (cited from ibid., p. 20.) Since Serres developed this not least with regard to French Naturalism (Zola), it would certainly be interesting to also read Hauptmann with Serres, taking into account the relations between the coal business, (social) decay and control in *Before Daybreak* once again from another angle. For reasons of space, however, I cannot pursue this further here.

27 See Vogel, "Sonnenpartituren," p. 157.
28 "Wo die Sonne nicht hinkommt, dort kommt der Arzt hin." Ibid., p. 157.

und Frische" ("fresh air and sunshine").[29] And it is certainly not by chance that the doctor in a way takes over the vacant paternal place here, while Loth bears all the traits of a rebellious son, so that the combination of medicine and politics again hints at a historical crisis of traditional (symbolic) authorities.

Now, one could certainly describe this constellation with recourse to Foucault's (somewhat overused) term "biopolitics." As we have seen, the fading of the classical solar order does indeed result in a hypertrophy of biopolitical efforts. However, in the light of Foucault's further considerations on governmentality and environmentality and also with regards to a pre-cybernetic history of control and behavior, it could be more expedient to emphasize another aspect. It is most interesting that Loth's (bio-)political agenda, insofar it is based on his (pseudo)-scientific discourse on heritable alcoholism and, once more, his devotion to the sun, ultimately aims at the establishment of circular structures relying on feedback mechanisms: not only is the sunlight addressed as a healthy environment affecting the (human) organism here; as Loth's glorifications of the healthy effects of the rural morning sun make perfectly clear, he would obviously love to re-establish a recurring course of the day. Furthermore, one can find a very similar structure in Loth's second and even more problematic project, i.e. in his dedication to genetics and eugenics (which in *Before Daybreak* leads to the final catastrophe of Helene's suicide). As this project develops in an eminent crisis of a classical paternal order, its attempt is ultimately to re-establish a family tree by biopolitical measures. And again, this attempt is about controlling and also optimizing a seemingly natural order based on circles and repetitions, with the generations taking over from each other in an orderly fashion. Therefore, *Before Daybreak* shows in both these reterri-

29 Hauptmann, *Vor Sonnenaufgang*, p. 44 / *Before Daybreak*, p. 35.

torialization projects constellations that led in the following decades into the well-known racial programs and state racisms of the early twentieth century.

Finally, what about the historical character of these constellations? From today, the depicted forms of control seem outdated primarily because they still remain bound to "terrestrial" milieus. This means, in other words, that regulating and controlling cannot yet happen from within the geosphere but rather occur within the framework of still relatively stable environments. *Before Daybreak* ultimately unfolds in the "World Interior of Capital"[30] but does not yet explore its cosmic expansion—although the prominence of the sun already points to later transgressions. This is precisely why the play is predominantly about biopolitical and not more "psychopolitical" control processes.[31] It centers around physiologists and eugenicists, not yet around psychologists and designers. The latter's careers tie in only with the following surges in control and further differentiation of the "control revolution."

30 See Peter Sloterdijk, *In the World Interior of Capital. Towards a Philosophical Theory of Globalization,* trans. Wieland Hoban (Cambridge, UK: Polity Press, 2013).

31 The term "psychopolitics" goes back to Bernard Stiegler, *Prendre soin: De la jeunesse et des générations* (Paris: Flammarion, 2008) and Alexandra Rau, *Psychopolitik. Macht, Subjekt und Arbeit in der neoliberalen Gesellschaft* (Frankfurt am Main: Campus, 2010). In 2015 Byung Chul-Han offered a more popular scientific version of the concept, see Byung-Chul Han, *Psychopolitik: Neoliberalismus und die neuen Machttechniken* (Frankfurt am Main: S. Fischer 2015). All three definitions are quite different but have in common that they try to readjust Foucault's older concept of disciplinary powers. However, only Rau considers Foucault's later discussions of governmentality, which in fact already contain important arguments Stiegler and Han try to set against him.

Malte Fabian Rauch

Critique de la Circulation

Remarks on the Design of Environments

"Critique de la circulation": the title of this essay alludes to Guy Debord's *Critique de la séparation* (1961), a movie that confronts the avant-garde phantasmagoria par excellence—the city as a field of unexpected encounters—with the relentless commodification of urban space, which is presented through the montage of "spectacular" images. Aerial views of Paris suggest that the city is increasingly coming under the purview of commodification. Stock images of war and catastrophe are employed to measure the extent of this devastation. Still images from Debord's private life punctuate the montage, bearing witness to a different experience of the city, an experience that is irreducible to the empty time and abstract routines of the society whose imaginary the film critiques. This fleeting intensity of "living differently"[1] is what the film seemingly tries to register, as it withdraws, by refusing to accord with what Debord takes to be the false cohesion and oppressive lethargy of documentary cinema (fig. 1). But in the face of the changing urban landscape, "the entire sphere of discovery, the exploration of a *terrain inconnu*, all forms of pursuit, of adventure, of the avant-garde"[2] seem bound to become increasingly tamed, silenced, if not all but obliterated—resulting in the sentiment of profound loss that reverberates in the author's hauntingly melan-

1 Guy Debord, *Critique de la Séparation*, in *Œuvres*, ed. Jean-Louis Rançon (Paris: Gallimard, 2006), pp. 541–557, here p. 547.
2 Ibid., p. 549.

Fig. 1: Film still from Guy Debord, *Critique de la séparation*, 1961, 20 min., 35 mm.

cholic voiceover. For even though some parts of the city are "still legible," they have, Debord laments, "lost their sense" for him and his friends.

The *détournement* of the film's title, however, is hardly one. Circulation is separation. Separation is the truth of circulation. Or, as the "Basic Program of the Bureau of Unitary Urbanism" states it, "circulation is the organization of universal isolation."[3] For the ever same itineraries of people in the metropolis—which *Critique de la séparation* depicts and resists, mourns and summons—are held captive by the flows of things, caught in a cycle of work and consumption that precludes any aberrant movements. The critique of separation must, therefore, be a critique of circulation. Yet this critique

3 Attila Kotányi and Raoul Vaneigem, "Basic Program of the Bureau of Unitary Urbanism," in *Situationist International Anthology*, trans. and ed. Ken Knabb (Berkeley, CA: Bureau of Public Secrets, 2006), pp. 86–89, here p. 87.

does not speak in the name of standstill, deceleration or rest. Circulation, the "Basic Program" continues, "is the opposite of encounter: it absorbs the energies that could otherwise be devoted to encounters or to any sort of participation."[4] The actual energies latent in the city are, as it were, held in check by the current mode of circulation, which is but a mode of generalized isolation. In a characteristically pathos-laden, but also undeniably topical fashion, Debord therefore declares that "urbanists will not limit their concern to the circulation of things, or to the circulation of human beings trapped in a world of things."[5] Rather, the restrictive economy of the circulation of things, Debord argues, will be unhinged, as the urbanists of the future will thus "break these topological chains, paving the way with their experiments for a human journey through authentic life."[6] Accordingly, the city of the future, Debord's collaborator, the architect Constant, maintains, will leave "the ground free for circulation."[7] Circulation as separation is critiqued in the name of circulation as participation—irreducible to, and hence irrecuperable for, the flows of commodification.

For the Situationists, there is an intimate link between the question of circulation and the semantics of milieu, environment, ambiance and atmosphere, including an explicit engagement with the theme of ecology. Strikingly, while the proliferating research on these notions in aesthetics, art history and media theory is prone to highlight the importance of the novel use of the term "environment" in 1960s New York visual arts, the Situationist's use of the concept, which pre-dates this seman-

4 Ibid.
5 Guy Debord, "Situationist Theses on Traffic," in *Situationist International Anthology*, pp. 69–70, here p. 70.
6 Ibid.
7 Constant, "A Different City for a Different Life," trans. John Shepley, in *Guy Debord and the Situationist International*, ed. Tom McDonough (Cambridge, Mass.: MIT Press / October Books, 2002), pp. 95–101, here p. 99.

tic shift by a decade, has by and large gone unmentioned.[8] The Situationists explored alternative ways of living, relating and moving in the city, which, in turn, are supposed to inform a new urbanism: such an ecology aimed at nothing less than "the transformation of the human milieu."[9]

The aim of this essay is to highlight the link between the concepts of circulation, milieu and ecology in the practice of the Situationists, and to draw out their consequences for contemporary aesthetics and media theory. Extending the exclusive focus on the New York artists associated with environment and ecology, it seeks to disclose the importance of the Situationist project for a genealogy of these terms.

Additionally, the essay suggests that the difference which Debord makes between the "circulation of things" and non-purposeful modes of moving and relating resonates with what Erich Hörl theorizes in terms of restrictive as opposed to general ecology. According to this approach, which describes a broad theoretical development that started at the end of the nineteenth century and accelerated dramatically after 1945, the notion of ecology partakes in a semantic shift. In the course of this development, the concept becomes increasingly denaturalized and ultimately turns into the key notion for

8 See Allan Kaprow, *Assemblages, Environments, and Happenings* (New York: Harry. N. Abrams, 1966); James Nisbet, *Ecologies, Environments, and Energy Systems in Art of the 1960s and 1970s* (Cambridge, Mass.: MIT Press, 2014); Fred Turner, *The Democratic Surround: Multimedia and American Liberalism from World War II to the Psychedelic Sixties* (Chicago: The Chicago University Press, 2013). Also see the references to Kaprow in Florian Sprenger, "Zwischen Umwelt und milieu – Zur Begriffsgeschichte von environment in der Evolutionstheorie," *Forum Interdisziplinäre Begriffsgeschichte* 2 (2014), pp. 7–18, here p. 7. Oddly, Peter Sloterdijk is the only theorist to have addressed the resonances between the Situationist project and the recent interest in ecology and atmospheric aesthetics. However, he also adopts the "topsy-turvy" interpretation that is criticized at the end of this essay. See Peter Sloterdijk, *Spheres, vol. 3: Foams*, trans. Wieland Hoban (South Pasadena, CA: Semiotext(e), 2016), pp. 611–623.

9 Guy Debord, "Écologie, psychogéographie et transformation du milieu humain," (1959) in *Œuvres*, pp. 457–461.

describing new modes of relationality between human and non-human agents. Exceeding the finality, purposefulness and normativity that has been traditionally ascribed to the concept of nature, ecology becomes, Hörl writes, "something like the cipher of a new thinking of togetherness and of a great cooperation of entities and forces," which essentially dissolves the opposition of nature and technology.[10] As a result, the very idea of an "environment" changes its meaning, as it can no longer designate a simple spatial surrounding. Rather, "along with the entities that inhabit or participate in them," environments themselves turn out to be "directly entangled in processes of becoming, processes through which these entities [...] grow, individuate or, rather, co-and trans-individuate."[11] This proliferation of agency, however, does not simply precipitate the turn to a brave new world of frictionless connectivity. Rather, the distinction between restricted and general ecology seeks to differentiate between opposing vectors at work in the dialectic of environmentalization. According to this genealogy, the process encompasses the transformation—since the onset of cybernetics—of technology into a new form of environmentalitarian power that works with "molecular and no longer molar, forms of individuation and subjectivation." This "restrictive" ecology is focused on shaping environments to predict and control behavior.[12] In opposition to this, "becoming-environmental" designates the care for world-making that is in sync with a general ecology. Here, the term "general" designates not universal connectivity, but, rather, "becoming-together,

10 Erich Hörl, "Introduction to General Ecology: The Ecologization of Thinking," in *General Ecology: The New Ecological Paradigm*, ed. Erich Hörl and James Burton (London: Bloomsbury, 2017), pp. 1–75, here p. 3.
11 Erich Hörl, "The Environmentalitarian Situation: Reflections on the Becoming-Environmental of Thinking, Power, and Capital," trans. Nils F. Schott, *Cultural Politics* 14, no. 2 (2018), pp. 153–173, here p. 156.
12 Ibid., p. 159.

becoming-with, and the great chain of cooperation" of multiple species that take care of their entanglement through partial and fragile relations.[13] And, as Hörl highlights, thinking though this project is a speculative exercise, a way of imagining new forms of world-making.

The resonances between this discourse and the Situationist lexicon—including the speculative moment, which Debord dubs "science fiction" understood "as a part of actual life"[14]—are far from contingent. Rather, they attest to several subterranean, barely researched links between Situationist practices and a variety of theoretical developments in critical theory, two of which shall be highlighted here by way of introduction. First, Hörl's differentiation between "restrictive" and "general" ecology takes up Derrida's reading of Bataille as a "Hegelianism without Reserve."[15] For Derrida, Bataille's thinking revolves around the risk of a pure expenditure, irrecuperable to any restrictive economy of purposes, ends and means. While Derrida seeks to show how this operation is put into play in Bataille's writing as a "potlatch of signs that burns, consumes, and wastes words in the gay affirmation of death,"[16] the Situation-

13 Ibid., p. 165.
14 Debord, "Écologie, psychogéographie et transformation du milieu humain," p. 457.
15 As Hörl puts it: "Although the difference between a general and a restricted ecology is a systematic difference—formulated in line with Bataille's distinction between a general and a restricted economy which Derrida referred to so concisely as an economy of sense—there is also a certain historical bias within this distinction. I think we have a tendency to move from a restricted to a general ecology, at least in terms of conceptual and political theory. A re-reading of Bataille would demonstrate that his own general economy is already a general ecology." Erich Hörl, "A Thousand Ecologies: The Process of Cybernetization and General Ecology," in *The Whole Earth: California and the Disappearance of the Outside*, ed. Dietrich Diederichsen and Anselm Franke (Berlin: Sternberg Press, 2013), pp. 121–130, here p. 128 n. 49. Here, Hörl refers to David Will's work, which explores the relation between general economy and general ecology. See David Wills, "Ecologies of communion, contagion, &c, especially Bataille," in *General Ecology*, pp. 235–252.
16 Jacques Derrida, "From Restricted to General Economy: A Hegelianism Without Reserve," in *Writing and Difference*, trans. Alan Bass

ists experiment with such an expenditure as a social and spatial *practice*. And, just like Bataille, the Situationists explore these critical practices through the model of the "potlatch" (the name of a proto-Situationist journal), with reference to Johan Huizinga's notion of play, and through "anti-architectural" forms like the labyrinth, to note but the most obvious parallels[17] Hence if, according to Derrida, Bataille's generalized economy designates the deconstruction of a metaphysics of finality, then the Situationists may be said to explore such a deconstructive movement as a practical refusal to accord with the imperatives of end, utility, and function as they are operative in the "circulation of things." And while the idea of the environment here necessarily retains a clear reference to concrete spatial surroundings, it will become evident that this notion of spatiality does not accord with a simple container logic. For the Situationists, space is already relational, and spatial relations are defined by their plasticity. However, in the Situationist's encounter with cybernetics, it will also emerge that the alleged absence of any goals that their view of relations proposes comes conspicuously close to technological fantasies of behavior control through large scale systems.

Second, and related to this, the elaboration of general ecology foregrounds the primacy of relations, to the extent that this theoretical paradigm "does not turn relations into minor and derivative entities but considers them to be originary."[18] This rethinking of relationality highlights its deep affinities with Jean-Luc Nancy's

(London and New York: Routledge, 2005), pp. 317–350, here p. 347.

17 Despite this obvious proximity, there is curiously little research on Bataille and the Situationists. Tom McDonough briefly compares them in "The Dérive and Situationist Paris," in *Situacionistas: arte, política, urbanismo,* ed. Libero Andreotti and Xavier Costa (Barcelona: Museu d'Art Contemporani, 1996), pp. 54–66. Jörn Etzold maintains that Debord's notion of the potlatch is directly inspired by Bataille and he goes on to link Debord's use of the concept to Derrida's work on the gift in *Die melancholische Revolution des Guy-Ernest Debord* (Zurich: Diaphanes, 2006), pp. 178–194.

18 Hörl, "Introduction to General Ecology," p. 7.

plural ontology—Nancy, in turn, is one of the few theorists who engages with the Situationists. In an intriguing fragment on the Situationist understanding of collectivity, Nancy argues that if "being-with is the sharing of a simultaneous space-time, then it involves a presentation of this space-time as such."[19] And this presentation, he insists, is beyond any re-presentation, inasmuch as it names "a *praxis* and an *ethos*: the staging of co-appearance, the staging which is co-appearing."[20] Precisely such a praxis is, again, what orients all of the Situationist writings on architecture, urban ecology and the design of environments. And while Nancy ultimately takes the late Situationist critique of the spectacle to task for remaining caught in an understanding of a social subject that represents itself to itself, this essay attempts to show how far the early work of the Situationists also offers traces of an attempt to develop new spatial practices for a relational form of being-with that exceeds this logic. Rather than an abstract exposition, however, this essay will visit three "scenes" in the trajectory of Situationist urbanism and architecture.

Dérives

In the 1950s, French sociology came under pressure to develop new methods capable of analyzing the transformation of post-war cities. One of the decisive figures in this development was Paul-Henry Chombart de Lauwe. A student of Maurice Halbwachs, Chombart became one of the most innovative researchers of the urban working class. In a project that was financed by the French state, Chombart worked with a team of colleagues on a research project that would directly influence urban

19 Jean-Luc Nancy, *Being Singular Plural*, trans. Robert D. Richardson and Anne E. O'Byrne (Stanford: Stanford University Press, 2000), p. 65.
20 Ibid., p. 73.

planning in Paris. The initial results of this research project were published in 1952 as the two-volume study *Paris et l'agglomération parisienne*. Significantly, the approach that informs this study discards a deterministic understanding of the milieu (current since Hyppolite Taine) and develops a more dynamic view of the relation between collective practices, social imaginary and urban space, which particularly focuses on the micro-dynamics within a *quartier*. Chombart introduces a variety of new media for the representation of the concrete dynamics in a city: aerial photography (which Chombart was familiar with due to his experience as a pilot), diagrams as well as maps of the physical qualities of specific parts of the cities. Through these techniques, Chombart offers a radically different view of the city, which brought to light how people themselves inhabit, perceive and interpret space in geographically demarcated neighborhood units, the *quartiers*, that also serve as the center of their social life. Thus Chombart employs, as Jeanne Haffner puts it with regard to his use of aerial photography, "a top-down technique to develop a bottom-up approach that, in turn, helped to promote sociological perspectives in government and planning circles in postwar Paris."[21] In a different idiom, one might say that Chombart's use of media seeks to make visible the practices that constitute a *world*, and not only neutral units in physical space (fig. 2).

All of the aerial views of Paris in Debord's films are taken from Chombart's research, a montage in which this new view of the city appears, however, as a technology of control rather than a visualization of world-making. And yet, there is a diagrammatic map developed by Chombart that was even more important to Debord than this high-altitude view of Paris. The diagrammatic map in question shows the yearly itineraries of a young stu-

21 Jeanne Haffner, *The View from Above: The Science of Social Space* (Cambridge, Mass.: MIT Press, 2013), p. 138.

Fig. 2: Chombart de Lauwe, *Aerial view*, 1952.

dent, who stubbornly follows the same trajectory, lead-
ing from her apartment to the university and the piano
lesson (fig. 3). For Debord, the emerging triangle came
to stand as the epitome of a restricted form of move-
ment in the city, which he describes as "modern poetry
capable of provoking sharp emotional reactions (in this

Fig. 3: Chombart de Lauwe, *Diagrammatic map*, 1952.

particular case, outrage at the fact that anyone's life can be so pathetically limited)."[22] At the same time, however, Debord became deeply influenced by Chombart's theories of the interrelations between social practices and urban space. Of particular relevance in this regard proved Chombart's reception of the "human ecology" of James Quinn and the Chicago School sociologists, who researched with ethnographic methods the "centers of attraction" and "ambiance" in specific neighborhoods.[23] Rosemary Wakeman succinctly describes the resulting position: "[I]n the Chombartian universe,

22 Guy Debord, "Theory of the Dérive," in *Situationist International Anthology*, pp. 62–66, here pp. 62–63.
23 James A. Quinn, *Human Ecology* (New York: Prentice-Hall, 1950); Ernest W. Burgess and Robert E. Park, *The City: Suggestions for Investigation of Human Behavior in the Urban Environment* (Chicago: The University of Chicago Press, 1925). Both works are discussed in Paul-Henry Chombart de Lauwe, *Paris: essais de sociologie 1952–1964* (Paris: Éditions ouvrières, 1965), pp. 45–47. The relation between Debord and Chombart de Lauwe has been the subject of extensive research, most of which neglects the theme of ecology. The most pertinent study is McDonough, "The Dérive and Situationist Paris." Also see Anthony Vidler, "*Terres Inconnues*: Cartographies of a Landscape to Be Invented," *October* 115 (2006), pp. 13–20.

material conditions did not dictate social phenomena and the city. Instead, urban morphology itself—that is, the spaces and practices of urban life—reflected or represented society as a whole."[24] Yet, Debord objects to the morphological division of the city into districts through specific "unities of ambiance" to the extent that these approaches conceive the district as something to which the population remains confined. In so doing, the urban ecologists, Debord argues, wrongly conceive the "centers of attraction" as being defined by work, consumption and leisure activities, which turn into the sole factors regulating people's movements in the city.[25] In contrast, Debord sought to discover an alternative urban morphology: marginal relations, centers of attraction, and unities of ambiance that are already latent in the city but need to be enhanced through a new architecture.

Nobody, Debord argues, has yet developed urban ecology in the sense of the active "construction of the milieu [*construction du milieu*]," for all that exists so far under this name is but "a collection of techniques for integrating people."[26] In turn, Debord develops what can be described as the manual of a "generalized" form of movement in the city. The name that Debord reserved for this practice is *dérive*, which is early on defined as "a technique for displacement without a goal."[27] In the twenty-sixth issue of *Potlatch*, a lexical note indicates that this term stems from *deriver*, whose Old French meaning is

24 Rosemary Wakeman, *The Heroic City: Paris, 1945–1958* (Chicago and London: Chicago University Press, 2014), pp. 17–18. Significantly, it was Marc Augé, the critic of "non-places," who co-edited the *Festschrift* on Chombart's work in the 1990s. See Paul-Henry Chombart de Lauwe and Marc Augé, eds., *Les hommes, leurs espaces, et leurs aspirations: Hommage à Paul-Henry Chombart de Lauwe* (Paris: L'Harmattan, 1994).

25 Editorial, "Critique of Urbanism," in *Guy Debord and the Situationist International*, p. 113.

26 Ibid. Translation amended.

27 Guy-Ernest Debord and Jacques Fillon, "Résumé," *Potlatch* 14 (1954), n. p.

said to be "diverting water [*détourner l'eau*]."[28] Remarkably, in this definition, the semantics of liquid flows intermingles with another signature term from the Situationist lexicon (*détournement*) that designates artistic practices of creative defiguration and repurposing. Tellingly, the entry goes on to trace the etymological roots of *deriver* to the Latin *derivare*, which, the text explains, is morphologically and semantically linked to "*rivus*," meaning stream or river.[29] This remarkable focus on etymology in an avant-garde journal attests to the Situationist's conscious choice of a metaphorical field of liquidity. The meaning of liquid flows is transposed into a metaphor for describing a floating form of movement. As McKenzie Wark rightly notes, the *dérive's* "whole field of meaning is aquatic, conjuring up flows, channels, eddies, currents," which suggests "a space and time of liquid movement, sometimes predictable but sometimes turbulent."[30] Highlighting the unintentional dynamic of this liquid metaphor, the entry in *Potlatch* ends with the succinct definition: "deriver: to undo what is riveted [*défaire ce qui est rivé*]."[31] If the existing forms of urban ecology are nothing but "techniques for integrating people," then the "dérive" emerges here as the technique for exploring disintegrative modes of movement. As such, Debord suggests, one can develop a map of alternative flows in the city, which he further conceptualizes as "psychogeography":

One of the basic situationist practices is the *dérive*, a technique of rapid passage through varied ambiences [*ambiances variées*]. [...] In a dérive one or more persons during a certain period drop their relations, their work and leisure

28 Editorial, "Pour un lexique lettriste," *Potlatch* 26 (1956), n. p.
29 Ibid.
30 McKenzie Wark, *The Beach Beneath The Street: The Everyday Life And Glorious Times of The Situationist International* (London and New York: Verso, 2011), p. 22.
31 Editorial, "Pour un lexique lettriste," n. p.

activities, and all their other usual motives for movement and action, and let themselves be drawn by the attractions of the terrain and the encounters they find there. Chance is a less important factor in this activity than one might think: from a dérive point of view cities have psychogeographical contours, with constant currents, fixed points and vortexes [*tourbillons*] that strongly discourage entry into or exit from certain zones.[32]

In regards to the enthusiasm for a semi-conscious exploration of urban space, the *dérive* bears an obvious resemblance to Surrealist *flânerie*. Yet, if the intoxication to which the flâneur surrenders is ultimately, to cite Benjamin's perceptive analysis, the "intoxication of the commodity immersed in a surging stream of customers"[33] the *dérive* was an explicit attempt to defy the rhythm of work and commodified leisure activities in an attempt to reappropriate public space for free movement. This is indicated by the minor importance of chance. In Debord's definition of the *dérive*, one clearly discerns how the metaphoric layers of liquidity—contours, currents and vortexes—are used to recast the ecologist's "centers of attraction," while fixed points and related concepts designate the resistances to this dynamic. Differing from the flows that are dictated by work and consumption, these flows reveal alternative modes of relating in the city. Drifting means to be drawn into these dynamics, to be carried away in their wake; it consists of experiencing urban space as porous, fluid, relational. In stark contrast to the repetitive patterns and the homogenous space of Chombart's diagrams, the psychogeographic maps chart the latent, psychogeographic flows in the city that were

32 Debord, "Theory of the Dérive," p. 62.
33 Walter Benjamin, "The Paris of the Second Empire in Baudelaire," trans. Harry Zohn, in *Selected Writings Volume 4, 1938–1940*, ed. Marcus Bullock, Howard Eiland, and Gary Smith (Cambridge, Mass. and London: The Belknap Press of Harvard University Press, 2006), pp. 3–92, here p. 31.

discovered through aimless drifts. For a considerable time, the Situationists were convinced that the discovery of these latent energies would provide the "data" for the active construction of a new milieu, which would be realized though architecture and urbanism.

A Different Environment for a Different Life

On March 21, 1959, Guy Debord sent a letter to the artist and architect Constant Nieuwenhuys to which he appended the aforementioned series of notes titled "Ecology, Psychogeography and Transformation of the Human Milieu." In the opening lines of this text, Debord declares: "Psychogeography is the playful part in contemporary urbanism. Through this ludic apprehension of the urban milieu, we will develop perspectives of an interruptive construction of the future."[34] Significantly, Debord returns here to his critique of the urban ecologists, which suggests that their theories played a crucial role in Debord's discussion with Constant. Against the ecologist's conception of the district, where the population remains essentially "*based*, rooted," psychogeography, Debord claims, "takes the point of view of passage."[35] For Debord, existing forms of urban ecology are right in that they refuse to consider the individual in isolation and highlight their interaction with the environment. But they focus on the wrong kind of relations. Urban ecology remains beholden to functional relations, relations that are governed by a restrictive form of circulation. By contrast, what one could call the Situationist's general ecology is supposed to explore non-functional relations, which manifest themselves in the heterogeneous flows explored by the *dérive*: "In the

34 Debord, "Écologie, psychogéographie et transformation du milieu humain," p. 457.

35 Ibid., p. 459.

margins of utilitarian relations, psychogeography stud-
ies relations through the attractions of ambiences [*les
relations par attirance des ambiances*]."[36] Against the
current understanding of urban ecology, Debord thus
calls for a radical deterritorialization of the very idea
of the environment: "Dissociating the habitat—in the
current, restricted sense—from the general milieu, psy-
chogeography introduces the notion of uninhabitable
ambiances [*d'ambiances inhabitables*] (for play, passage,
[...].)"[37] Uninhabitability is here a term that designates
nothing less than the redefinition of urban ecology,
which had so far been restricted through the focus on
work and domesticity as the governing parameters of
relating in urban space. In opposition to this reduction,
"uninhabitable ambiances" adumbrate flows and rela-
tions in the city that refer to alternative forms of behav-
ior, which are figured as play, expenditure and drifting.

There are no texts that document Constant's immedi-
ate response to Debord's 1959 letter. But it is clear that
it marks the last stage of an intense discussion. One year
before, in the co-written "Declaration of Amsterdam,"
Debord and Constant already maintained that "the con-
struction of a situation is the edification of a transitory
micro-ambiance [*micro-ambiance*]."[38] Debord himself
had frequently employed an almost scientific idiom
to describe this construction, speaking of the "combi-
nations of ambiences [*d'ambiances*], analogous to the
blending of pure chemicals in an infinite number of
mixtures."[39] Such was the declared goal of the Situation-
ist "unitary urbanism" at the end of the 1950s: "The the-
ory of the combined use of arts and techniques as means

36 Ibid.
37 Ibid., pp. 460–461.
38 Constant and Guy Debord, "Declaration of Amsterdam," in *Programs
and Manifestoes on 20th Century Architecture*, ed. Ulrich Conrads
(Cambridge, Mass.: MIT Press, 1990), pp. 161–162, here p. 162. Trans-
lation amended.
39 Guy Debord, "Introduction to a Critique of Urban Geography,"
(1955) in *Situationist International Anthology*, pp. 8–11, here p. 10.

contributing to the integral construction of a milieu [*la construction integrale d'un milieu*] in dynamic relation with experiments in behavior."[40] And yet, it was Constant's ambition to scale the Situationist experiments by translating the free flows discovered through the *dérive* into actual architectural form—a decidedly constructive vision of an entirely new urban eco-system that at first fascinated Debord, but one that he eventually resisted.[41] Two years later, in 1960, after the two had definitively broken, Constant presented a lecture in Amsterdam that outlines the first plan for a new city, *New Babylon*, where "atmosphere" itself would become an "artistic medium" by means of which the environment in its entirety could be re-shaped in accordance with the Situationist vision.[42] In brief, *New Babylon* became the project of a city built through transitory, uninhabitable ambiances, where the flows of the *dérive* would be the sole activity of its inhabitants. Albeit it never materialized as a built structure, Constant ceaselessly developed drafts, descriptions and models that visualize this city of constant flux, mobility and change. Webs of steel, glass and acrylic would allow for an absolute plasticity of the overarching structure. In this seemingly utopian city, all work would be automated underground, leaving almost the entirety of the available space "free for circulation."[43] Daily routines are replaced by "the principle of disorientation."[44] Nothing is fixed, everything is connected. This city tolerates no strict boundaries between the materiality of space and its symbolic interpretation: "In *New Babylon* social

40 Editorial, "Definitions," in *Situationist International Anthology*, pp. 51–52, here p. 52. Translation amended.
41 On this, also see Hilde Heynen, "New Babylon: The Antinomies of Utopia," *Assemblage* 29 (1996), pp. 24–39.
42 Constant, "Unitair Urbanisme," cited in Mark Wigley, *Constant's New Babylon: The Hyper-Architecture of Desire* (Rotterdam: Witte de With, 1998), p. 9.
43 Constant, "A Different City for a Different Life," p. 99.
44 Constant, "The principle of disorientation," trans. Robyn de Jong-Dalziel, in Mark Wigley, *Constant's New Babylon: The Hyper-Architecture of Desire*, pp. 225–227.

space is social spatiality. Space as a psychic dimension (abstract space) cannot be separated from the space of action (concrete space)."[45] Here, it becomes apparent to what extent the Situationist discourse exceeds the idea of the environment as a simple spatial surrounding. Rather, beyond the classical binaries of nature and culture, psychic and physical, internal and external, concrete and abstract, the environment itself is conceived as a process of becoming. Accordingly, Constant's "different city for a different life" encompasses the vision of an absolute, natureless ecology, where every facet of the environment is mediated through architecture and engineering. "Far from a return to nature [...] we see in such immense constructions the possibility of overcoming nature and regulating at will the atmosphere [*conditionnement de l'air*], lighting, and sounds in these various spaces."[46] Still couched in a Marxist idiom, Constant thus sketches a miniature model of a generalized ecological system that is completely mediated through technology: *New Babylon* is the interaction of life and environment, a city so mobile, so fluid that it pulsates in accordance with the rhythm of life itself. It is a system for permanent change and a system in permanent change. In light of this, Benjamin Bratton's important suggestion, according to which the impetus for Situationist urbanism is "not necessarily to retake the territory but unmake the possibility of universal addressability in the first place," needs to be complemented.[47] In truth, the Situationists unmake an addressability based on the existing, restrictive form of circulation, yet this unmaking always remains oriented by the attempt to

45 Constant, "New Babylon," cited in Mark Wigley, *Constant's New Babylon*, p. 14.
46 Constant, "A Different City for a Different Life," p. 96. Translation amended.
47 Benjamin H. Bratton, *The Stack: On Software and Sovereignty* (Cambridge, Mass.: MIT Press, 2016), p. 414, n. 10.

offer a new regime of relationality grounded in a generalized ecology.

Antinomies of Environmentality

On December 16, 1963, Abraham A. Moles, professor at the Ulm School of Design and at Strasbourg University, sent a personal letter to Debord. In this remarkable text, the theorist of a cybernetic aesthetics and a close collaborator of Max Bense attempts to convince Debord that "it is in the *axis of technology* that we need to look for new situations; and I ask in what way your movement accepts this."[48] Predictably, Debord published this letter in his journal only to dismiss it with a few condescending remarks about the "cybernetic bureaucratisation that you [Moles] so elegantly represent." And yet, there is, in this striking and entirely neglected document, a thought that merits attention, especially in light of the Situationists' own fascination with technology. Moles writes:

> Freedom within society is rolled back little by little to zero, as and when the technocratic cyberneticians – to which I belong – progressively record three billion insects. Daily life is a series of situations; these situations belong to a very limited repertoire. Can we extend this repertoire, can we find new situations? It seems to me that this is where the word "situationist" makes sense. A situation seems to me [to be] a system of perceptions linked to a reaction system in the short term.

48 Published in Guy Debord, "Correspondance avec un cybernéticien," *Internationale Situationniste* 9 (1964), pp. 44–48, here p. 46. All following quotes from this source. The translation is from Anthony Hayes, available at https://thesinisterquarter.wordpress.com/2013/06/10/correspondence-with-a-cybernetician/ (accessed August 13, 2021).

Here, the very idea of a situation is restricted to the behavioral effect of a perception that is modifiable through environmental effects. And the radical contingency and high intensity that the Situationists sought is thereby re-coded as the increment of novelty—for which Moles tentatively suggests the criteria of statistical rarity—through new technologies, especially biosciences. As examples of such technologically enforced novelty, Moles mentions the bizarre idea of the "manufacture, biologically conceivable, of women with two pairs of breasts"; as well as the more charming idea of the "invention, in addition to the two traditional sexes of one, two, three, n different sexes," since he deems it to be conceivable "that human beings change sex over the course of their life."[49] Apart from the nature of his examples, however, it is striking to note how readily Moles subsumes the Situationist approach into a cybernetic framework. In this regard, it is important to note that Moles employs the concepts of "environment" and "*Umwelt*" in his informational theory of perception,[50] a theoretical paradigm that Hörl highlights as a decisive aspect in the genealogy of "environmentalitarian knowledge of control" that requires further research.[51] Arguably it is due to this conceptual scheme that Moles felt prone to transpose the notion of "situation" into an effect of environmental variables. Thus the avant-garde vision of constructed "transitory micro-ambiances," encapsulating the highest degree of freedom and spontaneity, would be transformed into statistically measurable, predictable and hence determinable deviations that are fully integrated in a system of behavior control.

49 Ibid.
50 Abraham Moles, "Theorie informationelle de la perception," in *Le concept de information dans la science contemporaine*, ed. M. Louis Coffignal (Paris: Les Éditions de Minuit, 1965), pp. 203–230, here p. 204. It is suggestive to note that this collection of essays assembles the contributions to a conference whose program was organized by Gilbert Simondon.
51 Hörl, "The Environmentalitarian Situation," p. 160.

Considering this strange attraction of the Situationist project to Moles' cybernetic vision, one may be reminded of one of the most common contemporary criticisms of the Situationist view of the city. According to this narrative, their visions of flux, mobility and permanent play has become reality, and it has done so in the dystopian form of 24/7 neoliberalism.[52] Instead of rejecting such interpretations per se, the focus on ecology and environmentalization may offer a more nuanced view of this constellation than the old tales of recuperation, reversal and betrayal can afford. Seen in the perspective developed here, the Situationist project may appear as divided in itself, between critique and capture, restrictive and general ecology. There is a genuine attempt at thinking forms of entanglement, connectivity and relationality that would resist the shift to an environmentalitarian form of power. And yet, at the same time, the search for "new frames of behavior," which the Situationist seeks to develop in competition with "the very era of technologies that gave rise to functionalism,"[53] seems to partake in a regime of power that has, in Guattari's words, become "delocalized and deterritorialized."[54] Cast in this perspective, it might appear that their design of environments is not the topsy-turvy anticipation of contemporary neoliberalism, but the first appearance of the antinomies of environmentality. And if, as Agamben suggests, the Situationist utopia really is "perfectly topical because it locates itself in the taking-place of

52 See, most prominently, Rem Koolhaas, "The Topsy-Turvy as Utopian Architecture," in Constant, *New Babylon: To Us, Liberty*, exh. cat. (Den Haag: Gemeentemuseum, 2016), pp. 64–67, here pp. 64–65; Mark Wigley, "Extreme Hospitality," in ibid., pp. 38–49.

53 Editorial, "Unitary Urbanism at the end of the 1950s," in *On the Passage of a Few People Through a Rather Brief Moment in Time: The Situationist International, 1957–1972*, exh. cat., ed Peter Wollen and Elisabeth Sussman (Cambridge, Mass.: MIT Press, 1989), p. 144.

54 Félix Guattari, *The Three Ecologies*, trans. Ian Pindar and Paul Sutton (London: Athlone Press, 2000 [1989]), pp. 49–50.

what it wants to overthrow,"[55] then this might be the case because these antinomies are still very much with us, indeed that the contemporary environmentalization allows for their legibility.

55 Giorgio Agamben, "Marginal Notes on *Commentaries on the Society of the Spectacle*," in *Means Without End*, trans. Vincenzo Binetti and Cesare Casarino (Minneapolis: University of Minnesota Press, 2000), pp. 73–89, here pp. 78–79.

Flows of the Living

Esther Leslie

In Turbid Environments

Contemporary Fluidities

Liquidity is a state of being able to move, to flow, to shift around—the Oxford English Dictionary attests to a first use of it in English in 1620, though its specific economic use to name a form of asset interchangeability dates only from the second decade of the twentieth century. Liquidity is a state of flowing, from here to there, or, in economic terms, from asset into cash and back again. Liquidity has a ring of partial autonomy about it—a liquid state is in motion, contained only by a vessel that might hold the liquid matter. It goes anywhere, slips through, seeps, trickles, gushes. It takes something strong to hold it in. Liquidity confers autonomy on those who would use the possession of it to move value around, to adjust its forms.

Liquidity is a flow and flows have come to be associated with economic motifs, whereby the flow is not of the liquid itself but of the things carried by those flows. Flow is movement in a current or stream. At first flow referred to liquid solely, until the later years of the nineteenth century, when air or electrons were said to flow. What comes to flow over time, simultaneously with the spread of capitalism's influence across the globe, is trade, circulating through colonial and imperial vectors. Flows accumulate, at least in rhetorical power and by the later twentieth century flow has become a term annexed to what Zygmunt Bauman characterizes as "Liquid Modernity." What streamed for Bauman was not only time—

which flowed but did not march on—but everything. All becomes fluid and flowing: life, love, self, identity.[1] What flows into theory from all this perception of flow is, in the postmodern world, an economic perspective that becomes a descriptor for an entire mode of existence and that takes the name globalization. This flow is an updated version of a colonial conception of the world perceived from the aspect of trade, of goods being moved from place to place, shifting on a current that is unimpeded in its careering around the continents, around a world that is organized, imperialistically and still post-imperialistically, around oceans and trade routes and the apparatuses of free trade or other types of contracts designed to smooth the way of movement. Globalization is the unimpeded flow of goods, if not people, around the world. The globe becomes a liquid environment. A social imaginary depicts a world as spills of flowing commodities, transportation, data and more.

More recently, some might observe that such flow, such liquid carriage, hits barriers of various types. The appurtenances of life cannot be imagined to move so liquidly, so fluidly, neither ideologically (in terms of a self-justification on the part of the imperialist mindset or an attitude that refuses to take account of environmental costs), nor so easily in physical terms. This flow may be stuck when it should be flowing: an emblem of this is a massive tanker, the 220,000-ton, 400-meter-long Ever Given—a so-called megaship operated by the Taiwan-based firm Evergreen—blocking the Suez Canal in March 2021.[2] Another emblem of blockage might be a Brexit agreement rendering free movement difficult or holding up commodities at the border. There are imped-

1 Zygmunt Bauman, *Liquid Modernity* (Cambridge: Polity, 2000).
2 Jon Gambrell and Samy Magdy, "Massive cargo ship becomes wedged, blocks Egypt's Suez Canal," 24 March 2021, *AP News*, https://apnews.com/article/cargo-ship-blocks-egypt-suez-canal-5957543bb555ab31c14d56ad09f98810 (accessed October 12, 2021).

ances, it would seem, to the free flow of trade—whether brought about by the fatal logistics of ever more massive transportation that renders its own conditions of existence impossible, at least temporarily, or by botched policy that acts swiftly in response to populist sentiments, according to the modus operandi of risk-taking casino capitalism. And, in any case, those ocean waters are now thickened by plastics and particles that collect in the waters, choking wildlife and tangling up to produce floating islands the size of US states.[3] Lifting the purview to the skies, to the envelope of air above us and above the oceans—an airy flow that Kant once pegged as trade winds that allow the flow of global trade[4]—we see the air that long ago flowed as invisible winds now in different, visible form. It is particulated air, visible as smog—smoke-fog—or besmirched by other forms of pollution. In either case, as it circulates, it circulates a fog of something else with it. This fog has a surplus: confusion, obscurantism, stuff out of place, messed up. What this means is that a social imaginary of all this may shift—towards the turbid, particulated and foggy.

There is turbulence in the world. Fog rolls in, a busy agitation of particles. Obfuscation expands. Did we once say information—like commodities, like our connections in the world—is liquid? It moves around, freely, without limits, or borders, gets exchanged, siphoned off. Or, we might say, it leaks, its packet streams trickle out through timing channels. Or did we say, information—like commodities, dense collations of stored energy from labor—is crystal, or it is stored in crystals, in organic semiconducting materials, which make computer chips, and should hold it tight and fixed, like the crystal is—

3 See Michiel Roscam Abbing, *Plastic Soup: An Atlas of Ocean Pollution* (Washington and London: Island Press, 2019).
4 Immanuel Kant, *Neue Anmerkungen zur Erläuterung der Theorie der Winde* (Königsberg 1756) in *Kants Werke Band I* (Berlin and Leipzig: Reimer, 1910), pp. 489–503.

but also should let it reflect glitteringly in the world, refracted through crystalline materials, through screens of smartphones, desktops, laptops, devices of all kinds, sometimes glass on glass? Or was it that information is liquid crystal—those entities, that phase of matter that enables the intelligence of machines, just as they enable us to exist, to send information through encased nerves around our bodies and produce electrical signals. For liquid crystals are biological, are in blood, muscle, DNA. Liquid crystals are viruses and we eat and drink them in bread and milk. And they are in your pockets and bags and in your hand, on your screens. They are in smart windows, drugs and paints. Liquid crystals coagulate in the slimy mess of your soap dish and in snail trails. Liquid crystals are in your clothes, in long-existing materials such as silk or the newest synthetics. These soft materials might be used as foams and adhesives, detergents and cosmetics, paints, artificial flavorings or lubricants. Varied, in living bodies or cushioning, clamping and glossing the world, these soft matters draw increasingly the attention of physicists and biologists, in an age when prediction cedes to the superior systems of higher-level complex unpredictable predictions. But it also allows the intelligence of everything, enables everything to know and be known—for the liquid crystal is everywhere. But, then, the liquid crystal meshed with the cloud and it got clouded. The liquid crystal fogged over and information no longer flows and glimmers as we once might have thought it would. Information is a commodity, but its availability is contested, its capture obscure, and to what ends? What is this fog?

Fog, like froths and foams, is a state of substance that indicates to a viewer that some activity—industrial, meteorological and otherwise—has taken place. Often the state of being foggy, frothy or foamy is intensified by an interaction with other substances, or other activities. Fogs, froths and foams are part of a turbulent world, in which there is frenetic industrial activity and the after-

effects of that activity in global warming. Fogs, froths and foams are turbulent and turbid. Atoms of matter, particular types of particulate swirling in air, in environments, composing or destroying atmospheres, those actual and those sensed, even if dimly by those enveloped in them: these all are turbid, or comprised by and from turbulences. The root word of turbidity derives from *turba*, which means, in Latin, uproar and disturbance, or also, crowd. It is a cloudlike crowd of matter. Fogs, froths and foams are turbulent crowd clouds—of atoms, of entities, of particles and particulates in particular moments. There is circulation at work in the foggy, but it is not the flow of liquid, not the flow that in our imagination transports goods across oceans, just as it allows the free play of swarms of fish within the body of the sea. Fog allows movement under its cover, but indistinctly. Fog carries itself—and its contents, but does it carry anything else? Does it bring something else indistinct, but essential?

There is something about the current moment, coincidently or of necessity, which means that aerosols, and gels, and fogs, foams and froths, interstitial types of matter, focus scientific attention. These belong to that class of materials known as soft matter, which exhibit complex behaviors, such as self-organization and assembly. Their physics is distinctive, capricious. They exist at a mesoscopic, intermediate scale, between the atomic and the whole, and are always soft overall. Many tiny fluctuations act on their systems to decide the system's fate, a procedure known as symmetry breaking, leading from a symmetric yet disorderly state into something more definite and patterned. Contemporary science forces a re-accounting of matter, with persistent forms brought to light, anew, while products of second and third nature, engineered, nanoengineered, generate novel deployments. "Interesting behaviors" of self-organizing, atomically capricious materials—colloids, polymers, foams, gels, aerosol mists, granular materials and

liquid crystals—capture attention in laboratory investigations, instigating new versions of interrelating, subject-object, active-passive exchanges. Does something material in the characteristics and qualities of these pervading matters—fogs, froths and foams—impel our social worlds? From a quantum perspective, things do not exist, only processes, things are a blur of unthingness, a fog of activity, a river of constant change, akin to a turbid medium. How can we know it from the inside? We are inside it. We have been inside it for a while.

Respiratory coronaviruses such as SARS-CoV-2 focus the thoughts. A soft matter form, they are transmitted by another soft matter object, aerosols in which the liquid phase is rich in mucin and other biopolymers. The pandemic of 2020 onwards was a kind of fog, and it partakes of what a fog is and does. As a recent article on soft matter science and the Covid-19 Pandemic puts it:

> Importantly, it is not so much the "single-body" motion of isolated droplets but the collective motion of a propelled turbulent cloud of droplets that controls subsequent travel through air and deposition on surfaces.[5]

Everything is a fog or a cloud. What is not a cloud, if we choose to see it that way? What obscured cloudy atmospheres are ours? Through what do we try to flow, but barely find a way? What circulates through us? A cloud is a body of particles, ever changing, moving, disintegrating, reformulating. Recent atmospheric studies over the Eastern North Atlantic have observed that tiny aerosol particles that seed the forming of clouds can appear from almost nothing, when above the oceans. From a few atoms of gas clustered in the boundary layer

5 Wilson C. K. Poon, Aidan T. Brown, Susana O. L. Direito, Daniel J. M. Hodgson, Lucas Le Nagard, Alex Lips, Cait E. MacPhee, Davide Marenduzzo, John R. Royer, Andreia F. Silva, Job H. J. Thijssen and Simon Titmuss, "Soft matter science and the COVID-19 pandemic," *Soft Matter* 16, no. 36 (2020), pp. 8310–8324.

between the sea and the air, that is to say, the atmosphere that exists up to a kilometer above the surface of the earth, seeding particles for clouds are formed. Sunlight reacts with molecules of trace gases, and water condenses on these particles as cloud droplets. This tininess, this miniscularity, this particle particularity, scales up to affect and make whole atmospheres.[6] Such new knowledge about cloud formation through these instant particles is helpful to those who wish to build simulations of the climate of Earth from the past into the future, those models that draw on the other cloud's power of rapid calculation and play with the particularities of different aerosol properties—size, number, and spatial distribution—to calculate how the aerosol particles and the clouds they form will reflect and absorb sunlight and affect the temperature of the earth.

The particulate becomes particular. I am trying to say through all this slippage, this poetics of substance, this cloudy thinking and liquid thoughts that crystallize for a moment, before breaking up in fragments, that everything is implicated in everything else, and that too is why and how atmospheres bloom and seep. If that is so, then we need to understand everything, and need a model of thinking, critically, that apprehends this multifaceted totality in which metaphor bleeds into and out of science, technology and materials emanate thought, thought turns material or can conjure a mood, language generates a fog of ambiguity, a condensation of reference. Ambiance is legible and engineerable. And if

6 "Tiny particles that seed clouds can form from trace gases over open sea," 22 January 2021, *DOE/Brookhaven National Laboratory*, https://www.sciencedaily.com/releases/2021/01/210122140616. htm (accessed October 12, 2021). Originally Guangjie Zheng, Yang Wang, Robert Wood, Michael P. Jensen, Chongai Kuang, Isabel L. McCoy, Alyssa Matthews, Fan Mei, Jason M. Tomlinson, John E. Shilling, Maria A. Zawadowicz, Ewan Crosbie, Richard Moore, Luke Ziemba, Meinrat O. Andreae and Jian Wang, "New particle formation in the remote marine boundary layer," *Nature Communications* 12, no. 1 (2021), p. 527.

poetry—in its broadest sense—is the technique whereby atmosphere, mood, analogues, metaphors, layerings, significance are deployed, where gatherings and overspills of language, image, idea, overtones and undertones occur, then might it be the technique through which occurs an exploration and communication of the raising, harnessing, and manipulating of the political temperature of the times.

Linguistic Fluidities

When thinking of fluidity, of liquids, of flow, it is very easy to be drawn into another flow, another slipperiness, another mobile flow, which is that of language itself, specifically the slippages of puns and associations. Puns involve a heaping up of meanings, half-associations, mistaken connections based on nothing but a sonic similarity. It might be generative to think through puns, such as drawing together liquid solutions and political solutions or wondering about how the cloud in the sky is now the Cloud of data storage and access, and so something other to itself, just as clouds are anyway always tending to become. How revealing might be a perspective that considers how particulate (as in toxic, dusty particles) and the particular (as opposed to the universal) or, in another idiom, the concrete (as building material) and the concrete (as philosophical category), are, when smashed together. On this plane of fluid language, is it possible to gain access to a set of connections (and analytic work is often about finding connections, meshing something to another thing, finding the chains and links and causal relations). These sets of connections exist in the historical form that is language and are provoked by etymology, usage and metaphor that generates more knowledge. Milk, for example, is whole, and so, in a poetic sense, but not only in that sense, it can contain everything. It can be an extraordinary totality, and be

contradictory, from a Marxist materialist standpoint. In this way, all of the tensions and forces of the world are concentrated in it and can be drawn out of it.

For example, milk has lent itself to language, for it appears frequently in metaphor: to milk something, milking it, crème de la crème, milksop, fat cow and all that and all its associated language of a social and cultural matrix of metaphors of skimming, condensing, homogenizing, expressing, churning, curdling, culture, souring, combining, separating. Many of these participate in an emotion-soaked language here, as might be expected of so primal a fluid as milk. The world exists, milk exists, in its whiteness, but also has been thought in its blackness, and it is to be invented as such, imagined as such through the power of language or poetry. Out of milk arises all imagination—but not an expansive one for those who imagine milk to be white and only white and so without hope. Hidden in milk, beneath and inside that whiteness, is a multitude, another world or worlds, invisible things and knowledges. Milk fans out widely, from reason to imagination. This entirety of milk includes all that is magical, dreamlike, absurd and incredible, as well as all that is, all that is real and pellucid. Milk's whiteness plays into its mobilization in white supremacy discourses and the circularity of the milking carousel relates in some way to milk's enmeshing in circulation. Commerce and advertising mobilize this practice and a key text for any contemporary studies of the place of milk in the world today—amidst a system of global flows—is Tetra Pak's commercial document *Deeper in the Pyramid*, which is about the penetration of their vessel form into the poorer, bottom layers of the global market.[7] Strikingly, the corporation evokes Tetra Pak's signature form of the pyramid package. They too play with puns, with language's slipperiness, its prone-

7 For more on these links, see Esther Leslie and Melanie Jackson, *Deeper in the Pyramid* (London: Banner Repeater, 2018).

ness to slide and hint and suggest, especially while in the subtle art of persuading.

Marx noted, in *The German Ideology* (1845), that language is practical consciousness.[8] It is a material force, bruised and suffused by history, by usage—by exchange and change. These moves are not arbitrary (as the liquidity of asset and cash exchanges might appear to be) but motivated. There is a passage from language to world and world passes into language. Language is the realm of poetry and mishearing and objects in the world are tangled in those misapprehensions and expand or are reflected through them. Or words are tangled not in the world but in our bodies, come out only on condition of our bodily movements that smooth the passage into the world, through gesture.

How might we attend to the resonances of fog, to its surplus or deliberately overextended meanings, in order to compose and recompose the world and make it meaningful to us again, when it is in danger of becoming too fogged or opaque?

Back to the Foggy World

But we *are* too fogged. Today's social environs are beset by foggy pollution and the thick urban atmospheres produced by particulates hovering in the air, as well as toxic foams and froths of chemically polluted streams and oceans, a toxic waste produced by chemical effluence and climate change. All this foam is the foam of a world in turbulence, one in which there is unrestrained industrial activity and its after-effects of runoff, in the context of a global warming that it is bringing about, and the aftereffects from that of excessive organic pro-

8 Karl Marx and Friedrich Engels, *Selected Works in Three Volumes*, vol. 1 (Moscow: Progress, 1969), p. 32.

ductivity. Is it facetious to see its correspondent in the foams and froths that sit on top of the capitalist worker-consumer in the cities, dashing to work—"but first coffee," as the sign near me on Camden High Street insists, or picking a latte macchiato up on a break from work to keep on going through the rest of the day, or grabbing one post-work, as a pick-me-up to continue doing and being and acting at full capacity into the night. Coffee foam and froth is a symbol and a fuel of our networked economy, the one that takes place in every coffee bar, or on the street, the networker with a microfoam-topped latte in one hand, smartphone in the other. Every worker-consumer is a bubble of flexible labor, part of a post-world-recession economy in which jobs for life are something from another time, a world ago, and this current world is a world of reskilling, zero-hour contracts, precarious conditions, life paths that bend back on themselves, do not flow onwards like the river to the sea. Each bubble of labor may be tangled up with broader economic bubbles, inflations of sectors of the economy, with rapidly increasing asset prices bringing sudden rushes of confidence for investors and consumers alike (such as the Dot-Com bubble or the Japanese bubble economy of 1986–1991) until the bubble bursts. Illusions are pricked, again.

Fogs, foams, and froths are there in the world, but also as metaphors, emanations—ideological phantasms of our political and social condition. What is our environment, what fog of world envelopes us, whoever we are and where we are? What foggy atmosphere do we carry with us? Are we bound together in the same collectivity, or are we in many proximate fogs, only existing side by side, not breathing the same air, or only involuntarily?

An atmosphere is made by humans and it is one that is hostile to the individual, more hostile than other environments that have been made even. It is an atmosphere that penetrates the body—not to speak of the sickening mind—and forms a toxic bubble within which the

most disadvantaged are compelled to continue breathing, as they move closer to death. It is a real atmosphere through which people move, a microcosm of harm in a locality of London that focuses these thoughts. A fire in a tower block in London, Grenfell Tower, turned the air to fog, so said those who suffered it and breathed it and lost their loved ones in their scores. Fog reoccurs in the official report, on the basis of which there are efforts for justice, a justice that will likely never come to the extent that it should.

When she returned to her flat, Elizabeth Sobieszczak spoke to her daughter Florentyna Sobieszczak. Elizabeth Sobieszczak's recollection was that together they had looked out from a bedroom window facing south and had noticed first white smoke and then black smoke. They decided to go to the lobby where they encountered Betty Kasote. At that time, Elizabeth Sobieszczak noticed that there was some smoke in the lobby ("it was like coming slightly foggy").[9] On the night of the fire, Roy Smith first noticed smoke at around 01.10, when he got up to use the toilet. He immediately smelt "a funny smell like burning plastic". The windows in the flat were closed that night. Roy Smith checked the hallway, kitchen and his daughters' bedroom and returned to bed. He got up again as the smell became stronger in his bedroom. Roy Smith estimated that by now it was 01.20. Switching on the lights, he saw that his bedroom was full of a "fog and mist-like smoke" which was light grey in colour. He could not tell where the smoke was coming from and saw no signs of the fire. When he checked, there was less smoke in other rooms in the flat and no sign of smoke coming from the front door.

9 All citations are from the *Grenfell Tower Inquiry: Phase 1 Report of the Public Inquiry into the Fire at Grenfell Tower on 14 June 2017*, October 2019 Volume 2, available online: https://assets.grenfelltower-inquiry.org.uk/GTI%20-%20Phase%201%20full%20report%20-%20volume%202.pdf (accessed October 12, 2021).

In answer to CRO Adams, Naomi Li gave her flat number and confirmed that there was no smoke in the flat itself but she could smell smoke in the lobby. She referred to what she described as a "very light fog" throughout the lobby. It was not very smoky, more like a blur. Naomi Li could not tell where the smoke was coming from nor did she see it moving in a particular direction. The smell was different from that which she had noticed earlier, more like the smell of a distant wood fire.

Sid-Ali Atmani had remained in Flat 125 after his wife, Rashida Ali, had left with their daughter. Sid-Ali Atmani was unwell and Rashida Ali had been unable to persuade him to leave with them. He was woken by a "popping and crackling sound." From the bedroom window, which faced north, he could see smoke coming from the right side and the reflection of a flame below. There was no smoke in the flat. Having decided to leave, Sid-Ali Atmani found the lobby filled from floor to ceiling with thick dark smoke. He could not see any light and had to feel his way to the stairwell door. When he found it, he pushed it open. There was less smoke in the stairwell. It looked foggy.

This fog, this killer fog, floats out of sight, or rather, it lingers, but invisible to public view and social discourse. Sometimes it will be mobilized by politicians to make or score a point. Mostly it is left to a cluster of campaigners to keep it in view. And the rich will get fogs that combat fire, while the poor wait for the next catastrophe to arise from rule by cuts.

Surgeons hotel invests £1 million to fight fire with fog
Posted: 2nd July 2020
Hi-tech misting system is eco-friendly fire suppressant
A POPULAR hotel is crowning its refurbishment with a state of the art "fogging" system which fights fires while using a tenth of the water normally needed.
Ten Hill Place is Edinburgh's biggest independent hotel, with impressive green credentials. In the wake of the

Grenfell tragedy it wanted a new firefighting system that would reduce the risks from a blaze and give the ultimate reassurance to guests.

Now it has invested heavily to install the latest fire suppressant technology, which was originally developed for the cruise ship market.

Scott Mitchell, Managing Director at Surgeons Quarter, which owns the hotel, said: "We began our renovation planning in June 2018, when the Grenfell tragedy was still fresh in everyone's mind.

"Because of what we learned from the devastation of Grenfell, we put our project on hold and took a serious look at the systems and fire safety measures we had in place.

"Guest safety is our number one priority at all times, but being a hotel focused on sustainability, we also wanted to install an effective but green system which would use less water than traditional sprinkler systems."

Now it has completed the rollout of the £1m Marioff Hi-Fog system – going miles above what is legally expected in hotels, where such fire suppression systems are not a requirement.

Whereas traditional sprinkler systems release jets of water, the Hi-Fog technology works by issuing a highly pressurised mist of tiny water droplets. The complex chemistry involved means the droplets evaporate incredibly quickly, smothering flames, absorbing heat and displacing oxygen – all of which suppresses fires more thoroughly and effectively.[10]

Perhaps all this fog, this foam, these interstitial matters are just that—something getting in the way of thinking, as well as making thinking happen. Fog, blockage, fuzz and confusion is just a metaphor. It is an illusion, a

10 "Ten Hill Place hotel invests £1 million to fight fire with fog," 3 July 2020, News Item, *Royal College of Surgeons Edinburgh*, https://www.rcsed.ac.uk/news-public-affairs/news/2020/july/ten-hill-place-hotel-invests-1-million-to-fight-fire-with-fog (accessed October 12, 2021).

foggy cover under which the same-old-same-old continues. Trade still flows. It flows differently. It flows away from us, on the edges. It flows and flows incessantly, calibrated to the automatic movements of digital existences who manage it, from start to finish. In London, the Thames was once the route into the city and products from across the world—the Empire—would be unloaded in wharfs that still bear the names of their commodities: Cinnamon, Oyster, Pickle Herring—or the places from whence the goods have come—Jamaica, Cochin, Bombay, East India, Plantation. These areas are now redevelopment opportunities for gentrified brownfield sites—a view of water adding substantial value to the cost of real estate. An amassing of latte froth to fuel the daily business and keep it going into the night. The fog rolls across and hangs around the river from time to time—as it always did. The river is turbid with pollutants—there is sewage pumped directly in these days, post-Brexit. But further out from the center of the city the ports, or major shipping terminals, at Tilbury run by Forth Ports and DP World's Gateway, which had been increasingly given over to largely automated containerization, now come back to a certain type of life as warehousing and distribution centers, logistics hubs, for online shopping providers. The Cloud is essential to their existence. The Cloud has landed by the river. The Port Authority is buying land again and taking over old docks to develop a new shipyard, a hundred years after the last. If the fog ever lifts, we will see only more clearly that there is business as usual and we are doomed.

Christian Schwinghammer

Besides One Flow

Quantum Virtuality, Entangled Becomings, and the De-coherence of Ontology[1]

"But to return. Let us again pretend that life is a solid substance, shaped like a globe, which we turn about in our fingers. Let us pretend that we can make out a plain and logical story [...]."[2]

A torrent of prompts that makes one stumble. These are pretensions, so much charged with time-diagnostic tact they could be said to term the ontological running order of "modern" ways of existence, from its institutional backgrounds to its fleshed-out everyday life. After all, even after countless viral testimonies of disaccords and lived contradictions, various scientific "insults of the human condition," uncontrollable but unevenly spreading effects of so-called "natural events," ever-recurring seems to be this: the imperative that life, despite everything and down to the smallest detail, is ultimately a solid matter instrumentally controllable by an external agent or force; that existence is of such a rounded nature that it can be managed and narrated as an individualistic affair.

But, then again, from where does this gush of pretensions return, from what does it turn away? One answer

1 I want to thank Mathias Denecke and Milan Stürmer from the editorial team for their detailed readings of this essay and their help, suggestions and remarks. I also want to express my gratitude to Bernd Bösel, Henrike Kohpeiß, and Tanja Traxler, whose discussions of and feedback on this essay made it possible.
2 Virginia Woolf, *The Waves* (London: Vintage, 2000), p. 180.

can be found in its narrative setting. For Virginia Woolf's famous novel *The Waves* tells of a fundamentally unstable cosmos, of a physics of unclear bodily boundaries and fuzzy individual characters; for it tells of the rush of traffic, smoking chimneys, the electric machinery of daily life, indistinct lanes, voyages, and tempi, swinging revolving doors, all interrupted, yet interweaved by the wave-like movements of elemental earth, itself traversed by economic and political longings of colonizing, claiming and accessing it. In *The Waves*, something is going on between the lines, opaquely flowing through and confusing every scene and sequence: an impersonal pulse, occasionally, in all generality, just called "life."[3] It is this general thread that today, in the course of the recent revitalization of ontological modes of inquiry, gets picked up, to likewise understand the "nature" of all existence differently, to elucidate and intensify existence's thoroughly worldly conditions in terms of a fluidity of becoming. In this, however, the current return to ontology is marked by the same suspense that runs through *The Waves*. For despite its undertones, here, everything plays out quite literally on the scene: in regards to specific constellations and the life effects that various existences are confronted and imbued with.[4] What Woolf's storytelling stages is a tension between generality and specificity, between broad frames of reference and the particularities of lived realities. This essay returns to this tension. Not to solve or straighten it, by any means, but to interrogate it amid the revived tendency to narrate everything under the heading of a world in perpetual flow.

3 See, for instance, ibid., p. 45, p. 79, p. 174, p. 179, p. 205.
4 For an equal assessment that has guided these introductory thoughts, also vis-à-vis the recent turn to ontology, see Derek Ryan, *Virginia Woolf and the Materiality of Theory: Sex, Animal, Life* (Edinburgh: Edinburgh University Press, 2015), especially pp. 171–202.

1. Introduction

A reverse beginning, then: life as it constantly wipes away its portrayal as a solid and easily controllable substance. Starting from existence's material make-up and thus out of the research area of the natural sciences, life always already tells of a blurring of clear handiness and fixed consistency—something that *The Waves* already embraced, insofar as it, in its subtext, engages with a physics turning quantum at the beginning of the last century.[5] In close alignment to natural scientific findings and tropes, the ontological interventions traversing *The Humanities* for years now have been attending to the material matters of existence, its fleshly corporality, its fundamental involvement in inorganic dynamics. And they have thereby articulated a stance against any claim of substantial solidity. "For materiality," as Diana Coole and Samantha Frost put it in an often-quoted passage introducing a heterogeneously voiced *New Materialism*, "is always something more than 'mere' matter."[6] In essence, in their material ontology, there is a vibrant surplus to everything and everyone, without exception—that would be the point.

Meanwhile, however, and as Coole and Frost's guiding passage continues, this *more of materiality* is itself anything but settled, shifting in a hover of multiple possible signifiers ("excess, force, vitality, relationality, or difference"[7]). Nevertheless, Coole and Frost do provide a concretizing hint, a few pages later, also by touching upon quantum physics. They state that what moves a contemporary materialism is essentially an understanding of material reality as based on "forces, energies,

5 Compare ibid.
6 Diana Coole and Samantha Frost, "Introducing the New Materialisms," in *New Materialisms. Ontology, Agency, and Politics*, ed. Diana Coole and Samantha Frost (Durham and London: Duke University Press, 2010), pp. 1–43, p. 9.
7 Ibid.

intensities (rather than substances)."[8] Indeed, *such* an ontological turn has been very influential. Driven by it, corresponding considerations have reached beyond the scenic "thereness" of lived actuality in an attempt to give a grounding grasp to that which, at least in Coole and Frost's short text passage, is indicated only in the plural. What is thereby brought into the discussion is a dimensionality often appearing under the name of a "life force"[9] or "matter-energy."[10] "Something," that is at once virtual and real, and in this sense irreducible to any realm or instance of life, ultimately of extrasensory, cosmic reach, but still, in the most intimate way, the animating pulse of every appearance. At issue here is an originary element that accounts for existence's uncontrollable dynamics, for its anti-substantialist surplus; a new "molecular" code against any essentialism of immutable essences associated with current ontology's metaphysical predecessors. On this, then, would be the main emphasis: when invoked, such an element would gather all existences under the same fluent basic condition, as *per se* implicated in a dynamism of endless becoming, a grand flow of change. But if in this respect, as Jane Bennett vitalistically tunes it in her argumentation about a monistic "matter-energy," everything is in some sense made of the same pulsating "stuff,"[11] how then to account for the deep non-unison of life? In other words, and even if it is now written in a grammar of fluid non-solidity: how to circumvent an overemphasis on an indifferent oneness of all life, turning the specifics of lived actuality into a neglected, trailing question, or, worse, supporting a trend of life, which would make all

8 Ibid., p. 13. For Coole and Frost's recourse on quantum physics, see ibid., pp. 10–13.
9 Compare here especially Rosi Braidotti's work, for instance, Rosi Braidotti, *Transpositions. On Nomadic Ethics* (Cambridge: Polity Press, 2006).
10 Compare here, for instance, Jane Bennett, *Vibrant Matter. A political ecology of things* (Durham and London: Duke University Press, 2010).
11 Ibid., p. xi.

that is subject to a new "must" of ceaseless transformation no matter what?[12]

To ask these questions alongside this revival of ontology ultimately requires consideration of what Deboleena Roy and Banu Subramaniam, in their divergence from any (onto-)logic of the One, have formulated as follows: "[T]here can be no decontextualized generic body or matter, be it human or nonhuman, organic or inorganic."[13] To some extent, of course, this is a statement running parallel to comparable differentiating assertions within the continuum of current ontological work.[14] However, regarding ontological investigations of something like a vibrant "stuff" originally inherent in every being, it is foregrounding the irreducible weight of contextual settings and constellations; and consequently that the verve of such investigations is always already traversed by the "empirics" of lived existence's varying conditions and conditionings, in a persistent climate of uneven exposure to hostile, exploited and obliterated living spheres, amid an associated "progress," that long since has inscribed its effects and implications deep under the skin of material worlds. Concerning recent ontological initiatives, what is brought to the fore with this is an irrevocable tension, itself engendered by a shift in emphasis, from "the waves" of an

12 For a related questioning gesture, see, for instance, Claire Colebrook, "On Not Becoming Man: The Material Politics of Unactualized Potential," in *Material Feminisms*, ed. Stacy Alaimo and Susan Hekman (Bloomington and Indianapolis: Indiana University Press, 2008), pp. 52–84, especially pp. 57–60.
13 Deboleena Roy and Banu Subramaniam, "Matter in the Shadows. Feminist New Materialism and the Practices of Colonialism," in *Mattering. Feminism, Science, and Materialism*, ed. Victoria Pitts-Taylor (New York and London: New York University Press, 2016), pp. 23–42, p. 28.
14 Compare here, for instance, Braidotti's argumentation under the heading "We-Are-(All)-In-This-Together-But-We-Are-Not-One-And-The-Same," in Rosi Braidotti, *Posthuman Knowledge* (Cambridge: Polity Press, 2019), pp. 52–55. Compare also Bennett's continuous insistence on life as a matter of relational assemblages, in Bennett, *Vibrant Matter*.

elemental force or energy of matter to how life materializes differently "on the ground." The emphasis here falls on existence as a complex "topos" of becoming: on how the "stuff" of each existing being, contrary to any positioning as simply given, must be understood as an enfleshed "lifespan" full of ties to and dependencies on life-defining conditions, as profoundly intricated with other beings, things, forces, and pulses.[15] In this essay, I want to trace this shift of accent. To this end, I will follow up on a quantum-inspired thought, alongside its recent specifications under formulations such as "differentiation within entanglement"[16] (Karen Barad), "difference without separability"[17] (Denise Ferreira Da Silva), or (following the latter) "differential inseparability"[18] (Fred Moten).

2. The Strange Rhythms of Quantum Virtuality

When it comes to the idea that each individual being, in its hidden virtual depths, mirrors a cosmic flow of life, quantum physics sparks the imagination. Indeed, it has offered sense to the vanishing groundedness of any self-confident recourse to elemental solidity, via mathematical rigor and remarkable experimental reliability. However, with all that, quantum physics hasn't provided a clear ontological groundwork for how to make sense of the world instead. Its grammar still tells of a tensed side

15 Compare here, again, Roy and Subramaniam's insistence on the question of material becoming as always complex, multilayered and variously "contextualized," in Roy and Subramaniam, "Matter in the Shadows," especially pp. 35–39.
16 Karen Barad, "What Flashes Up: Theological-Political-Scientific Fragments," in *Entangled Worlds. Religion, Science, and New Materialisms*, ed. Catherine Keller and Mary-Jane Rubenstein (New York: Fordham University Press, 2017), pp. 21–88, p. 74.
17 Denise Ferreira da Silva, "Difference without Separability," in *Incerteza viva* (São Paulo: São Paulo Fundaçao Bienal, 2016), pp. 57–65.
18 Fred Moten, *Stolen Life* (Durham and London: Duke University Press, 2018), p. 244.

of contradicting philosophical interpretations; and if the notion that the "nature" of existence lies in an elemental, all-energizing flux has gained momentum here, so have radically contrary ontological renderings.[19] As, for instance, Carlo Rovelli has prominently rephrased it in recent times, it is still about "quantum"; that is, about discrete and discontinuous events.[20] Which would suggest something far from sketching material reality in the broad continuous strokes of one universal wave-like movement (with the stress, above all, on a "wave-function of the universe"): a "pointillist" ontology with non-monistic consequences, in fact, tracing only the constitutive significance of particular happenings and interactions.[21]

The quantum-inspired works occupying me in this essay, in turn, could be said to engage in this pause of interpretational clarity, invested in the critical openings between those diverging quantum-ontological views. They do take off where quantum physics challenges "the metaphysics of individualism."[22] That ontological doxa, operative in "modern" common sense, demanding from lived existences to ultimately express the idea of self-contained, particular individuals essentially demarcated from and above all otherness. Life, as it is indeed framed—over and over again—as substantially solid and thus manageable at discretion. Classical

19 The fact that quantum theories provide a point of departure for notions of a general energizing "flux" can be traced, for example, in David Bohm's prominent quantum physical thinking. See, for instance, David Bohm, *Wholeness and the Implicate Order* (New York: Routledge, 2005) and David Bohm and Basil J. Hiley, *The Undivided Universe. An ontological interpretation of quantum theory* (London and New York: Routledge, 1993).

20 See Carlo Rovelli, "An Argument Against the Realistic Interpretation of the Wave Function," *Foundations of Physics* 46 (2016), pp. 1229–1237, especially p. 1236.

21 See ibid., p. 1236. Compare also Carlo Rovelli, *Seven Brief Lessons on Physics* (New York: Riverhead Books, 2016), p. 18.

22 See Karen Barad, *Meeting the Universe Halfway. Quantum Physics and the Entanglement of Matter and Meaning* (Durham and London: Duke University Press, 2007), p. 5.

physics provided a highly influential outlook for such metaphysics. It defined individual particles as god-given in their immutable essence, just superficially touched by external forces.[23] And it proposed that all this is arranged against an inert existential background—the void, "space," vacuous of any blurring activity, guaranteeing the straightforward unfurling of all "courses of life."[24] These axioms of a "classical world" remain, even when physics starts to fill such "void" with an energetic field. Still, material entities are said to be solid in every touch; and while the field is now highlighted as a ubiquitous medium that transmits all possible contacts between entities, the "classical" background assumptions are left intact. For this field, among other things, just stirs in reaction to those forces of touch, just when they actually occur.[25]

In her stance against such an ontological framework, Barad draws on the radical change of scenery quantum field theory (QFT) has introduced. QFT undermines any determination of existence as taking place against a settled backdrop, a field that would support it as a clear state of affairs. As for the idea that there ever could be something like a literal "void," a "setting" of foundational stillness, it instead allows for so-called "quantum vacuum fluctuations" around the value "zero," suggesting that there always, at any point, could be energetic field-vibrations.[26] What follows from this, at least after

23 See Karen Barad, "After the End of the World: Entangled Nuclear Colonialisms, Matters of Force, and the Material Force of Justice," *Theory & Event* 22, no. 3 (2019), pp. 524–550, especially p. 528.
24 See ibid.
25 See especially Karen Barad, *What Is the Measure of Nothingness: Infinity, Virtuality, Justice* (Berlin: documenta (13)/Hatje Cantz Verlag, 2012), pp. 10–11.
26 See ibid., pp. 8–11. These "vacuum fluctuations" are often derived and illustrated via quantum mechanics' *uncertainty principle*, which speaks of an impossibility to simultaneously measure energy and time (respectively position and momentum), so that at a particular point in time, there can be no exact determination of the field's "energetics," also not one as exactly null. For Barad's understanding of

Barad, is an overthrow of the entire architecture of a "classical world." It follows that, contra to any punctuation of a "particular" existence as simply given in and through profound separation, material entities must be acknowledged as constitutively tangled with a life-stage that is always already pulsing against the directive of clearly bounded becoming.[27]

As read through Barad, QFT thus shifts the matters of existence from their status as an individualistic issue over to something else. And yet, it thereby doesn't denote *one* "element": *one* flux, *one* energy or force of life. It's just that QFT deeply complexifies even such a designation as soon as it formulates what "backs" material entities as something that always fluctuates—vibrates, pulsates—against a description that would take it as void. Turning to the material details of an electron, Barad outlines this: that an electron is always already pulsed by a myriad of varied energetic vibrations, or rather (because QFT quantizes the "energetics" of the field) by the intricate play of uncountable animating "throbs"; that an electron is thus (and because special relativity allows a materialist expression of those "throbs") always also a matter that is energized by an immense field of other kinds of being(s)—so-called "virtual particles" which may evade a classification as "present" (not least because they are not directly detectable), but nevertheless form the prerequisite for even speaking of an electron's existence.[28]

And while Barad will accordingly, following QFT's modes of description, start to emphasize that even the smallest material facets of life, like an electron, are

this insight, which she reads towards being a case of ontological indeterminacy, see again ibid.

27 For a different approach to questions around the "particulate becom[ing] particular," see Esther Leslie's contribution in this volume.

28 See Barad, "After the End of the World," p. 529. See, for this reading of Barad's corresponding interpretational turns, especially Barad, "What Flashes Up," pp. 38–75. Concerning the more technical aspects interweaved here, see especially Barad, *What Is the Measure of Nothingness*, pp. 10–11.

always surrounded and constitutively touched by such vast strangeness, the implication looming here is not just that a "virtual" element gains radical life-relevance. What is also implied is that this element is tipped into infinite otherness, literally. I want to highlight the existential weight of these implications, by way of what Barad pointedly underlines in designating a quantum virtuality as "a polyrhythmic structured nothingness."[29] Namely, that existence is a scene of boundless spatiotemporal complexity, never fully "here and now," as its "stuff" is constitutively permeated by an endless manifold of other beings, life-decisive pulses and forces, including those of apparatuses, procedures and technologies strategically directed to control, calculate, and handle its physics of becoming. This is a quantum shift that from the beginning comes with a "downshift" of an onto-logic of the One to contrapuntally foreground difference and specificity in regards to lived existences instead.[30]

3. The Specificities of Entangled Becoming(s)

In fact, what Barad's take on virtuality points to is that every existence is always already deviating from a common elemental denominator, because each is vivified

29 Barad, "After the End of the World," p. 530. See also Barad, "What Is the Measure of Nothingness," p. 13.
30 Regarding Barad's work, such insistence can be especially sensed where she engages with Jacques Derrida's "différancing" thought of alterity, with Walter Benjamin's work, and also where she discusses the Lurianic Kabbalah and its reading of the theological doctrine of a *creatio ex nihilo*, woven around a primordial (and recurrent) withdrawing contraction (*Tsimtsum*) of the divine All/One. Since a detailed discussion of this crucial "backdrop" of Barad's work is beyond the scope of this essay, compare, for Barad's Derridean inspiration especially, Karen Barad, "Quantum Entanglements and Hauntological Relations of Inheritance: Dis/continuities, SpaceTime Enfoldings, and Justice-to-Come," *Derrida Today* 3, no. 2 (2010), pp. 240–268; and for her reading of Benjamin in tandem with the Lurianic Kabbalah, Barad, "What Flashes Up."

by manifold otherness—always, in each moment, over-crowded, to say it together with the characterization of "polyrhythm" Fred Moten makes in a different, but not separate, context.[31] Thus, when Barad recites this differentiating thought through the tangled specifics of the smallest matters of life, such as an electron, it is then to underpin that such is the case for "all material beings, each of which *is an enormous entangled multitude*"[32]— in this exact and radical sense. For entanglement is in a crucial sense more-than-relational; it doesn't follow the spatiotemporal (geo-)metric of simple co-existence, the tact of a mere being or becoming together, the count of one plus one. Entanglement happens when there is touch, yet, it doesn't signify a simple merging of two or more.[33] It persists between what is assumed to be separated by spatial and temporal distances, and yet, it thereby vehemently unsettles the separating lines a "between" would assume.[34] Components that quantum physics describes in an entangled state are taken as one single system, termed in one (wave-)function.[35] That is, to be entangled means that regarding the "entities" in question, there simply exist no demarcated, determinate features. And it is precisely in this sense that Barad's statement that each being is immensely entangled indicates not merely that the "touch of otherness" is of constitutive relevance; the point is, rather, that the "make-up" of beings always speaks of such an indeterminate (superimposed) state of entanglement, of how this systemic "bond" never vanishes even when an entity appears as *this* or *that*.[36] It is in this sense,

31 See Fred Moten, Stefano Harney and Stevphen Shukaitis, "Refusing Completion: A Conversation," *e-flux* 116 (2021), unpaginated.
32 Barad, "What Flashes Up," p. 73.
33 See Barad, "Quantum Entanglements," p. 251.
34 Ibid.
35 See Barad, *Meeting the Universe Halfway*, p. 271; compare also ibid., pp. 247–352.
36 Compare ibid.; compare also Karen Barad and Daniela Gandorfer, "Political Desirings: Yearnings for Mattering (,) Differently," *Theory*

then, that the quantum notion of entanglement diverges from, in Moten's words, the "metaphysics and mathematics of individuation-in-relation."[37] It expresses that an existing being, in its becoming, can never be sufficiently counted down as an individuate particular, simply "there," unambiguously locatable in and as a solid here and now. Rather, entanglement requires taking into account that this being exists solely and always as "more and less than one."[38] As more than an individual "here-now," which is also to say, as less than one.[39]

However, to do so, to approach the becoming of a being in this manner, is at the same time to insist that it is already about more (and less) than simply stating that everything is enormously entangled. "[N]ot all [...] entanglements matter equally or in the same way,"[40] Barad writes. Entanglements, in other words, inhere different implications; they materialize differently. So, for all generality, even if entanglement is tipped into a universalistic principle: what is decisive considering one entity's way(s) of living, what matters here, is that its existence is specifically pulsed, patterned and touched by ongoing "entanglings," that its persistent (non-)state of being overcrowded by manifold otherness indicates its never-ending intrication with specific conditions of becoming. The descriptor "entangled" is thus to be differentiated from any ontological neutrality. It does lose such indifference here, as both Ferreira da Silva and Moten take it up through the subsisting expressions of a "blackness of physics,"[41] given in the movements besides and under-

& *Event* 24, no. 1 (2021), pp. 14–66, especially pp. 32–33.

37 Fred Moten, *The Universal Machine* (Durham and London: Duke University Press, 2018), p. 87.

38 See, for Moten's "more + less than one," which he uses mantra-like throughout his work, and, here, in regards to the question of the human, Fred Moten, *Black and Blur* (Durham and London: Duke University Press, 2017), p. 217.

39 See ibid. Compare also Barad, "Quantum Entanglements," p. 251.

40 Barad and Gandorfer, "Political Desirings," p. 33.

41 Moten, *Stolen Life*, p. 209.

neath the spacetime of the "classical world."[42] The move-
ments of those denied a life or body proper, displaced
through and from this world, shipped, in refuge, forced
into the enfleshed physicality of an overcrowded site, of
those non-isolated against various touches and forces,
suspended into the statelessness of the void of wrecked
spacetimes and foundational breakdowns.[43] It is in this
ongoing denial of firm foundations that lived entangle-
ment "violates the scheme, or frame, or home of xeno-
phobic/egocentric particularity."[44] Which is not solely a
disruption with/in individualism's normativism aimed
at stand-alone existences essentially untouched by any-
thing else.[45] Rather, it prescribes the ongoing break with
and of the upheld basic assumption that there ever
could be a moment in which an existence wouldn't
profoundly attest to specific material conditions, to an
"elementary *entanglement*,"[46] as Ferreira da Silva has it,
however exceptional, full of control and fully on track,
straight aligned and smoothly unfurling it may appear.
This is, ultimately, what in my understanding Fer-
reira da Silva's quantum notion of "difference without
separability"[47] concerns and opens up. Namely, a "more
complex reality,"[48] where "each existant's singularity is
contingent upon its becoming one possible expression of
all the other existants, with which it is entangled beyond
space and time."[49] And it is also what Barad's approach
to virtuality in light of an electron implies.

42 See ibid., p. 209, pp. 243–245; and Denise Ferreira da Silva "Toward a
Black Feminist Poethics. The Quest(ion) of Blackness Toward the End
of the World," *The Black Scholar* 44, no. 2 (2014), pp. 81–97, p. 84.
43 Compare, for instance, Ferreira da Silva, "Difference without Sepa-
rability," pp. 63–65; Moten, *Black and Blur*, p. xiii, p. 221, p. 279;
Moten, *Stolen Life*, p. 251, p. 261; Moten, *Universal Machine*, p. xiii,
p. 112.
44 Moten, *Universal Machine*, p. 117.
45 Compare Ferreira da Silva, "Black Feminist Poethics," pp. 89–91.
46 Ferreira da Silva, "Difference without Separability," p. 65.
47 Ibid., p. 57.
48 Ibid., p. 64.
49 Ibid., p. 58.

For Barad suggests as much: an electron is, in its "essence" (its energy/mass), a thorough expression of an "entangling" with a complex field of otherness. It tells that there is no "touch" of its existence that wouldn't owe its "being-there" to a vast, yet specific, detour—one that quantum mathematics, even if it has defined the regular being of a "normal" electron, mimics.[50] A detour of detours, to be precise, over an endless weave of other forces and energetic pulses, of all kinds of matters, beings, appearances and nuances. An electron is thus, following Barad's reading of QFT, a becoming which is always radically non-uniform with itself. Bound to constitutive otherness, it is dislocated beyond a status of particulate spatiotemporal locatability: It is always an entangled "scene" where myriad modes of (its) becoming, patterns and histories of expressing its existence are at play—a testimonial against chronology's progressive direction.[51] However, since such a quantum recourse cannot do without addressing the operative significance of mathematical procedures at work here, these matters of an electron also testify to the fact that in the physics of becoming forces of strategic control and invest-

50 See Karen Barad, "Troubling Time/s and Ecologies of Nothingness: Re-turning, Re-membering, and Facing the Incalculable," *New Formations: A Journal of Culture/Theory/Politics* 92 (2017), pp. 56–86, especially pp. 79–82. The figure of the detour (or detour of detours) references the figurative-mathematical Feynman Diagrams used in QFT—and used by Barad to open up QFT's interpretative possibilities (compare, for instance, ibid., pp. 80–82). Barad explains such a detour (of detours) as follows: An electron only becomes through the touch of others, and regardless of what this touch denotes in a particular case, it always involves the contribution of a boundless span of virtual particles. A touch includes, for instance, a virtual photon, that "emerges," and can, even before contact was made, transform into a virtual electron-positron-pair—"and so on," which is Barad's formula for an infinity of activity possibly included in one touch as well as an infinite number of "ways" this one touch considering that one electron can come about (see Barad, "After the End of the World," pp. 529–532). This boundlessness of becoming requires a complex mathematical detour called "Renormalization" to settle—and thereby acknowledge—this vastness and come up with the concrete factuality of an "electron" (see ibid., pp. 531–532).
51 See ibid., pp. 530–532; Barad, "What Flashes Up," pp. 70–73.

ment can never be bracketed out. As for "our" actuality, this recourse thus recalls that those forces also extend to the most minute dynamics of existence's material, fleshly constitution.[52] And this, furthermore, with vehemently different effects and implications, regardless of how elemental, abstract or general such interventions might appear: quantum physics' practical advances to the most "fundamental" matters of existence are themselves also tangled with the progression of histories of violence, of destructed and blasted spheres of life.[53]

As for this actuality, therefore, crucially besides a universal register of flow and flux, all this opens onto a profound sensibility to the peculiarities of every "here-now" as entailing, beyond its recognizable current state, a dense "more" of manifold, inscrutable otherness.[54] Attempting to amplify this accentuation in what follows, I now turn to one surrounding of the joint work between Moten and Wu Tsang, in which not only the previously referenced voices and quantum thoughts are threaded through.

4. Sensing Entanglement.
Gravitational Feel and Quantum Decoherence

From the ceiling down to the ground, uncountable corded and varied knotted fabric strands like a thicket of tendrils one barely can see through. *Gravitational Feel*, a sculptural performance by Moten and Tsang, is a surrounding whose texture is constantly quivering, directly or indirectly, sometimes only in the manner of

52 See Barad and Gandorfer, "Political Desirings," p. 21.
53 Regarding quantum physics' involvement in the development of atomic weapons and the historicities of specific violences this entails, compare Barad, "After the End of the World," and Barad, "Troubling Time/s."
54 Compare here Barad's corresponding descriptions of a "thick-now" in reference to Benjamin's "Now-Time" (Jetztzeit), in Barad, "What Flashes Up."

the slightest tremor, other times in visible movement, induced by turning devices, animated by other movement passing through, by tracks of sound, noise, and spoken words (plate 6).[55]

Here, like in my quantum-descriptions above, the tangle of touch is everywhere—and nowhere, if you try to constrict it to a proper locus. Strands upon strands, as if every contact were spread over a whole field. Not only are all present bodies constantly touched, but every encounter is itself never just one, never just an instant, but permeated by a whole scenario of different signs and indications, living materialities, impersonal systematics and machinic activities. That existence is profoundly touched by an overspill of different matters, pulses, temporalities: in *Gravitational Feel*, tactility is given to this. Strand for strand, each differently animated by the whole dynamism of this same environmental denseness, each leading beyond the very same scene, as their fabric varies in being differently crisscrossed by multiple knots, reminiscent of Quipu, an Incan technique to track data through times and histories via knotted strings.[56] *Who Touched Me?*—Moten and Tsang's work indeed performs the title of its accompanying publication. And it indeed takes it from its theological-inflected scripting into quantum physical terrain. "The research/experiment is in how to sense entanglement,"[57] they say amidst a conversation with Ferreira da Silva, passages from her text *Difference without Separability*, poems, ideas, sketches.

55 The sculptural performance *Gravitational Feel* was presented as part of the Finale for Edition VI – Event and Duration (2015–2016) of the art organization *If I Can't Dance, I Don't Want To Be Part Of Your Revolution*, at Splendor, Amsterdam, from November 26 to November 27, 2016.

56 See Fred Moten and Wu Tsang, *Who Touched Me?* (Amsterdam: If I Can't Dance, I Don't Want To Be Part Of Your Revolution, 2016), p. 54; see also Frédérique Bergholtz and Susan Gibb, "Introduction," in Fred Moten and Wu Tsang, *Who Touched Me?*, pp. 1–4, p. 2.

57 Moten and Tsang, *Who Touched Me?*, p. 30.

In this regard, and as I want to propose, *Gravitational Feel* and its quantum subtext allows following up the implications of a quantum physical reading of virtuality, touch, and entanglement. *Gravitational Feel* gives a sense that each existence, however much it may seem to be of clear contours and clear-cut locatability, is an entangled yet specific articulation of a highly multifaceted and boundless field of otherness. To say it together with Moten's recourse to Ferreira da Silva's thoughts: it is about how "the empirical is or shows up for us particularly, but in a way that defies particularism, defies [...] the subjectivist expression of here and now, the absolutes of space and time."[58]

More pointedly, Moten and Tsang's collaborative work allows and requires to keep following what is discussed in quantum physical research under the heading of "decoherence." Namely that, while "our" everyday world may not appear and be taken as such, it is still thoroughly "quantum"; and the concept of decoherence can provide a quantum mechanical mode for approaching how lived actuality necessarily, in and through its appearance, entails what quantum physics describes as entanglements.[59] I introduce decoherence here alongside *Gravitational Feel*, insofar as both speak of the fact that the infinite touch of otherness is thereby of unmeasurable importance. To begin with, in regards to the dynamics of how entities and bodies of the everyday

58 Ibid., p. 47.
59 See Elise M. Crull, "Exploring Philosophical Implications of Quantum Decoherence," *Philosophy Compass* 8/9 (2013), pp. 875–885, especially pp. 881–882. My following all-too-brief passages concerning the quantum concept of decoherence are, in their provisional interpretative assessments, especially based on Crull's and Maximilian Schlosshauer's work. See for the former also Elise M. Crull, "Quantum Decoherence," in *The Routledge Companion to Philosophy of Physics*, ed. Eleanor Knox and Alastair Wilson (New York: Routledge, 2022), pp. 200–212; and for the latter Maximilian Schlosshauer, *Decoherence and the Quantum-to-Classical Transition* (Berlin: Springer, 2007). As far as I can tell, decoherence is not mentioned in Ferreira da Silva's or Moten's work and is only rarely addressed by Barad (see, for instance, Barad, *Meeting the Universe Halfway*, p. 279, p. 287, p. 349).

world come to be, decoherence suggests that the decisive "measures" involve an unfathomable bandwidth of possible "environmental touches." Accordingly, decoherence emphasizes that far more than only human-directed activities, even often ignored basic conditions, such as the incoming light or the ambient air, must be taken into account.[60] And maybe it is precisely this, then, what is fleshly sensed amid *Gravitational Feel*'s environmental maze: that the way everything (including you) "takes place," the way everything (including you) "happens," is a matter of a surrounding measuring everything (including you) with an immensely intricated field of pulses (plate 7).

Moreover, in tandem with each other, *Gravitational Feel* and decoherence give a sense that all this always also implies the matter of entanglement, suggesting that this quantum concept, along with its implications, does hold at the layer of mundane experience as well. Decoherence can stress as much, against the claim of a total breakdown of quantum features (as intonated by the formulation of a "collapse of the wave-function").[61] Also concerning the everyday world, decoherence indicates that whenever something is touched by an environ-

60 See Schlosshauer, *Decoherence*, pp. 65–68. Accordingly, this goes against a quantum interpretation that would—in the wake of the prevailing Copenhagen interpretation—reduce the question of decisive "measures" to human-directed observations or measurements through experimental apparatuses. Barad offers a critique of this reduction in Barad, *Meeting the Universe Halfway*, pp. 132–185. In general, with decoherence, "environment" has a very loose meaning. Besides physically external aspects, it can name anything and everything with regards to an entity or aspect under consideration (see Crull, "Exploring Philosophical Implications," p. 883).

61 That is, as it can be belatedly underlined here, the concept of decoherence is engaged in discussions about one focal point of the so-called "measurement problem": namely why it is that in everyday life, all entities seem to be in a state anything but "quantum." Decoherence offers a way to approach this issue, as I only sketch in the following, without having to involve the notion that there would ever be a physical collapse of quantum behavior (see Crull, "Quantum Decoherence," pp. 200–203). Barad's understanding of entanglement can also be approached through its "no-collapse" arguments (compare especially Barad, *Meeting the Universe*, pp. 342–350).

ment, it is now entangled with it, and it is only *through* such entanglement that it can exhibit determinable physiques.[62] The crucial point here is that the constitution of what can be denoted as a body of particular contours and its being indistinguishably entangled with one vaster system happen together. Never just one, perpetually "more and less than one": a way, then, to address the specificity of how a particular being becomes, "but without having to keep the idea of particularity (and the related ontological separability),"[63] as Ferreira da Silva puts it in *Who Touched Me?* The mathematical operations underlying decoherence formulate it accordingly: focusing on one physical entity means approaching it in a complex detour because everything is, rather than ever being truly separate or separable, an affair of ongoing entanglement.[64] However, what is also at stake here, in this salience of the systemic necessity of entanglements, is their respective specificity. While the mathematical methods and conceptual tools associated with decoherence generally allow to approximately track but never definitely pinpoint how entities become, the becoming of one "thing" is always a question of the specifics of its entangling with an environment.[65] And even more: conceptually, this amounts to that even this question cannot be reduced to one "pure" entanglement; the specifics of this one becoming are instead a question of an endless set of further entanglements.[66]

62 See Crull, "Exploring Philosophical Implications," pp. 877–880.
63 Moten and Tsang, *Who Touched Me?*, p. 46.
64 For an insight into the mathematical background of the corresponding "instrument" of a *Reduced Density Matrix* that I am hinting at here, see especially Schlosshauer, "Decoherence," pp. 33–49.
65 See Crull, "Quantum Decoherence," p. 207, p. 209, p. 210.
66 See Crull, "Exploring Philosophical Implications," pp. 877–879. I draw here on Crull's philosophical interpretation of the "mathematics" of decoherence. For this interpretation, which discusses technical terms like the so-called "preferred basis" and the so-called "eigenstates," as well as the question of probability and statistics, compare especially Crull, "Quantum Decoherence." Crull here points also to the fact that decoherence names the lasting difficulties to control,

Gravitational Feel, with its non-fixed surround, senses this intertwining between infinite entanglement and specificity. Here, each strand of its quipu-like fabric surpasses the outlines of the "here-now," as each is variously knotted and underwritten with an opaque record of references to vital matters, moments and histories: the reason why each touch, each entangling of this environmental composition comes with different effects and implications. The profound sensibility *Gravitational Feel* exhibits is that everything one encounters becomes (as) a tangled "spectrum" traversed by uncountable other tracks and traces, including the marks of ungeneralizable violences, as Frédérique Bergholtz and Susan Gibb highlight the resemblance of the sculptural performance's architecture with instruments of flagellation.[67] This is, then, about more than just that everything becomes in an uncontrollable manner (in both senses of the word). In the midst of *Gravitational Feel*'s environmental denseness, and in discussion with *Who Touched Me?*, felt significance is given to what is bracketed: "Our bodies are anything but fixed—they are constantly morphing (some more than others)."[68]

5. Besides One Flow: Living Around

It is thus indispensable to systematically call into question the lived-by narrative of existence as a matter of substantial solidity. So that, to start again with Woolf's introduction, any invocated return to life as a compact and hand-tight "thing" loses its all-too-impactful standing. It is such a need for a systemic questioning attitude that is expressed in the range of today's ontological modes of inquiry. There is, however, also a need

compute, and put to work the world's quantum dynamics (see ibid., pp. 206–207).
67 See Bergholtz and Gibb, "Introduction," p. 2.
68 Moten and Tsang, *Who Touched Me?*, p. 49.

to retract from the tendency to implicate lived exis-
tences in a basic metric, into "the waves" of one grand
becoming, universally applicable independent of life's
"ontics." When ontology today, through its animation
by natural scientific insights, detects such an elemen-
tal *more* and applies it to all beings from scratch, in the
end, this essay is about confusing this *more* with exis-
tence's profound incompleteness:[69] to where its "stuff"
is always already a matter of its entangled life-condi-
tions. This shift in emphasis doesn't sidestep ontologi-
cal questioning nor its natural scientific texturing. But
what it does is hand it over to the already given contex-
tualizing work that existence does and speaks of, from
and out of the margins of ontology's expertise, radically
displacing ontological footings towards articulations
of life that exist, not least, against the backdrop and in
inheritance of dispossession, denial and destruction. For
now, then, the contrapuntal theoretical work and prac-
tices with which I have been engaging, along and beside
the rhythmics of attraction that an ontology of one flow
might exude, return to the following opening: that after
all, in every sense, "down to the ground," it is still a
question of the open rounds through which existences
are around.[70]

69 In reference here, again, to Moten's "more + less than one."
70 This is also a late nod to Judith Butler and her reading of Walter Ben-
jamin's notion of an everlasting "rhythm of transience," with which
Barad also engages extensively (see Barad, "What Flashes Up"). But-
ler ends this reading with the questioning lines: "[M]usic to some-
one's ears, but whose, and in what key? And who will be around
to sense it?" See Judith Butler, "One Time Traverses Another: Ben-
jamin's 'Theological-Political Fragment'," in *Walter Benjamin and
Theology*, ed. Colby Dickinson and Stéphane Symons (New York:
Fordham University Press, 2016), pp. 272–285, p. 285.

Beny Wagner

Plasmaticness and the Boundaries of Human Perception

In recent years, I have observed a prevalence of artistic practices that explicitly aim to reach beyond the limitations of human perception in order to formalize expressions of a continuum between human and nonhuman entities.[1] The motivations driving this expansion of human subjectivity into previously imperceptible realms might include, but are not limited to: wide scale recognition of the destructive impact of human behaviors towards other life forms manifested in perpetual ecological crises, the discoveries in recent decades of a deep material continuity between the human body and the environment on a microbiological scale, a historical decentralization of human subjectivity made tangible through networked technologies. Contemporary artistic practices have grappled with such issues through a wide range of expressions by attempting to make scientific knowledge approachable through the senses. The central challenges of this task involve developing new aesthetic frameworks capable of mediating processes that are either too big or too small, too slow or too fast; in other words, too widely distributed through space and time to be absorbed by the unmediated human perceptual apparatus. What do long term changes in an ecosystem look or feel like for the human perceiver? How might we consciously experience the decentralized functions of the microbiome? How do we grasp the ways in which

1 See for example the work of artists such as Annika Yi, Jenna Sutela, Andreas Greiner, Ian Cheng.

agency is exchanged between different life forms? As an artist and filmmaker, I am particularly invested in exploring how moving image media, in their relationship to indexicality and time, confront such questions. Throughout their history, moving image technologies have been crucial mediators between human perception and processes that unfold in otherwise imperceptible spatiotemporal dimensions. The historical emergence of cinema was predicated on the realization that a sequence of images set in movement at a rate of twelve or more frames per second, allows the human eye to perceive a continuous duration. This newfound ability to reproduce duration was simultaneous with the realization that such a constructed duration is malleable; it can be slowed down to create slow motion or accelerated to create time-lapse. These techniques, central to the use of moving images in science as in art, demonstrate the tension manifest in the human drive to transcend its perceptual limitations. On the one hand, moving image technologies allow us to perceive—and crucially, to acknowledge—the many nonhuman processes among which human life unfolds and upon which humans depend. On the other hand, moving images absorb the many heterogeneous dimensions of different life forms or distributed processes into the specifically determined logic of cinematographic motion, actively transforming the objects of inquiry in the process. Can moving image technologies de-center human subjectivity to the extent that it would be possible to escape the limitations of human perception, or do we, in the process of trying to make nonhuman entities and processes comprehensible to us, alter the nonhuman to fit into our limitations? Is it possible to recognize the broader implications and potential pitfalls of the human drive to reach beyond itself?

In the following text, I situate these concerns in two specific historical objects that I have found illuminating with regards to the central tensions and contradictions

in the cinematographic extension of human subjectivity into nonhuman life forms and processes. The first half of my inquiry concerns Sergei Eisenstein's concept of "plasmaticness," a theory of continuum between human and nonhuman processes that the cinema, according to Eisenstein, allowed humans to experience directly. Originally formulated in the early 1940s in response to Eisenstein's admiration of Walt Disney's animated films, the concept of plasmaticness emerged from a broader discussion among early filmmakers and commentators about the perceived privileged access that cinema had to "life." The relationship of cinema to a particular conception of life in the first half of the twentieth century was not simply metaphorical or poetic. In order to underline this, I will also deal with the scientific application of cinematography to microscopic observation—microcinematography—which produced unprecedented views of organic processes. Films of cellular generation and transformation testified not only to fundamental building blocks of life but to a fluid exchange between the human and nonhuman. Cinematography was the means by which interdependencies between entities and scales were made visible. But in fusing organic movement to cinematographic movement, it became difficult if not impossible to determine where agency was situated, whether in the otherwise imperceptible organisms or in the technology itself.

The second half of the text contrasts the idealism with which Eisenstein conceived of plasmaticness with the short educational film *The Enemy Bacteria*, produced by the US Navy in 1945. Made in exactly the same period as Eisenstein was elaborating the qualities of plasmaticness in relation to Disney animations, *The Enemy Bacteria*, produced by several Disney animators, combined animated cartoons, microcinematography, and live action to construct a narrative of microorganisms as dangerous and unruly forces of nature. For Eisenstein, the plasmatic fluidity that eradicated the boundaries between

human and nonhuman beings was a revolutionary force of liberation from the shackles of a cultural logic of regulation, but for the creators of *The Enemy Bacteria*, the same ability of organisms to fluidly transform, made visible through the same techniques of animation, represented a grave threat to humans, one that needed to be dominated.

The stark, even polar, contrast between these two approaches to the cinematographic mediation of nonhuman life, is, I believe, not simply a matter of ideological perspective, but is in fact constitutive of the material conditions of moving image technologies in themselves. The tension between perpetual transformation and regulation, fluidity and stasis, freedom and domination, is present at the base level of cinematography, before any decision has been made as to what kind of images should be made and to which purpose they should be applied. By reading the concept of plasmaticness in relation to *The Enemy Bacteria*, I aim to probe the ways in which technological mediation extends human subjectivity and the conclusions such extension affords about the nonhuman processes within which human lives emerge.

Plasmaticness

Sergei Eisenstein wrote the sketches for his essay *On Disney* between 1941 and 1945. In these writings, he formulated the concept of plasmaticness, a term that combined a range of ideas about movement, change, plasticity, fluidity and rhythm that pervaded the ideas of many filmmakers and commentators of the early cinema. In trying to define plasmaticness, Eisenstein repeatedly appealed to a primal power of ceaseless transformation exhibited by organisms, but also by fire or water, a quality of things that "behaves like the primal protoplasm, not yet possessing a stable form, but capable of

assuming any form."[2] Eisenstein understood this primal protoplasm to be pulsing through the moving image. Cinema, in his conception, was not a passive receptacle of plasmaticness but its very catalyst; it had managed to break through the layers of cultural convention that had buried the primal force of metamorphosis under its logic, and tap into the flow of life itself. Plasmaticness emerged from the union of a prototypically modern technology—cinematography—and the boundless energy of organic transformation unbound to cultural logic or history. Plasmaticness didn't simply impart organicism to the apparatus, or mechanism to living things,[3] but as Esther Leslie elaborates, it usurped the very idea of nature, so that: "nature becomes non-nature, anti-nature, something in movement."[4] The power of plasmaticness was its *integration* of elements—human, organism, mechanism—that have been conceptually separated by a culture that Eisenstein viewed as "shackled by logic, reason, or experience."[5] Walt Disney's animations, particularly from the *Silly Symphonies* series (1929–1939) pulsed and vibrated with plasmaticness (fig. 1). The seemingly inexhaustible plasticity of the figures that stretched, contorted and metamorphosed on screen was, in Eisenstein's eyes, the manifestation of an elemental force: "Disney's art [is] the purest model of *inviolably natural* elements, characteristic of any art and here presented in a chemically pure form."[6] Eisenstein depicted Disney as a sort of modern magician who had learned to conjure the otherwise invisible rhythm of life itself and transform it into the vibrant beings

2 Sergei Eisenstein, *On Disney*, ed. Jay Leyda, trans. Alan Upchurch (London, New York, and Calcutta: Seagull Books, 2017), p. 32.
3 Thomas Lamarre, "Coming To Life: Cartoon Animals and Natural Philosophy," in *Pervasive Animation (AFI Film Readers)*, ed. Suzanne Buchan (New York: Routledge, 2013), pp. 117–141.
4 Esther Leslie, *Hollywood Flatlands: Animation, Critical Theory and the Avant-Garde* (London and New York: Verso, 2002), p. 230.
5 Eisenstein, *On Disney*, p. 6.
6 Ibid., p. 20.

Fig. 1: Film still from *Merbabies* (dir. Walt Disney, USA 1938).

on screen. The experience of freedom that came from watching the process of perpetual transformation had far reaching implications for Eisenstein, who initially saw in Disney a force of liberation "for the suffering and unfortunate, the oppressed and deprived. For those who are shackled by hours of work and regulated moments of rest, by a mathematical precision of time, whose lives are graphed by the cent and dollar."[7] Plasmatic cinema had the power to fuse the elemental power of organic change with individual experience and in the process, awaken a primal force latent within each person as the desire for freedom as transformation.[8]

7 Ibid., p. 8.
8 Plasmaticness emerged from a range of ideas and concepts about life, movement and change that drove both practitioners and theorists of early cinema, including Germaine Dulac, Jean Epstein and Jean Painlevé, to point to a few of the best-known thinkers who sought to understand cinema as a set of relations intertwined in the transformation of living things. Recent scholarship in film and media studies has sought to recontextualize these figures and their perspective on cinema, as film scholarship departs from the psychoanalytic and semantic approach of mid and late twentieth century film theory, to views of cinema as an evolving set of material, ecological, energetic

Fig. 2: Film still from *Spirochaeta Pallida (Agent de la Syphilis)* (dir. Jean Comandon, France 1909).

If life is that which moves itself, and cinema produces motion, is cinema life? In his work on the history of animation, Thomas Lamarre refers to the "movement-as-life"[9] paradigm, so central to the scientific and philosophical investment in early moving images, and which invokes the dual meaning of the word animation: at

and affective relations. The preoccupation of early cinema with notions of life, movement and change therefore presents a rich reservoir of ideas for recent scholarship to recontextualize the moving image in those relations. Examples of recent scholarship in this area include but are not limited to: Inga Pollmann, *Cinematic Vitalism: Moving Images and the Question of Life* (Amsterdam: Amsterdam University Press, 2018); Teresa Castro, "An Animistic History of the Camera: Filmic Forms and Machinic Subjectivity," in *A History of Cinema Without Names*, ed. Diego Cavalotti, Federico Giordano, and Leonardo Quaresima (Milan and Udine: Mimesis, 2016), pp. 247–255; John Mackay, "Film Energy: Process and Metanarrative in Dziga Vertov's *The Eleventh Year* (1928)," *October* 121 (2007), pp. 47–78; Katherine Loew, "The Spirit of Technology: Early German Thinking about Film," *New German Critique* 122 (2014), pp. 87–116; Shane Denson, *Postnaturalism: Frankenstein, Film, and the Anthropotechnical Interface* (Bielefeld: transcript, 2014); Jesse Olszynko-Gryn and Patrick Ellis, eds., *The British Journal for the History of Science (*Special Issue: *Reproduction on Film)* 50, no. 186 (2017).

9 Lamarre, "Coming To Life," p. 118.

once a humble gesture of making something move, and at the same time, the mighty act of bringing something into being. The slipperiness between these two meanings is nowhere more apparent than in the emergence of microcinematography, which can be traced to as early as 1891, in Étienne-Jules Marey's application of chronophotography to microscopes.[10] Much more than a tool of representation, microcinematography was, as Jimena Canales writes, "a metaphysical machine";[11] in providing unprecedented access to the movements of organic transformation, microcinematography was a central foundation of cinema's ontology. Working at the intersection of science and film, figures such as Jean Comandon, F. Martin Duncan, Frank Percy Smith and Jean Painlevé introduced views of moving and transforming microorganisms into the public sphere such as Comandon's hugely popular early films showing the bacteria that caused syphilis (fig. 2). While early microcinematographic films were often viewed in the context of entertainment, Hannah Landecker outlines the profound implications such films had in the cultural and scientific imagination: "For both biologists and cultural observers, these [microcinematographic] films were experiments in seeing and perceiving life, not just living things, but that which was understood and narrated as the fundament of life."[12] Eisenstein's concept of "plasmaticness" emerged from a close engagement with the vibrant exchange between the cinema and the life sciences. Marie Rebecchi has pointed to Eisenstein's close friendship with Jean Painlevé, as evidence of how closely Eisenstein's own ideas grew from his encounters

10 Oliver Gaycken, "'The Swarming of Life': Moving Images, Education, and Views Through the Microscope," *Science in Context* 24, no. 3 (2011), pp. 361–380, here pp. 361–366.
11 Jimena Canales, "Dead and Alive: Micro-Cinematography between Physics and Biology," *Configurations* 23, no. 2 (2015), pp. 235–251, here p. 237.
12 Hannah Landecker, "Cellular Features: Microcinematography and Film Theory," *Critical Inquiry* 31, no. 4 (2005), pp. 903–937, here p. 905.

with scientific films, such as Painlevé's *Mouvement du protoplasme d'Élodea canadensis* from 1927, which must have influenced his theory of a primal protoplasm.[13] It is clear, when Eisenstein refers to Disney's cartoons as "the purest model of *inviolably natural elements*,"[14] he is drawing on an idea of life as essence. Microcinematographic films, which presented what Oliver Gaycken calls the "swarming of life"[15] everywhere in our midst, seemed to validate the idea that *life* was a unifying flow that permeated but was separate from specific *lives*.

Yet the movements of life forms glimpsed through microcinematography were inseparably fused with cinematographic movement, presenting a perspective of organic movement that exists nowhere outside of the moving image. Microcinematography combined the microscope's spatial magnification with the "temporal magnification" afforded by time lapse techniques. By recording a cell, for example, at regular intervals, and recombining each image into an animated sequence, it became possible to observe microbiological processes that are otherwise too slow or too fast to be observed by the human eye and microscope alone. In this way, the spatial and temporal dimensions intrinsic to microorganisms are converted into what Marie Rebecchi calls the "hetero-temporality of the vegetal world."[16] Organic phenomena are contorted to perform an altered version of their own transformation, shaped by the standards of cinematography, which themselves derived from the study of the human physiology of perception.[17] In early

13 Marie Rebecchi, "'The Beginning of Life'. The Birth of the Cinema, the Birth of a Flower," *La Furia Umana* 39, http://www.lafuriaumana.it/index.php/73-archive/lfu-39/947-marie-rebecchi-the-beginning-of-life-the-birth-of-the-cinema-the-birth-of-a-flower (accessed October 29, 2021).

14 Eisenstein, *On Disney*, p. 20.

15 Gaycken, "The Swarming of Life."

16 Rebecchi, "The Beginning of Life."

17 See Jonathan Crary, *Suspensions of Perception: Attention, Spectacle and Modern Culture* (Cambridge, Mass.: MIT Press, 2001); Pasi Väliaho, *Mapping the Moving Image: Gesture, Thought and Cinema*

microcinematography, what appeared to observers as unprecedented access to the miracle of life in its primordial form, was, in fact, the technological regulation of organic movements necessary for their conversion into spatial and temporal scales that could be perceived by humans.

Animation, whether applied to indexical images, such as photographs taken through a microscope, or line drawings requires highly complex technical regulation of motion in order for it to be perceived as fluid. As Phillip Thurtle writes:

> In animation, the immediate task is not, how does one put this world into motion [...], but, rather, how does one best create stability in a world prone to constant change? [...] The need to create stability in animation images is so important that a student of animation can fruitfully think about the history of animation as the development of techniques for regulating how images change over time.[18]

Thurtle's insight has meaningful implications for how to consider the tension between the perception of fluidity encapsulated in plasmaticness and the technical regulation that is ingrained in cinematography. How do we reconcile the tremendously compelling notion that animation can summon a plasmatic force of primordial life with the material conditions of regulation necessary to produce the perception of fluid movement?

circa 1900 (Amsterdam: Amsterdam University Press, 2010); Henning Schmidgen, *The Helmholtz Curves: Tracing Lost Time*, trans. N. F. Schott (New York: Fordham University Press, 2014); Ute Holl, *Cinema, Trance and Cybernetics* (Amsterdam: Amsterdam University Press, 2017).

18 Phillip Thurtle, *Biology in the Grid: Graphic Design and the Envisioning of Life* (Minneapolis and London: University of Minnesota Press, 2018), p. 184.

The Enemy Bacteria

The tension between fluidity and regulation under-
lay every aspect of production in the Disney anima-
tion studios. While part of the "magic" of early Disney
animations was the apparent ease and flexibility with
which the animations moved, this perceived fluidity
was enabled by a vast workshop of laborers whose job it
was to create the technical conditions of stability within
which the perception of fluidity could take place. Given
that the actual design and animation of all the Disney
characters were done by other animators, Disney's true
innovation was in creating the conditions in which the
labor of movement regulation could become industri-
alized.[19]

In 1945, exactly as Eisenstein was working on his
essay on Disney's plasmaticness, a number of the key
animators from the Disney workshop (Dick Lundy, who
animated many of the *Silly Symphonies* as well as *Snow
White* [1937], Grim Natwick, who likewise worked on
Snow White and early Mickey Mouse films, and Art
Heinemann, one of the main animators on Disney's *Fan-
tasia* [1940]) worked on the animated sections of a short
educational film titled *The Enemy Bacteria*, produced by
the US Navy.[20] The film integrates live action, microcin-
ematography and cel animation to depict a scenario in
which bacteria, invisible to the naked eye, infiltrate a
hospital patient undergoing surgery and cause him per-
manent disability. Despite being labelled as educational,
the film, somewhat bizarrely, doesn't impart any les-
son, such as how to better avoid infections. Instead, an
almost comically misanthropic voiceover leads viewers

19 See Leslie, *Hollywood Flatlands*; Sean Cubitt, "Ecocritique and the
Materialities of Animation," in *Pervasive Animation (AFI Film Read-
ers)*, ed. Suzanne Buchan (New York: Routledge, 2013), pp. 94–114.

20 Jerry Beck, "The Enemy Bacteria (1945)," *Cartoon Research*, June
19, 2013, https://cartoonresearch.com/index.php/the-enemy-bacte-
ria-1945-2/ (accessed October 22, 2021).

towards a view of bacteria as an invisible enemy against which any feeble human attempts to protect themselves are rendered hopeless.

The film is remarkable in the context of this study, because of the way in which the bacteria are depicted using the very same animation techniques that were cultivated in the Disney studios and which Sergei Eisenstein hailed as plasmatic. If the Disney animations in which Eisenstein identified plasmaticness behaved like the primal protoplasm whose incessant metamorphosis was the very force of *resistance* to control, *The Enemy Bacteria* adopted the same animation techniques to depict bacteria as a rogue force of nature whose resistance to control must be dominated at any cost. The bacteria are first introduced via microscopic images, framing them within a context of nonnegotiable scientific authority. But their real plasmaticness is represented figuratively, by means of cel animations. Midway through the film, a doctor visits the patient who has undergone surgery to check up on his recovery. While everything seems fine on the live action surface appearance, another crash zoom into the patient's plastered leg transports the viewer into the body's interior. At the end of several animated crossfades depicting the various layers of the body, we encounter a plump and slightly sinister looking cartoon microbe, taking a nap in the middle of a blood clot, which is depicted in the style of ominous lairs familiar from many early cartoons. Suddenly a tremor passes through the microbe, whose humanoid features jolt into the expression of surprise. The tremor becomes increasingly violent until the microbe's elastic body splits in the middle to become two identical, fully formed versions of the first (plate 8). What is particularly striking about the logic of this sequence is that the humanoid character of the bacteria is depicted as shocked by the plasmatic force that overrides its anthropomorphized identity. The untameable force is not bound to the figures themselves but merely

occupies them in the service of its ceaseless reproduction and transformation, which the viewer is being taught to understand as dangerous and threatening. Even though cel animation has been very explicitly applied in this case in order to depict physiological processes that otherwise elude visibility, the logic of this scene leads to the conclusion that the animations themselves are ultimately driven by a force that remains obscure behind or in between the characters to which it momentarily bestows form. As we identify, to some extent, with the anthropomorphized bacteria, we also come to understand our own bodies to be inhabited by some greater, unruly force.

In her comprehensive study of the turning point in Disney's history, marked by *Snow White* (1937), the first animated feature film ever, and the outbreak of the second World War, Esther Leslie addresses Eisenstein's disenchantment with the post-*Snow White* Disney. It seemed that Disney's focus had turned towards disciplining viewers, whether in the romantic nostalgia for a lost innocence personified by *Snow White* and shortly after by *Bambi* (1942), or in the ideological propaganda of animations made for the US military by the Disney studios. Had Eisenstein seen *The Enemy Bacteria*, he would have surely despised it for compromising his idea of the plasmaticness that had appeared so revolutionary in Disney's early work. Yet in the tension between the ideal of plasmaticness, and the multiple processes of regulation necessary to produce the perception of fluidity in cel animations and microcinematographic films, we can observe a particularly poignant intersection between scientific observation, technological mediation and cultural narratives. *The Enemy Bacteria* incorporates every aspect—scientific, technological, rhetorical, aesthetic—of the biopolitical absorption of organic fluidity into the logic of technoscientific regulation. In merging live action, microcinematography and cel animation, the film shows how the material con-

figuration of animation techniques establishes certain underlying possibilities of observation and how these in turn shape the cultural narratives that influence how humans come to perceive the boundaries of self, somewhere between the machine and the organism, the concrete form and the invisible plasmatic force.

Conclusion

In this text I have sought to explore Eisenstein's plasmaticness as a powerful concept of continuity between life forms and processes, central to the medium of moving image. In doing so, my aim was also to problematize any straightforward readings of the concept, in order to draw out its latent contradictions. I find that the nuances of these contradictions illuminate tensions that continue to reverberate through contemporary artistic and scientific practices engaging with fundamentally unknown nonhuman agencies through technological means. The medium of moving image, in particular, demonstrates that the challenges of stretching beyond human subjectivity are not only about intention or narrative, but are ingrained in the material conditions of mediation and that these create the foundation upon which perception is possible.

As I see it, the central challenge in reaching out towards the nonhuman lies in how we might engage with a multiplicity of spatial and temporal dimensions within which heterogeneous entities and processes unfold, without in the process forcing these to transform into altered and therefore partial versions of themselves in order to be perceivable by humans. In my own practice, this involves acknowledging that the embodied human position, even when extended through technological means, cannot understand everything, and that the drive to create a comprehensive whole is itself an inherent quality of structural violence. An operative "plasmaticness" would

therefore have to account for multiple orders of being, situating what we can experience directly in relation to everything we can't. While technologies enable us to extend our senses, it is equally important to develop a means of engaging with absence as a form of recognition and perhaps celebration of the inevitable limits of human subjectivity. Cinematography does this, even if indirectly, since its operations are predicated on our inability to perceive the gaps between frames. A concept that includes absence not as something to overcome, but as a plasmatic force in itself, would then also allow for the recognition of heterogeneity that is essential to life processes.

Unruly Liquids

Yvonne Volkart

Flowing, Flooding, Fibbing

From Fluid Subjects to Environmental Becoming

> *"Fluid—like that other, inside/outside of the philosophical discourse—is by nature, unstable. Unless it is subordinated to geometrism, or (?) idealized."* Luce Irigaray[1]

> *"I am a singular dynamic whorl dissolving in a complex, fluid circulation."* Astrida Neimanis[2]

Representations of techno-organic bodies in which something had become fluid populated the media and art at the turn of the millennium. Doll bodies appeared, numerical bodies, bodies subjected to algorithms. There were cyborgs, whose sex characteristics were mutilated or erased, and whose gender seemed somehow strange, feminized. While in the 1990s the beings were human-like, they began to transform into fluid structures, relational entities and microcellular collectives at the beginning of the twenty-first century. From today's perspective, one would say they became environmental.[3]

1 Luce Irigaray, *This Sex Which Is Not One* (Ithaca and New York: Cornell University Press, 1985), p. 112.
2 Astrida Neimanis, "Hydrofeminism: Or, On Becoming a Body of Water," in *Undutiful Daughters: Mobilizing Future Concepts, Bodies and Subjectivities in Feminist Thought and Practice*, ed. Henriette Gunkel, Chrysanthi Nigianni, and Fanny Söderbäck (New York: Palgrave Macmillan, 2012), pp. 85–100, here p. 85.
3 This text has been written in the context of my research project *Eco-data–Ecomedia–Ecoaesthetics* (2017–2021), funded by the Swiss National Science Foundation, and hosted by the Academy of Art and Design FHNW Basel. https://www.fhnw.ch/de/forschung-und-dienstleistungen/gestaltung-kunst/forschung/forschungsprojekte-des-in-

I investigated this phenomenon in my dissertation *Fluide Subjekte. Anpassung und Widerspenstigkeit in der Medienkunst.*[4] Referring to scholars such as Fredric Jameson, Donna Haraway and Gilles Deleuze, I read these images of fluid bodies as concepts of subjectivity in times of "immaterial" and "fluid" techno-capitalism. My thesis was that images of fluid bodies and genders negotiate "fluidizing" effects in global capitalism and short-circuit them with images of psychic and physical constitutions of dissolution and/or salvation. I showed that bodies and genders literally liquefied, becoming feminine and queer, when subjectivity reached its limits, when normativity was threatened to be "liquidated." And I showed that this liquefaction and feminization of battered subjectivity has a history in art: it has been culturally idealized since Romanticism and Surrealism—the times of the beginning of industrialization and of the full mechanization of everyday life.[5] The notion that new technologies "feminize," minoritize or queer the body and destroy androcentric subjectivity is echoed in those positions that record and mourn the loss of the dominant fictions of the "strong man" and celebrate it as a (redemptive) re-embodiment in the feminine. I stated that these phantasms of liquidity embody the two sides of the coin and fulfill a rather conventional affectivity between horror and salvation. Referring to artists such as Matthew Barney and Mariko Mori, I criticized that such images of resolved fluid "femininity" help naturalize our state of being in the "control

stituts-kunst-gender-natur-iagn/ecodata-ecomedia-ecoaesthetics (accessed October 28, 2021). It draws on material previously published as "Matrix, Mother Animal, Birth Mother, Uterus: From Cyberfeminism to Techno-Eco-Feminisms," in *Producing Futures*, ed. Heike Munder (Zurich: JRP Editions, 2019), pp. 18–34.

4 In English: *Fluid Subjects. Adaptation and Unruliness in Media Art.* Yvonne Volkart, *Fluide Subjekte. Anpassung und Widerspenstigkeit in der Medienkunst* (Bielefeld: transcript, 2006).

5 Silvia Eiblmayr, *Die Frau als Bild. Der weibliche Körper in der Kunst des 20. Jahrhunderts* (Berlin: Reimer Verlag, 1993).

society" and stabilize current forms of global capitalism. "Femininity" lends itself well because it is already a cultural-historical topos in relation to images of the fluid, the open, the oceanic, the utopian.[6]

However, beyond these dominant phantasies, I also found promising models of becoming fluid, which again and again eroded identities and images, and succeed in diffusing meaning. I emphasized the thesis of the fluid symptom and effect body. That is, the body that symptomatizes phantasms and forces of the fluid, like digital media, cybernetic circuits and finance capital, but that simultaneously transforms these "immaterial" flows into body fluids and discharges them, for example, as stinking secretions. In this artistic strategy of materializing and re-embodying the disembodied flows of the capitalism-machine, I perceived possibilities to deconstruct *and* reappropriate "for theirself" the power of the fluid and its metaphors. Examples were the video essays of Ursula Biemann, (*Performing the Border* was the first in a series), the *Cyberfeminist Manifesto for the 21st Century* by VNS MATRIX[7], videos like those of Jennifer Reeder (*White Trash Girl*) and Ashley Hans Scheirl (*Dandy Dust*) (plate 9) as well as Shu Lea Cheang's sci-fi porno *IKU*. Their strategic identification with womanhood as fluid and abject refers to an association found in many cultures, as Julia Kristeva and, expanding on her work, Elisabeth Grosz demonstrated. The cultural unconscious fantasizes the female body as a perpetually leaky vessel and source of smelly discharges.[8] Feminists such as Luce Irigaray, Hélène Cixous and Julia Kristeva took up these attributions in the 1970s and appropriated them

6 Klaus Theweleit, *Male Fantasies: Vol 1.: Women Floods Bodies History* (Minneapolis: University of Minnesota Press, 1987).

7 VNS Matrix, *A Cyberfeminist Manifesto for the 21st Century*, https://vnsmatrix.net/the-cyberfeminist-manifesto-for-the-21st-century/ (accessed October 23, 2021).

8 Elisabeth Grosz, *Volatile Bodies. Toward a Corporeal Feminism* (Bloomington and Indianapolis: Indiana University Press, 1994). See also Hannah Schmedes' contribution in this book.

for a feminist theory of fluid subjectivity, femininity, and writing/speaking as a woman. In the 1980s, European difference feminism and its supposed essentialism were harshly criticized within feminist ranks. It is only recently, apart from the cyberfeminists' interest in them in the 1990s, that they are reread.

"My Body is Marshland, Estuary, Ecosystem"

While the discourse about fluidization has been quiet for more than a decade, in recent years it has been discussed with a newly awakened urgency. Various exhibitions are dedicated to the topic.[9] In the meantime, the (metaphor of the) fluid has become unimaginably environmental due to the rapid melting of the poles, the coronavirus pandemic, and the flood disasters of 2021 in Central Europe and Asia: the anthropogenically caused climate heating—the Anthropocene—is experienced not only as drought and desertification, but also on the contrary as melting and (over)flooding, as (viral) intrusion and dissolution of the stable. In other words, not only fixed subjectivity liquefies, but also the built worlds of artificial paradises and the grounds of planetary existence erode.

Thus, this contribution was a good opportunity to revise my old research and to seek for continuities and changes in artistic articulations of the fluid. Does it make sense, to speak in this context of a cultural logic of environmentalization, as the editors propose? If so, what could be gained? Drawing on three contemporary art projects, I want to show that we can observe both a (feminist) rearticulation—I call it a "counter appropriation"—of the fluid and the articulation of a cultural

9 A prominent example is the thirteenth Shanghai Biennale *Bodies of Water* (2020/21), which is cooperating with the e-flux journal: https://www.biennialfoundation.org/2020/05/bodies-of-water-the-13th-shanghai-biennale/ (accessed October 28, 2021).

logic of environmentalization. The art of *flowing, flooding, fibbing* succeeds, so I claim, in breaking up naturalizations by means of strategies of counter appropriation and in producing a surplus of meaning towards the liveliness of being-with.

When I speak of environmentalization, I mean not only the dispersal of media technologies into the environment, and the becoming onto-power of (mobile) computing and datafication. In addition, and contrary to this technical takeover of the planet, there is a new sensibility toward planet Earth's grounding on physical forces like atmospheric and oceanic flows, and humans' dependence on them. Think of the container ship that blocked the Suez Canal for six days due to strong winds, or the COVID-19 pandemic. Both generated, among others, default in delivery of electronic goods and economic depression. Technologies are everywhere, but "nature" is everywhere, too. "Gaia intrudes," Isabelle Stengers says. Gaia is a "ticklish being" that not only backfires when she is offended, she is also "blind to the damages she causes, in the manner of everything that intrudes."[10] Countering the dominant perception of climate change as something "distant and abstracted," Astrida Neimanis and her colleagues propose "our relationship to climate change as one of 'weathering'."[11] These new perceptions of the onto-power of the material world reveal the becoming-environmental of the body. They open up to what I will call "environmental becoming."

Furthermore, I want to re-articulate Fredric Jameson's words from 40 years ago, that "a whole new type of emotional ground tone—what I will call 'intensities'"—

10 In Isabelle Stenger's adaptation, "Gaia" is neither Earth "in the concrete" nor the connective cybernetic organism of Deep Ecology; rather it is an ontological force, beyond humanity, beyond all the various species inhabiting Earth. Isabelle Stengers, *In Catastrophic Times. Resisting the Coming Barbarism* (Lüneburg: Open Humanities Press in collaboration with meson press, 2015), p. 43.

11 WEATHERING. a collaborative research project: http://weathering-station.net/about/ (accessed October 26, 2021).

emerged.[12] Two generations after Jameson's words, the new emotional ground tone in the arts performs touching instead of coolness, intimacy instead of surface, mourning and empathy instead of irony, and immersion instead of essayism. In short, we perceive an affective turn and a loss of critical distance, as Jameson already observed. It led him to plead for "an aesthetic of cognitive mapping— a pedagogical political culture which seeks to endow the individual subject with some new heightened sense of its place in the global system."[13] In the heyday of globalization, Jameson dreamed of an aesthetics, in which art became a medium of knowledge transfer. He did not despise this pedagogical function as qualitative bad art, as the modern art ethos did at those times, whereas today, we find it quite normal, that art may deliver knowledge.[14] Postmodernism is for Jameson, as he pointed out later, "the culture of globalization, and globalization is the third phase of capitalism."[15] He believed that the global economy and the cultural logic of globalization are synonymous, and that cartographic strategies could help to disclose the power relations and develop human agency. Jameson's aesthetics of "cognitive mapping" has been proved very vital. Mapping as a counter strategy has been adopted and adapted by many artists up to the present, especially in the context of new media (graphs), surveillance technologies (GPS, sensors, drones), and social and environmental justice movements.[16]

12 Fredric Jameson, "Postmodernism, or the Cultural Logic of Late Capitalism," in *New Left Review* 146 (1984), pp. 53–92, here p. 58.

13 Ibid., p. 92.

14 See more specifically Tom Holert, *Knowledge Beside Itself. Contemporary Art's Epistemic Politics* (London: Sternberg Press, 2020).

15 Jameson in German: "Die Postmoderne ist die Kultur der Globalisierung, und die Globalisierung ist das dritte Stadium des Kapitalismus," in Tomislav Medak, "Menschen über neue Realitäten belehren. Interview mit Fredric Jameson," in *Springerin* 3 (2000), https://www.springerin.at/2000/3/menschen-uber-neue-realitaten-belehren/ (accessed October 26, 2021).

16 We might consider Frédérique Aït-Touati/Alexandra Arènes/Axelle Grégoire's cartographies of the inhabited space of the "Critical Zones" as the continuation of such a "cognitive mapping." See the exhibi-

In the new cultural logic of environmentalization the new emotional ground tone is understood as deeply political: there is nothing left except your sorrow in a world in which individual (and even collective) action seems doomed to fail due to the power of, and our involvement with the economy of, extractivism.[17] Thus, awareness of the mutual dependence of beings on each other, of the human on the non-human, of the fragility of co-existence, and the need to come into another mode of living has become the great theme of innovative artistic practices today. Much of the current interest in flow, including my own, is referring to ontological questions in the tradition of Deleuze and Guattari's and Luce Irigaray's subject theories of the 1970s. I state that the current subject discourse of the fluid seeks techniques and events that enable and celebrate our environmentalization as a political practice of counter appropriation[18] and becoming more than human.

Therefore, many artists today, especially from ecofeminist contexts, are not afraid of bringing the quasi-essentialism of the corporeal flux back into play. Adopting different strategies, they try to escape the catastrophe and to set in motion moments of transformation in a run-down world. For example, Zurich-based artist Riikka Tauriainen translated a sentence by feminist theorist

tion *Critical Zones. Observatories of Earthly Politics*, ZKM Karlsruhe, 23.05.2020–05.01.2022: https://zkm.de/en/exhibition/2020/05/critical-zones (accessed October 28, 2021).

17 Tobi Müller quotes from a videotext of a young climate activist: "My tear is political!" [Translation by Yvonne Volkart] "Meine Träne ist politisch! Sie ist ein Zeichen davon, dass die gegenwärtige Struktur nicht mehr funktioniert, dass wir als Einzelne nichts lösen können," in "Das Sekret des Theaters sucht den Weg ans Licht," in *WOZ Die Wochenzeitung*, October 7, 2021, p. 21.

18 Thomas Edlinger has introduced the term "counter appropriation" as a critique of the tendency towards essentialist undertones in discourses of cultural appropriation. It means "forms of (re)appropriation of what is withheld, which challenge hegemonic forms of power, productively destabilize the view of the own and the foreign [...]." Thomas Edlinger, *COUNTER APPROPRIATION, donaufestival reader* (Vienna: Verlag für Moderne Kunst, 2022), editorial. [Translation by Yvonne Volkart]

Astrida Neimanis into German and proposed it as a luminous neon sign on the facade of an administrative building on the busy banks of the Limmat river: *Mein Körper ist Moor, Mündung, Ökosystem.*[19] The sentence, which comes across like an advertising slogan, addresses the people of Zurich in our corporeality as being-environmental. We might realize that the river on our doorstep is water that, connected to us physically and infrastructurally, always flows into the sea. And we might feel that even faraway waters are related to my toilet, and that I am part of this as well as of the oceans which might contain my wastes.

The title of my text *Flowing, Flooding, Fibbing* is a variation/appropriation of Luce Irigaray: "Woman never speaks the same way. What she emits is flowing, fluctuating. *Blurring*. And she is not listened to, unless proper meaning (meaning of the proper) is lost."[20] What sounds here like an attribution and fixation of womanhood as the non-fixable, and has been criticized accordingly, is an elaborate experimental search/writing/thinking/dissolving of that which cannot be fixed and seeks to hybridize any form of identarian closure (between woman and flow). Flow is less image and metaphor (for the flowing woman) than material-semiotic writing gesture. But, as Astrida Neimanis argues, materiality goes a

19 "To say that *my body is marshland, estuary, ecosystem*, that it is riven through with tributaries of companion species, nestling in my gut, extending through my fingers, pooling at my feet, is a beautiful way to reimagine my corporeality." [Emphasis Yvonne Volkart] Astrida Neimanis, "Hydrofeminism," p. 93.

20 Luce Irigaray, *This Sex Which Is Not One*, p. 112. My title is inspired by the German translation of Irigaray's sentence: "La femme ne parle jamais pareil. Ce qu'elle émet est fluent, fluctuant. *Flouant.*" *Flouant* means in English *framing*. It is translated into German with *flunkern*, which means *fibbing/telling a lie*. So, in French and German there is the phonetic wordplay with the alliteration *f* and the semantic meaning of *swindling*, which might produce a *blurring*, although *blurring* includes none of these playful associations. Thank you, Hannah Schmedes, for providing the French original version! Luce Irigaray, *Ce sexe qui n'est pas un* (Paris: Les éditions de minuit, 1977), p. 110.

step further and becomes literally *water*: "But surely, the watery body is no *mere* metaphor. The intelligibility of any aqueous metaphor depends entirely upon the real waters that sustain not only material bodies, but material language, too."[21] Not only most biotic creatures consist of more than 90% water, but also (human) language, whose sounds are formed in the mouth, with saliva, cartilage, blood, etc., and whose characters are also written with water-soluble liquids, despite computerization (which also consumes a lot of water).[22]

When we engage with the existential dimension of water and the fact of our being water, according to Neimanis it becomes clear that we human beings are not as autonomous and proper as we like to claim. Rather, we are always already leaky and porous, toxic and swampy, connected to others and collective. "It is here, in the borderzones of what is comfortable, of what is perhaps even livable, that we can open to alterity— to other bodies, other ways of being and acting in the world—in the simultaneous recognition that this alterity also flows through us."[23] Human subjectivity and identity is thus always grounded in a *with*, in cohabitation, coexistence, conviviality.[24] Not only do we not own ourselves, but we are always already hybrid, fluid, queer and trans.

21 Neimanis, "Hydrofeminism," p. 89.
22 On the liquidity of language and its connection to flows in *Before Daybreak* by Gerhart Hauptmann, see the contribution by Sebastian Kirsch in this volume.
23 Neimanis, "Hydrofeminism," p. 96.
24 "While 'cohabitation' primarily means living together, 'coexistence' refers to the coexistence of different species in the same habitat to the exclusion of competition. 'Conviviality,' on the other hand, is understood as a friendly form of togetherness and communality." Jessica Ulrich, call for papers, *Tierstudien* 22 (2022), (translation by Yvonne Volkart), https://arthist.net/archive/34710 (accessed October 10, 2021).

Dams, Knots, Patterns

What does the El Cercado dam represent for the people of the Sierra Nevada? The mamo answered: The dam is like a knot in the veins. No! It's even worse: the dam is like a knot in the anus.[25]

Carolina Caycedo's ongoing transmedia project *Be Dammed* is a good example of the new emotional tone in art, of the becoming environmental of the body and the becoming lawful subject of the other-than-human-beings, e.g. rivers.[26] In drawings, installations, collective performances, videos, satellite images, essays, and Instagram posts she problematizes the realization of huge dam projects and the privatization of water in Central and South America at the expense of the poor. Empathy and anger take turns. In addition, she tries to deal with the fact that she, as a mother, Colombian, and earthling, is affected by this destruction, but at the same time also belongs to the class of former colonialists and, as an artist living in the Global North and possessing various technologies, suffers in a different way than indigenous people living on the river.

Whirling, rushing water, waterfalls bathed in sunlight, flowing backwards or horizontally instead of vertically. They overlap with dams, forming kaleidoscopic patterns, variations of a story that is told to us during the video *A Gente Rio* (fig. 1). For centuries, indigenous peoples inhabited the banks of the Rio Doce, from which, as we hear, they have been able to make a good living with fishing and gold panning. A life that ended abruptly when a dam burst in a basin containing toxic residues at the Samarco mining company in Brazil: a

25 Carolina Caycedo, "Hunger as a Teacher," *Social Text Online. Beyond the Extractivist View*, June 7, 2018, https://socialtextjournal.org/periscope_article/hunger-as-a-teacher/ (accessed October 1, 2021).

26 http://carolinacaycedo.com/be-dammed-ongoing-project (accessed October 29, 2021).

fertile with theatrical
scenes of dreams

Fig. 1: Video still from Carolina Caycedo, *A Gente Rio/We River*, 2016,
29 min. 20 sec., 1-channel HD video.

toxic mudslide of hundreds of kilometers wiped out all
life in the water, destroying the very basis of the people
living there. In the drawing *Watu River Book* (from the
series *River Books*), the description of the dam burst is
mixed with indigenous cosmogony: according to this,
all the rivers of the world are connected like veins; the
river is grandfather; the water is nurturing mother; it
is body, part of us. Both the drawings and texts in the
Watu River Book or the people in *A Gente Rio* indicate
that there could be forms of coexistence with the river.
Even fishing or gold mining could be done differently.
For those affected to regain their rights, techniques of
resistance would have to be tested: in the video, these
are the images of devastation captured by cell phone
cameras that have found their way onto the internet
with the help of activists.

How the story of the Rio Doce (in English *Sweet River*)
or Watu, as the indigenous people call it, will develop is
left open with the film's backward or horizontal flow-
ing patterns. Will the fisherman be right, according to
whom the transnational companies will not rest until
they have transformed all local life into consumable

commodities? Will the river continue to be dammed and cursed (*Be Dammed* alludes to this phonetically as well), or will it find new patterns of flow? Repetitive overlapping images transforming into abstracted patterns and confrontations with the inappropriate bring us into the video's own time: there is the almost mythical beginning of the video with the bubbling waters and the voice-over speaking about the river as a loving being, embracing other living beings. This take is followed by dams, made from concrete and blocking the direction of the water. In these parts of the video—the waters and the bus on the dam—run backwards, so that in the video's time industrial progress is a regress, a blockage of the running linear time, evocating a strange way of circularity which is none, or at least not without friction: we commonly share the kinematical loss of linear flow and perspective. But our co-experiencing the loss of a one-dimensional perspective might also be an opening up of a multiplicity of ways of being beyond the opposition of back and forth.

When I had my intrauterine device removed in 2013, I felt that any internal or external dam, regardless of its size, can be removed or dismantled. I had it inserted in 2005 to prevent having any more children. During eight years I had an internal dam inside of me which interfered with my periods; an object designed and produced by a patriarchal system which insists on possessing and abusing women's bodies, just as it does with bodies of water. When I held the device in my hand, its T-shape evoked certain blueprints for the building of dams. The "T" and its copper sheath reminded me of electricity transmission towers and of the materials and substances which transmit electricity, energy and power in my body. I thought of my body as a field of learning. My body, my territory. My right to life, my right to territory. And I thought, when a voice is returned to the lands and waters that have been used as resources, when we take a collective stance for the earth,

for the water itself, we stop being a threat and we become a promise.[27]

Caycedo's argument leads us into the field of environmentalization as counter appropriation: although she has benefited from these "patriarchal" (body) technologies, she does not accept their origin and criticizes them. Not only does she try to free herself from them and thus show that nothing must stay as it is, but she also makes analogies between the invasive contraceptive spiral and a built dam. As problematic as such analogies between body and environment, sex, race, and the North-South divide are, in this case it leads to an identification with those to whom Caycedo does not directly belong. She personalizes a problem that is usually either dismissed as the problem of "The Others" or with which, according to the argument of Cultural Appropriation, she should not identify because her Colombian body of water is not indigenous. Both her vocabulary and her aesthetics of being flowing/dammed seem quite definite at first in their stereotypical reference. Yet her verbal offensiveness in interplay with her involvement in these technologies as accomplice, as well as the filmic staged counter-flowing and glittering image patterns in *A Rio Gente*, leave the impression of something incongruous. *Be Dammed*'s aesthetic counter appropriation of the cultural logics of the fluid and the environmental articulates as a flowing and fibbing. *Blurring*. It melts with collective movements of resistance against huge hydroelectric plants in various countries of Latin America: Carolina Caycedo conducted *Geochoreographies*, community performances with activists from Rios Vivos in Columbia (fig. 2). Together, they formed colorful interlaced body-alphabets on the riverbanks that can be easily posted on Instagram. A geochoreography is "a political act [...] performed by the body, individual or collective, being fully

27 Carolina Caycedo, "Hunger as a Teacher."

Fig. 2: Carolina Caycedo, *Geocoreografías: Aguas Para A Vida*, collective action in Ibirapuera Park in São Paulo, November 5, 2016.

aware of the relationship with its environment."[28] In the face of the catastrophe, and despite the diversity of the actors, common ground must be developed, alliances forged with all means possible, even with those technologies which take part in the depletion of this area.

Womb of the Earth

Tabita Rezaire's video *Sugar Walls Teardom* (2016)[29] is another example of this new emotional tone that seeks to reconnect with the existential flow of living in a colonized world (plate 10). The video unfolds its power not only by telling of the silent exploitation of women of color for the development of modern gynecology in the

28 Carolina Caycedo, http://carolinacaycedo.com/geochoreographies-2015 (accessed October 28, 2021).
29 https://player.vimeo.com/video/171318210 (accessed October 28, 2021).

mid to late nineteenth century, but also by performing a posthumous form of healing on and with us viewers. The video passes through various aesthetics, its two parts are held together by an underlying aesthetics of flux and flow (of energy, of uterus and ovaries, blood, tears, water, magma, advertising, invitations to shop, streams, growing plants) as well as an unremittingly fast-paced rhythm. Both this visually structured flow and the specific design of certain shots interpellate the viewers and involve them in the action. In one take, a female physician is seen framed by two black legs raised in the characteristic posture of a body in a gynecological chair. We see her speaking to "us" while hearing someone else saying in voice-over: "I am sorry to announce that your womb is traumatized due to a long and painful history of institutionalized violence." The composition of the shot puts us directly in the vulnerable position of the "black womxn" exploited "as medical testing ground for white middle class."[30]

The pink gynecological chair, initially introduced as a fun prop, has rapidly revealed itself to be a technology of subjugation. But the video does not end there. The restless ghosts of the dead haunt us, tormenting us as billowing wombs. Queen Afua, a healer who uses African spiritual practices to treat gynecological conditions, explains how to placate them. The Kundalini yoga practicing performer—it is the artist herself who studied these techniques—also champions the healing powers of meditation and the connection to the earth.

Due to the stereotypes used and the seemingly tinkered digital aesthetics, *Sugar Wall's Teardom* is reminiscent of cyberfeminist parodies of the 1990s. Yet with its focus on healing, the incorporation of indigenous techniques and mythical imageries, and the summons to build relationships with the earth, it articulates concerns that are innovations in today's discourses. The

30 Textual narration in the video.

fact that in the video a female doctor of color brings "our" uterus out, not only points to intersectionality, but also to complicity with the powerful—references that, contrary to the video's clear positioning, cancel out simple victim-perpetrator dualisms. The focus on the healing of body and earth as well as the inclusion of indigenous techniques brings up concerns that are negotiated in decolonial eco-feminism, specifically: the theft of indigenous (female) knowledge, the patenting of living beings (such as medicinal plants), the commodification of organs (such as surrogate motherhood and organ removal), and the ethics of care. And the recourse to the body, to a new ancient mode of "uterine birth-motherhood," is not just the subject of the video narrative, it is enacted as a filmic event. In addition to the aesthetic of flow mentioned above, key elements contributing to this event include the yoga teacher's incantatory voice and the fairly long session, which allows us to float off into a different state of being: the film metamorphoses into an immersive yoga lesson in which we learn to "feel" the uterus—regardless of whether we "have" one or not. Such an event is the performance of a quest to work through and to heal the problem that is commensurate to its gravity. In this video too, a certain analogy between body and environment is at work: the patriarchal dismissal of the uterus is the equivalent of the capitalist devastation of fertile land and must be overcome.

And yet something about the film remains incongruous, something chafes; the digital aesthetic refuses to be seamlessly retranslated into ancient healing practices just as, years ago, the progressive energies of cyberfeminism would not be smoothly channeled into digital technologies. It is such moments of friction that generate reality and jolt humans who affirm the uterus out of the accelerating flow of images, data, and resources.

Flowing and Fibbing

With the contemporary works, we saw that there is a bold and conscious counter appropriation of the aesthetics of fluidity as site for the reconceptualization of an alternative, relational and collective subjectivity that goes beyond the human and becomes environmental, even planetary. This counter appropriation of "the flow" as existential energy and ontology that humans share with all living beings, including the body of water of planet Earth itself, must be understood as a decolonial and feminist environmental turn which is decidedly political: it claims and takes back—socially, psychically, and environmentally[31]—what has been stolen and despised by global capitalism: the possibility and joy to become a subject, an earthling, a co-being which is porous, and open to the Other, which literally "cares" about "care," in the care-feminist sense of the word.

Like the fluid subjects of the turn of the millennium and in Surrealism, these subjects too are challenged by capitalist economy and its technologies, they too live "in catastrophic times" (Stengers), in spaces of concern, trouble and ecocide. But in opposition to the earlier concepts, their becoming fluid is not about the loss of a whole and autonomous (male) subjectivity, but about the acceptance of being a fragile and vulnerable part both of terrestrial life itself and of the conditions of the Anthropocene. This is how I understand the present cultural logic of environmentalization, and how I would answer my initial questions of what can be gained by defining it.

In this sense, the dimension of the fluid as biological, physical, and chemical reality, as water-liquid and self-acting, even intruding and flooding matter in restless circulation are given a lot of weight. And the digital is

31 To refer to Félix Guattari, *The Three Ecologies* (London and New Jersey: New Brunswick, 2000).

part of this: bodies are neither codable circuitry nor viral entities, as they were described earlier. Rather, they are affected and affectable material beings, conglomerates of age-old stories and colonial power-relations, or actual chemical molecules seeking diverse modes of interrelations and deployed as consciously operating with the unpredictability of things on a planetary level. Parody and irony have yielded to feelings of disillusionment, anguish, grief, and anger. Art articulates yearnings for empathy, care, and intimacy and rehabilitates ancient knowledge and spiritual practices. And art plays joyful, as we see in the projects of Riikka Tauriainen, Carolina Caycedo and Tabita Rezaire, with transcultural formats of knowledge transfer, deploying "a pedagogical political culture," as Jameson hoped.[32] It even could be interpreted as a further development of Jameson's "cognitive mapping." Especially in *Be Dammed*, every part of the project represents another version of a map: the *Watu River Book* consists of sketches of the course of the Rio Doce and its surroundings, accompanied with cosmological stories; the three-dimensional *Serpent River Book* performs the model of the meandering of the Magdalena River in the exhibition space combining maps, satellite photos, archive material, photos of the artist, poems etc.; *Yuma, or the land of the Friends* is a huge marble-like mural installation, made with satellite photos of the Magdalena River (*Yuma*) in Colombia, the video of the same title contains variations of maps (plate 11). Even the *Geochoreographies*, Riikka Tauriainen's neon sign *Mein Körper ist Moor, Mündung, Ökosystem* and Tabita Rezaire's *Sugar Walls Teardom* can be called maps, as they represent specific approaches to the environment (as body). These "maps" are "cognitive," because they trace and track the position of the humans in their relation to the flux of the more-than-human (bodies and rivers) and their being turned into

32 Jameson, "Postmodernism," p. 92.

liquid capital.[33] All these artists do not deliver abstract data, graphs, and values, or endless posts, as our dominant culture does, rather they condense experiences and fictions, and deliver images and concretions: as such, these "cognitive mappings" help to intervene into the abstract action of land grabbing and flooding and to translate this process into a bodily experience of common concern.

In today's cultural logics of environmentalization there is a broad interest in the appropriation of technology as means of experiencing the other-than-human—as in citizen science—and sharing this knowledge via social media with the community. Whereas at the turn of the millennium the body concepts were about becoming a technological-fluid body, to become, in the best cases, a toxic effect/weapon eroding capitalism from within, we now perceive a believing in the adoption of technologies of care. But unlike, for example, feminist movements in the 1970s, which quite uncritically believed in the power of new technologies as tools for the liberation of female bodies subjected to being an exploited container (for motherhood, sex etc.), today's stand is more corrupted, more that of an accomplice of global capital: technologies and their infrastructures are so ubiquitous, environmental and normalized—they are material-semiotic forces that consolidate *and* erode global capitalism—that it would be an idiocy to play the ascetic. Media and technologies are counter-appropriated, too: Carolina Caycedo's use of publicly accessible NASA satellite images as well as Instagram to inform the people, and Tabita Rezaire's use of the internet to practice yoga with us are only a few techniques among many others. This might be a concession to the totalization by media (companies), but it might also be

33 On the connection between "cognitive mapping" and the flux of more-than-human rivers, see the contribution by Maryse Ouellet in this volume.

nourished from the comprehension of the cultural logic of environmentalization as antagonistic, contradictory, and undetermined forces. Astrida Neimanis' "I am a singular dynamic whorl dissolving in a complex, fluid circulation" could be interpreted further—as expression of this open mode of the cultural logic of environmentalization: positioned inside/outside of global capitalism, dispersed and collective, we are *flowing, flooding, fibbing.*

Hannah Schmedes

The Im:permeable Sieve

Following Gendered Imaginaries
of Containers and Leaks

The *Plimpton Sieve Portrait* (1579) is an oil painting by
George Gower depicting Queen Elizabeth I of England
(plate 12). In this portrait of the otherwise known "Vir-
gin Queen," the luminous foreground layer is charac-
terized by the pompous textile that adorns the Queen's
body.[1] Elizabeth's robe takes up most of the "mid-shot"
frame. In a symmetrical, calm pose that appears a little
stiff, her body is depicted in a triangular composition.
Elizabeth wears a beaded headdress to which a trans-
parent gold veil is attached and a red velvet dress that is
richly embroidered and bejeweled with pearls. Her arm
dress is cream-colored and the hems of the textile consist
of a white ruff and cuffs that encircle neck and wrists.
Elizabeth's robe, dominating the portrait, is a textile that
lets almost nothing through, only her hands and head
indicate that there is a skin-covered body present. The
prominence of her body disappearing in textiles gener-
ates the impression that in Elizabeth's depiction, every-
thing is containerized, her clothing becoming a shell,
with the help of which her person is clearly delineated
and enclosed. The round shapes of the globe in the back-
ground and the sieve even reinforce this impression of

1 In the upper left half of the dark background layer, a shaded globe
 showing South America and the west coast of Africa can be seen. The
 connection of the globe and the colonial aspirations of England with
 Elizabeth's portrait and the depiction of her virginity is beyond the
 scope of this essay. It is nevertheless noteworthy since it plays into
 the imaginary of the "virgin land," indicating how colonialism and
 sexism are closely linked to each other.

containerized order, but both symbols are porous. The imperial object of the globe is immersed in the background and the sieve, while its edges are sharp, is a perforated object. At second glance it looks like a strange object to me, precisely because not only its permeability but also its ordinariness stands in direct contrast to Elizabeth's lush robe.

I came to find that behind the sieve lies the story of Tuccia, dating back to the year 230 B.C. Tuccia was a Vestal Virgin, one of the Roman priestesses of the goddess Vesta, who was venerated as the guardian of the sacred fire of home and as the protective deity of the city. As they were obliged to remain chaste, the task of the priestesses was to never let this fire go out and to carry out ritual sacrifices and purification acts. Suffering and states of crisis were attributed to the fact that a Vestal Virgin broke her vow of celibacy. This accusation was also brought against Tuccia, who proved her innocence by filling a sieve with water, carrying it from the Tiber to the Temple of Vesta without spilling a drop.[2] An otherwise permeable object is sealed, signaling that Tuccia's body too is a closed container, untouched and virgin. This sieve, which does not lose water, which remains self-contained, becomes therefore an iconographical attribute of virginity. Bearing this virgin token of Tuccia, the sieve is attached to the Queen's clothes with a buckle and cord and thus becomes an extension of her body.[3] With this instrument, a connection is made between the "Queen's physical anatomy and the resonant symbolism of the mundane object"[4] as well as between her gendered, indeed sexualized body and government. Besides, the welfare and prosperity of

2 Robin Lorsch Wildfang, *Rome's Vestal Virgins. A Study of Rome's Vestal Priestesses in the Late Republic and Early Empire* (London and New York: Routledge, 2006), pp. 85–86.
3 Barbara Baert, "Around the Sieve. Motif, Symbol, Hermeneutic," *TEXTILE* 17, no. 1 (2019), pp. 4–27, p. 6.
4 Louis Montrose, *The Subject of Elizabeth: Authority, Gender, and Representation* (Chicago: University of Chicago Press, 2006), p. 124.

the kingdom of England are guaranteed by Elizabeth's pledge to remain virgin.[5]

Contained Fluid

Assuming that in the *Plimpton Sieve Portrait* lies a very peculiar representation of the body politic of the Queen, one that attaches her physical virginity to the welfare of the state, I will draw on Elizabeth's portrait in order to reflect upon the linkage between containment, liquidity and the female-gendered, -sexed body. This begins with the paradox that both containment and liquidity are woven into what is culturally constructed and read as female. On the one hand, within the colonial West, solidity, firmness and order are associated with the masculine image of a bounded "body armor,"[6] while liquidity and flow are often appropriated as metaphors for a supposedly female corporeality.[7] Furthermore, feminized

5 Contemporary election campaigns are still marked by the argument that women are "not built" to rule and govern because of "hormonal imbalances." Therefore the role as "asexual mother" is not as antiquated as one might think. See Mel Robbins, "Hillary Clinton and the clueless hormone argument," 21 April 2015, *CNN*, https://edition.cnn.com/2015/04/20/opinions/robbins-hillary-clinton/index.html (accessed August 29, 2021); Cerstin Gammelin, "Die Frau an der Macht wird sichtbar – endlich!," 26 January 2019, *Sueddeutsche Zeitung*, https://www.sueddeutsche.de/politik/merkel-frauen-macht-1.4302568 (accessed August 29, 2021).

6 Klaus Theweleit, *Männerphantasien* (Berlin: Matthes & Seitz, 2019), pp. 120–121.

7 Elizabeth Grosz, *Volatile Bodies. Toward a Corporeal Feminism* (Bloomington and Indianapolis: Indiana University Press, 1994), pp. 203–207. In addition, gendered body parts like genitals and breasts as "the loci of (potential) flows" are charged differently according to the categories of race, class, and status. A text that deals with the current discriminations of "Leaky Women," is Michelle Fine's take on menstruation. Like Grosz, building upon the landmark monograph *Purity and Danger*, written by anthropologist Mary Douglas in 1966, Fine highlights that the western cultural imaginary of "feminine" fluids such as menstruation is inseparable from the notion of "pollution." As seen in the case of Alisha Coleman, who was fired for a "lack of personal hygiene" and soiling "herself and company property" after two accidental period leaks, menstruation is not only rendered polluted. Its attested soiling and "impurity" is measured with great disparities

liquids, for example in the form of "menstrual flow," are "regarded not only with shame and embarrassment but with disgust and the powers of contamination."[8] Quite paradoxically though, another western-modern construct of the female body is centered around containment: the imaginary of standardized female anatomy as a cave, reduced to sexual organs and equated with women as reproductive containers.[9] A highly simplifying and essentialist cultural construct that, when unfolded, reveals how western imaginaries parallelize bodies ascribed to the female gender with contained fluid, as a conglomerate of both containment and fluidity.[10] I argue that beyond their materiality, the female gender is metaphorically charged with imaginaries of containers, fluids and leaks. In what follows, I will refer to different "scenes" where those gendered metaphors of containment and fluidity surface, along the iconographic axis of Elizabeth's sieve, in order to address how they materialize preconceptions of gender in western-modern societies and therefore hetero-patriarchal power dynamics. Methodically, I am jumping between these scenes while situating the patterns encountered, to reach a differentiated understanding of their gendered semantics.

Since I am looking at a portrait from the sixteenth century as well as texts, examples and theories from the twentieth and twenty-first centuries, my approach is anachronistic, insofar as I am depriving the portrait of its art historical significance and context to a cer-

depending on the person's race, ethnicity, sexual identification, (dis)ability, class and status. See Michelle Fine, "Leaking Women: A Genealogy of Gendered and Racialized Flow," *Genealogy* 3 (2019), pp. 3–4, https://doi.org/10.3390/genealogy3010009.

8 Grosz, *Volatile Bodies*, p. 206.

9 Ibid.

10 At this point I would like to point out Monique Allewaert's research, in which the contrast between fluid, open and closed, controlled bodies is historically localized in the colonized tropics of America. See Monique Allewaert, *Ariel's Ecology: Personhood and Colonialism in the American Tropics, 1760–1820* (Minneapolis: University of Minnesota Press, 2013), p. 3.

tain extent. The *Plimpton Sieve Portrait* functions rather as an image that provoked a thought process and that I re-read from my perspective, which is colored by an upbringing with western values that attribute to the female "hormone-controlled" body the inability to self-control.[11] Coming from a perspective that is informed by Donna Haraway's "Situated Knowledges,"[12] I want to pay tribute to this question of situatedness by reflecting and emphasizing that I use the portrait as an illustration onto which I project the parallelization between female gendered bodies, fluidity and containment. In order to create a basis for a possible queering of the same, I will investigate the concomitant semantic registers, symbolic narratives and imaginaries surrounding containers and their inherent dysfunctions in their relation to gender. In doing so, I will firstly sketch out a reading of containers and containment, continuing with the nexus of gendered containment and im:permeability to delve into a reading of leakage as a third component that has been taken up by feminist theorists as a figure for feminist critique.[13]

"that which is designed to be the background"[14]

Tuccia, whose virginity is directly entangled with Rome's prosperity, deems herself appropriate to the task by turning a permeable object into a leakproof container. In continuation, Elizabeth graces herself with this impermeable sieve, so that her virgin body is shown as a surrogate for a stable stately rule. I subsume both entanglements of female virginity with containment under the term

11 Elizabeth Grosz, *Volatile Bodies*, p. 204.
12 Donna Jean Haraway, "Situated Knowledges. The Science Question in Feminism and the Privilege of Partial Perspective," *Feminist Studies* 14, no. 3 (1988), pp. 575–599.
13 Sara Ahmed, "Queer Use," November 8, 2018, *Feministkilljoys*, https://feministkilljoys.com/2018/11/08/queer-use/ (accessed August 29, 2021).
14 Zoë Sofia, "Container Technologies," *Hypatia* 15, no. 2 (2000), p. 188.

"container technologies." Coined by Zoë Sofoulis (Zoë Sofia) in her 2000 article, container technologies outline a feminist perspective on western philosophy and history of technology that focuses on containers, resources and supply. Her thesis is that containers and containment were neglected in western historiography while connotated as passive and feminine.[15] This seems to be the result of the inherent inconspicuousness of containers and utensils, which are more integrated into processes of collecting and historically linked to "women's traditional labors."[16] Altogether, facilitating containers like water pipes and power lines fabricate an environment resembling a material, infrastructural "Super Mother" who appears in the form of always accessible and available resources, but remains anesthetic when operating efficiently.[17] By concentrating on questions of containerization and supply, these anesthetic infrastructures can be questioned and attention can be drawn to "phallic biases in the interpretation of technology," Sofoulis concludes.[18] Her article suggests to reformulate containment, i.e. environment and enclosure as an (inter-)active process, and thus deconstruct a historically-grown dualism of activity/passivity as well as its gender-specific dimension.[19] Meanwhile, it also testifies to a biologized parallelization of women's bodies and reproductive work with containers and vessels within western philosophy. Sofoulis writes: "since the female body provides our first sheltering container and source of supply, containers tend to be interpreted as generically feminine."[20] According to Sofoulis' definition, a sieve would be deemed a "strategically inefficient" con-

15 Nevertheless, she finds "unexpected all[ies]" such as Martin Heidegger and his "later writings on technology," as well as Don Ihde and Lewis Mumford. ibid., pp. 181–201.
16 Ibid., p. 182.
17 Ibid., p. 181, p. 189.
18 Ibid., p. 198.
19 Ibid., p. 185, pp. 191–192, p. 198.
20 Ibid., p. 187.

tainer technology, but attached to Elizabeth's lush robe in the *Plimpton Sieve Portrait*, its technological use is neither filtering nor sifting. Also, it is depicted outside of the context of a "traditionally 'feminine' domain of domestic equipment."[21] Is it then merely an attribute of Elizabeth's virginity?

Louis Montrose speculates that around the time Elizabeth's Sieve Portraits were made, rumors of Elizabeth's unchastity spread.[22] Thinking this speculation further, Elizabeth, in order to stabilize her precarious role as a female ruler, must therefore promote herself as the *Virgin Queen*, as a chaste woman denying her gendered "fluid, fluctuating[,] *Blurring*"[23] self by practicing ultimate self-control and bodily containment, by becoming a leakproof container. In order to depict Elizabeth I as a representative of an orderly state, her femininity—rendered as fluid—has to be allegorically shown as containerized. Seen in light of this interpretation, the portrait then illustrates a gender bias that in colonial western thought is structured firstly by a binary and hierarchic gender order and secondly by the stereotyping of women's bodies as fluid, "as a leaking, uncontrollable, seeping liquid; as formless flow; as viscosity, entrapping, secreting; as lacking not so much or simply the phallus but self-containment"[24] as Elizabeth Grosz claims in *Volatile Bodies*. Moreover, following Gerburg Treusch-Dieter's cultural history of the liquid, the semiotic-material connection of women and fluids was used as a justification for oppression. Women were seen as lacking moral stability, something Treusch-Dieter identifies as a repeating pattern in western culture from ancient metaphysics, through Christian theology, to modern psychoanalysis (prominently in Sigmund Freud's invo-

21 Ibid., p. 189.
22 Montrose, *The Subject of Elizabeth*, pp. 125–127.
23 Luce Irigaray, *This Sex Which is Not One* (Ithaca and New York: Cornell University Press, 1985), p. 112.
24 Elizabeth Grosz, *Volatile Bodies*, p. 203.

cation of the hysteric), down to today's postmodernist theory.[25] The nexus of fluidity and femininity is then accompanied by the idealization of female bodies and sexuality as "contained, private and invisible."[26] Understood in this way, in the impermeable sieve and thus in the chastity of the Virgin Queen lies her political legitimacy to be perceived as a sovereign and controlled ruler.

Im:permeability

The paradox of the metaphors of containment, being a feminized technology, and the liquid, rendered as a characteristic of female corporeality, is also carried by the dysfunctional sieve-made-container. "The sieve now becomes a receptacle, a water pitcher,"[27] writes Barbara Baert in her investigation of the sieve's depiction in Elizabeth's portraiture. Taking the historical parallelization of the feminine and the fluid into account, Baert further articulates "the woman as water that is retained, as an impermeable and therefore untouched hymen."[28] Parallel to Barbara Baert's runs Montrose's interpretation of the sieve's depiction in the painting: "she holds an empty sieve in a vertical position that emphasizes its circular form and thus its analogical relationship both to her own female anatomy and to the globe that appears in the background."[29] The evocation of the uterus and hymen as supposedly standardized physical features of women recalls the tension between containment and fluidity.

25 Gerburg Treusch-Dieter, "Wasser zum Leben. Eine kleine Kulturgeschichte des Flüssigen," *Sinn-Haft* 12 (2002), http://web.archive.org/web/20030829230227/http://sinn-haft.at/nr12/nr12_treusch_dieter.html (accessed August 29, 2021).

26 Wendy Chun and Sarah Friedland, "Habits of leaking: Of Sluts and Network Cards," *Differences* 26 (2015), pp. 1–28, here p. 9.

27 Baert "Around the Sieve," p. 21.

28 Ibid.

29 Montrose, *The Subject of Elizabeth*, p. 125.

I am more than aware that this parallelization repro-
duces a stereotyped gender binary. Most certainly, I am
re-installing a dichotomy of female/male in relation
to fluid/solid, which is a simplification that simulta-
neously bothers me. Because of this, I think it is very
important to introduce ambivalence into the motif of
the sieve by including a different reading of its func-
tion within the depiction.[30] Following Ernst Kantoro-
wicz's seminal *The King's Two Bodies*,[31] the sieve could
also be interpreted as a representation of the power of
discernment. Itself a symbol of governing, the sieve fil-
ters between "good" and "bad" and between Elizabeth's
royal and private body. Baert observes that the etymol-
ogy of the term "sieve" points in a similar direction:
"The prehistoric, proto-Indo-European word for sieve
has been reconstructed as *kreidhrom*—giving *cribrum* in
Latin and *kroskinon* in ancient Greek—meaning sifting
or sieving substances, but also by transference 'to distin-
guish', and to reach a decision (*cerno* in Latin, *krino* in
Greek)."[32] A sieve's primary function is to classify, filter,
control and separate: "The sieve derives its nature from
the binary, separating the undesirable refuse from the
desired residue, thus placing it in 'opposition' to mod-
els of thought that seek to embrace cohesion, uncer-
tainty, inter-mixture, and intuition."[33] Although both
interpretations of the sieve, being a device of discern-
ment or an indication of Elizabeth's virginity, do stand
to reason, Montrose outlines that "the sieve as pictured
does not conform to either tradition. The Queen is
shown neither winnowing grain nor carrying water."[34]

30 While writing this I think of possible approaches towards queering the
 portrayal of Elizabeth. Recontextualizing it, for example, as a repre-
 sentation in which Elizabeth stylizes herself as a fluid body, in which
 she moves fluidly between the permeable boundaries of gender.
31 Ernst Hartwig Kantorowicz, *The King's Two Bodies: A Study in Medi-
 aeval Political Theology* (Princeton: Princeton University Press, 1997).
32 Baert, "Around the Sieve," p. 12.
33 Ibid., p. 17.
34 Montrose, *The Subject of Elizabeth*, p. 127.

While the association with Tuccia transforms the sieve into an impermeable container, it becomes perforated again as a symbol of distinctive character. The resulting *im:permeable* sieve carries these two contradicting "properties of impermeability and (selective) permeability simultaneously,"[35] resulting in an ambivalent subtext. Itself a classification process, the sieve represents the porous boundary between Elizabeth's roles: a chaste woman whose virginity is not separated from her role as sovereign, but rather flows through and manifests it. It is she herself who figures as the missing water, as fluid that is bounded and contained by her virgin body. To remain chaste, she asserts power over her own body by containing her "feminine fluid self." Nevertheless, I suspect precisely this absent leaking liquid as the basis for the allegory of the sieve that is at the same time porous and sealed.

The Virtue of Virgin Interfaces

With this in mind, I will take yet another leap towards a more contemporary text that deals with gender and its strained relationship with leaking and containment. In the article "Habits of Leaking," Wendy Chun and Sarah Friedland put forward the thesis that also in digital spheres, female sexuality is rendered as something that needs to be contained, controlled and that should be kept private and therefore invisible to the public. A well-known example for this patriarchal instruction is slut-shaming, which is the accusation to have been "stupid enough" to have exposed yourself online. Chun and Friedland specifically take a closer look at "Revenge Porn" websites, where nude pictures or sex tapes are *leaked* without consent. They argue that leaks are fundamentally and structurally predisposed to so-called new

35 Ibid., p. 125.

media, with the leak being the unauthorized release of disclosed information. They declare: "[N]*ew media are not simply about leaks: they are leak.*"[36] According to the authors, within the slut-shaming discourse the systemic vulnerability of new media is transformed into an allegation against putative "sluts": "Through slut-shaming, machinic and social habits are rewritten as individual habits of leaking."[37] The violent breach of the private—perceived as closed and internal—is seen as a permanent ruin of the—mostly female—subject who was exposed. This ruin reveals that the "traditional idea of female virtue [...] positions ideal female sexuality as contained, private, and invisible."[38] The idea of a violent breach of a private interior, as well as the equation of radical openness and "sluts," depends on the promise of reclosing, or containing female sexuality. "This desire to maintain female sexuality, to uphold the virtue of virginity, now plays out both in our orifices and our interfaces. The very logic of virtuous containment and enclosure bears the destructive threat of the leak."[39] The authors show that a gender-specific accusation is not only supported by the structure of new media, but that the "promiscuousness" of the digital sphere in conjunction with its infrastructures of information transfer is made an accusation against women. I like to point out that this example shows how the desire for invisible, private roles for women is reinforced. It also illustrates how the very fabric of networked computing is infiltrated by a fundamental gender bias. Francesca Dragotto, Elisa Giomi and Sonia Melchiorre call this "'technology-facilitated sexual violence', where digital technologies are used to facilitate both virtual and face-to-face sexually based

36 Chun and Friedland, "Habits of leaking," p. 4.
37 Ibid., p. 8.
38 Ibid., p. 9.
39 Ibid.

harms."[40] Within this digital container infrastructure, leaks, as a breach of contained fluid, stain—mostly, but not exclusively—the bodies of women with the failure of their private, invisible role.

With this expanded, different meaning of the leak, the very association with the information leak is invoked. Taking up the previously elaborated semantic pattern, I will dive into another recent example of an image of leakage in order to gain a more nuanced understanding of how its semantics are gendered. Because, as Michelle Fine writes, "[i]t is not only fluids, of course, that leak but mouths – another dangerous orifice if attached to a woman's body."[41]

Becoming a Leaky Pipe

In their article, Daniela Agostinho and Nanna Bonde Thylstrup reflect on the thesis that "truth-speaking" is structured by gender-specific inclusions and exclusions, which are also reflected in the way in which infrastructure is perceived. For Agostinho and Thylstrup, this shared characteristic is the starting point for their investigation of the interweaving of gender, infrastructure and parrhesia—understood as "to speak truth to power."[42] Their analysis builds on the concept of the leak, from which they undertake a critical study of "container infrastructures"—as an extension of Sofoulis'

40 Francesca Dragotto, Elisa Giomi and Sonia Maria Melchiorre, "Putting women back in their place. Reflections on slut-shaming, the case Asia Argento and Twitter in Italy," *International Review of Sociology* 30, no. 1 (2020), pp. 46–70, here p. 46.

41 Michelle Fine, "Leaking Women," p. 7.

42 Daniela Agostinho and Nanna Bonde Thylstrup, "If Truth Was a Woman: Leaky Infrastructures and the Gender Politics of Truth-telling," *Ephemera: Theory & politics in organization* 19, no. 4 (2019), pp. 745–775, here p. 746.

"container technologies"—that brings to the fore what is actually intended to remain hidden.[43] They write:

> As in previous histories of gendered sexualization, the organization of truth-telling also tells tales that both infantilize and sexualize those who perform the invisible infrastructural labor, to the extent that the subjectivity of women whistle-blowers is sexualized, diminished and even erased.[44]

In contrast to the practice of whistleblowing, which is associated with the police whistle and therefore with an authoritarian gesture that maintains an orderly state, the leak is an act connected to heedlessness, failure, a deprivation of secrets.

In 2016, the feminist writer Sara Ahmed was faced with this attribution of heedless leakage, when she terminated her position as professor at Goldsmiths College in London in protest, due to the university's failure to address sexual assaults that took place within the institution.[45] She frames her move as *speaking out*, as a strategy of making things visible. In her later published lecture titled "Queer Use," she revisits her termination as a protest against university politics, which kept the cases secret or tried to conceal them through confidentiality agreements.[46] In the lecture Ahmed reflects on the reaction towards her decision: "When I shared the reasons for my resignation, in protest at the failure of the

43 Ibid., p. 751.
44 Ibid., p. 752.
45 Sara Ahmed, "Speaking Out," 2 June 2016, *Feministkilljoys,* https://feministkilljoys.com/2016/06/02/speaking-out/ (accessed August 29, 2021); Sara Ahmed, "Resignation is a Feminist Issue," 27 August 2016, *Feministkilljoys,* https://feministkilljoys.com/2016/08/27/resignation-is-a-feminist-issue/ (accessed August 29, 2021).
46 Sally Weale and David Batty, "Sexual harassment of students by university staff hidden by non-disclosure agreements," 26 August 2016, *The Guardian,* https://www.theguardian.com/education/2016/aug/26/sexual-harassment-of-students-by-university-staff-hidden-by-non-disclosure-agreements (accessed August 29, 2021).

institution to deal with sexual harassment, I became quite quickly the cause of damage, what a mess Sara, look how much work you have created."[47] This is followed by the picture of a pipeline with a tap on which a drop of water is beading. Below it says: "I became a leaky pipe: drip, drip" (fig. 1).[48]

This picture clearly plays with gendered metaphors of containment and fluidity while concurrently twisting and reappropriating them. Ahmed writes: "There is hope here; they cannot mop up all of our mess. One spillage can lead to more coming out; can lead, does lead. A leak can be a lead."[49] While a whistleblower is supposed to act consciously and courageously, Ahmed—like other female leakers—is placed in historical line with leaky blabbers, stereotypically women who cannot contain themselves, who babble and gossip and "accidentally" divulge secrets: "'leaking' materializes the act of disclosing information as a loss (a failure to contain), the term 'whistle-blowing' frames the act as a contribution (sending a signal)," write Agostinho and Thylstrup.[50] As a gender-specific sexualization of women *speaking out*, this carries the connotation of women as defective beings present in western historiography—defective insofar as their visibility depends upon dysfunction. "Both qualified as lacks, women and infrastructures alike are discursively constructed to leak."[51] Just like the absent fluid in Elizabeth's portrait, the assigned leakiness of women's bodies and women's speech is theorized as serving as constitutive other to a dominant heteropatriarchal matrix. This forms the basis

47 Sara Ahmed, "Queer Use," 8 November 2018, *Feministkilljoys*, https://feministkilljoys.com/2018/11/08/queer-use/ (accessed August 29, 2021).
48 This brings to mind the metaphor of the "leaky pipeline" that is used to illustrate the gradual decline of female employees in academic careers, especially in STEM disciplines. In this picture, women are not active actors leaving or boycotting the system, but rather water that accidentally leaks.
49 Ahmed, "Queer Use."
50 Agostinho and Thylstrup, "If Truth Was a Woman," p. 755.
51 Ibid.

I became a leaky pipe: drip, drip.

Fig. 1: Sara Ahmed, Screenshot from Blogpost "Queer Use," November 8, 2018, *Feministkilljoys*.

for my reading of Elizabeth as "tightly contained," in her robe as well as in her vow of celibacy.

Leaky Infrastructures, Unruly Loss

If I identify leakage, as indicated in the beginning, as a component inherent to containment, then leaks, both discursive and material, are elementary components that serve as constitutive other. And while containers as technologies and infrastructures seem neutral, their imaginaries and semantics are "frequently gendered feminine, but in such a way that it has tended to reinforce the invisible and private realms and home-based role for women, or rendered women dangerous, excessive, or pathological."[52] This "destructive threat"

[52] Matti Siemiatycki, Theresa Enright and Mariana Valverde, "The Gendered Production of Infrastructure," *Progress in Human Geography* 44, no. 2 (2019), pp. 1–18, here p. 11.

is inscribed onto the female gender by their cultural metaphorization as seeping liquid, the leak forms the breach, where restrained liquids burst out. It signifies this potential danger of the feminine that needs to be contained and thus continues to serve as a justification for policing and oppressing women. This pattern seems to be deeply woven into the "fundamental dynamics of difference and hierarchy upon which modern society is being built."[53]

Correspondingly, a further finding of this text is the inherent "dys-appearance" that sticks with cultural imaginaries of the female gender in its tension between leakiness and containment. By this "dys-appearance," I refer to two things: first, the self-contained virgin female that is idealized though made invisible. Just like Elizabeth I, who can only be recognized as a representative of stately order when her female sexuality is intertwined with a contained vessel, imaginaries of the "female" work with the same implications of operating in the background, of staying "contained, private, invisible." Secondly, "dys-appearance" refers to the excessive female that leaks, therefore becomes graspable, but only as a dysfunction. Like the "cultural imaginary of the leak is evocative of the infrastructure that becomes visible when it fails, when it breaks down,"[54] leakiness is perceived as failure. As a result, its "visibility is bound to be negatively perceived."[55] Because female corporeality emerges from the tradition of western-colonial cultural history as fluid and leaky, people read as women are more likely to be charged with "being out of order," while at the same time compelled to the "patriarchal ideal of contained, and virginal, white female sexuality."[56] Elizabeth, by the ambivalence of her im:permeable sieve, is thus at the same time visible and invisible. Re-reading

53 Ibid., p. 13.
54 Agostinho and Thylstrup, "If Truth Was a Woman," p. 754.
55 Ibid., p. 753.
56 Chun and Friedland, "Habits of leaking," p. 9.

and re-contextualizing the parable of the im:permeable sieve implies showing how by gaining visibility solely upon dysfunction, the assigned "lack" of women's corporeality in western historiography is reproduced. Chun and Friedland's text supplements this by stating that the inherent leakiness of digital infrastructures reinforces already existing structural gender norms, even equating "leaky platforms with leaky bodies."[57] Along the intersection of gendered imaginaries of containers and infrastructures as well as their inherent leakiness, biologizing and naturalizing aspects dissolve in the imaginaries of "women as container" or "leaky blabbers." Both, I argue, although seeming paradoxical at first, are two sides of the same coin. Leakage thus relates to an unruly loss, to an uncontrollable failure, and is appropriated as a figure for critique, too. As Jennie Olofsson states, "unlike fluidity, the concept of leakage seems to sound dull, unwelcome and unhappy – a failure – and with the color of shame on the cheek."[58] Leakage is thus itself a "gendered infrastructural imaginary of the passive female's failure to contain,"[59] but as the case of Sara Ahmed has shown, it allows awareness of these biased semantics to be gained. Hence, leakage is an ambivalent, multifaceted imaginary, but one that either way remains a signifier for a gender bias.

57 Agostinho and Thylstrup, "If Truth Was a Woman," p. 766.
58 Jennie Olofsson, "Normativa strömmar och underliggande motstånd: om fluiditet, läckage och kvinnors kroppar," *Tidskrift för Genusvetenskap* 36, no. 4 (2016), pp. 118–138, here p. 120. [Translation Hannah Schmedes]
59 Agostinho and Thylstrup, "If Truth Was a Woman," p. 766.

Yannick Schütte

Lead Fish Story

On the Cultural Logic of Fluidity
in Architecture

In March 2010 the University of Minnesota's College
of Design in Minneapolis dissected a fish sculpture by
architect Frank Gehry—a remnant from his 1986 exhi-
bition at the Walker Art Center. The dean's office issued
a statement which explained that the fish was removed
from the foyer of the building due to violations of the
fire code as the lead scales would have prevented water
from the sprinkler systems reaching the wooden skel-
etal structure. Previously the college's administration
had opted for the removal of the scales, but technicians
detected that even the screw holes were permeated by
lead. In light of the costs this led to the decision to dis-
assemble the whole structure and to put it into storage.

In the late 1980s this very sculpture became the sub-
ject of a photograph by Allan Sekula titled *"Lead Fish."
Variant of a conference room designed for the Chiat/Day
advertising agency. Architect: Frank Gehry. Installation at
the Museum of Contemporary Art, Los Angeles. May 1988*
(fig. 1). It was the first photograph he took and used
for his exhibition and book project *Fish Story*. Sekula's
work focusses in particular on the maritime world and
its logistical circumscription. It observes the erasure of
the sea's fluidity by a new fixity of transport routes and
the imposition of a terrestrial, perspectival ground plan
due to the circulation of shipping containers. Obversely,
the land as a site of production has become increasingly
fluid by means of a global informational infrastructure

Fig. 1: Allan Sekula, *"Lead Fish." Variant of a conference room designed for the Chiat/Day advertising agency. Architect: Frank Gehry. Installation at the Museum of Contemporary Art, Los Angeles. May 1988*, 1988, silver-dye bleach print, 69 x 84.2 cm.

and the flows of labor, finance, logistics, and more precisely due to the containerization of cargo shipping.[1]

Gehry's fish suggests that this phase transition also appears in the built environment and as a discursive architectural logic which seems to claim the fluidity of the sea for the realm of architecture. Located near the sculpture, a panel featuring a quote from Gehry sheds light on the architect's fascination with fish: "The interesting thing about all the fish studies for me has been the ability to capture movement in a built form. The

1 With regard to this development Sekula notes: "To the extent that transnational capital is no longer centered in a single metropole, as industrial capital in the 1840s was centered in London, there is no longer 'a city' at the center of the system, but rather a fluctuating web of connections [...]. [T]he new fluidity of terrestrial production is based on the routinization and even entrenchment of maritime movement." Allan Sekula, *Fish Story* (Düsseldorf: Richter, 2002), p. 49.

movement of the scales of a fish is something I'm try-ing to transmit into architecture."[2] These attempts to capture movement in scales or undulating, curvilinear structures are examples of a fairly recent architectural style. Concepts such as ecology, bio-mimicry, topologi-cal complexity or emergence and other "hallmarks of the computer age"[3] are, as Alexander R. Galloway points out, applied as design strategies. Thus, these aqueous forms are also inextricably linked to the advent of com-puter-aided design (CAD) software. Its use enables the immersive and dynamic design of models, where the modification of individual parts can affect the overall structure and also makes such designs economically via-ble in the first place. While architectural explorations of networks and ecology were already fashionable in the early twentieth century (for example in the work of Konrad Wachsmann or László-Moholy Nagy), modern architecture is traditionally associated with rectangular structures. In contrast, the formal language of so-called "digital architecture" draws on fluidity, curvilinearity and continuous movement, infusing an aesthetic of curves and flows into the solidity of built forms.[4]

2 Sam Hall Kaplan, "The Undisputed Arrival of Frank Gehry: The Expe-rience of Architecture as Art," February 21, 1988, *Los Angeles Times*, https://www.latimes.com/archives/la-xpm-1988-02-21-ca-44021-story.html (accessed November 11, 2021).

3 Alexander R. Galloway, "Informatic Brutalism," in *Architecture and Control*, ed. Annie Ring, Henriette Steiner and Kristin Veel (Leiden: Brill, 2018), pp. 11–25, here p. 22.

4 As a matter of fact, we can observe instances of liquid forms liter-ally transpiring. Take as an example the MIT Stata Center which was designed by Gehry and opened in 2004. The academic complex consists of cascading structures that insinuate movement and the liquefaction of forms. Yet, it encountered ongoing complications with liquids and humidity such as the formation of leaks, mold and occurrences of ice falling from the roof—blocking emergency exits. Another pertinent issue was the malfunctioning of a sprinkler sys-tem, accidentally flooding parts of the building. According to a pass-erby who photographed the incident, the explosion of the sprinklers occurred in between fish-shaped and circular decorative elements hanging under the ceiling which were engraved with messages laud-ing the virtues of water conservation. Due to the continuous issues the MIT sued Gehry in 2007 for the failures of his building, which

Multiple cultural theorists and architectural scholars such as Luciana Parisi, Antoine Picon or Douglas Spencer have described this emergence of a fluid architecture—each of them with very different focal points and objectives.[5] Still, the notion of fluidity is not by any means a new phenomenon, as it has been used metaphorically in different ways in the context of the built environment since the nineteenth century. Certainly there are continuities with previous architectural styles, such as a renewed experience of disorientation due to constructions that deviate from preceding spatial configurations, which has been the case in modern as well as in postmodern architecture.[6] However, the distinctive characteristic of a cultural logic of fluidity in architecture which succeeds the dominant spatial conception of postmodernism could be that it "seek[s] to produce heterogeneity within an intensive cohesion rather than out of extensive incoherence and contradictions."[7] What this implies is a way of conceiving the architectural object in continuity with its environment. In this sense, curvilinear architecture appears to be an expression of an uninterrupted relationality and thereby reflects the notion of "a sociocultural-economic system in which the

recalls the old joke: "If it bends it's funny; if it breaks it's not funny." See also Alexander Galloway, "Are Some Things Unrepresentable?," *Theory, Culture & Society* 28, no. 7–8 (December 2011), pp. 85–102.

5 See Luciana Parisi, *Contagious Architecture: Computation, Aesthetics, and Space* (Cambridge, Mass.: MIT Press, 2013); Antoine Picon, *Culture numérique et architecture. Une introduction* (Basel: Birkhäuser, 2010); Douglas Spencer, *The Architecture of Neoliberalism: How Contemporary Architecture Became an Instrument of Control and Compliance* (New York: Bloomsbury Academic, 2016).

6 See for example Adrian Forty, "Spatial Mechanics: Scientific Metaphors in Architecture," in *The Architecture of Science*, ed. Peter Galison and Emily Ann Thompson (Cambridge, Mass: MIT Press, 1999), pp. 213–232 and Christoph Asendorf, *Planetarische Perspektiven: Raumbilder Im Zeitalter Der Frühen Globalisierung* (Paderborn: Wilhelm Fink, 2017).

7 Jeffrey Kipnis, "Towards a New Architecture," in *Space Reader: Heterogeneous Space in Architec*ture, ed. Michael Hensel, Achim Menges, and Christopher Hight, AD Reader (Chichester, UK: Wiley, 2009), pp. 97–116, here p. 101.

supposedly frictionless movement of information func-
tions as a sovereign concept."[8] Buildings in fluid shapes
appear to be extruded out of the "immaterial" realm of
the digital design and then seamlessly integrated into
their surroundings and described as transcending class
or other social determinators. Thereby they follow the
rationale of the information economy, which implies a
dominance of "intellectual" over "manual labor." Thus,
Gehry's lead fish—originally designed as a conference
room for an advertising agency—might be seen as an
architectural symptom of a cultural logic of fluidity.
Nevertheless, its dissection as a toxic and fire-hazard-
ous artifact also counters the narrative of immaterial-
ity and seamlessness that is associated with the infor-
mation economy. In the same vein, *Fish Story* argues
against the "conceptual aggrandizement of 'informa-
tion'" and questions "the corollary myth of 'instanta-
neous' contact between distant spaces."[9] It invites think-
ing about inconsistencies and discontinuities as well as
the material conditions of labor within a cultural logic
of fluidity. Not only idiomatically has *Fish Story* always
been in reference to Herman Melville's *Moby Dick*.[10] It is
also a reinterpretation of the classic novel that pursues
the implications of a global economic entity through
an additive method "in a relentless drive to totalization
that never arrives."[11] In his conversations with Alexan-
der Kluge, Joseph Vogl characterizes Melville's story as a
lead sinker [Senkblei] of history—a piling up of different
layers of the past that freezes the movements of its time

8 Seb Franklin, *Control: Digitality as Cultural Logic*, Leonardo Book Se-
 ries (Cambridge, Mass.: MIT Press, 2015), p. XIII.
9 Sekula, *Fish Story*, p. 50.
10 Allan Sekula et al., "A Walk with Allan Sekula through his Exhibi-
 tion 'Polonia and Other Fables'," n.d., https://www.diaphanes.net/
 titel/a-walk-with-allan-sekula-through-his-exhibition-926 (accessed
 November 11, 2021).
11 Steve Edwards, "Allan Sekula: Fish Story," (2016), p. 9, https://www.
 academia.edu/40135540/Allan_Sekula_Fish_Story. See also Steve
 Edwards, "In Allan Sekula's Wake," *Photographies* 7, no. 1 (2014),
 pp. 113–116, here p. 114.

for a moment, reveals it for inspection and leads to an archaeology or mythology of the nineteenth century.[12] Following this, I would like to propose to view the image of Gehry's lead fish as a means to focus on the recent history of a cultural logic of fluidity in architecture.

Defining a Cultural Logic

To speak of a cultural logic is a "theoretical provocation."[13] The term suggests the possibility to recognize an underpinning norm that not only runs through cultural production in all of its diverse forms but also elucidates the state of the current political economy. As Baumbach, Young and Yue show, it is a historical concept as it outlines a possibly dominant form that "is also available as a domain of contestation, resistance, and activism, even as it makes the critical distance typically implied by those terms appear outmoded."[14] The principal challenge laid out by Fredric Jameson's use of the term, they argue, is that it seems unimaginable to develop alternatives due to the dominance of an existing hegemonic logic. Yet, the assessment of alternatives, Jameson contends, could only be developed against the backdrop of a hegemonic cultural logic. His stance with regard to the cultural logic of postmodernity is not to be understood in the sense that all cultural productions are postmodern. Rather, it is described as a "force field in which very different kinds of cultural impulses – what Raymond Williams has usefully termed 'residual' and 'emergent' forms of cultural production – must make their way."[15]

12 Alexander Kluge and Joseph Vogl, *Senkblei der Geschichten: Gespräche* (Zurich: Diaphanes, 2020), p. 24.
13 Nico Baumbach, Damon R. Young, and Genevieve Yue, "Introduction: For a Political Critique of Culture," *Social Text* 34, no. 2 (127) (2016), pp. 1–20, here p. 4.
14 Ibid.
15 Fredric Jameson, *Postmodernism, or, The Cultural Logic of Late Capitalism* (London: Verso, 2008), p. 6.

Similarly, I would like to stress that while fluidity may be discerned as a dominant formal criterion in signature buildings, particularly from the late 1980s to the early 2010s, most of the built environment still adheres to rectilinearity as a primary organizing principle.

Architecture serves as a crucial mode of cultural production for Jameson's denomination of a hegemonic norm of postmodernism. In reference to Gilles Deleuze's thinking through film he argues for conceiving of architecture as a means to attack problems that pertain to the cognitive or philosophical realm.[16] His widely known discussion of the Westin Bonaventure Hotel in Los Angeles (designed by John C. Portman, Jr.), identifies an incapacity to process the spatial arrangement of the building as a key feature of the cultural logic of late capitalism. The lack of a perceptual apparatus to sense this mutated hyperspace that deviates significantly from the spatial logic of high modernism is thus considered as an "imperative to grow new organs, to expand our sensorium and our body to some new, yet unimaginable, perhaps ultimately impossible, dimensions."[17] A case in point for the disorienting effects of the Bonaventure is the atrium with its four residential towers organized in symmetrical fashion. According to Jameson, everything seems to look alike and nobody seems to find their bearings. Hence, his principal point comes down to the thesis that "postmodern hyperspace has finally succeeded in transcending the capacities of the individual human body to locate itself, to organize its immediate surroundings perceptually, and cognitively to map its position in a mappable external world."[18]

Another architectural object of his study—the home of Frank Gehry in Santa Monica—is deemed "one of the few postmodern buildings which does seem to have some

16 Ibid., p. 125.
17 Ibid., p. 39.
18 Ibid., p. 44.

powerful claim on revolutionary spatiality."[19] For Jameson it is indicative of the economic and spatial incoherence as it eschews visual representation in two dimensions. One of the distinctive components of the Gehry family home is a wrapper consisting of corrugated metal that extends the interior space of the original structure built in the 1920s. For the most part this zone, created in between the old building and the wrapper, is encompassed by a glass structure and forms a space which can no longer be discerned from the former outside. In Jameson's view this "formal innovation" leads to an "effacement of the categories of inside/outside, or a rearrangement of them."[20] Apart from Jameson's reflections on the Santa Monica house the "Architecture" chapter of *Postmodernism* also features an account of the architect in which Gehry voices the suspicion that the apparently unfinished form might confuse his family members. He mentions organizational challenges and chaos in the house, as he meticulously observes his wife leaving papers or other objects on the table: "I was beginning to think that it has something to do with her not knowing whether I'm finished or not."[21]

All of these previously mentioned phenomena perceived by Jameson in the context of Gehry's home and Portman's hotel (such as the receding of the difference between exterior and interior space as well as disoriented subjects increasingly incapable of organizing themselves) are presented as symptoms of the emergence of the postmodern hyperspace.[22] Certainly, Jameson's examples are to be understood not literally but allegorically, and spatial arrangements undoubtedly do have an effect on subjectivity. Yet, one might ask if the "mess" at Gehry's home can really be attributed to the architecture. Or, to pose the question differently:

19 Ibid., p. 107.
20 Ibid., p. 112.
21 Ibid., p. 109.
22 Ibid., pp. 117–118.

has there ever been an occurrence of chaos or disori-
entation in a modern building?[23] This is not to ques-
tion the "sharper dilemma" that is outlined by Jameson,
which is the "incapacity of our minds, at least at pres-
ent, to map the great global multinational and decen-
tered communicational network in which we find our-
selves caught as individual subjects."[24] Yet, by following
Fish Story's conception as a work against "cognitive
blindness"[25] or Sianne Ngai's wariness[26] against an aes-
theticization of "the (seeming) breakdown of our ability
to think our own social totality"[27]—which is explicitly
not aimed at Jameson—I will elaborate on the histori-
cal through-lines in the development of an architectural
logic of fluidity.

Environmental Continuities

Both Jameson's assertion that the Bonaventure aspires to
be "a total space, a complete world" and the observation
of a fading difference between inside and outside in the
case of the Santa Monica house point to the history of
the notion of fluidity within architecture. According to
Christoph Asendorf, architectural fluidity can be traced
back to 1851 when Joseph Paxton's Crystal Palace was
built for the Great Exhibition in London.[28] The immense

23 See for example the iconic trials and tribulations of Monsieur Hulot
 in Jacques Tati's *Mon Oncle* or *Playtime*, or Felicity D. Scott, *Disorien-
 tation: Bernard Rudofsky in the Empire of Signs*, Critical Spatial Prac-
 tice 7 (Berlin: Sternberg Press, 2016).
24 Jameson, *Postmodernism*, p. 44.
25 Edwards, "Allan Sekula: Fish Story," p. 4.
26 For more on the relation between Ngai's wariness and the question
 of the sublime see Stefan Yong's contribution to this volume.
27 Sianne Ngai, "Critique's Persistence: An Interview with Sianne Ngai,"
 interview by Mikkel Bolt Rasmussen and Devika Sharma, February
 27, 2017, http://quarterly.politicsslashletters.org/critiques-persis-
 tence/ (accessed November 11, 2021).
28 The building was constructed within a short span of a couple of
 months because it relied on a system of prefabricated as well as non-
 traditional building materials that could be assembled by many

glass pavilion carried by a thin iron framework embodies the idea of a construction that appears spacious enough to perhaps never have to leave it, or could be described, in Peter Sloterdijk's terms, as a "world-shaped [weltförmige] hall."[29] Thus, the Crystal Palace presents itself no longer in opposition to its environment but becomes an environment itself. Additionally, as the site of the Great Exhibition that claims to represent the world in one place it serves as a metaphor for an unhindered flow of things (fig. 2).[30] Apart from presenting artifacts from different parts of the globe, the seemingly disembodied, floating structure allowed visitors a limitless view beyond the building's facade. In keeping with its name, the building absorbs the atmosphere of the external environment through refraction of daylight, blurring the distinction between interior and exterior space. As contemporary critics struggled to orient themselves within the Crystal Palace, it seems to anticipate Jameson's assessment of postmodern hyperspace which transcends the "capacities of the individual human body to locate itself."[31] The lack of windows, walls or a ceiling to be distinguished, resulted in difficulties for the visitors to define either the size of or the distance to the fine symmetrical grid structure. A reporter of *The Times* described the palace as "something more than the senses could scan or imagination attain."[32] The construction's

workers and through the division of labor. See Philip Ursprung, "Phantomschmerzen der Architektur: Verschwindende Körper und Raumprothesen," *Kritische Berichte, Zeitschrift für Kunst und Kulturwissenschaften* 2, (2006), pp. 17–28, here p. 24.

29 As cited in Asendorf, *Planetarische Perspektiven*, p. 436. [Translation Yannick Schütte]

30 Ibid.

31 Jameson, *Postmodernism*, p. 44.

32 Philip Ursprung, "Phantomschmerzen der Architektur," p. 22. Similar to the Bonaventure the Crystal Palace's structure also seems impossible to grasp in terms of volume, see Jameson, *Postmodernism*, p. 43. This is mirrored in the experience of Lothar Bucher who published an oft-cited collection with reports on the Great Exhibition. Bucher describes the Palace as an infinite space whose margins seem to disappear in blue dust. Due to the lack of any shadow from the

Fig. 2: George Cruikshank, *All the World is Going to See the Great Exhibition of 1851*, 1851, etching, plate: 21.4 x 28 cm, sheet: 31.8 x 50 cm, New York: The Metropolitan Museum of Art, The Elisha Whittelsey Collection.

boundlessness leads Asendorf to regard this building as an early example of the spatial configuration described by Manuel Castells, consisting of a *space of places* and a *space of flows* where "[t]he traditional ties in the local space of places are juxtaposed with the possibilities of free circulation, the fixed with the flowing."[33] While this early architectural instance of a space of flows deviates from more recent works, it shows the existence of the characteristics that Jameson describes long before postmodern architecture.

Yet, with curvilinear architecture we observe a new cultural logic of fluidity within architecture. Through its mobilization of surface digital architecture challenges the notion of the architectural object on a more

building's structure he deems it impossible to determine the distance of the iron weaving which seems to float a hundred or thousand feet away. See Asendorf, *Planetarische Perspektiven*, p. 419.

33 Asendorf, *Planetarische Perspektiven*, p. 418. [Translation Yannick Schütte]

fundamental level. Constructions such as Foreign Office Architect's Port of Yokohama or the Ravensbourne College in London illustrate this intention especially well. The port complex seems to completely disavow the categories of inside and outside or up and down and blends into the landscape of the city's harbor "like a moebius-strip,"[34] suggesting a seamless connection with its environment. By contrast the college's architecture aims at the liquefaction of the building's volume by smoothing the change of planes through staggered staircases. Combined with only mobile partitions separating spaces this is supposed to create the feeling that you are always in between floors and rooms in order for students to become "intelligent nomads."[35] Thus, what distinguishes curvilinear architecture from previous challenges to the indoor-outdoor distinction, according to Picon, is the mobilization of surface that puts into question the discipline's belief in an "immutable presence."[36] This implies a transition within the conception of space from a static Euclidean grid to a dynamic entity. The first model is based on a panoptical diagram, consisting of discrete, inert and atemporal points defined within unchanging equations (as can be observed in the elusive, yet gridded Crystal Palace), while the second model captures intervals or qualitative movement between coordinates, interactive parameters or vectorial flows unfolding in and through time.[37]

But how does a static structure mutate? Or, how is it possible to infer movement into concrete other than via fish scales? One visual artifact that expresses the relation between form and flux are the chronophotographs of physiologist Étienne-Jules Marey. His pictures from the late nineteenth century depict bodies of animals and humans disintegrating into a continuous series of

34 Picon, *Culture numérique et architecture*, p. 91.
35 Spencer, *The Architecture of Neoliberalism*, p. 137.
36 Picon, *Culture numérique et architecture*, p. 91.
37 Parisi, *Contagious Architecture*, p. 101.

movements.[38] Inspired by this, architect Gregg Lynn illustrates the possibility of casting dynamic into static form, citing the hull of a boat as an example:

Although the form of a boat hull is designed to anticipate motion, there is no expectation that its shape will change. An ethics of motion neither implies nor precludes literal motion. Form can be shaped by the collaboration between an envelope and the active context in which it is situated. While physical form can be defined in terms of static coordinates, the virtual force of the environment in which it is designed contributes to its shape. The particular form of a hull stores multiple vectors of motion and flow from the space in which it was designed. A boat hull does not change its shape when it changes its direction, obviously, but variable points of sail are incorporated into its surface. In this way, topology allows for not just the incorporation of a single moment but rather a multiplicity of vectors and therefore a multiplicity of times into a single continuous surface.[39]

This translates into a conception of the constructed form, animated by its environment or thought of as a spatiotemporal event. The dynamic of a site is thus to be integrated into a concrete form shaped by the forces of the site over time.

As these spatial configurations are grounded within a larger development of softwarization in management, communication and logistics, Luciana Parisi argues that digital design and the fluid structures it allows to be created are pivotal elements of a reformalization of power.[40]

38 On the animating qualities of early cinematography see Beny Wagner's contribution to this volume.

39 Greg Lynn, *Animate Form* (New York: Princeton Architectural Press, 1999), p. 10.

40 Erich Hörl and Luciana Parisi, "Was heißt Medienästhetik? Ein Gespräch über algorithmische Ästhetik, automatisches Denken und die postkybernetische Logik der Komputation," *Zeitschrift Für Medienwissenschaft* 5, no. 8 (2013), pp. 35–51, here pp. 49–50.

With this in mind Lynn's understanding of dynamic forms not only echoes Kipnis's notion of heterogeneity produced within intensive cohesion but also corresponds to the wide range of shifts in the mode of production that have occurred since the 1990s under the umbrella term of the information economy. It is in particular his vision of the architectural artifact as a fluid, responsive (and when we think of Picon ultimately erasable) object that parallels the conception of matter within the information-based mode of production. As Alan Liu outlines, this economic transformation imagines the ideal corporation as "designed for resistance-free flow of information—an alignment of technology and technique so perfect that it is free from the friction of matter."[41] It is in *The Laws of Cool. Knowledge Work and The Culture of Information* (2004) that Liu has attended to the contemporary dominant mode of production and its corollary myths. Here, he states that the emerging hegemony of knowledge work urges businesses to become nothing but information processing entities or "at least matter that can be made to act like information processing."[42] To underpin his assertions, Liu cites the writings of economists and scholars such as Martin Kenney and Richard Florida, Thomas A. Stewart or Kevin Kelly. In 1998, the latter argued that one of the crucial premises of the twenty-first century political economy would be its softening due to software, media and services: "Of course, all the mouse clicks in the world can't move atoms in real space without tapping real energy, so there are limits to how far the soft will infiltrate the hard. But the evidence everywhere indicates that the hard world is irreversibly softening."[43] Along these lines, Stewart as well as Kenney and Florida

41 Alan Liu, *The Laws of Cool. Knowledge Work and the Culture of Information* (Chicago: University of Chicago Press, 2004), p. 43.

42 Ibid.

43 Kevin Kelly, *New Rules for the New Economy: 10 Radical Strategies for a Connected World* (New York: Viking, 1998), p. 2.

claim that this delineates a mode of production where abstract intelligence replaces sweaty and greasy physical labor practices.[44]

The pronouncement of such a sociocultural economic system based on frictionless information thus finds its architectural counterpart in fluid structures that incorporate the information flows of their environment into continuous surfaces. Yet, not unlike the information economy's premises, which suggested the liquefaction or differentiation of a formerly rigid social order structured by fixed categories as well as a rather immaterial mode of production, some of these curvilinear forms appear somewhat stale today. Similar to Liu pointing out that the shift from matter to mind work in the West was only possible due to the growth of industrial work in the developing world, the material circumstances of certain buildings break with the narrative of environmental continuity.[45]

Work Flows

In concordance with the previous remarks, Douglas Spencer argues that the fluid architectural structures which at times seem to have come into existence "out of thin air" participate in such an "occultation of production,"[46] as the undulating surfaces attest to a feigned absence of labor or obscure its existence. Following Marx, Spencer argues that in order to entertain the mystifying and phantasmagorical character of architectural forms the labor that produces the object needs to

44 Martin Kenney and Richard L. Florida, *Beyond Mass Production: The Japanese System and Its Transfer to the U.S* (New York: Oxford University Press, 1993), p. 54 and Thomas A. Stewart, *Intellectual Capital: The New Wealth of Organizations* (New York: Doubleday / Currency, 1997), p. X. On the sweated labor of contemporary service workers see also Annie McClanahan's contribution to this volume.

45 See Liu, *The Laws of Cool*, p. 43.

46 Spencer, *The Architecture of Neoliberalism*, p. 1, p. 74.

be obscured.[47] This is also exemplified by architectural historian Kurt Forster's writings on Gehry's Guggenheim Bilbao. Forster lauds the manner in which CAD-software has been employed in the project, claiming that "[t]he age-old distinction between the hands that design and the instruments that execute has been overcome: the separate phases and techniques of conceiving and executing a building here were woven into an unbroken 'loop.'"[48] While it is undisputed that the development of architectural CAD- or parametric design software is significant for the development of curvilinear structures, the narrative of an unbroken loop must yet again be called into question. Commenting on Forster's observation, Sekula notes that he would like to "see [Forster] deliver this argument with a straight face to the construction engineers and iron workers who painstakingly translate the plan into the skewed geometry of the steel structure that is ultimately obscured beneath the glistening convoluted surface."[49]

This narrative is further perpetuated in the audio guide of the museum, which informs the visitor about its manufacturing process through "computers and robots, obsession and magic, fantasy and imagination, facility and freedom. It's the product of a world in which

47 Ibid., p. 73.
48 Kurt W. Forster, "The Museum as a Civic Catalyst," in *Frank O. Gehry – Guggenheim Bilbao Museoa*, ed. Ralph Richter and Frank O. Gehry (Stuttgart: Ed. Menges, 1998), pp. 6–11, here p. 11.
49 Allan Sekula, "Between the Net and the Deep Blue Sea (Rethinking the Traffic in Photographs)," *October* 102 (2002), pp. 3–34, here p. 20. Also, for the construction of the Guggenheim Museum in Bilbao, the local, Spanish construction companies had to visit the IBM CATIA Competency Center in Madrid to learn how to use the software used by Gehry as well as the models. In addition to the process optimization that this entailed, it brought previously independent contractors under the aegis of a technical know-how controlled by large multinationals such as IBM. See Andrew Friedman, "Build It and They Will Pay: A Primer on Guggenomics," *The Baffler*, November 2002, https://thebaffler.com/salvos/build-it-and-they-will-pay (accessed November 2, 2021).

the human labor of production does not exist."[50] Both accounts can be read as a testament to the hegemony of so-called "knowledge work" or "intellectual labor" over the labor of production, which is portrayed as if obsolete or non-existent. Further listening to the audio guide strengthens the story of liquefaction of social categories. As Andrea Fraser notes with a hint of irony in her *Tour of a Tour of the Guggenheim Bilbao*: "Here, we can escape the boundaries of our discrete bodies. We become formless matter, fluid, pumped through the building's heart, its arteries, its corporeal passages."[51] But not only subjectivity is said to be unbound. The curving surfaces are also said to transcend categories such as class, age or education—a claim that also has to be questioned in light of the fact that the urbanist concept of Bilbao has solidified existing inequality patterns and generated new social and spatial modes of exclusion.[52] As if in order to illustrate that argument Sekula's diptych *Bilbao* (plates 13 and 14), photographed from a hillside of the Basque capital, depicts a perceptible discontinuity from the building to its environment as well as a confrontation of different modes of production.

To counter the narrative of curvilinearity as an expression of a liquefied social order, I would like to conclude with a photo that Sekula took of a different form of fluid architecture (plate 15). It tells the story of a night in May 1990 when he photographed a former worker's housing

50 Andrea Fraser, "'Isn't This a Wonderful Place?' (A Tour of a Tour of the Guggenheim Bilbao)," in *Learning from the Bilbao Guggenheim*, ed. Ana María Guasch and Joseba Zulaika, Center for Basque Studies Conference Papers Series, no. 2 (Reno: University of Nevada Center for Basque Studies, 2005), pp. 37–58, here p. 50. Fraser's essay reflects and comments on the instructions that one would hear from the audio guide during a tour at the Guggenheim. It also features images and references to her work *Little Frank and his Carp* (2001) which was recorded in the foyer of the building with multiple hidden cameras and satirizes the sensuous description of the building's characteristics.

51 Ibid., p. 39.

52 Ibid., p. 48.

being moved from the abandoned San Pedro shipyard to South Central, LA. In opposition to an invocation of fluidity that neutralizes social difference and determination, the photograph reveals a different kind of materialism. The landowner sold the facilities to build more lucrative real estate on the site, while the houses became homes for immigrants from Central America and Mexico. Again, but in a different way, the conflation of land and sea is tangible. As the houses float through the streets at night, they transform into ships.

Logistical Circulation

Jacob Soule

Circulation and the City Novel

In his 1970 classic *The Urban Revolution*, the geographer and philosopher Henri Lefebvre made the striking claim that as the world becomes more urbanized, cities become less relevant to the urban. The city, Lefebvre argued, "exists only as an historical entity."[1] Half a century later, pronouncements of the city as a disappearing geographic formation have been asserted with increasing confidence. Whether it be Lars Lerup's provocatively titled *After the City* (2000), or The Invisible Committee's claim, in *The Coming Insurrection* (2007), that "it is because the city has finally disappeared that it has now become fetishized, as history," everywhere there is the same idea, repeated with ever intensifying force: the city no longer serves as a coherent marker of the new geographical agglomerations that face the contemporary urbanist.[2]

Why, then, does there continue to be such a persistent fascination with cities in the contemporary moment? For surely, as much as the idea of the city has been deconstructed to within an inch of its life by various urban theorists, we still speak of cities, or "the city," as the figurative site of all that is new and important. The city remains, almost despite itself, an object of supreme intellectual, political, and even utopian (or dystopian) investment. Perhaps an answer to this conundrum lies in Lefebvre's own diagnosis of the "end of the city" in

1 Henri Lefebvre, *The Urban Revolution*, trans. Robert Bononno (Minneapolis: University of Minnesota Press, 2003), p. 57.
2 The Invisible Committee, *The Coming Insurrection* (Pasadena: semiotext(e), 2009), p. 52. See also Lars Lerup, *After the City* (Cambridge, Mass.: MIT Press, 2000).

his 1970 work, in which he remarked that the "image or representation of the city can perpetuate itself, survive its conditions, inspire an ideology and urbanist projects" well beyond its waning as a coherent object of analysis.[3]

Lefebvre's observation—that hard geographic fact does not always correspond to the modes of representation by which geography gets put to use—was most forcefully grasped by his contemporary Raymond Williams, who, a mere three years after the publication of *The Urban Revolution* published *The Country and the City*, in which he set out to show how the structuring opposition in the history of the British novel between country and city did not involve the representation of "real" places, but rather the ideological production of a set of cultural norms and associations that would instantiate an imagined geography in its readership. The novel, in attending to the everyday experience of geography, was the form most responsible for instantiating the ideology of country and city as two distinct regimes of life, as opposed to one indissoluble process—what we would now call "urbanization." The central problem identified by Williams is the jarring distinction between a supposedly empirically verifiable geographical "situation," and the cultural mediation of that situation such that we can begin to make sense of the geography that surrounds us; in other words, to subject it to a critique. It stands to reason, then, that if the novel instantiated a way of seeing geography that persisted for generations, the fate of the novel in the midst of the more recent vast upheavals in what we will have to unsatisfyingly call "urban space" bears some significance for the wider discussions alluded to in the opening of this article. But

3 Lefebvre, *The Urban Revolution*, p. 57. For a more recent assessment of the ideological function of the *idea* of the city, versus its material reality in the twenty-first century, see David Wachsmuth, "City as ideology: reconciling the explosion of the city form with the tenacity of the city concept," *Environment and Planning D: Society and Space* 32, no. 1 (2014), pp. 75–90.

first, it will be necessary to say something more precise about what the exact nature of the relationship between the urban and the city is in the contemporary moment.

Writing in 1973, Williams recognized that he was doing so at a fraught juncture in the history of the relationship between city and country. He concludes his study with the observation that his own moment is instantiating "a general crisis" of oppositions, one in which the city and the country are increasingly fused into a continuous "network," devoid of a centralized command center.[4] From Williams to Lefebvre, through to the more recent urban theorists dealing with these questions, this new space that confronts us reconfigures the old conceptual opposition between country and city from one which separates spaces by population density (on a sliding scale from the urban to the rural) in favor of circulation: the urban is what moves, what circulates, not what coagulates or massifies.

The traditional notion of the city's scope sees it as being delimited by its outsides (the suburb, the exurb, the country, and finally nature itself) whereas the urban cannot abide an exterior because its limitlessness and capacity for replication ad infinitum is its reason for being. The urban, for Lefebvre, was thus its own conceptual category independent of the "city." It was to be understood as unique to modernity whereas cities, with their ancient forms, were not. Ross Exo Adams has recently extended this analysis to make the broader claim that the urban in fact has a history quite separate from the city, beginning as a set of spatial techniques of governance instantiated in colonial practices of mapping—only later brought to cities by urban planners. Adams directly links the concept of the urban to the concept of circulation, as both appear as key epistemological frameworks in nineteenth century Europe, from

4 Raymond Williams, *The Country and the City* (Oxford: Oxford University Press, 1973), p. 292.

revolutions in transportation, to emergent discourses of hygiene: "If there is a history of the urban, it is a history of what circulates."[5] What is important for our purposes in such accounts, though, is not to dismiss the city as an erroneous object of focus for writers and artists because, as one urban theorist has put it, they fail to see "the global urban wood rather than just the city trees," but rather to ask why (beyond reductive sociological claims about the city as the site of cultural production, and that writers write what they know) it is that in the history of the novel the city was the form of appearance of urbanization for so long and, indeed, why it continues to serves this purpose.[6]

One answer lies, I think, in the history of the nineteenth century city novel, which tied the novel and the city irrevocably together. In the annals of realist fiction in particular, the city holds a unique position, as the prime locus of bourgeois existence, but also as the stand-in for the social totality itself: to know the city is to know society. In its nineteenth century iteration, the city novel has been analyzed by Emily Steinlight as a response not to the city in its "architectural" or "geographical" qualities, but as a literary mode developed to comprehend the space in which population as a category became visible as such. The nineteenth century city, for Steinlight, was to be characterized by the "size" and "density" of its population, and the novel turned to it not as mere setting or background, but as the space in which "abstract statistical indications of human aggregation become empirically perceptible."[7] According to

5 Ross Adams, *Urbanization and Circulation* (London: SAGE Publishing, 2018), p. 3.
6 Andy Merrifield, "Strategic Embellishment and Civil War: More Notes on the New Urban Question," 7 January 2013, *Cities@Manchester blog*, https://citiesmcr.wordpress.com/2013/01/21/strategic-embellishment-and-civil-war-more-notes-on-the-new-urban-question/ (accessed August 31, 2021).
7 Emily Steinlight, *Populating the Novel: Literary Form and the Politics of Surplus Life* (Ithaca: Cornell University Press, 2018), p. 75.

Steinlight, the city novel thus emerged as both reflection and critique of an emergent discourse of overcrowding, the massification of the working class, and the regulation of disease and sexual deviance.

While Steinlight is right to argue that the city novel in the nineteenth century defined the city as a space characterized by density—a density driven by capitalism's structural requirement for reserve armies of labor—this no longer quite names the problem of the city in the twenty-first century. For as the city has moved from the site of industrial production, housing an urban proletariat distinct from their rural counterparts, cities are now increasingly defined by deindustrialization, and the prioritization not of production but of circulation.[8] Population remains a central category, to be sure, but it is always a question of populations in motion. Indeed, if the city novel of the nineteenth century was preoccupied with density, it was as essentially a problem of stagnation: the issue became how to open urban space to circulatory flows, to clear the city of its accumulated "filth," whether considered literally, or figuratively as "social filth." Thus, the city in the city novel has always been presented as a space with aspirations towards becoming a circulatory space—towards becoming urban. The great projects of urban renewal—Bazalgette's sewers, Haussmann's boulevards, Cerdá's replicating grids or Moses' highways—have all had this aim in mind. The city novel, rather than exclusively interested in the massification of human life into the new category of "population," was also a staging ground for imagining the new

8 For Jasper Bernes, the explanation for this shift lies in the emergence of "logistics" as the dominant form of capital circulation in the late twentieth century. Logistics, for Bernes, "indexes the subordination of production to the conditions of circulation, the becoming-hegemonic of those aspects of the production process that involve circulation." Jasper Bernes, "Logistics, Counterlogistics and the Communist Prospect," *Endnotes* 3, September 2013, https://endnotes.org.uk/issues/3/en/jasper-bernes-logistics-counterlogistics-and-the-communist-prospect (accessed August 31, 2021).

forms of circulation that would displace the city and its density with the urban and its abhorrence of densification insofar as it forestalls possibilities for circulation.[9]

The city novel thus involves the presentation of the city as a space that is always in flux and in transition, rather than a merely inert background or setting. Indeed, one of the traits of the modernist city novel was a tendency to view the emergence of one thing—urbanization—in terms of the dissolution of another—the city. The old city, with its sordid alleyways and its jostling masses, whose intricacies the novelist was tasked with tracking, stands in tension with the urban that emerges in its midst: the arrival, for example, of the American motorcar, and the wide boulevards on which it travels. Nowhere is this tension more at work than in the opening pages of Robert Musil's *The Man Without Qualities*:

> Automobiles shot out of deep, narrow streets into the shallows of bright squares. Dark clusters of pedestrians formed cloudlike strings. Where more powerful lines of speed cut across their casual haste they clotted up, then trickled on faster and, after a few oscillations, resumed their steady rhythm. Hundreds of noises wove themselves into a wiry texture of sound with barbs protruding here and there, soft edges running along it and subsiding again, with clear notes splintering off and dissipating. [...] We overestimate the importance of knowing where we are because in nomadic times it was essential to recognize the tribal feeding grounds. Why are we satisfied to speak vaguely of a red nose, without specifying what shade of red, even though degrees of red can be stated precisely to the micromillimeter of a wavelength, while with something so infinitely more complicated such as what city one happens to be in, we always insist on knowing it exactly? [...]

9 This is why each urban renewal project, from Balzagette to Moses, is also a project of displacement and gentrification.

So let us not place any particular value on the city's name. Like all big cities it was made up of irregularity, change, forward spurts, failures to keep step, collisions of objects and interests, punctuated by unfathomable silences; made up of pathways and untrodden ways, of one great rhythmic beat as well as the chronic discord and mutual displacement of all its contending rhythms. All in all, it was like a boiling bubble inside a pot made of the durable stuff of buildings, laws, regulations, and historical traditions.[10]

In this passage alone, we can begin to parse the oppositions with which this article is concerned. Firstly, there is the figure of the automobile, the new subject of the urban, bursting onto the scene from the "depth" of the old space, with its "deep narrow streets," and bringing with it the flat surfaces of the new: "the shallows of bright squares." The movement across space of the automobile is also a movement from one time to the next, from an older spatial order to a new one—it arrives from the future to terrorize the present. And then from this observation comes the narration's sudden questioning of the relevance of place versus that of space. Why should we care which city we are in? Each city is only an expression of a singular system, and each city harbors the same essential conflict: between the urban, "one great rhythmic beat," and the residues of the older city form, with its "unfathomable silences."

We can see, then, that the urban versus the city is rendered as a conflict between order and chaos, between a new system that wants untrammeled circulation (the urban), and the dense accumulation of people, buildings, and history which threatens to clog it up (the city). So, what happens to the city novel's project "after" the city? The story of the urban since the 1970s is one in

10 Robert Musil, *The Man Without Qualities*, trans. Sophie Wilkins (London: Pan Macmillan, 2017), p. 3.

which the "city" is no longer a singular space, one that absorbs people and things into its orbit, but rather is the placeholder by which we name the larger process of geographical reorganization associated with "logistical capitalism": a world in which circulation replaces production as the central category of analysis, and in which density as the defining metric of urban space is increasingly replaced by dispersal.

At the moment of Dickens and Balzac, but also of Musil and other modernists, the expansion of capitalism into its peripheries, and thus urbanization's accompanying spread across the surface of the globe, remained a wish, a dream, a pursuit, but far from a *fait accompli*. There still seemed to be undeveloped spaces into which capital could expand and from which it could extract value. It seemed safe to assume, in other words, that urbanization named only one tendency within the expansionist repertoire of capital accumulation. By the 1970s, however, this ideology lost its foothold in territorial expansion. As capital approached its geographical limit for expansion, its frontier became urbanization itself—the ends became the means. By the 1970s, the kind of abstract space of untrammeled circulation that could only be imagined by nineteenth century urbanisms was in the process of being fully realized through the logistics revolution and the emergence of what Deborah Cowen calls "the logistical city," in which "urban space is conceived for the singular purpose of securing the management and movement of globally bound stuff."[11] In other words, the city is no longer the locus of production but rather only a conduit or destination (both financial and geographical) for the circulation of commodities produced elsewhere. Thus the rise in the 1970s of logistics and the liberalization of financial markets served as twin

11 Deborah Cowen, *The Deadly Life of Logistics: Mapping the Violence of Global Trade* (Minneapolis: University of Minnesota Press, 2014), p. 171.

engines of a new wave of planetary urbanization, one in which cities formally central to their national contexts become fully "global" by dint of their implication in the circulation of capital.[12]

For an understanding of the contemporary fate of the city novel in a context in which the city itself would seem to be entirely subordinated to the imperatives of the urban, I want to conclude with a brief discussion of Tom McCarthy's *Remainder* (2005), perhaps one of the most critically appraised novels of the twenty-first century thus far. *Remainder* tells the story of a man hit by falling debris in London who uses his settlement of 8.5 million pounds to stage a series of "reenactments"—of both fragmentary memories and eventually of the accidental happenings he witnesses around him and that he deems, for one reason or another, to be significant. The novel's plot is almost impossible to pithily summarize, and this is in and of itself significant: it is, in the tradition of many city novels (Dos Passos' *Manhattan Transfer* comes to mind), an iterative, repetitive narrative structure, in which a bored and affectless protagonist drifts from one reenactment to the next, attempting, in his own words, "to feel real again."

This affectless quality to *Remainder*'s protagonist is important, especially since it has been much noted by critics.[13] McCarthy's novel, written more than a decade after Fredric Jameson's infamous characterization of postmodern aesthetics as evincing a "waning of affect," would confirm it as a symptom of the postmodern era and postmodern subjectivity. But crucially, we must identify the source of this affective waning, and in

12 For the classic definition of the idea of the "global city" separating from national networks of exchange and becoming integrated in fully globalized networks, see Saskia Sassen, *The Global City: New York, London, Tokyo* (Princeton: Princeton University Press, 1991).

13 Mark McGurl, for example, describes the narrator/protagonist of the novel as "for the most part kind of dumb." Mark McGurl, "The Novel's Forking Path," 1 April 2015, *Public Books*, https://www.public-books.org/the-novels-forking-path/ (accessed August 31, 2021).

Remainder this source has its roots in the novel's specific formal structure: it begins with an act of accumulation (the 8.5 million pound settlement) that then establishes the unfolding of the novel's narrative, which lurches from this initial act of accumulation into first financial forms of circulation (the narrator's use of a financial adviser to speculate his way into increasing his settlement), then to an obsession with the city itself as a space that must be "captured" and subordinated to this circulatory imperative: not just to make things move, but to control and apprehend such movement.[14] The narrator begins by purchasing a block of flats in order to stage reenactments of a memory he thinks he has, but cannot locate in a specific time or place. He hires "actors" to inhabit a facsimile of the building he remembers, and has them all "work in shifts" repeatedly performing a series of mundane movements and tasks: the taking out of some rubbish, the frying of liver in a pan, and the practicing of piano.[15] Once these reenactments begin to take place, the narrator is not brought back to a subjective memory, and nor does he regain the feeling of "reality" that he had hoped to recover: he feels merely a pleasant "tingling sensation" that courses through his body.[16]

Thus the city here is no longer the site of profound self-discovery, as in the city novel in its *Bildungsroman* iterations. But nor is it productive of the profound alienation and anxiety that the modernist city novel sought to invoke. Rather, the city in *Remainder* functions only as a conduit for *flows*: flows of affect, flows of money, and flows of traffic (the narrator drives, or is driven, everywhere). The narrator's only real desire is to appre-

14 Circulation and accumulation are twin processes, for it is only by circulating that capital can accumulate: whether that circulation is literal, as in the transportation of raw materials or commodities, or virtual, as in the movement of money.

15 Tom McCarthy, *Remainder* (London: Vintage, 2007), p. 179.

16 Ibid., p. 51.

hend these flows and to achieve the aforementioned "tingling sensation": a motivation that hardly makes for rich characterization, but one whose increasingly dire consequences propel what narrative movement there is in the novel. For the narrator is obsessed with overcoming "matter" as the chief impediment to his achievement of a state of unadulterated being: "messy, irksome matter that had no respect for millions, didn't know its place."[17] Early in the novel, while undergoing physiotherapy for the injuries sustained in his accident, the narrator describes being asked to hold a carrot: "I closed my fingers around the carrot. It felt – well, it *felt*: that was enough to start short-circuiting the operation."[18] As the narrator embarks on his less orthodox methods for recovering from his accident, it is the city itself that appears as the matter that will "short-circuit" such an "operation": he knows that he has the newly acquired financial means to purchase property all over London, to "buy the shops, the cafes, cinemas, whatever."[19] And yet, he would "still be exterior to them, outside, closed out. This feeling of exclusion coloured the whole city as I watched it darken and glow, closing ranks."[20] Here there is the identification of the city as a space that threatens to collapse in on itself. Like the carrot's materiality as a thing interrupting the circuity of his bodily functioning, the narrator perceives the city as a space that must not be allowed to interrupt some larger, inexplicable imperative for unceasing repetition and movement, but whose density threatens to overwhelm such an imperative: "just too much, too much to absorb."[21]

It is worth pausing here for a moment to dwell on *Remainder*'s title. For if indeed the novel marks the recognition of circulation as an increasingly dominant

17 Ibid., p. 17.
18 Ibid., p. 21.
19 Ibid., p. 51.
20 Ibid.
21 Ibid., p. 295.

spatial imperative in the twenty-first century, one that attempts to absorb the city into the broader spatial logic of urbanization, then it must be noted that circulation cannot be reduced to mere repetition, but must be understood as both repetition *and* accumulation. For it is precisely through the incorporation of the excess (in Marx, surplus-value) that circulation provides the engine for accumulation. That which cannot be accumulated, by this logic, must be expunged. The narrator's obsession with "matter" thus translates into an obsession with this idea of a "remainder." In the novel's opening pages, he is perplexed with the .5 of his 8.5 million, and later in the novel he becomes preoccupied with the tenth free coffee that comes with the purchase of nine previous ones (in a cafe that bears obvious resemblance to Starbucks).

If the narrator is then without affect or a full and coherent subjectivity, it is because, I would argue, he has been reduced to the embodiment of a cultural and economic logic that insists on the incorporation of all phenomena into a poorly defined but irresistible process. In a sense, then, the narrator of the novel *is* the city, or at least *becomes* the city, since it is only through him that we perceive it: the restricted focalization of the novel forces a reckoning with the logic of a circulation that will not cease, and cannot end. And perhaps more importantly, the narrator embodies a process that also cannot self-reflect: "A drug addict doesn't stop to ask himself: Did it work?"[22]

Almost precisely contemporaneous with the publication of *Remainder*, the *Invisible Committee* described their concept of the "metropolis" as "a flow of beings and things, a current that runs through fiber-optic networks, through high-speed train lines, satellites, and video surveillance cameras, making sure that this world keeps running straight to its ruin. It is a current that would like to drag everything along in its hopeless mobility,

22 Ibid., p. 240.

to mobilize each and every one of us."[23] In both cases, in theory and in fiction, there is simultaneously a sense of urgency and a sense of paralysis regarding urbanization. It is an historical process whose unfolding leads nowhere, but whose motion cannot be arrested. It is, in spatial terms, the very embodiment of Gramsci's famous "interregnum": a historical punctum that is simultaneously stalled *and* spinning out of control. But of course, as Fredric Jameson would point out repeatedly in his commentaries on the fate of history in the postmodern, it is not that history has *actually* ended, but rather only our capacity, as a culture, to think historically. In relation to the questions of urban space raised in this article, the urban appears as the spatial analogue of this temporal impasse, with the decline of the city as a space through which history can be perceived and lived as it is diluted by the spread of the urban. Again, this does not mean that the urban has no history. Rather, this history can no longer be perceived and felt simply by taking the city as the exemplary spatial form of capitalism.

Remainder is a novel that not only confirms, or seems to confirm, these hypotheses, but enacts in its narrative logic the absurdity of the spatial unfolding of the urban as a system whose only imperative is for self-expansion: the plot goes nowhere, there is no development of character, no profound reckoning. Indeed, the narrator's attempt to locate a past for himself that "feels" authentic through the capturing of the city's flows, and his ultimate failure to do so, provides a narrative analogy for the spatial conjuncture of the postmodern: in terms of narrative focalization, we are trapped in the mind of a man spinning out of control, and whose unravelling is explicitly tied to the city's own disintegration as a site of coherent meaning. Indeed, unwittingly reiterating Musil's own insistence on the irrelevance of the city as a specific location, and its absorption into a general-

23 The Invisible Committee, *The Coming Insurrection*, pp. 58–59.

ized spatial system of which it is only a component part, McCarthy has himself remarked in an interview that the London of *Remainder* is insignificant to its meaning (London is almost always referred to only as "the city" in the novel): "People like Andy Warhol and J. G. Ballard understood that cities are the same: every city is the Terminal City. The Infinite City. It's one giant thing."[24] This flattening of geography would once again seem to confirm the Jamesonian hypothesis of the flattening of affect that accompanies postmodern spatialization. In this sense, *Remainder* is an exemplary postmodern novel because it performs its own inability to historicize space, reducing a much-historicized city to a mere point in a spatial network.

And yet, what is significant about *Remainder*, at least in the reading I have tried to (all too briefly) provide, is its revealing of the foundational role of circulation in the emergence of the urban and the dissolution of the city. And it makes clear, through the novel's conclusion, that circulation can, ultimately, never hope to *fully* install itself as the immanent terrain of the city. As the novel progresses, the narrator's grasp over the various reenactments he has repeating themselves throughout the city begins to weaken, and his final project, the robbery of a bank and the hijacking of a plane, are destined (and indeed designed) to fail. The narrator, though, is indifferent. His assistant Naz, the narrator notes towards the end of the novel, as their carefully constructed plans descend into chaos,

wanted everything perfect, neat, wanted all matter organized and filed away so that it wasn't mess. He had to learn too: matter's what makes us alive—the bitty flow, the scar tissue, signature of the world's very first disaster and prom-

24 Matthew Hart, Aaron Jaffe, and Jonathan Eburne, "An Interview with Tom McCarthy," *Contemporary Literature* 54, no. 4 (2013), p. 664.

issory note guaranteeing its last. Try to iron it out at your peril. Naz had tried, and it fucked him up.[25]

Appropriately enough, the novel's final image is of the narrator in his hijacked plane, instructing the pilot to fly in circles until they run out of fuel:

I looked out of the window again. I felt really happy. [...] Eventually the sun would set forever—burn out, *pop*, extinguish—and the universe would run down like a Fisher Price toy whose spring has unwound to its very end. Then there'd be no more music, no more loops. Or maybe, before that, we'd just run out of fuel.[26]

Tellingly, the novel refuses to end at the point of collapse: it is suggested as an inevitability but the narrative is suspended at the moment just prior to this inevitability. This is then a novel whose very plot circulates seemingly aimlessly to its conclusion, repeating the same story of a narrator cajoling the city to his whims, only to refuse to indulge the cathartic apocalyptic ending. But we know the game is up, that this is a process that ultimately cannot complete itself without descending into crisis. And it is important to note that this crisis is figured here as fundamentally an ecological one, since it is a question of fuel which will ultimately end the fantasy of the narrator's endless circulation in the air, and thus also end his capacity to subjugate the environment to his own ends.[27]

Remainder, then, despite its theoretical sophistication, its indifferent and detached tone, seems to want to provoke a recognition of the depths of the urban crisis,

25 McCarthy, *Remainder*, p. 305.
26 Ibid, p. 308.
27 For the connection between the (now irrelevant) circulation of the sun and the control of flows of energy in Gerhart Hauptmann's play *Before Daybreak* (1889), see the contribution by Sebastian Kirsch in this volume.

and the subordination of social space to the demands of circulating capital. There is, after all, an allegorical function to this novel, even as it seems to want to resist all obvious allegories. McCarthy is not a political novelist per se, but rather a self-proclaimed philosopher. But nevertheless *Remainder* is a political novel. McCarthy's experimental engagement with the city novel, his performative rejection of literature being able to provide a portal into the real "feel" of a city, seems designed to probe the limits of the imaginary of the city novel, to ask what "remains" of an idea or imaginary of the city long after its waning as a marker of a distinct mode of life. The answer the novel provides is not definitive, but rather couched in the negative: the city cannot be subordinated to the urban and its regime of circulation without ceasing to exist. Currently, the city survives, if only, as Lefebvre would have it, as an "image." The question, as ever, is whether, in this suspended state of animation, the city can be reclaimed, at the expense of the urban.

Stefan Yong

The Sublime and the Logistical

Containment Strategies in the Aesthetics of Circulation

There is something vast and ineffable about circulation. Jesse LeCavalier speaks of the "logistification" of everyday commodities, a horizontal process concerning the entire life of the product, working to "flatten, connect, smooth, and lubricate" the movement and organization of things through space and time.[1] Take any produced object whatsoever. In principle, it is possible to track that object in its journey through the manifold features of logistical circulation: transport technologies like containerized shipping and intermodal transit underpinned by the transmission and processing of data; intra- and inter-firm outsourcing and subcontracting relations; and the built environment of storage, road, rail, and port infrastructures. These carefully managed flows are calculable "in principle" because they are or have been, for one or several someones along the object's supply chain, calculable in practice. The point, however, is that when refracted into the everyday encounter, the giganticness of circulatory processes, precisely by virtue of their quantitatively enormous calculability, are experienced as qualitatively incalculable.

In an age governed by circulation, where the self-expansion and social relations of capital meet the physical coordination and movement of capital's object-worlds, where

1 Jesse LeCavalier, *The Rule of Logistics: Walmart and the Architecture of Fulfillment* (Minneapolis: University of Minnesota Press, 2016), pp. 5–6.

what Karl Marx called "value in process" meets what David Harvey terms "value in motion," the quotidian sense-perception of commodities shades into a contemplation of large-scale logistical processes.[2] The label of "logistical" is an evaluative as well as a descriptive designation, implying a judgment of success, efficiency, or optimization, and perhaps even a felt sense of satisfaction: through some technical wizardry, the right things have gotten to the right place at the right time. Taken as an abstract whole, though, the aggregation of these technical processes expresses an enormity of indifferent forces against which the mental faculty of representation discovers the shock of its incapacity. The problem of figuration here is twofold. On the one hand, there is the analytical judgment of the unfigurability of the capitalist world-system as an objective material condition for political economy and for class struggle. On the other hand, these very conditions invite affective responses to, or feeling-based judgments about, figuration's impossibility. The examination of such responses put us squarely in the domain of culture; they cohere into an aesthetic logic in which most vast and abstract circulatory systems are at once faintly visible and tremendously opaque from the standpoint of everyday perception.

In this vein, many critics within the ambit of Marxist cultural theory have returned to the old aesthetic category of the sublime to better comprehend the cultural logic of circulation. Indeed, the aesthetic quandaries briefly outlined above in the quotidian experience of logistical systems are nicely captured in Jean-François Lyotard's formula for the operation of the Kantian sublime: "to present the unpresentable."[3] The use of the sublime in cultural theory is an attempt to name and

2 Karl Marx, *Capital: A Critique of Political Economy, Volume One*, trans. Ben Fowkes (Harmondsworth: Penguin Classics, 1990), p. 256; David Harvey, *The Limits to Capital* (London: Verso, 2018), p. 405.

3 Jean-François Lyotard, *Lessons on the Analytic of the Sublime* (Stanford: Stanford University Press, 1994), p. 141.

describe the inadequacies of human perception and control in the face of the complex enormities of those logistical networks which structure everyday experience. It combines this sense of the aesthetic impossibility of representation with certain accompanying feelings of awe or powerlessness specific to historical conditions of capital accumulation. In the first part of this essay, I outline the affordances and limits of the notion of the sublime as it has appeared in the formulations of three cultural critics: Sam Halliday, Bruce Robbins, and Fredric Jameson. Subsequently, in the second part, I draw on the recent work of the aesthetic theorist Sianne Ngai to argue for a move away from the sublime and towards alternative and undertheorized aesthetic experiences. Ultimately, I suggest that Ngai's attention to post-sublime or anti-sublime aesthetic categories constitutes a timely contribution to a reinvigoration of the aesthetico-political project of cognitive mapping.

1. Sublime Containment

The sublime aesthetic of circulation suggests a certain feeling of cognitive powerlessness before the power and agility of capitalist circulation as it operates across hitherto unimaginable scales. Thus, for Sam Halliday, Bram Stoker's *Dracula* dramatizes the "logistical sublime" of the early industrial era, in which the fortunes of the characters hinge upon the punctualities and delays of the various means of transport and communication traversing an unevenly developed Europe. The logistical theme of the timeliness or untimeliness of alien powers of machine-based transport are present from the novel's very first lines: "Left Munich at 8:35 pm on 1st May, arriving at Vienna early next morning; should have arrived at 6:46, but train was an hour late."[4] As

4 Bram Stoker, *Dracula* (New York: Random House, 1897), p. 1.

the novel unfolds, the motivations of individual char-
acters continue to be constrained in their determination
of the narrative by the contingencies of their realization
through trains that might be variously on time, late, or
simply adhering to irregular schedules; or through the
unpredictable maritime exigencies of a ship's voyage; or
through the anticipated arrival of an unpunctual tele-
gram whose contents contain the information necessary
for the characters to take action. This is a form of sublim-
ity which is, as Halliday puts it, "emphasized by the very
technical glitches that occasionally disrupt the best laid
plans of [the] protagonists."[5] In this narrative frame, the
logistical sublime arises by way of contrast with "unlo-
gistical" experiences associated with necessarily imper-
fect and narrowly human coordination of action, in
which too many or too few things or people are always
arriving too early or too late and at the wrong location.

But the logistical sublime is both a technical and an
aesthetic effect. It contrasts efficiencies and inefficien-
cies in order to reveal not only synchronized perfection
as an outcome of logistical technique, but also the aes-
thetic contemplation of that technique. The unreliable
punctualities of industrial-era transport and communi-
cation networks in the novel are a complex of imper-
sonal forces set against protagonists' best intentions and
capacities for action, which find their figural double
in the inhuman persona of Dracula himself, the villain
whose status as an anachronism stems most obviously
from his oddly outdated manner and his embodiment of
an undying feudal social order. But, as Halliday argues,
he is also anachronistic in the sense of embodying a
uniquely efficient experience of temporality; in con-
trast to the flustered rushing of his enemies, Dracula acts
with fastidiously planned designs and a conspicuously

5 Sam Halliday, *Science and Technology in the Age of Hawthorne, Mel-
 ville, Twain, and James: Thinking and Writing Electricity* (Basing-
 stoke: Palgrave Macmillan, 2007), p. 29.

unhurried pace. The fear or awe accorded to this unruf-fled antagonist may then be understood as a displaced congealment of the awe accorded to the large technical systems of capitalist modernity, insofar as these are expe-rienced as an alien power appearing within, but always exceeding, individual experience and action. So while Halliday wants to define the logistical sublime as an "acme of coordinated action, involving many technolo-gies and many agents, disparate in time and space," we might also stress its character as the *experience* of that coordinated action from the outside, as an unavoidably interpretive appraisal of technical effectiveness that comes to regard the human-made as fearsomely more-than-human.[6]

In late capitalism, the opacity of circulation then gen-erates new forms of sublime experience, as exempli-fied in the commodity consciousness of the scandalized First World consumer, who becomes paralyzed in her everyday encounters with a specific commodity when she plunges into the vertiginous contemplation of net-worked connections linking workers and production processes along the commodity's supply chain. This is the aesthetic of what Bruce Robbins calls the "sweatshop sublime." For Robbins, the sweatshop sublime stages the heady realization "that one is the beneficiary of an unimaginably vast and complex social whole," gener-ally involving the "unpleasant and underremunerated" labor of distant and unseen others.[7] The consciousness of the existence of a world-system which both exceeds and determines metropolitan experience prompts a self-recognition of the metropolitan subject as a benefi-ciary, a figure whose genealogical ties to the sweatshop sublime Robbins traces from the "tangled skeins" and "tangled webs" of George Eliot all the way through to

6 Ibid., p. 189.
7 Bruce Robbins, "The Sweatshop Sublime," *PMLA* 117 (2002), pp. 84–97, here p. 84.

the newfound critiques of the international division of labor in the anti-globalization campaigns that were contemporary with his own essay.

The invocation of the anti-globalization and anti-sweatshop movements testifies most obviously to the world-spanning character of the system that gives rise to this sublime experience. The epiphanies associated with the sweatshop sublime are all the more striking for their inability to motivate socially transformative action, and indeed for their seemingly inevitable tumble into an unequivocal *absence* of action. The modulations of this aesthetic experience foreground not only the "obscure infinity of the social whole," but more fundamentally the ways in which the reflexive recognition of our power to perceive this daunting largeness allows us to "sink back into ourselves": "Your sudden, heady access to the global scale is not access to a commensurate power of action *on* the global scale [...] Just as suddenly, just as shockingly, you are returned to yourself in all your everyday smallness."[8] On this read, the notion of the sweatshop sublime names the moment at which the complex and systematic immensity of global capital, with no necessary aesthetic qualities of its own, flashes up into aesthetic experience, only to recede again. It is as if the hidden globality at work behind one's own First World existence periodically looms so incredibly large over perceptual experience that the resultant coping mechanism has to recalibrate the balance all the way in a depoliticized opposite direction, by reaffirming "the illegitimate but seemingly irremediable tyranny of the close over the distant."[9]

We can already observe an element common to Halliday's logistical sublime and Robbins's sweatshop sublime alike: sublime experience is a structural barrier to practical human activity, whether this latter takes the

8 Ibid., p. 85.
9 Ibid., p. 86.

form of narratively decisive action (Halliday) or socially transformative action (Robbins). These manifestations of the capitalist sublime, in other words, confront everyday perception with forms of ideological closure that Fredric Jameson once named "strategies of containment." Strategies of containment, the analytical inverted double of cognitive mapping techniques, are narrative or aesthetic frames, often exhibiting spatial characteristics, which "seek to endow their objects of representation with formal unity" in order to "at once imply and repress" a genuinely political confrontation with the social totality of capital.[10] The sea in Joseph Conrad's *Lord Jim*, for instance, is for Jameson a containment strategy par excellence. As raw narrative content, Conrad's sea is "a border and a decorative limit," but also "a highway, out of the world and in it at once, the repression of work [...] as well as the absent workplace itself." Yet the ultimate fate of the sea as content is that of containment and "derealization," so that it becomes immediately "available for consumption on some purely aesthetic level."[11] The logistical and sweatshop sublimes partake of such logics of derealization inasmuch as they stage the encounter with global capital as a defeat of everyday perception and a retreat from practical activity, where the ultimate stakes of the latter must surely include some generalized dilution of the political.

Meanwhile, Jameson's own forays into the notion of the sublime stress the ways in which developmental leaps in technology under late capitalism necessarily inaugurate new forms of sublime experience. Crucially, in Jameson's account of what he terms the "technological sublime," the foil for the human faculty for representation is technological only insofar as technology is "itself

10 Fredric Jameson, *The Political Unconscious: Narrative as a Socially Symbolic Act* (Ithaca: Cornell University Press, 1981), pp. 52–54.
11 Ibid., pp. 210–214.

a figure for something else," namely "that enormous properly human and anti-natural power of dead human labor stored up in our machinery [...] which turns back on us and against us in unrecognizable forms."[12] The capillary complexity of such forms is the sign of capital's "quantum leap" beyond the technological singularities of an earlier period of frenetic modernization, when the individual machine could still command modernist fascination or futurist exhilaration as a spectacularly distilled node of motive energy. In late capitalism, Jameson suggests, the single machine "articulates nothing," losing its former capacity for representation as it becomes eclipsed by diffused and unfigurable systems of distribution. Even Jameson's own candidate for the paradigmatic postmodern machine—the computer—is itself, he admits, comprehensible only as part of "some immense communicational and computer network," and thereby dissolves into the spatially dispersed topology of the logistical system, understood as pure technological concatenation.[13] Where we previously saw the sublime emanating from capital's technological networks (Halliday) or in capital's uneven patterns of global distribution and circulation (Robbins), Jameson's vision of the technological sublime as a horrifically concatenated global assemblage of anonymous dead labor gives us both pieces of the puzzle at once. This figural blend of smoothly integrated technology and sublimely opaque circulation is clearly instantiated in the aesthetic contemplation of a technical object like the modern intermodal shipping container, which, as Alberto Toscano and Jeff Kinkle point out in their recent and very Jamesonian study of capitalist visuality, has become a veritable "synecdoche for logistics, circulation, and capital in

12 Fredric Jameson, *Postmodernism or, The Cultural Logic of Late Capitalism* (Durham and London: Duke University Press, 1991), pp. 34–35.
13 Ibid., p. 37.

the arts."[14] The container's physical form authorizes a vacillation between tropes of hiddenness and revelation in the enormity of global circulatory systems, where the other side of being mesmerized by the perfectly standardized and stackable modularity of the opaque box is the fantasy that one might throw open the container and discover within it the final truth of capital's horror.

But can circulation only ever be sublime? I wish to assert at this point that in addition to the sublime dampening of action examined above there is a second problem, namely that of the analytical imprecision of the category of the sublime with respect to the phenomena that it purports to grasp. More specifically, I am arguing that the concept of the sublime becomes catachrestic and inadequate to its object, especially when this object is capitalist circulation. In order to elaborate this second problem, describe its relation to the first, and identify alternative concepts that would sidestep their combined faultiness, it will be necessary to lean on the considerable powers of Sianne Ngai, an unparalleled thinker on contemporary capitalist aesthetics whose cultural theory evinces a relatively under-synthesized but strongly consistent engagement with both the sublime *and* circulation. In the next section, I examine each of Ngai's major works to show that her identification of minor aesthetic categories and experiences provides three generative points of departure for thematizing capitalist circulation beyond the framework of the sublime.

2. Sublime, Contained

The problem with the sublime lies in the necessary rarity and brevity that accompanies its intensity as an experience. The sublime is "sudden blazing, and without

14 Alberto Toscano and Jeff Kinkle, *Cartographies of the Absolute* (London: Zero Books, 2014), p. 196.

future" (Lyotard), and is understood as "a kind of thunderbolt, or in terms of instantaneity, suddenness, and once-and-for-allness" (Ngai).[15] The forceful immediacy of sublimity would seem to be a strange descriptor, then, for circulatory *processes*. Even in the most abstract sense, an act of circulation never happens once and for all without also presupposing innumerable other circulatory moments endlessly and matter-of-factly unfolding elsewhere and elsewhen. The material objects and technological symbols of our circulatory systems accrue aesthetic fascination because, and not in spite of, their bland ubiquity; they are, as Toscano and Kinkle say of the shipping container, "exquisitely banal."[16] Even the cultural critics I cited earlier would concede that the largeness of circulation must coexist with a quintessential everydayness, connoting an accessibility to quotidian experience as well as a certain iterability.

Ngai's critique of the sublime is staged most frontally in the pages of *Ugly Feelings* with an affective category of her own invention: "stuplimity," the sublime's stupid and stupefying double. The central lesson of stuplimity is that not everything is overwhelmingly large in the same way, that some immense objects of aesthetic contemplation inspire not the instantaneous flash of the sublime, but the processual boredom of something else. Ngai's illustrative examples include the irritatingly "thick" language of Samuel Beckett's late novels, with their agglutinative sentences which constantly self-correct and self-refine only by continually accreting to previous ones, as well as the *Atlas* of Gerhard Richter, where what astonishes and bewilders is not the content of any single aesthetic unit, but instead the way that these units pile up together in tedious heaps. Where Kant's corpus of sublime objects privileged the sheer power of nature

15 Lyotard, *Lessons*, p. 55; Sianne Ngai, *Our Aesthetic Categories: Zany, Cute, Interesting* (Cambridge, Mass. and London: Harvard University Press, 2012), p. 134.
16 Toscano and Kinkle, *Cartographies*, p. 188.

and the mathematical limitlessness of the infinite, Ngai wants instead to reflect on aesthetic encounters with "vast but bounded artificial systems, resulting in repetitive and often mechanical acts of enumeration, permutation and combination, and taxonomic classification."[17] The undeniably gigantic works she analyzes indeed operate like unfolding affective systems, staging a different temporality by initially flirting with the sense of the sublime, but the classically "abrupt, instantaneous defeat of comprehension (in the face of a singularly vast or infinite object)" always shades into "extended cycles of exhaustion and recovery (in the effort to manipulate finite but repeated bits of material or information)."[18] This is stuplimity, the fatigued response to a laborious engagement with largeness and the comically exhausted cousin to the sublime's tragic terror. With stuplimity, Ngai makes the shift—as I am suggesting we must do with capitalist circulation—from the singularity of the moment to the ongoingness of process, a shift which concerns the specificity of the aesthetic object. Affective stuckness and stuplimity's play of temporal suspensions demonstrate "the limits of our ability to comprehend a vastly extended form as a totality," but unlike the sublime, these limits are staged "not through an encounter with the infinite but with finite bits and scraps of material in repetition."[19] I note here the way that Ngai's description of stuplime objects might quite felicitously characterize the no less "vast but bounded artificial systems" of sorting and processing that are the technical preconditions for the contemporary circulation of stuff.

But the switch of emphasis from astonishing moment to dull process also positions the subject of aesthetic experience within a stance quite distinct from the sublime defeat of cognition. While the sublime, as we have

17 Sianne Ngai, *Ugly Feelings* (Cambridge, Mass. and London: Harvard University Press, 2007), p. 36.
18 Ibid., p. 277.
19 Ibid., p. 271.

seen, is an ideological strategy of containment with respect to capital's totality, Ngai understands keenly that in its classic Kantian formulation, the sublime also contains its own strategy of containment, exhibiting, as it were, a containment strategy to the second power. Just as stuplimity stages a tension between the two opposed affective responses of awe-struck terror and exhausted tedium, so too did the Kantian sublime pit the over-whelmed faculty of imaginative figuration against the disinterested yet self-affirming faculty of reason. The crucial moment in Kant is not, as with our latter-day catalogue of capitalist sublimes, the freezing paralysis of terror provoked by incalculable infinity and the mas-siveness of rude nature. The true sublimity of the sub-lime arrives belatedly and as inversion, where the initial moment of terror is always repackaged as a triumph for the superior faculty of human reason, which ultimately perceives itself capable of grasping that before which the imagination could only gawp in mute awe. Paral-ysis alone is overly involved, whereas the "precondi-tion for experiencing the sublime," Ngai writes, "is that the observer feel safely removed from the object that inspires this emotion."[20] From this angle, the various sublimes examined earlier place the subject in a double bind: awestruck paralysis or a retreat into cognition. But stuplimity, since it inspires neither transcendental nor ironic distance from its object, draws the subject into extended affective postures of boredom and exhaustion which are proper not to the realm of cognition but to the realm of activity. If the extraordinary sublime cul-minates in a triumph for thought, then its containment or suspension by stuplimity narrows the horizon of experience to ordinary action and ordinary tedium.

It is difficult not to read these critiques of the sub-lime into Ngai's analysis of the aesthetic category in the sweep of her work that is most explicitly "about"

20 Ibid., p. 268.

circulation: the interesting. The interesting, a mutedly ambivalent zero degree of evaluative judgment, is, for Ngai, is a "distinctively modern" way to register the barest flicker of novelty against a background of sameness. To call something "interesting" is to articulate a response to the first reverberations of affective stimulation prefacing an as-yet-unconceptualized thought. It is a provisional and non-committal pause before a cognitive fullness which could equally lapse into a dismissive finality (the "merely interesting"), self-negation (to say "interesting" of something that is precisely "not interesting"), and temporal postponement of judgment by way of hidden ellipsis ("interesting..."). This indeterminate temporality arises, Ngai argues, because the diachrony of the interesting expresses the tension between a set of binary oppositions which are proper to capitalist modernity writ large: seriality and novelty, familiarity and strangeness, typicality and difference, standardization and individuation, rationalization and ephemerality, order and change. It manifests stylistically in contemporary art as a "styleless style" that constructs provisional typologies in order to highlight minor variations at the level of the detail, a move which in turn elevates typology itself to the status of an object of aesthetic contemplation. The exemplar of interesting style for the contemporary period comes from the cultivated commitment to neutrality in conceptual art. Ngai lingers on the 1960s and 1970s output of Ed Ruscha, whose books of photography seem better described as "inventory-style" than "documentary-style," as witness the formulaic rhythms of their titles: *Twentysix Gasoline Stations*; *Thirtyfour Parking Lots in Los Angeles*; *Various Small Fires*; *A Few Palm Trees*. The genericness of the photographed objects is amplified by a careful attention to sequence, so that the photographs are deliberately ordered to foreground the recognition of minor differences on an unspectacular theme, above

all to vigilantly forestall the emergence of a determinate affective orientation or mood.

As compared with the sublime, the interesting is a noticeably weak aesthetic category, a low and indeterminate affect of ongoingness that is always "surprising— but not that surprising."[21] Whereas the stuplime (as process) neutered the force of the sublime (as moment), the interesting encodes process *within* the moment. In other words, the interesting qua aesthetic judgement reflexively thematizes its own precondition, namely aesthetic plurality as such, or, to speak with more historical specificity, the movement and exchange of aesthetic plurality as a "technologically mediated dissemination of information."[22] It suggests the "seemingly endless pursuit, in the felt absence of any totalizing vision, of the next new thing and then the next one after that," in a manner that both expresses and responds to the conditions of late capitalist social life, where "change is paradoxically constant and novelty paradoxically familiar."[23] In Ngai's explicit remarks in *Our Aesthetic Categories*, interesting style encodes new historical conditions of rapid circulation of aesthetic works through a commitment to minimality and near-redundancy alongside a fascination with low-stakes typological differences. If stuplimity is "about" the contained largeness of enumerated materials internal to a single work, then the interesting is conversely "about" the constantly shifting largeness of circulation as such. Crucially, though, the grand totality of circulating information presupposed by the interesting is, in the phenomenology of interesting experience, conspicuously *not* experienced as huge at all. Rather, the interesting operates like a localizing force (or indeed another second-degree containment strategy) that manages an uncountable mass of infor-

21 Ngai, *Categories*, p. 145.
22 Ibid.
23 Ibid., p. 146.

mation by miniaturizing its largeness into a suspended zero degree of affect.

If the stuplime and the interesting both dissipated the paralyzing enormity of the sublime through smothering blankets of ordinariness, Ngai's most recent work in *Theory of the Gimmick* places the capitalist aesthetic of the gimmick in a directly antagonistic relation with the sublime. There, she dwells at length on the video and sound art of Stan Douglas, who works in his installations with a finite set of video images and audio tracks that are fed through "an invisible looping + randomizing device" known as the "recombinant machine."[24] Like a logistical process unto itself, the recombinant machine processes individual scenes as modular and fungible units, applies a set of simple operational rules, and recomposes the final narrative sequence into a seemingly infinite range of variations whose total playback time amounts to a duration on the order of thousands of hours. For Ngai, this play of recombinations relies on a mechanism akin to that of the exchange-abstraction in the capitalist circulation of money and commodities. She understands exchange-based circulation as a kind of social machine for relating, and therefore measuring and equating, the products of previously independent acts of human labor. We "see" the exchange-abstraction only in the sense that we "see" Douglas's machine: by recognizing it as that which combines and recombines the raw materials of circulation to produce "more than the sum of their parts."[25] But whereas the high-tech, digital capacity of the recombinant machine "enables Douglas to produce works of gigantic, viewer-resistant, mathematically sublime *size*" or *scale*, the cheap analog technologies employed in the installation's execution ultimately present works with a "off-brand" and gim-

24 Sianne Ngai, *Theory of the Gimmick: Aesthetic Judgment and Capitalist Form* (Cambridge, Mass. and London: The Belknap Press of Harvard University Press, 2020), p. 231.
25 Ibid., p. 247.

micky *look*, *sound*, or *feel*.[26] These rogue elements, like the intentionally "botched special effect" of fake Technicolor or an annoyingly out-of-sync sound dubbing job that promises but thwarts the pleasurable meshing of sound with image, are countervailing aesthetic forces against the inhuman precision of the sequencing algorithm at the center of the installation.

We "so often find the flagrantly disappointing gimmick in the vicinity of the capitalist sublime" because, Ngai argues, such a "proximity of banality to extremity" expresses the volatility and unevenness constitutive of capital itself.[27] But whereas sublime capitalist circulation yields only opaque wonder, the gimmick's diagnosis of cheapness and trickery offers both opacity and transparency at once, and does so by thematizing that element most central to capitalist enormity yet most occluded from capitalist sublimity: labor. The gimmick, any labor-saving device which also somehow seems to be working too hard to impress us, is ultimately a category "about" the organization of our social life by value, time, and labor. If the logistical sublime repackages capitalist technique as unknowable supernatural magic, the gimmick cuts through the "halo-effect of technical difficulty" by contrasting technique's mysterious effects against its strained efforts.[28] If the sweatshop sublime promises a merely fleeting glimpse of hidden and distant labor, the gimmick judges the seemingly laborless smoothness of technical execution against *one's own* capacity for familiar forms of laborious exertion, where it is not technique itself that is alien and powerful, but only its unfamiliar degree of refinement relative to our own familiar abilities. By not only expressing but also *quantifying* aesthetic disappointment in terms of units of necessary labor, the gimmick suggests that a given

26 Ibid., p. 235, p. 248.
27 Ibid., p. 31.
28 Ibid., pp. 99–101.

capitalist phenomena might appear here as distantly sublime, but there as digestible contrivance.

The sustained engagement with Ngai in this section has examined alternative aesthetic categories which each afford a variation on post- or anti-sublime experience. By offering a stuplime exhaustion of sublime enormity, or a recapitulation of sublime circulation in interesting miniature, or even an antagonistically gimmicky opponent to the sublime's dynamic grandeur, they confront the aesthetic paradigmatically "defined by its defeat of our cognitive powers" with "a different way of thinking what it means to be aesthetically overpowered" and a new way of lingering with banality while holding paralysis at bay.[29] Through exhaustion, or tiny flickers of interest, or dubious evaluations about expended labor, the contemplation of sublime totality might pass through, rather than eclipse, the practical field of the everyday. Practical confrontations with capitalist circulation can, and perhaps must, begin with rather unspectacular forms of inquiry, action, and affective orientation. For such purposes, the sublime defeat of the everyday before an unrepresentable absolute is a "derealizing" operation and a strategy of containment that must itself be contained by the *re-realizations* of a post-sublime everyday, of tedious and disappointing but still ongoing struggle, which might allow for other possibilities entirely.

29 Ngai, *Feelings*, p. 270; Ngai, *Gimmick*, p. 263.

Annie McClanahan

Essential Workers

Gigwork, Logistics, and the Sweated Labor of Circulation

Since the beginning of the pandemic, we have thought a lot about circulation. We have thought, in ways we rarely do, about supply chains: the shipping container, the warehouse, the big rig; about the loading bay, the pallet, the shelf.

There's a version of this kind of thinking that Bruce Robbins describes as the "sweatshop sublime": the sudden realization "that one is the beneficiary of an unimaginably vast and complex social [system]...that brings goods from the ends of the earth to satisfy your slightest desire." For Robbins, the "sublimity" of this moment lies in the unsettling sense of powerlessness that attends it, a powerlessness that leaves us inclined, as Robbins says, to notice the "Made in Thailand" label but still "put on the shirt and forget about it."[1]

Robbins' sublime echoes Milton Friedman's favorite way to imagine the "impersonal operation of prices" that mysteriously coordinates supply chains. Often, Friedman described his own "sweatshop sublime" with a little fable he called "The Story of the Pencil." With a mix of mansplainery confidence and fake aw-shucks naivety, Friedman would say: "Look at this lead pencil. There's not a single person in the world who could make this pencil....The wood from which it is made, for all I know, comes from a tree that was cut down in the state

1 Bruce Robbins, "The Sweatshop Sublime," *PMLA* 117, no. 1 (2002), pp. 84–97, here p. 85.

of Washington…This black center…I'm not sure where it comes from, but I think it comes from some mines in South America."[2]

Yet Robbins and Friedman are describing this vast, networked system when it works, at least for those *for whom* it works. This is first-world thought, boom-time thought. It's not crisis thought, so it's not what we were doing when we looked at the empty shelf where the toilet paper or dried beans should be or wondered why virus testing kits or vaccine vials were stuck in warehouses rather than going where they were needed most. It's not what we were doing as we saw unopened containers full of consumer goods pile up in ports, or watched truckers stuck in snaking lines outside the shipping terminals on California's coast.

In Friedman's tale, things "come from" places by "impersonal" alchemy, as if they are untouched until they end up in *your* hand. In those pandemic early days, a friend said, "I can't stop thinking about all the hands that touched everything I buy." Unlike Friedman, then, we sometimes thought about the people: about the bike deliverer who brought us take-out, the shopper who got our groceries, the delivery driver who tossed the package onto the porch. Our pandemic awareness of what it took to get milk and bread into the refrigerator was thus shaped by our awareness of the *fragility* of the system. It also required that we turn away from the vastness of supply chains and provision networks and toward their intimacy, the human labor whereby goods move hand to hand to hand.

In Marx, hands are usually synecdoche for human industrial labor—*manual, manufacturing*. Sometimes, the substitution is manifestly ironic, as when he skewers the nineteenth-century metonymization of workers

2 Anne Elizabeth Moore, "Milton Friedman's Pencil," *The New Inquiry* (2012), https://thenewinquiry.com/milton-friedmans-pencil/ (accessed February 25, 2022).

as disembodied hands. Elsewhere, the relation between the hand and the *homo faber* it stands for is more positive, when hands symbolize the special power of human social labor: "many hands co-operate in the same undivided operation, such as raising a heavy weight."[3] When Marx talks about circulation, however, the metaphor itself does different work:

All commodities are non-use-values for their owners, and use-values for their non-owners. Consequently, they must all change hands. [T]his changing of hands constitutes their exchange...The process of circulation...does not disappear from view once the use-values have changed places and changed hands...When one commodity replaces another, the money commodity always sticks to the hands of some third person. Circulation sweats money from every pore.[4]

Because the making of objects is hidden while their exchange is highly visible, Marx argues, we become the victims of a kind of slight-of-hand: we assume that profits spring naturally from these commodities' circulation, missing entirely the real sweat occurring in the hidden abode of their production.

Although this essay will focus on the not-so-hidden abode of circulation, I am not suggesting that the revolutionizing of supply chains, logistics, and exchange has caused a full-scale transformation of the mode of accumulation. Capital still depends (as Marx makes clear) on the productive labor that must "take place in the background."[5] Yet supply chains today are both vaster and faster than ever before, and this has transformed both production and circulation accordingly. As Jasper Bernes has influentially argued, the logistics revolution depends on "a circulationist production philosophy, ori-

3 Karl Marx, *Capital Volume 1* (New York: Penguin Books, 1986 [1867]), p. 443.
4 Ibid., p. 209.
5 Ibid., p. 268.

ented around a concept of 'continuous flow' that views everything not in motion as a form of waste."[6] Since at least the eighteenth century, when economic thinkers began to describe circulating capital as the blood that ran through the body economic, capital has always yearned to be as freed from the fixity of the material world as possible and to take the most liquid form available. Financialization marked one attempt to enable this transition from the fixity of productive capital to the flexibility of circulating capital. But even financialization's air-blown bubbles still depended on the presumption that elsewhere or later real value would be created. The logistic revolution, in turn, marked another attempt to achieve pure flow: to make the distribution of goods as frictionless and risk-less as circulating money itself.

Of course those invested in production also want to create value ceaselessly, with maximum speed and as little waste and friction as possible—typically this has meant advancing mechanization and automation so as to minimize human labor. As Bernes notes, computerized information systems, network technology, and high-tech infrastructure—from modernized cargo ships to automated distribution centers—enabled the logistics revolution. But of course much of this technology had been developed in or borrowed from the productive economy. In this sense, the logistics revolution has brought circulation up to date with automated manufacturing: in both sectors, the dream has been to restrict human labor to the work of controlling technological networks while making it unnecessary to their operation. Turning disparate actions into an unbroken flow, Jason Smith argues, automated production models—like the circulationist world view Bernes describes—imagine

6 Jasper Bernes, "Logistics, Counterlogistics, and the Communist Prospect," *Endnotes* 3 (2013), https://endnotes.org.uk/articles/logistics-counterlogistics-and-the-communist-prospect (accessed July 27, 2022).

Fig. 1: Containers on covers: book jacket images for Martin Christopher's *Logistics and Supply Chain Management* and Deborah Cowen's *The Deadly Life of Logistics: Mapping Violence in Global Trade*.

the possibility that goods could be "assembled entirely without the intervention of human touch."[7]

Much as the fully robotic manufacturing center has become the signal image of automation in manufacturing, the image of sublimely mountainous (or monstrous, depending on your perspective) stacks of shipping containers has become the signal figure of the logistics revolution, appearing on the covers of books as diverse as management and logistics guru Martin Christopher's textbook *Logistics and Supply Chain Management* and Deborah Cowen's ruthlessly critical *The Deadly Life of Logistics* (see fig. 1).

Just as the production worker is nowhere on the scene of the robotic factory, the circulation worker is cropped

7 Jason Smith, *Smart Machines and Service Work: Automation in an Age of Stagnation* (London: Reaktion Books, 2020), p. 25.

from the visual frame of these images of circulation without human intervention. Yet much as the fully automated factory remains out of reach, so too does fully automated circulation, especially when it comes to consumer goods (the distribution of completed products, as distinct from the supply chains that move raw materials, components, or parts from one production center to another).

For all their technological innovation, online marketplaces often require more human workers to transport, guard, sort, and deliver goods than did more traditional "brick and mortar" retail distribution. Much of this labor—to say nothing of the labor of production that made the product in the first place—seems to disappear when a click of a mouse brings a package to our door in fewer than 24 hours. Yet every time we take advantage of Amazon's automated transaction system to select and pay for a product, we also set in motion an army of *human* workers, many of them doing things we would once have done ourselves: finding the item, moving it from the shelf, packaging it, and taking it home. Far from creating technological marvels of frictionless speed and fluid instantaneity, in other words, contemporary circulation requires goods to pass through ever more hands. The global supply-chain crisis that began in the summer of 2021 exemplifies this axiom well. This crisis was catalyzed by a massive and sudden increase in consumer demand: US consumers coming out of the worst of the pandemic remained unwilling to spend on services but returned with wild enthusiasm to buying globally-produced consumer goods. The chain reaction of supply-chain bottlenecks that has ensued was caused first by intractably material issues in the productive economy, from COVID-19 outbreaks that forced plants to shut down, to the climate-change-driven fires, droughts, and energy crises that hit semiconductor manufacturing in Asia, causing what has been termed a "chip famine." On the logistics end, likewise, the prob-

lems weren't with the high-tech information systems themselves but rather with their capacity to anticipate the consequences of what supply chain experts term the "bullwhip effect," where relatively small shifts in demand create exponential volatility as they wind their way through the chain.[8] Where the bullwhip's force has been most evident, since the summer of 2021, is not in computer technology or containers but rather in the labor still required to get goods from one place to another: a shortage of workers to fulfill jobs like port trucking, long-haul trucking, warehouse staffing, and delivery service has caused goods to essentially get stuck before they can reach stores. As trucks pile up for hours waiting to pick up containers stacked in towers, circulation no longer "disappears from view" but remains persistently visible precisely as it ceases to function effectively.

Marx skewers the mirage of "circulation sweating money from every pore," but if circulation doesn't sweat, circulation workers do: in much of the logistics sector, technology is used not to replace workers (the dream of the frictionless logistics flow) but rather to force more labor out of them. So-called "lean logistics," which operates on principles similar to the just-in-time production management models that formerly transformed manufacturing, prevents overproduction and overstocking by making distribution itself more efficient. That efficiency has come largely by centralizing distribution and through the forceful control of the labor process: ensuring that wages are kept as low as possible while

8 See Josh Wingrove, Jill Shah, and Brenan Case, "Supply-Chain Crisis," October 21, 2021, *Bloomberg News*, https://www.bloomberg.com/news/articles/2021-10-21/biden-tackles-supply-chain-crisis-with-few-tools-clock-ticking (accessed February 25, 2022); Joe Weisenthal and Tracy Alloway, "How Global Supply Chains Have Gotten Even Worse," October 14, 2021, Odd Lots podcast/*Bloomberg News*, https://www.bloomberg.com/news/articles/2021-10-14/ryan-petersen-on-how-global-supply-chains-have-gotten-even-worse?srnd=oddlots-podcast (accessed February 25, 2022).

the work itself is as productive and efficient as possible. As David Hill describes it, "to keep goods in perpetual motion, any impediment to the extraction of effort must be removed": as in the semi-automated manufacturing centers of the Fordist economy, the semi-automated warehouses of the logistics revolution deploy everything from time and motion studies to high-tech surveillance systems not to replace human labor but instead to intensify it.[9] To take the example of the port truckers, for instance, the "bullwhip effect" seems to apply not just to how necessary these drivers are to the supply chain as a whole, but also to the violence of their treatment. Mostly immigrant workers, port truckers are unprotected either by regulation or by collective bargaining agreements and have been described as "modern indentured servants": forced to finance their own trucks, truckers are trapped by debt and forced to work up to 20 hours in a single shift—even being physically prevented from leaving—and to work without wages.[10]

In the contemporary circulation economy, then, "sweat" might not suggest the liquidity of capital but rather something like "sweated labor," and circulation labor in the present might likewise be understood by looking at the productive labor of an early moment of industrialization. Although "sweating" eventually came to mean any work done for low wages, the term originally referred to a system of outsourcing whereby manufacturers used middle-men to subcontract workers to do unskilled work in their own homes. This kind of outsourcing was most common in periods of early industrialization and in phases of the production process with relatively low levels of mechanization. The example

9 David Hill, "The Injuries of Platform Logistics," *Media, Culture, and Society* 42, no. 4 (2020), pp. 521–536, here p. 527.
10 Brett Murphy, "Rigged," June 16, 2017, *USA Today*, https://www.usatoday.com/pages/interactives/news/rigged-forced-into-debt-worked-past-exhaustion-left-with-nothing/ (accessed February 25, 2022).

Marx uses is the production of lace: the portion of the labor process that was mostly mechanized, he explains, was also regulated, but the finishing of lace was largely performed outside the factory by women and children. This system kept parts of the industrial workforce decentralized, preventing collective labor unrest. Most important, sweating kept wages artificially low:

> The great production of surplus-value in these branches of labour was chiefly due to the minimum wages paid, no more than requisite for a miserable vegetation, and to the extension of working-time up to the maximum endurable by the human organism. It was in fact by the cheapness of the human sweat and the human blood which were converted into commodities that the markets were constantly being extended.[11]

Here, Marx sets natural bodily liquids (sweat and blood) and the organic necessity of adequate means of subsistence (vegetation) against the unnatural lowering of wages. The extension of the working day beyond its natural, human limit allows for the inhuman extension of the markets themselves—even, he goes on to suggest in a remarkably prescient turn to the global division of labor, the extension of markets into Britain's inhumane colonies.

Marx's figures of embodiment here are not just rhetorical flourish—just as his description of factory life in the famous "Working Day" chapter of *Capital* relied on the "Blue Books" written by British factory inspectors, his fierce condemnation of domestic sweated labor relied on the health and safety reports written by doctors and social reformers working to expose these conditions as a threat to public health. Using these government documents in a kind of defamiliarizing bricolage, Marx constructs a powerful and vivid image of these

11 Marx, *Capital Vol. 1*, p. 829.

conditions as they impact the bodies and health of the workers. We find in these descriptions of early industrial labor an echo of the circulation work of the pandemic present, as when Marx draws out particularly gothic moments in the health inspectors' reports. He quotes their descriptions of the lack of oxygen in the tenements where many thousands of artisans "breath[ed] through protracted days and nights of labor," creating a "mephitic atmosphere" that "rendered an otherwise comparatively innocuous occupation pregnant with disease and death."[12] In resisting new ventilation requirements giving workers a regulated amount of breathing space, Marx writes, the employers suggest "that lung diseases among the workpeople are necessary conditions to the existence of capital."[13] Marx emphasizes disease and health in part because the political pressure to regulate outworkers' working conditions emerged out of concerns about infectious disease, especially smallpox, which was often transmitted through the clothes the workers made.[14] He wanted to radicalize the link between the health of the most exploited workers and the health and welfare of the body politic: the chapter ends with his famous comparison of the fatal immiseration of the worker's body by capitalist labor processes to the permanent ruination of the soil's fertility by capitalist agriculture.

Far from being a radically new phenomenon, the circulation workers of the twenty-first century logistics economy—especially those who have fought, in the last year, precisely over issues of ventilation and breathing room, individual safety and public health—recall the outworkers of nineteenth-century informalized industry. This is especially true insofar as both the outwork of the past and the circulation work of the present are

12 Ibid., pp. 611–612.
13 Ibid., p. 612.
14 See John Bellamy Foster, Brett Clark, Hannah Holleman, "Capital and the Ecology of Disease," *Monthly Review* (June 2021), pp. 1–23.

at once the *complement* of mechanization and technology's *other*. The hiring-out system allowed capitalists to expand work and output *without* investing in larger factories or better machines: rather than increasing productivity by improving technological efficiency, they were able to increase it simply by forcing workers to sweat harder for less. They also often forced workers to make the fixed capital investments themselves, for instance requiring seamstresses to provide sewing machines and raw materials. Yet hiring-out also paradoxically *enabled* mechanization, insofar as it allowed capitalists to accumulate excess profits they could then use to centralize and update manufacturing technology: the many workers/low wages/no technology pre-industrial phase made possible the fewer workers/middling wages/high technology phase of peak industrialization.

The contemporary logistics economy indicates the long-term consequences of this process whereby the misery of sweating is linked to the immiseration of technological unemployment: the service and circulation sector remains technologically stagnant in part because it has been able to rely on a pool of workers forced to settle for insecure, low-wage jobs because deindustrialization and automation elsewhere and previously have left them no other choice. Given access to this desperate workforce, capital, in turn, has responded by providing them the barest form of employment at little cost but also little benefit either to workers or to overall economic growth. The contemporary port truckers forced to pay (typically with debt) for their own rigs are thus an echo of the nineteenth-century tenement seamstresses forced to provide their own sewing machines. Elsewhere in the circulation economy we find other kinds of historical regression, away from machines and goods and back towards inefficient but cheap manual alternatives: whereas the manufacturing revolution that powered twentieth-century accumulation depended on the transformation of nineteenth-century services like laundry and hackney

driving into durable goods like washing machines and private cars, the twenty-first century has seen the intensified mediation of goods consumption by service work, from ride-share services to grocery delivery.

A description of the labor process at an Amazon warehouse written by John Holland, a UK Amazon worker, recounts the multiple human hands through which goods must pass: "work is divided into small repetitive tasks," the writer explains while narrating the process by which packages pass from receivers unloading boxes off lorries; to preppers, who open each box, attach a barcode to individual items, and reseal them in new boxes; to stowers, who scan each item's barcode; to pickers, who collect items from bins and scan them again; to deliverers, who sort the picked items and pack them by geographic destination.[15] While some of this work could potentially be automated—though development of robots with the fine motor skills to do a task like unpacking a box is still farther away than one might think—for now, warehouse work is labor-intensive and depends both on the specific capacities of humans to perform even highly deskilled tasks more accurately, flexibly, and responsively than machines, *and* on the ability to pay those workers very low wages.

Where there *has* been automation in this sector, it has primarily been the automation of management. Gig-work firms from Uber and Deliveroo to Upwork and Mechanical Turk turn over the entire human resources process—hiring, scheduling, matching, paying—to the algorithms of an app. An amazing piece of worker knowledge production produced by an anonymous team of Chinese journalists in collaboration with *waimai* bicycle delivery workers includes a worker describing the way the algorithm functions: "the moment a customer places an order, the system immediately begins look-

15 John Holland, "Amazon Inquiry," in *From the Workplace: A Collection of Worker Writing,* ed. Notes from Below (2020), p. 7.

ing for the closest rider with the most direct route. After determining which rider to assign the individual order, the system will usually assign that rider a batch of three to five orders....The system will [then] consider 11,000 possible routes [for pickup and delivery]. It is possible for the system to simultaneously assign 10,000 orders to 10,000 people in one second, with each rider receiving the optimum route."[16] The profitability of this model depends precisely on its scalability: a single algorithm can manage more humans engaged in more complicated processes than a dozen human dispatchers could.

Technology is also used as part of the deskilling process, a way to divide tasks into smaller and smaller segments and to rob workers of autonomy and knowledge—another *waimai* driver explains that because the algorithm "determine[s] the best sequence for delivering food and giving directions for each delivery route, the riders do not need to use their own brains, they just have to completely follow the system's directions."[17] Sometimes, the automated management of workers is part of a longer-term effort to automate the jobs themselves—Amazon worker Holland, for instance, describes the position Amazon calls "Problem Solvers," workers who monitor the work process for errors. Holland writes: "the constant going back and forth to Problem Solvers feels like we are Alpha Testing Amazon's systems, so that all the errors in the system can be ironed out before the inevitable introduction of robot workers who will take all our jobs."[18]

Most of all, and just as in the early days of industrialization, technology in the circulation sector is used to "sweat" labor—to force workers into a kind of perpetual self-management and thereby squeeze as much

16 Renwu, "Delivery Workers, Trapped in the System," (2020), https://chuangcn.org/2020/11/delivery-renwu-translation (accessed February 25, 2022), n.p.

17 Ibid.

18 Holland, "Amazon Inquiry," p. 10.

work out of each hour of labor as possible via forced speed-up, tracking, and workplace discipline: Holland describes the timing system where workers' speed and output are constantly tracked via wearable surveillance devices: "you must stow at least 1 item every three, four, five minutes (the precise time changes regularly) and are liable to have your pay docked for idle time...We're told that we're allowed to have toilet breaks but in reality there's no way you can get to the toilet and back in time to prevent being flashed as idling."[19]

These uses of technology notwithstanding, how-ever, a large part of the twenty-first- century circula-tion economy still depends on a mechanism that Marx first described in his account of the nineteenth-century sweating system: not a machine but a means of wage payment, namely piece-rate or payment by results. We tend to assume that the standard for wage payment is an hourly wage, but in fact, as Marx notes, piece-rate wages, where workers are paid by output or performance, are the mode "most in harmony with the capitalist mode of production."[20] Hourly wages are the method of wage payment suited specifically to mechanized manufactur-ing labor: the standardization and regulation of hourly wages depended on the development of industrial tech-nology that could regulate output automatically. When first introduced, the hourly minimum wage in the US was only applied to a narrow portion of industrial work-ers laboring in highly mechanized industries. Workers in the service economy were not included under labor protections until many decades later, and even then a large portion of service workers were excluded from the standard minimum wage and dependent instead on tips to make up the difference between the legally codified "subminimum wage"—still set, at the US federal level, at $2.15 an hour. According to a 2009 study, piece rate

19 Ibid., pp. 13–14.
20 Marx, *Capital Vol. 1*, pp. 697–698.

or performance-based pay has risen substantially since the 1970s and has contributed significantly to income inequality; in the years since that study was released, the rise of gigwork and independent contracting, especially in the service and logistics economies, has increased the portion of workers earning a non-guaranteed income yet again.[21] Port truckers for companies like Amazon, for instance, are independent contractors who are only paid—in a "logistics revolution" version of nineteenth-century piece-work—when they are actually moving goods, not when they are waiting to pick them up, which means that workers sometimes are earning less than a dollar a week, especially when they are forced to wait in line for hours due to supply chain bottlenecks.

A worker's inquiry by a Deliveroo driver likewise notes that in many European cities, the app started as a pay-by-hour system and then moved to a pay-by-delivery system whose rules tended to change constantly to ensure that improvements in average wages were only temporary.[22] Piece-rate systems of payment reduce the cost of management since the worker essentially "sweats" herself—as Marx puts it, "it is naturally the personal interest of the labourer to strain his labour-power as intensely as possible; this enables the capitalist to raise more easily the normal degree of intensity of labour [and]....to lengthen the working day."[23] Delivery riders in Wuhan confirm the relevance of Marx's insight for contemporary circulation work, describing the piece-rate system as a kind of gamification which draws workers' self-worth in line with capitalist management techniques: "They want us to work day and night ... Last month, I hit 'Black Gold' status, and if I

21 Thomas Lemieux, W. Bentley MacLeod, Daniel Parent, "Performance Pay and Wage Inequality," *Quarterly Journal of Economics* CXXIV, no. 1 (2009), pp. 1–49, here pp. 1–2.
22 Alice Barker, "Cycling in the City," in *From the Workplace: A Collection of Worker Writing*, ed. Notes from Below (2020), p. 59.
23 Marx, *Capital Vol. 1*, p. 695.

want to keep that ranking, I still need 832 points—I've got a lot of work to do still."[24] Along with increased informalization, contemporary piece-rate methods of wage payment indicate that the contracted, hourly, formal wage may be not the norm towards which capitalism tends but a temporary twentieth-century exception. More and more work arrangements in the circulation and service economy have been (or remained) informalized, especially in underdeveloped countries which effectively skipped the long period of industrialization that shaped the development of labor regulations and unionization in the US and Europe and moved directly from agriculture to services.[25]

The *volte face* of the logistics economy's modernized infrastructure, technology, and information systems is thus its use of much older, proto-industrial forms of labor organization, management, and wage payment. Likewise, the complexity and scale of logistics has as its complement the far more simple and direct exchanges that occur in the low-waged service sector. Much as the pandemic revealed the imperfections in both the free market and the revolutionized logistics economy, it has also exposed the relationship between circulation and this small-scale human labor, particularly insofar as it normalized hiring others to do tasks like grocery shopping and food delivery and as consumers became willing to shift their own risk onto low-waged delivery workers. From this perspective, the best image of the liquid circulation economy might not be the infrastructural sublime of shipping containers stacked high, but rather a photograph of a *waimai* delivery driver (fig. 2) forced to walk across a flooded road because instructed

24 Renwu, "Delivery Workers."
25 Aaron Benanav, "The Origins of Informality: The ILO at the Limit of the Concept of Unemployment," *Journal of Global History* 14, no. 1 (2019), pp. 107–125 and Aaron Benanav, "Service Work in the Pandemic Economy," *International Labor and Working-Class History*, no. 99 (2021), pp. 66–74.

Fig. 2: Liquid circulation, photograph from Renwu, "Delivery Workers, Trapped in the System" (November 2020).

by the algorithmic boss, or a photograph of port trucks[26] waiting in line for hours to pick up backlogged cargo, time for which their drivers are not paid.

For Robbins, the sweatshop sublime registers the vastness of global production, a vastness larger than the capacities of the imagination itself. Confronted with the abyss of late capital, we sink back into ourselves: our "sudden, heady access to the global scale is not access to a commensurate power of action *on* the global scale."[27] The logistics revolution depends on access to similarly vast views of the whole, the globe, the cognitive map. But such perspectives can never achieve the self-perfecting,

26 See the photograph by Jason Armond illustrating an article by Chris Megerian and Don Lee, "Biden will announce expanded operations at Port of Los Angeles as supply chain crunch continues," 13 October 2021, *LA Times*, https://www.latimes.com/politics/story/2021-10-13/biden-will-announce-expanded-operations-at-port-of-los-angeles-as-supply-chain-crunch-continues (accessed December 22, 2021).

27 Robbins, "Sweatshop Sublime," p. 85. Anna Tsing aptly names this problem one of "supply chain bigness," though her account of the alternatives to bigness is fairly different from my own. See Anna Tsing, "Supply Chains and the Human Condition," *Rethinking Marxism* 21, no. 2 (2006), pp. 148–176.

subjectless omniscience toward which they yearn—Friedman's "magic of the free market." Hence the cascading failures of supply chains both early in the pandemic (as demand tumbled) and later (as it rebounded more quickly than expected, driven—as is so much of the global economy—mostly by US consumers eager to spend their way out of the lockdown doldrums).

But what if understanding circulation work—reckoning with the human touch and human labor that actually allows for the liquid flow of all those goods—requires not sublime unknowability, but painfully proximate knowledge? What if what is demanded of us today is not to feel the paralysis of distant complicity but to confront the equally challenging fact of our close and immediate participation in the exploitation of service, circulation, and logistics workers? What has it meant to accept the idea that others might take on risk so that we might receive goods into our hands?

To try to think through our involvement in this process—to understand it ethically and socially but also analytically—we might need not just genres of the sublime but also genres of intimate solidarity. The genre I have in mind—the genre from which I have been quoting throughout the second half of this essay—is the worker's inquiry. Marx used the Blue Books and health and safety reports to produce workers' inquiries from above: what, he asked, are the empirical conditions of factory work? The contemporary workers' inquiries cited in this essay, by contrast, have been inquiries from below: here, they say, is what it takes for you to receive a bag of groceries or a takeaway carton or an Amazon package.[28]

28 These kind of workers' inquiries were developed out of various strands and groups of twentieth-century Marxist thought, especially the Johnson-Forest Tendency group in the US and the autonomist/operaisti thinkers in Italy and France. See Asad Haider and Salar Mohandesi, "Workers' Inquiry: A Genealogy," *Viewpoint Magazine* 3 (2013), https://viewpointmag.com/2013/09/30/issue-3-workers-inquiry. Not incidentally, in the US these projects often emerged from workers and theorists at some remove from the clas-

Written by workers at Amazon and Deliveroo and Ubereats and *waimai* services, the inquiries quoted in this essay provide vivid, intimate descriptions of both the technical and the political composition of modern circulation work. Read from the inside of circulation work, they offer tactical advice to workers trying to prevent time and wage theft (or even just fuck with management a little bit) as well as strategic advice to those working to unionize.[29] Read from the outside of circulation work, they ask us to name and see and feel the cataclysm of our complicity without being paralyzed by it—or, put otherwise, they demand that we don't just shamefully acknowledge our participation in exploitation, but actually participate less, that we directly and immediately refuse to accept the calculus by which risk and misery can be absorbed by those "without reserves."[30]

<hr />

sic industrial working-class: from Black workers first subject to the ravages of deindustrialization (deskilling and sweating as well as technological unemployment) and from Marxist-feminists committed to understanding the politics of reproductive work. See Annie McClanahan, "Industry Culture: Labor and Technology in Marxist Cultural Theory," in *After Marx: Literature, Theory, and Value*, ed. Colleen Lye and Christopher Nealon (Cambridge, UK: Cambridge University Press, 2022 [forthcoming]).

29 On the difference between the strategy and tactics of circulation workers, to whom the point-of-production strikes that expressed the power of the industrial working-class are not available, see Joshua Clover's *Riot Strike Riot*, e.g. "In addition to disaggregation and deskilling as barriers to organization, the traditional downing of tools presupposes a sense of moral possession by the workers of their equipment, a remnant of artisanal and craft cultures that provides a legitimating function alien to the realm of circulation." Joshua Clover, *Riot Strike Riot: The New Era of Uprisings* (London: Verso, 2016).

30 I am indebted here to Chris Nealon's beautiful work on left anti-humanism, in his 2017 talk "Marxism without Antihumanism": arguing that "we all still need good ways to take in the data of suffering and struggle," Nealon seeks out "another way to honor and combat suffering that doesn't construct elaborate theoretical arguments whose ultimate payoff can sometimes seem like nothing other than an insistence on the moral superiority of bad feeling?" I quote (with permission) from an unpublished manuscript, but Nealon makes a similar argument in "The Anti-Humanist Tone," *Affect and Literature*, ed. Alex Houen (Cambridge, UK: Cambridge University Press, 2020).

These are genres not of awesome distance but of temporary intimacy, not vast scales but minor knowledge, not cogs in a massive machine but goods moved hand to hand, not the awe of the unrepresentably sublime totality but the demand to respond to what is directly before us. The possibilities are right there, in our hands.

List of Illustrations

Ursula Biemann: Devenir Universidad

1 *Donald Moncayo acting as a forensic soil chemist.* Video still from: Ursula Biemann and Paulo Tavares, *Forest Law*, 2014, 38 min., sync 2-channel video essay, copyright Ursula Biemann. **2** *Marine biologist.* Video still from: Ursula Biemann, *Acoustic Ocean*, 2018, 18 min., video installation, copyright Ursula Biemann. **3** *Visiting the future site for the university in Plamonte*, March 2021, copyright Ursula Biemann. **4** *Community meeting with the Inga authorities on the University project*, March 2021, copyright Ursula Biemann. **5** *Field excursion with ETH students of Studio Anne Lacaton in the Inga territory*, October 2019, copyright Ursula Biemann.

Maryse Ouellet: A Realist Aesthetic of the Sublime

1 Edward Burtynsky, *Xiaolangdi Dam #1*, Yellow River, Henan Province, China, 2011, photo(s): © Edward Burtynsky, courtesy Nicholas Metivier Gallery, Toronto. **2** Ursula Biemann, "Hydro Geographies," Video still from Ursula Biemann, *Deep Weather*, 2013, 9 min., video in color, copyright Ursula Biemann. **3** Edward Burtynsky, *Rice Terraces #2*, Western Yunnan Province, China, 2012, photo(s): © Edward Burtynsky, courtesy Nicholas Metivier Gallery, Toronto.

Martin Doll: Utopias of Flow and
Circulation in the Nineteenth Century

1 Charles Fourier, *Plan du traité de l'attraction passionnelle qui devait être publié en 1821*, oblong folio, approx. 34 x 51 cm, [Paris], imprimerie E. Duverger, n.d. [1844], photo: Bibliothèque nationale de France, Paris. **2** Charles Fourier, *Table with Daily Sessions of Labor with Meals in a Phalanstère*, from: Charles Fourier, *The Passions of the Human Soul*, ed. Hugh Doherty, vol. 2 (London: H. Bailliere et al., 1851), p. 47. **3** Charles Fourier, *Ground Plan of a Phalanstère*, from: Charles Fourier, *Le nouveau monde industriel et sociétaire*, 3. ed., *Œuvres complètes*, vol. 6 (Paris: Librairie sociétaire, 1848), p. 122. **4** Charles Fourier, *Aerial View of a Phalanstère* (approx. 1814), ink on paper, Archives Nationales, Paris, from: Ruth Eaton, *Die Ideale Stadt. Von der Antike bis zur Gegenwart* (Berlin: Nicolai, 2001), p. 125. **5** *Map of Utopian Settlements in the USA before 1860*, from: Alice Felt Tyler, *Freedom's Ferment. Phases of American Social History to 1860* (Minneapolis: University of Minnesota Press, 1944), p. 113.

Sebastian Kirsch: "Where the Sun Does Not Reach,
There the Doctor Will Appear"

1 Interior of the Krause's homestead, sketch from Gerhart Hauptmann, *Vor Sonnenaufgang. Soziales Drama* (Berlin: C.F. Conrad's Buchhandlung, 1889), p. 7. **2** Exterior of the Krause's homestead, sketch from Hauptmann, *Vor Sonnenaufgang*, p. 36.

Malte Fabian Rauch: Critique de la Circulation

1 Film still from Guy Debord, *Critique de la séparation*, 1961, 20 min., 35 mm, extracted from Guy Debord, *Contre le cinéma: œuvres cinematographiques completes*, 3 DVDs (Neuilly-sur-Seine: Gaumont, 2005). **2** Chombart de Lauwe, *Aerial view*, from: Chombart de Lauwe, *Paris et agglomeration Parisienne* (Paris: Presses Universitaires de France, 1952),

from: Thomas F. McDonough, "Situationist Space," *October* 67 (1994), pp. 58–77, here p. 71. **3** Chombart de Lauwe, *Diagrammatic map*, from: Chombart de Lauwe, *Paris et agglomeration Parisienne* (Paris: Presses Universitaires de France, 1952), from *Internationale Situationniste* 1 (1958), p. 28.

Beny Wagner: Plasmaticness and the Boundaries of Human Perception
1 Film still from *Merbabies* (dir. Walt Disney, USA 1938), extracted from The Big Cartoon Database. **2** Film still from *Spirochaeta Pallida (Agent de la Syphilis)* (dir. Jean Comandon, France 1909), extracted from Wikimedia Commons.

Yvonne Volkart: Flowing, Flooding, Fibbing
1 Video still from Carolina Caycedo, *A Gente Rio/We River*, 2016, 29 min. 20 sec.,1-channel HD video, courtesy the artist. **2** Carolina Caycedo, *Geocoreografias: Aguas Para A Vida*, collective action in Ibirapuera Park in São Paulo, November 5, 2016, photo courtesy the artist.

Hannah Schmedes: The Im:permeable Sieve
1 Screenshot from Blogpost, Sara Ahmed, "Queer Use," November 8, 2018, *Feministkilljoys*, https://feministkilljoys.com/2018/11/08/queer-use/ (accessed August 29, 2021).

Yannick Schütte: Lead Fish Story
1 Allan Sekula, *"Lead Fish." Variant of a conference room designed for the Chiat/Day advertising agency. Architect: Frank Gehry. Installation at the Museum of Contemporary Art, Los Angeles. May 1988*, 1988, silver-dye bleach print, 69 x 84.2 cm, courtesy the Allan Sekula Studio. **2** George Cruikshank, *All the World is Going to See the Great Exhibition of 1851*, 1851, etching, plate: 21.4 x 28 cm, sheet: 31.8 x 50 cm, New York: The Metropolitan Museum of Art, photo: The Elisha Whittelsey Collection, The Elisha Whittelsey Fund, 1966.

Annie McClanahan: Essential Workers
1 Containers on covers—book jacket images for Martin Christopher's *Logistics and Supply Chain Management* (Harlow: Pearson, 2016) and Deborah Cowen's *The Deadly Life of Logistics: Mapping Violence in Global Trade* (Minneapolis: University of Minnesota Press, 2014). **2** Liquid circulation, photograph from Renwu, "Delivery Workers, Trapped in the System" (November 2020), https://chuangcn.org/2020/11/delivery-renwu-translation/ (accessed December 22, 2021).

List of Color Plates

1 Ursula Biemann and Paulo Tavares, *Forest Law*, 2014, 38 min., sync 2-channel video installation at BAK, basis voor actuele kunst, Utrecht, 2015, © Ursula Biemann. **2** Ursula Biemann, *Acoustic Ocean*, 2018, 18 min., multimedia installation at Taipei Biennial, 2018, © Ursula Biemann. **3** Edward Burtynsky, *Colorado River Delta #2*, Near San Felipe, Baja, Mexico 2011, photo: © Edward Burtynsky, courtesy Nicholas Metivier Gallery, Toronto. **4** Ursula Biemann, "Carbon Geologies," black ponds. Video still from: Ursula Biemann, *Deep Weather*, 2013, 9 min., video in color, © Ursula Biemann. **5** Charles-François Daubigny, *View of a Phalanstère [Vue d'un phalanstère, village français]* (1847), lithography, 44.8 x 30 cm, imprimerie Prodhomme, photo: Bibliothèque nationale de France, Paris. **6** Fred Moten and Wu Tsang, *Gravitational Feel*, 2016, performance, photo: Florian Braakman, courtesy If I Can't Dance, I Don't Want To Be Part Of Your Revolution, Amsterdam. **7** Fred Moten and Wu Tsang, *Gravitational Feel*, 2016, performance, photo: Florian Braakman, courtesy If I Can't Dance, I Don't Want To Be Part Of Your Revolution, Amsterdam. **8** Film stills from *The Enemy Bacteria* (dir. Walter Lanz, USA 1945), extracted from the Internet Archive. **9** Film still from Ashley Hans Scheirl, *Dandy Dust (cybernetic planet 3025)*, 1998, 94 min., 16 mm, courtesy of the artist. **10** Video still from Tabita Rezaire, *Sugar Walls Teardom*, 2016, 21 min. 30 sec., HD video, courtesy of the artist and Goodman Gallery, South Africa. **11** Carolina Caycedo, *Yuma, Or The Land of Friends*, 2014, digital print on acrylic glass, installation view, 8th Berlin Biennial photo: courtesy of the artist. **12** George Gower, The Plimpton Sieve portrait of Queen Elizabeth I., 1579, oil on wood, 104.4 x 76.2 cm, Washington D.C.: Folger Shakespeare Library, photo used by permission of the Folger Shakespeare Library, ART 246171 (framed), DIFN 3219. **13** Allan Sekula, *Bilbao* (diptych, left side), 1998, color photograph, 32.5 x 64 cm, courtesy the Allan Sekula Studio. **14** Allan Sekula, *Bilbao* (diptych, right side), 1998, color photograph, 32.5 x 64 cm, courtesy the Allan Sekula Studio. **15** Allan Sekula, *Shipyard-workers' housing—built during the Second World War—being moved from San Pedro to South-Central Los Angeles from the series Fish Story May 1990*, 1990, silver-dye bleach print, 61.3 x 77.8 cm, courtesy the Allan Sekula Studio.

Contributors

Ursula Biemann creates video essays and texts that address the interconnection of politics and the environment across local, global, and planetary contexts. Based in Zurich, Switzerland her research involves fieldwork in remote locations from Greenland to Amazonia, where she investigates climate change and the ecologies of oil and water. She is involved in the co-creation of an Indigenous University for biocultural knowledge for which she generates video archives, exhibitions and the online platform deveniruniversidad.org. The newest video work *Forest Mind* (2021) emerges from this context of bridging western and indigenous knowledge systems. Her video installations are exhibited worldwide in museums and international art biennials. She has had numerous solo exhibitions, has published several books and launched an online monograph *Becoming Earth*. Biemann has a BFA from the School of Visual Arts and attended the Whitney Independent Study Program in New York (1988). She received a doctorate *honoris causa* in Humanities from the Swedish University Umea, as well as the Swiss Grand Award for Art-Prix Meret Oppenheim and the Prix Thun for Art and Ethics.

Mathias Denecke is a researcher at Ruhr-Universität Bochum. He holds a BA and MA dregree in Literature Arts Media Studies at University of Konstanz and defended his doctoral thesis "Flows in Digital Cultures" in 2021 at Leuphana University Luneburg. Denecke's key research areas are media theory, data infrastructures, and logistics. Recent publications include "'Work it.' Demands and entitlements of post-medial participation," *Augenblick* 80 (2021) and "Flows and streams of data: Notes on metaphors in digital cultures," in *Explorations in Digital Cultures*, ed. Marcus Burkhardt, Mary Shnayien and Katja Grashöfer (Lüneburg: meson, 2020).

Martin Doll earned his PhD in Media Studies in Frankfurt am Main with a thesis on forgeries and hoaxes (published as *Fälschung und Fake. Zur diskurskritischen Dimension des Täuschens*) after studying Drama, Theater, Media in Gießen. Following two years as a postdoctoral fellow at the ICI Berlin, he was an Assistant Professor in the research project "Aesthetical Figurations of the Political" in Luxemburg. Currently, he is Junior Professor for Media and Cultural Studies at the Heinrich Heine University Düsseldorf. He has published articles and book chapters on architecture as a medium, utopias and media, politics and media. Martin Doll is currently working on a book project on the technologization of politics/the politicization of technology in the nineteenth century. During his stays at Yale University, which were funded by the German Research Foundation (DFG), he established together with Paul North the "Yale-Düsseldorf Working Group on Philosophy and Media."

Katerina Genidogan is a doctoral candidate within the Research Training Group "Cultures of Critique" at Leuphana University Lüneburg. Her research lies at the intersection of postcolonial, black, environmental and critical development studies, and focuses on the relationship between the reconceptualization of racial difference since the mid nineteenth century, the environment, and modes of governance. Fieldwork in Ghana and Nigeria has been part of her research process. She has completed a BA in Business Administration with a major in Financial Management at Athens University of Economics & Business, a Graduate Diploma in Contemporary Art History and a MRes in Curatorial/Knowledge within the Visual Cultures Department at Goldsmiths University of London. She has taught the modules "Chronobiopolitics" and "Raciality, Ecology & Blackness" at Leuphana University. Recent publications include "Race Re(con)figurations through Speculative and Environmental Futurity," *View. Theories and Practices of Visual Culture*

(2021), and "Slow Cinema as an Ethico-Aesthetic Paradigm," *Counterfield Publication* (2020).

Sebastian Kirsch is a theater scholar who has taught at the universities of Bochum, Düsseldorf, Stockholm and Vienna and was most recently affiliated as a Feodor Lynen research fellow at the *Leibniz-Zentrum für Literatur- und Kulturforschung*, Berlin. Having worked on a wide range of issues concerning theater as well as questions of literature and media theory, Sebastian Kirsch holds his PhD (*Das Reale der Perspektive*, Berlin: Theater der Zeit, 2013) and his habilitation (*Chor-Denken. Sorge, Wahrheit, Technik*, Paderborn: Fink, 2020) from the Ruhr-Universität Bochum. He also held research and fellowship positions at the universities of Vienna and Düsseldorf as well as at the New York University. Besides his academic work, Sebastian Kirsch worked as an editor and regular author for the German theater magazine *Theater der Zeit* (2007–2013) and has been cooperating as a dramaturg with directors and performers Johannes M. Schmit and Hans-Peter Litscher.

Holger Kuhn works as assistant professor (Juniorprofessor) for Visual Culture and Art History at Bielefeld University. From 2016 to 2021 he was postdoctoral researcher at the DFG research training group "Cultures of Critique" at Leuphana University Lüneburg. From 2012 to 2016 he worked at the Department of Art History at Leuphana University. He is currently working on a book project on "Liquidity: The Cultural Logic of Governmentality in Contemporary Video and Film." His current research focuses on the questions of financialization and environmentalization in contemporary art. Recent publications include a book on the "holy kinship" and the construction of family in early capitalism, *Die Heilige Sippe und die Mediengeschichte des Triptychons* (Emsdetten and Berlin: Edition Imorde, 2018) and a book on the depiction of merchants in

paintings from the sixteenth century, *Die leibhaftige Münze. Quentin Massys' Goldwäger und die altniederländische Malerei* (Paderborn: Fink, 2015).

Esther Leslie is Professor of Political Aesthetics at Birkbeck, University of London. She studied for her BA in German and European Studies, MA in Critical Theory and PhD at the University of Sussex with some years also spent at the Free University Berlin. Much of her work has tracked connections between liberatory and repressive politics and forms of art. She has focused in the last couple of decades on an expanded sense of animation. This work developed out of a fascination with color, which led her towards political, aesthetic and interdisciplinary inquiries in the study of technology and science, under the mantle of what she calls a *poetics of science*. Newer work explores the poetics and politics of milk and butter production, specifically in Ireland, the metaphorical impulses of Fog and Cloud Computing, and what type of atmospheres they produce and are produced by, and the impact of chemical production on landscape and personhood in the North East of England.

Annie McClanahan is an Associate Professor of English at the University of California, Irvine. She is the author of *Dead Pledges: Debt, Crisis, and Twenty-First-Century Culture* (Stanford: Stanford University Press, 2016). She is currently completing a book tentatively titled *Tipwork, Gigwork, Microwork: Culture and the Wages of Service*. She is co-editor of the online, open-access peer-reviewed journal *Post45*, co-directs UCI's Black Studies Cluster Ph.D. recruitment project, and is on the advisory board for UCI-LIFTED, a prison education program.

Maryse Ouellet is an art historian and research associate in the Department of Media Studies at the University of Bonn. She was the organizer of the conference "The Real Within Reach: Contemporary Realisms and the

Arts" (2020) and is currently working on a volume on art's realism in collaboration with Amanda Boetzkes. Her writings on the sublime, realism, and melancholia in contemporary art have been published in *Konsthistorisk tidskrift*; *Racar, Canadian Art Review*; *Etc. Montreal*; and the volume *The Imaginary: Word and Image/ L'imaginaire: texte et image* (Leiden: Brill/Rodopi, 2015).

Malte Fabian Rauch works in the interdisciplinary research project "Cultures of Critique" at Leuphana University Lüneburg. His work focuses on recent continental philosophy, contemporary art and aesthetics, as well as design theory. After studying in Hamburg, London and at the New School in New York, he is currently completing his PhD on aesthetic theories of disintegration.

Hannah Schmedes works at the Brandenburg Center for Media Studies (ZeM). She completed her BA in Philosophy and Cultural Studies at Leuphana University Lüneburg and her MA in Media Studies at the University of Potsdam with a thesis on "Containing: Leaks. A research on figures of the porous." Schmedes' key research focuses on feminist science studies, media culture history, anthropology and infrastructure, as well as their gender-specific metaphorization. She organizes feminist writing workshops on Wikipedia's publishing and interface policies. Recent publications include "A Laboratory for Living Off-World: Re-narrating Biosphere 2," in *Earth and Beyond in Tumultuous Times*, ed. Réka Gal and Petra Löffler (Lüneburg: meson press, 2021).

Yannick Schütte is a researcher and writer interested in the cultural and spatial ramifications of information technology and digital media. Drawing on architecture, media theory, philosophy of science and literary studies his current research centers around the aesthetic and poetological dimensions of knowledge

production. Schütte holds a Master's degree in European Media Studies from University of Potsdam and a Bachelor's degree in Cultural Studies from Leuphana University Lüneburg with a visit at Université Bordeaux Montaigne. After two years working at Humboldt University Berlin's Cluster of Excellence "Matters of Activity" he has recently joined Berlin-based art publisher Hatje Cantz. Schütte's publications include "Richtungslose Relationen. Über Die Beziehung von Mensch und technischem Objekt," in *Mensch und Welt im Zeichen der Digitalisierung*, ed. Anna Henkel et al. (Baden-Baden: Nomos, 2019).

Christian Schwinghammer is a PhD student at the research group *SENSING: The Knowledge of Sensitive Media* in Potsdam. With a background in Political Sciences, which he studied at the Free University of Berlin, his research is positioned in the overlap of media studies, philosophy and the natural sciences. He is currently working on a doctoral project about the recent re-negotiation of ontology in the name of indeterminacy and relationality, interrogating its ethico-political potentials in light of and in regards to changed self and world understandings and questions of alterity.

Jacob Soule is Assistant Teaching Professor of English at Drew University in Madison, New Jersey. In 2019, he received his PhD in Literature from Duke University after completing his BA and MPhil at the University of York and the University of Cambridge respectively. He is currently working on adapting his doctoral dissertation, "The City Novel After the City: Planetary Metropolis, World Literature," into a monograph. He has written on infrastructure and the historical novel for *Contemporary Literature* and has contributed articles on the contemporary city novel to *Novel: A Forum on Fiction* and *The Oxford Research Encyclopedia of Literature.*

Milan Stürmer is a research associate for the research project "Media and Participation" at Leuphana University Lüneburg, where he works on the economic elements of participation. At the intersection between media theory, economics, anthropology and the philosophy of technology, his research centers on the proliferation of forms of debt in the twentieth and twenty-first century in the context of the breakthrough of an ecological, relational thinking. His current additional work focusses on the philosophies of Alfred North Whitehead and Bernard Stiegler. He completed his BA at the University of the West of England in Bristol (UK) and his MA at Leuphana University, where he is currently undertaking his doctoral studies. He has taught at Leuphana University and the University of Cambridge. Together with Michel Schreiber, he has recently edited a special issue on *Post-Mass-Media and Participation* (Augenblick, 2021) and has written on the question of the organism in contemporary finance in *Fit for Finance* (Parole Compendium, 2021).

Yvonne Volkart is head of research and lecturer in art theory and cultural media studies at the *Institute Art, Gender, Nature*, Academy of Art and Design FHNW Basel. She also holds a teaching position at the Master of Arts in Art Education, Zurich University of the Arts and works as freelance curator and art critic. From 2017–2021 she headed the research project *Ecodata–Ecomedia–Ecoaesthetics*, funded by the Swiss National Science Foundation SNSF, for which she is completing the monograph *Technologies of Care. From Sensing Technologies to an Aesthetics of Attention* (Diaphanes, in print). From 2022–2026 she directs the SNSF research project *Plants_Intelligence. Learning like a Plant*. In collaboration with Sabine Himmelsbach and Karin Ohlenschläger she curated the exhibition and book project *Eco-Visionaries. Art, Architecture and New Media After the Anthropocene* (Hatje Cantz, 2018). Recent publications include "AbfallMaschinen"

in *Reichweitenangst. Batterien und Akkus als Medien des Digitalen Zeitalters*, ed. Jan Müggenburg (Bielefeld: transcript, 2021).

Beny Wagner is an artist, filmmaker, researcher, and writer. Working in moving image, text, installation, and lectures, he constructs non-linear narratives that probe the ever-shifting threshold of the human body. He has explored themes ranging from the social and political histories of measurement standardization to the material politics of waste, to taxonomies of monsters in European science. He has presented his work at Berlinale, IFFR, Eye Film Museum Amsterdam, Museum of Moving Image New York, Transmediale, Los Angeles Film Forum, 5th and 6th Moscow Biennale for Young Art, Berlin Atonal, Venice Biennale, White Columns among many others. His writing has been published in *e-flux*, *Valiz* and *Sonic Acts Press* among others. He is a PhD candidate at the Archaeologies of Media and Technology Group at Winchester School of Art. He was a lecturer at Gerrit Rietveld Academy Amsterdam and is currently an assistant lecturer at Queen Mary University London.

Stefan Yong is a PhD candidate in the department of History of Consciousness at the University of California, Santa Cruz. He holds a BA in Black Studies from Amherst College. His current work examines questions of logistics, capital, and power through approaches from international political economy, maritime economic history, critical finance studies, and Marxist cultural theory. His dissertation research focuses on the place of maritime shipping in the political economy of the postwar capitalist regime.

Color Plates

Plate 1: Ursula Biemann and Paulo Tavares, *Forest Law*, 2014, 38 min., sync 2-channel video installation at BAK, basis voor actuele kunst, Utrecht, 2015.

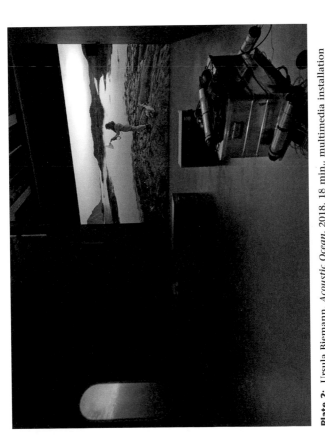

Plate 2: Ursula Biemann, *Acoustic Ocean*, 2018, 18 min., multimedia installation at Taipei Biennial, 2018.

Plate 3: Edward Burtynsky, *Colorado River Delta #2*, Near San Felipe, Baja, Mexico, 2011.

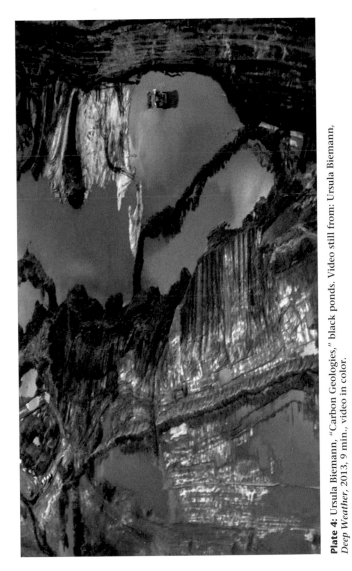

Plate 4: Ursula Biemann, "Carbon Geologies," black ponds. Video still from: Ursula Biemann, *Deep Weather*, 2013, 9 min., video in color.

Plate 5: Charles-François Daubigny, *View of a Phalanstère [Vue d'un phalanstère, village français]* (1847), lithography, 44.8 x 30 cm, imprimerie Prodhomme.

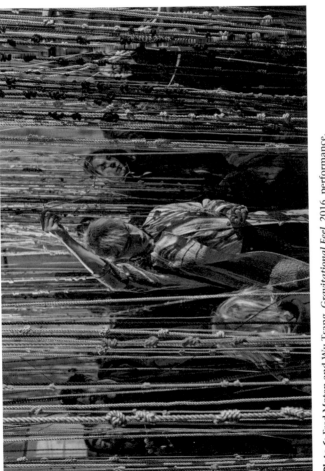

Plate 6: Fred Moten and Wu Tsang, *Gravitational Feel*, 2016, performance.

Plate 7: Fred Moten and Wu Tsang, *Gravitational Feel*, 2016, performance.

Plate 8: Film stills from *The Enemy Bacteria* (dir. Walter Lanz, USA 1945).

Plate 9: Film still from Ashley Hans Scheirl, *Dandy Dust (cybernetic planet 3025)*, 1998, 94 min., 16 mm.

Plate 10: Video still from Tabita Rezaire, *Sugar Walls Teardom*, 2016, 21 min. 30 sec., HD video.

Plate 11: Carolina Caycedo, *Yuma, Or The Land of Friends*, 2014, digital print on acrylic glass, installation view, 8th Berlin Biennial.

Plate 12: George Gower, The Plimpton Sieve portrait of Queen Elizabeth I., 1579, oil on wood, 104.4 x 76.2 cm, Washington D.C.: Folger Shakespeare Library.

Plate 13: Allan Sekula, *Bilbao* (diptych, left side), 1998, color photograph, 32.5 x 64 cm.